Transcultural things and the spectre of Orientalism in early modern Poland–Lithuania

Manchester University Press

rethinking
art's histories

SERIES EDITORS
Amelia G. Jones, Marsha Meskimmon

Rethinking Art's Histories aims to open out art history from its most basic structures by foregrounding work that challenges the conventional periodization and geographical subfields of traditional art history, and addressing a wide range of visual cultural forms from the early modern period to the present.

These books will acknowledge the impact of recent scholarship on our understanding of the complex temporalities and cartographies that have emerged through centuries of worldwide trade, political colonization, and the diasporic movement of people and ideas across national and continental borders.

To buy or to find out more about the books currently available in this series, please go to: https://manchesteruniversitypress.co.uk/series/rethinking-arts-histories/

Transcultural things and the spectre of Orientalism in early modern Poland–Lithuania

Tomasz Grusiecki

Manchester University Press

Copyright © Tomasz Grusiecki 2023

The right of Tomasz Grusiecki to be identified as the author of this work has been asserted by him in accordance with the Copyright, Designs and Patents Act 1988.

Published by Manchester University Press
Oxford Road, Manchester M13 9PL
www.manchesteruniversitypress.co.uk

British Library Cataloguing-in-Publication Data
A catalogue record for this book is available from the British Library

ISBN 978 1 5261 6436 0 hardback

First published 2023

The publisher has no responsibility for the persistence or accuracy of URLs for external or any third-party internet websites referred to in this book, and does not guarantee that any content on such websites is, or will remain, accurate or appropriate.

Typeset by Newgen Publishing UK
Printed in Great Britain by TJ Books Ltd, Padstow, Cornwall

This book is dedicated to Tadeusz Mańkowski (1878–1956)

Contents

List of figures	*page* viii
Acknowledgements	xiii
A note on names	xv
Map: The Polish–Lithuanian Commonwealth in the sixteenth and seventeenth centuries	xviii
Introduction: Between worlds	1
1 Where is Sarmatia?	30
2 How do you dress like a Pole?	57
3 Who speaks for Poland?	101
4 Where do Polish carpets come from?	147
Epilogue: Beyond the binary	194
Bibliography	203
Index	237

Figures

0.1 Emanuel Pendl, Monument to Georg Franz Kolschitzky, 1885. Vienna, corner of Kolschitzkygasse and Favoritenstraße (photograph taken by the author) 2
0.2 Kolschitzky Coffee. Screenshot of the Julius Meinl official website, www.meinlcoffee.com/gb/products/kolschitzky-coffee-ground-250g, 30 November 2020 3
0.3 Martin Dichtl (attributed), *Georg Franz Kolschitzky as Scout in Ottoman Dress, 13 August 1683*, from Johann Constantinus Feigius, *Wunderbahrer Adlers-Schwung, oder fernere Geschichts-Fortsetzung Ortelii redivivi et continuati: das ist eine aussfuerliche Historische Beschreibung dess noch anhalten den Tuerchen-Kriegs*, Vienna: Voigt, 1694, vol. 2, fol. 48, engraving. Munich, Bayerische Staatsbibliothek, Eur. 914 0-1/2 (photograph provided by Bayerische Staatsbibliothek, Munich) 7
1.1 Andrzej Pograbka, *Partis Sarmatiae Europeae quae Sigismundo Augusto Regi Poloniae Potentissimo subiacet, nova descriptio*, 1570, printed in Venice, 68 x 46 cm. Munich, Bayerische Staatsbibliothek, 2 Mapp. 464 (photograph provided by digitale-sammlungen.de/MDZ: Münchener DigitalisierungsZentrum, Digitale Bibliothek) 31
1.2 Nicolaus Germanus, Eighth Map of Europe (Sarmacia Europea), in *Cosmographia Claudii Ptolomaei Alexandrini*, c. 1460. New York, Manuscript and Archive Division, New York Public Library, Astor, Lenox and Tilden Foundations, 427027 (photograph provided by the New York Public Library Digital Collections) 39
1.3 Bernard Wapowski, fragment of a proof print of the map of Sarmatia, facsimile (original woodcut made in 1526; lost during World War II), from Karol Buczek, *The History of Polish Cartography from 15th to the 18th Century*, Wrocław: Zakład Narodowy im. Ossolińskich, 1966, fig. 9 (photograph provided by University Library, University of Illinois) 41

1.4 Wacław Grodecki, *In Poloniae laudem, et tabulae huius commendationem*, facsimile (original printed in 1562 by Johann Oporinus in Basel), from *Monumenta Poloniae Cartographica*, ed. Karol Buczek, vol. 1, Cracow: Polska Akademia Umiejętności, 1939, Tab. VI (photograph provided by polona.pl/Biblioteka Narodowa) 44

2.1 Giovanni de Monte, *Portrait of Sebastian Lubomirski*, c. 1560, oil on canvas, 173 × 113 cm. Warsaw, Muzeum Pałacu Króla Jana III w Wilanowie, Wil.1150 (photograph provided by Muzeum Pałacu Króla Jana III w Wilanowie) 58

2.2 Anonymous (Poland?), *Portrait of Sebastian Lubomirski*, after 1603, oil on canvas, 200 × 120 cm. Warsaw, Muzeum Narodowe, MP 5510, provenance: the Potocki of Krzeszowice collection (photograph by Piotr Ligier/Zbigniew Doliński, provided by Muzeum Narodowe w Warszawie) 59

2.3 Martin Kober, *Portrait of King Stephen Báthory*, 1583, oil on panel, 236 × 122 cm. Cracow, Historical and Missionary Museum of the Congregation of the Mission (photograph provided by Muzeum Historyczno-Misyjne Zgromadzenia Księży Misjonarzy w Krakowie) 66

2.4 Workshop of Tommaso Dolabella (?), *Shuysky Czars before Sigismund III*, seventeenth century, restored in 2011–13, oil on canvas, 340 × 340 cm. Copy of a lost painting by Dolabella of c. 1611. Lviv Historical Museum, Pidhirtsi Castle Collection (photograph provided by Lviv Historical Museum) 68

2.5 Anonymous, *Variety of Polish Costumes*, seventeenth century, oil on panel, 117 × 89.5 cm. Poznań, National Museum, Mp 841 (photograph provided by Muzeum Narodowe w Poznaniu) 73

2.6 Leszko II, from Marcin Bielski, *Kronika wszytkiego świata*, Cracow: Mattheusz Siebeneycher, 1564, fol. 341v., woodcut. Cracow, Biblioteka Książąt Czartoryskich – Muzeum Narodowe w Krakowie, 22 III Cim (photograph provided by polona.pl/Biblioteka Książąt Czartoryskich) 76

2.7 Stawisz's family line, from Bartosz Paprocki, *Gniazdo cnoty zkąd herby rycerstwa sławnego Krolestwa Polskiego … początek swoy maią*, Cracow: Andrzej Piotrkowczyk, 1578, fol. 66, woodcut. Warsaw, Biblioteka Narodowa, SD XVI.F.64 (photograph provided by polona.pl/Biblioteka Narodowa) 78

2.8 Daniel Schultz, *Portrait of Stanisław Krasiński*, c. 1653, oil on canvas, 93 × 77 cm. Warsaw, Muzeum Narodowe, MP 4312, provenance: the Krasiński Museum collection (photograph provided by Muzeum Narodowe w Warszawie) 80

2.9 Polish–Lithuanian sejm in session, from Alessandro Guagnini, *Sarmatiae Europeae descriptio: quae regnum Poloniae, Lituaniam,*

Samogitiam, Russiam, Massoviam, Prussiam, … et Moschoviae, Tartariaeque partem complectitur, Speyer: Bernhard Albin, 1581, fol. Aiiii, woodcut by Jörg Brückner (blockcutter, attr.) and Wendel Scharffenberg (printmaker). Cracow, Biblioteka Jagiellońska, BJ St. Dr. Cim. 8138 (photograph provided by polona.pl/Biblioteka Jagiellońska) 83

3.1 Stefano della Bella, *Entry of the Polish Embassy into Paris*, drawing on paper in pen and brown ink, over graphite, 2.30 × 4.84 cm. London, British Museum, 1895, 0617.399 (photograph provided by the British Museum) 107

3.2 François Campion (engraver), Nicolas Berey (printer), *Le festin nuptial du Roy et de la Reine de Pologne—La magnifique entrée des Ambassadeurs Polonois dans la ville de Paris*, 1645, engraving. Paris, Bibliothèque nationale de France, département Estampes et photographie, RESERVE QB-201 (38)-FOL (photograph provided by gallica.bnf.fr/Bibliothèque nationale de France) 109

3.3 Stefano della Bella, *Entry of the Polish Ambassador into Rome*, 1633, sheet 1, etching, first or second state of three, 17.1 × 264.8 cm. 'Entrata in Roma dell'Eccl.mo ambasciatore di Polonia l'anno MDCXXXIII'. Metropolitan Museum of Art, New York, bequest of Phyllis Massar, 2011, 2012.136.965(1–6) (photograph provided by The Metropolitan Museum of Art) 118–19

3.4 Stefano della Bella, *Entry of the Polish Ambassador into Rome*, 1633, sheet 2 120–21

3.5 Stefano della Bella, *Entry of the Polish Ambassador into Rome*, 1633, sheet 3 122–23

3.6 Stefano della Bella, *Entry of the Polish Ambassador into Rome*, 1633, sheet 4 124–25

3.7 Stefano della Bella, *Entry of the Polish Ambassador into Rome*, 1633, sheet 5 126–27

3.8 Stefano della Bella, *Entry of the Polish Ambassador into Rome*, 1633, sheet 6 128–29

3.9 Melchior Lorck, *Turkish Horseman with Fantastical Winged Costume*, from *Wolgerissene und geschnittene Figuren zu Ross und Fuss, sampt schönen türckischen Gebäwden, und allerhand was in der Türckey zu sehen*, Hamburg: Michael Hering, 1626, fol. 19, woodcut. Copenhagen, Royal Library, Hielmst. 188 2° (photograph provided by Det Kongelige Bibliotek) 130

3.10 Stefano della Bella, *Turkish Horseman with Fantastic Winged Costume*, pen on white paper. Florence, Gallerie degli Uffizi, Gabineto Disegni e Stampe, inv. 6024 Santarelli, fol. 75 of the artist's sketchbook (photograph provided by Gallerie degli Uffizi) 131

3.11 Melchior Lorck, *Turkish Archer*, from *Wolgerissene und geschnittene Figuren zu Ross und Fuss, sampt schönen türckischen Gebäwden, und allerhand was in der Türckey zu sehen*, Hamburg: Michael Hering, 1626, fol. 39, woodcut. Copenhagen, Royal Library, Hielmst. 188 2° (photograph provided by Det Kongelige Bibliotek) 132

3.12 Stefano della Bella, *Studies of a Headress, Horse, and Turkish Archer*, pen and black pencil on white paper. Florence, Gallerie degli Uffizi, Gabineto Disegni e Stampe, inv. 6018 Santarelli, fol. 69 of the artist's sketchbook (photograph provided by Gallerie degli Uffizi) 133

3.13 Stefano della Bella, *Entry of the Polish Ambassador into Rome*, 1633, sheet 1, detail 133

4.1 Carpet, seventeenth century, Czartoryski Collection, from *Les collections cèlèbres d'oeuvres d'art, dessinées et gravées d'après les originaux par Édouard Lièvre*, ed. Ambroise Firmin-Didot et al., Paris: Goupil, 1879, plate 60, photolithograph by Édouard Lièvre. Paris, Bibliothèque nationale de France, département Sciences et techniques, FOL-V-347–2 (photograph provided by gallica.bnf.fr/ Bibliothèque nationale de France) 148

4.2 Carpet, seventeenth century, Czartoryski Collection, from Alfred Darcel, *Les tapisseries décoratives du garde-meuble … Choix des plus beaux motifs*, Paris: J. Baudry, 1881, plate 94, photolithograph by P. Dujardin. Westsächsische Hochschule Zwickau, 92050530 (photograph provided by sachsen.digital/SLUB Dresden) 149

4.3 The *Czartoryski Carpet*, seventeenth century, 'Polonaise', made in Iran, probably Isfahan, cotton (warp), silk (weft and pile), metal-wrapped thread, asymmetrically knotted pile, brocaded, 486.4 × 217.5 cm. New York, Metropolitan Museum of Art, gift of John D. Rockefeller Jr. and Harris Brisbane Dick Fund, by exchange, 1945, 45.106 (photograph provided by the Metropolitan Museum of Art) 156

4.4 So-called Polish carpet with the coat of arms of King Sigismund III of Poland, c. 1600, made in Iran, silk and golden thread, 243 × 134 cm. Munich, Residenz, BSV.WA316, formerly ResMü. WC3 (photograph by Lucinde Weiss, provided by Bayerische Schlösserverwaltung) 161

4.5 So-called Polish carpet with the coat of arms of King Sigismund III of Poland, c. 1600, made in Iran, probably Kashan, silk and metal thread, tapestry weave, 245 × 135 cm. Munich, Wittelsbacher Ausgleichsfonds, WAF Inv.-Nr. T I b 1 (photograph provided by Wittelsbacher Ausgleichsfonds) 162

4.6 Safavid 'Polonaise' kilim with the coat of arms of Sigismund III of Poland, c. 1600, made in Iran, probably Kashan, silk and metal

thread, tapestry weave, 206 × 59 cm. Washington, DC, Textile Museum, R33.28.4, acquired by George Hewitt Myers in 1951 (photograph provided by the Textile Museum) 163

4.7 Safavid 'Polonaise' kilim with the coat of arms of Sigismund III of Poland, c. 1600, made in Iran, probably Kashan, silk and metal thread, tapestry weave, 250 × 134 cm. Rome, Quirinal Palace (photograph by Foto Azimut s.a.s., Maurizio Necci, Rome, provided by Segretariato Generale della Presidenza della Repubblica) 164

4.8 Tapestry with the coat of arms of Princess Anne Catherine Constance Vasa, Brussels, 1630/40. Munich, Residenz, BSV. WA0172 (photograph by Peter Fink, provided by Bayerische Schlösserverwaltung) 167

4.9 Polish rug, second half of the seventeenth century, Ghiordes knot, linen thread, and wool, 195 × 145 cm. Cracow, Muzeum Narodowe, NMK XIX-4451 (photograph provided by Pracownia Fotograficzna Muzeum Narodowego w Krakowie) 170

4.10 Johann Hoffman (printer), *Equestrian Portrait of King John Casimir*, second half of the seventeenth century, engraving and etching, 34.5 × 25.5 cm. Warsaw, Biblioteka Narodowa, G.45497 (photograph provided by polona.pl/Biblioteka Narodowa) 171

4.11 Medallion Ushak-type carpet with the coat of arms of Krzysztof Wiesiołowski, before 1635, Anatolian or Polish, knotted wool, 348 × 227 cm. Cracow, Wawel Royal Castle, inv. 240 (photograph by Łukasz Schuster, provided by Wawel Royal Castle) 174

4.12 Medallion Ushak-type carpet with the coat of arms of Krzysztof Wiesiołowski, first half of the seventeenth century, Poland(?), wool, 363 × 197 cm. Berlin, Museum für Islamische Kunst, 4928 (photograph by Christian Krug, provided by Museum für Islamische Kunst der Staatlichen Museen zu Berlin – Preußischer Kulturbesitz) 176

4.13 Carpet with ornamental design, seventeenth century, Poland(?), wool, 240 × 167 cm. Munich, Bayerisches Nationalmuseum, Inv.-Nr. T 1612, Foto Nr. D52101 (photograph by Bastian Krack, provided by Bayerisches Nationalmuseum) 177

4.14 Henryk Weyssenhoff, *Story of a Yatagan*, 1891, oil on canvas, 73 × 90 cm. Warsaw, Muzeum Narodowe, MP 5357 (photograph by Krzysztof Wilczyński, provided by Muzeum Narodowe w Warszawie) 180

5.1 Mosque in Kruszyniany, eighteenth century(?), renovated in 1846 (photograph provided by Wikimedia Commons, https://commons.wikimedia.org/wiki/File:Meczet_w_Kruszynianach_front_side.jpg) 195

Acknowledgements

Like many authors, I have accumulated numerous intellectual debts in the course of writing *Transcultural Things*. I owe particular thanks to Angela Vanhaelen, without whose unwavering support and invaluable advice a project of this breadth could never have been kicked off in the first place. Several other scholars read parts of the manuscript at various stages, helping me sharpen my thinking on a number of issues. These selfless people are, in alphabetical order, Stan Bill, Letha Ch'ien, Andrzej Drozd, Carolyn Guile, Cecily Hilsdale, Suzanna Ivanič, José R. Jouve-Martin, Igor Kąkolewski, Simon Lewis, Robyn Radway, Christine Ross, Itay Sapir, Braden Scott, Maria Taboga, Milena Tomic, Wojciech Tygielski, and Danijela Zutic. More recently, the anonymous readers chosen by Manchester University Press offered thoughtful and incisive criticism that led me to further refine this book's arguments. My terrific line editor and wordsmith extraordinaire, Amyrose McCue Gill of TextFormations, read multiple drafts of the completed manuscript with a steadfast commitment to clarity of expression and the broader stakes of the project. I am incredibly grateful to all of these readers; any remaining errors are my own.

At Manchester University Press, I have had the privilege of working with Amelia Jones, whose passion for the project was seminal for turning my work into book form. Emma Brennan, Alun Richards, and Katie Evans made the process of bringing this manuscript to fruition a pleasure at every step.

The research and writing of *Transcultural Things* were supported by McGill University, Central European University, Boise State University, and the Fonds de recherche du Québec – Société et culture. I also received funding from the Dean of the College of Arts and Sciences at Boise State University and the RSA-Samuel H. Kress Research Fellowship in Renaissance Art History to help offset some of the production costs.

For their interest, support, and insight, I thank Robert Born, Amy Bryzgel, Stephen J. Campbell, Waldemar Deluga, Niharika Dinkar, Karin Friedrich, Robert Frost, Andrea Gáldy, Anu Gobin, Anna Grasskamp, Jan Hennings, Maria Ivanova, Grażyna Jurkowlaniec, Thomas DaCosta Kaufmann, Nikos Kontogiannis, Ruth Sargent Noyes, Craig Peariso, Olenka Pevny, Stephanie

Porras, Alessia Rossi, Dan Scott, Allie Stielau, Alice Sullivan, Anatole Tchikine, Lee Ann Turner, and Bronwen Wilson. Special thanks again to Suzanna Ivanič and Robyn Radway for our ongoing collaborations, in particular the *Connected Central European Worlds, 1500–1700* networking project that continues to give me hope for the future of early modern Central and Eastern European studies, a field that barely existed in English-speaking academe when we were students.

Portions of this book have appeared elsewhere, adapted and revised here: 'Doublethink: Polish Carpets in Transcultural Contexts', *The Art Bulletin* 104, no. 3 (2022), and 'Sarmatia Revisited: Maps and the Making of the Polish–Lithuanian Commonwealth', in *Multicultural Commonwealth: Poland–Lithuania and its Afterlives*, eds. Stanley Bill and Simon Lewis (Pittsburgh: University of Pittsburgh Press, 2023), earlier versions of parts of chapters 3 and 1, respectively. I thank the editors and readers of these publications for their stimulating feedback.

Last but by no means least, my love and thanks go to Emanuel Chabot for all his support and patience through years of research, writing, and rewriting.

A note on names

There is no satisfactory solution to rendering in English the personal and place names of the Polish–Lithuanian Commonwealth. The polity, one of the largest in early modern Europe, was multi-ethnic, multi-denominational, and multi-lingual, and many of its inhabitants themselves used different versions of their names in different contexts. To facilitate readability and consistency, I have left the most commonly used versions of personal names in their respective native or dominant languages; thus, for example, Jerzy Ossoliński and Christoph Hartknoch. Whenever an individual may have been known by different names in different places or languages, I have listed all possible versions at first use; thus, Adam Kysil (Polish: Adam Kisiel); Iodocus Ludovicus Decius (German: Jost Ludwig Dietz; Polish: Justus Ludwik Decjusz); and Marcin Kromer (German: Martin Cromer; Latin: Martinus Cromerus). I have made an exception for Polish–Lithuanian rulers who were kings of Poland as well as grand dukes of Lithuania and were, therefore, known by Polish names in Poland and Lithuania, Ruthenian names in Ruthenia (and Lithuania), and German names in Prussia and Livonia. To strike a balance among these local variants, I have opted for English and Anglicized Latin equivalents; thus, Sigismund I, Sigismund II, Stephen I, Sigismund III, Ladislaus IV, John Casimir, and John III. Needless to say, the fact that Polish was the first language of Lithuanian and Ruthenian families like the Houses of Radziwiłł (Lithuanian: Radvila), Pac (Lithuanian: Pacas), and Wiśniowiecki (Ukrainian: Vyshnivetskii) says nothing about their national identity.

Place names present yet another challenge for historians writing in English about the Polish–Lithuanian Commonwealth, and this includes the very name by which the polity itself is known today in Anglophone scholarship. The term most frequently used by early modern Polish–Lithuanian nobility is the Polish proper name *Rzeczpospolita*: Republic or Commonwealth. Whenever it is clear from context that I refer to all the lands of the post-1569 union, therefore, I use the English term 'Commonwealth'. In most instances, however, I prefer the clarity of the modern English short form 'Poland–Lithuania', which does not exist in Polish, Lithuanian, Ukrainian, or Belarusian, but is typical of

Anglo-American and German scholarship. For other place names, I employ the standard English form where one exists; thus Warsaw and Cracow. I also use the most globally recognizable modern versions of names of major towns like Vilnius, Lviv, and Kyiv. I apply the same principle to names of lands and provinces; thus Mazovia (rather than Mazowsze), Little Poland (rather than Małopolska), and Ruthenia (rather than Rus'). The latter refers to the early modern Ukrainian and Belarusian communities as well as their territories, language (various dialects of Eastern Slavic), and ecclesiastical life (Orthodoxy and Greek Catholicism) before the distinction between Ukrainian and Belarusian identities was increasingly taken for granted during the nineteenth century. In all other cases, I spell place names as they appear in the language most often used by my sources; thus—most notably—Danzig (rather than Gdańsk). In solidarity with Ukrainian colleagues whose country has suffered insurmountable losses following the Russian invasion in February 2022, I have made an exception for all place names in today's Ukraine; thus Kulchytsi (rather than Kulczyce), Kamianets-Podilskyi (rather than Kamieniec Podolski), and Pyliavtsi (rather than Piławce). This choice will not please everyone, but at least it counters the longstanding Polonocentrism in the historiography of the Polish–Lithuanian Commonwealth.

Admittedly, most sources and case studies in this book come from Poland. I have nevertheless framed this study as one of the entire Commonwealth, first because I make frequent reference to Ruthenia—and to a lesser extent also to Lithuania and Prussia—and second because I believe that the history of early modern Poland cannot be told without referring to its entanglements with all the constituent lands of the union. An ideal scholar of Poland–Lithuania would need to read German, Low German, Latin, Hebrew, Kipchak, Lithuanian, Latvian, Old Slavonic, Old Ruthenian, Ukrainian, Belarusian, and Polish to conduct research in the archives and have full access to the secondary literature on this vast polity. The complex linguistic landscape points to the problem of untranslatability of much scholarship on Polish–Lithuanian material and visual culture—not in the sense of being unable to translate accurately from one language to another but rather in the sense of never being able to stop revising and updating the scholarship produced in the many national contexts of Poland–Lithuania's successor states, let alone construct an accepted scholarly synthesis. What on the surface may appear a disadvantage, however, can become a strength if we consider Poland–Lithuania a case study for dialogic scholarship that stresses different kinds of historical experience as well as the need to mediate their meaning in a modern context dominated by nation-states. New collaborative projects and networks have emerged in recent years, promising to take the study of the union in a new transcultural and international direction.

As for the region of Europe encompassing Poland–Lithuania, my preference is for 'Central and Eastern Europe'. 'Eastern Europe' still reeks of Cold

War binaries, despite Larry Wolff's widely publicized, if controversial, claim in *Inventing Eastern Europe* (1994) that the concept is in fact much older and can be traced back to the eighteenth century. Following the revolutions of 1989, which brought to an end most communist regimes, attempts have been made to blur the dividing lines among the continent's nations, with Poland and Lithuania joining the European Union in 2004. The 2022 Russian invasion of Ukraine has ushered in a new potential division of Europe between West and East, with Belarus relegated to the latter as Russia's ally and Ukraine steadily pushing for membership in NATO and the EU. With all these changes underway, 'Eastern Europe' is as unstable as a geopolitical signifier as it is historically imprecise. Other framings of the region currently in use are no less controversial. 'Central Europe' recalls Friedrich Naumann's *Mitteleuropa* (1915) and offers an imperialist vision for the area as allegedly predestined for Germanic domination and tutelage. Yet the idea of Central Europe was attractive enough for the Moravian philosopher-turned-first president of Czechoslovakia Tomáš Masaryk (1850–1937) and the Polish historian Oskar Halecki (1891–1973), who resuscitated the term after World War I. Masaryk in particular believed that the history of the region was connected to Western Europe via Austria and Germany. Halecki's 'East-Central Europe' in his mind better rendered the region's status as an in-between place at a crossroads between East and West (though, for him, it was invariably part of the Western world). Drawing on these ideas in the 1980s, writers like Milan Kundera (b. 1929), Václav Havel (1936–2011), Czesław Miłosz (1911–2004), and György Konrád (1933–2019) argued that Czechoslovakia, Poland, and Hungary were culturally situated not in Eastern but in Central Europe, and therefore had the right to leave the Soviet Bloc and join the Western camp, where—as the argument goes—they had always belonged. The question remains whether it is productive to fight one binary with another—the idea of Central Europe simply moves the notional boundary of East versus West to the easternmost corners of Poland, Slovakia, and Hungary, keeping its divisive logic intact and leaving Ukraine and Belarus on the other side of the equation despite major dissimilarity between them (the former is a democracy, the latter a dictatorship). But, as this book argues, there is nothing contradictory in belonging to multiple cultural worlds simultaneously. For this reason, I believe that the open-ended phrase 'Central and Eastern Europe' is the least contentious and most accurate term: it embraces the widest possible geographical expanse of the region, connects rather than divides, and defies modern geopolitics in favour of early modern realities.

Translations are my own unless otherwise indicated. Where I used an early modern English translation of a source, I retained the original spelling but altered punctuation for clarity. Substantive changes to others' translations are marked with square brackets.

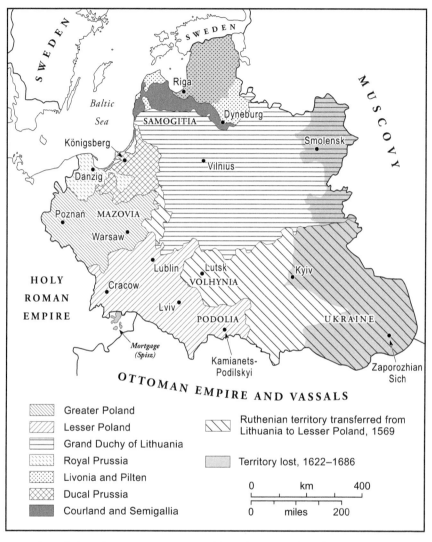

Map: The Polish–Lithuanian Commonwealth in the sixteenth and seventeenth centuries

Introduction: Between worlds

> I wasn't well received in Essex. I remember trying to reason with some white Cockney kids calling me 'Paki' at school once. 'I'm North African. I ain't Pakistani.' Blank looks. 'You're still a fucking Paki.' That summed it up. 'Paki' was how they saw anything 'other', between their understanding of complete whiteness and what they could clearly discern as blackness.
>
> <div align="right">Yann Demange, 'The Long Answer'[1]</div>

> Yet what if identity is conceived not as [a] boundary to be maintained but as a nexus of relations and transactions actively engaging a subject? The story or stories of interactions must then be more complex, less linear and teleological.
>
> <div align="right">James Clifford, Routes[2]</div>

A statue of an exotic looking man (Figure 0.1) adorns the corner of a grand apartment building at the intersection of Favoritenstraße and Kolschitzkygasse in Vienna's fourth district. The man wears a fez-like cap, an Ottoman kaftan, billowing trousers, and pointy shoes. And he pours coffee into a cup placed on a tray that he holds in his hand. Although his appearance is strikingly non-Viennese, the drink he presents to the passers-by has become synonymous with Vienna and its culture. The man's association with coffee is precisely the reason why he was memorialized in this prestigious location: many Viennese would still recognize the monument as a tribute to Georg Franz Kolschitzky (c. 1640–94), alleged owner of the first coffeehouse in the city and, by tradition, a hero of the 1683 Battle of Vienna—one of the most memorable events in the city's history, during which the Ottoman army besieged and almost captured the Habsburg capital. The statue was commissioned from the prominent sculptor Emanuel Pendl (1845–1927) for the three-hundred-year anniversary of the siege, and was fittingly placed on the façade of a building facing a street that had been named in memory of Kolschitzky just a year before.[3] One of the men involved in the commission was Karl Zwirina, proprietor of a well-known coffeehouse that occupied the site of the sculpture's location.[4] Thus, while promoting Zwirina's business, the monument also celebrates a vernacular Viennese custom as well as the city's local history.[5]

2 Transcultural things

0.1 Emanuel Pendl, Monument to Georg Franz Kolschitzky, 1885. Vienna, corner of Kolschitzkygasse and Favoritenstraße (photograph taken by the author)

Despite his importance for Vienna's self-image, however, purists could not call Kolschitzky a local man. Probably born in Kulchytsi (Polish: Kulczyce) into a noble family from the province of Ruthenia (województwo ruskie) in the Kingdom of Poland (today in Ukraine), his biography remains a subject of

Introduction: Between worlds 3

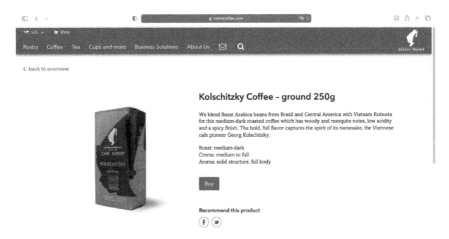

Kolschitzky Coffee. Screenshot of the Julius Meinl official website, 30 November 2020 **0.2**

debate.⁶ But while it is clear that he was not originally a citizen of Vienna, his foreign birth and exotic costume matter little to locals who value his contributions to the city's cultural landscape and treat the public monument dedicated to him as an important landmark, imbuing it with local significance. For all intents and purposes, Kolschitzky is not to them an outsider but a genuine Viennese, a sentiment evident in the names of several local businesses, including the coffee roastery Kafeekontor Kolschitzky and the Kolsch Coffee Shop in Wiener Neustadt.⁷ There is even a specialty coffee blend dedicated to Kolschitzky (Figure 0.2) roasted by Vienna's leading coffee purveyors, Julius Meinl, of which the professed 'bold, full flavour' described on the company's website 'captures the spirit of its namesake, the Viennese cafe pioneer Georg Kolschitzky'.⁸ The near-complete disavowal of the man's foreignness, so clear in this product description, rests on accepting both Kolschitzky's Viennese credentials and his impact on the city's sense of identity and place. His naturalization into the local tradition of a place that had not always been his home is by no means exceptional: it is just one example of the relatively common if seemingly paradoxical practice of upholding and reinforcing the collective identity of a community or society by assimilating foreign elements into its cultural vocabulary. But how is it even possible for foreign things to be perceived as local? This book sets out to examine this apparent contradiction.

Foreign as local

As a foreigner who introduced a once-exotic drink to the Viennese while making a name for himself in his adopted homeland, Kolschitzky offers us

an entry point into the world of foreign people, strange things, and new ideas that become an inseparable aspect of localness.[9] Although in surviving visual representations he appears visibly different from Vienna's native inhabitants, Kolschitzky's non-local origins and appearance fade into the background as his ethnic difference gets lost in the shuffle of Viennese cultural references—like coffee-drinking—that now feel entirely familiar and are indeed often seen as an 'essential part of Austrian culture'.[10] It is important not to lose sight of the decided non-nativeness of this now familiar national pastime, especially as today's defenders of European nations' cultural homogeneity on the political right continue to peddle a stream of nativist schemes premised on protecting the allegedly coherent nation and its supposedly native and authentic traditions from external—or foreign—influences.[11] Through the lens of often neglected Central and Eastern Europe—a region that throughout history has been situated at a crossroads of commercial routes, cultural interactions, and demographic flows—this book offers a rebuke to exclusionary and divisive views by demonstrating that European customs, pastimes, and traditions are seldom unique to a specific community. Instead, they are cultural conventions more often than not reappropriated—that is, employed not as originally intended—from abroad and yet treated as local, with their origins ignored, unknown, or unknowable.[12] In fact, European nations and societies often imagine themselves through the medium of foreign things without seeing this intermixture as a contradiction. While several studies have pointed out that nation-making often depends on tangible objects of material culture to make the abstract notions of 'nation' and 'national identity' palpable and accessible,[13] the foreign provenience of many such objects has still to be fully addressed. 'Provenience'—an important nodal point in this conflux of geography and culture—is a term derived from archaeology that refers to the location where an artefact is found during excavation within the grid of an archaeological site. Lacking both the ownership valence of 'provenance' and the rigid geographical determinism of 'origin',[14] provenience is well suited to the present study because it signals the act of uncovering an object's place in the art-historical sequence of its transmission—not whence an artform originally came but the site of its most recent incarnation. The term thus avoids the fruitless quest for the ur-origins of artforms as well as unproductive discussion of their singularity in national contexts.

A revision of national heritage along these lines is particularly overdue for the early modern period, the era of nations without ethno-nationalism, or before 'nationalism began to hate', as Brian Porter aptly put it,[15] when belonging to a nation was reserved for citizens of the realm, synonymous with politically enfranchised elites.[16] Exclusionary on the basis of social status, the early modern nation was a civic formation, and thus less reliant on ethnic solidarity than its modern namesake with its narrow fixation on language and

confession—particularly in the context of Central and Eastern Europe, where Kolschitzky's peripatetic life story is set.[17] As a political community of the realm rather than a bond of imaginary bloodlines, the early modern nation still professed a belief in its distinctive origins, distinguishing customs, and a unique way of life.[18] But before the rise of modern ethno-nationalism in Europe, a member of one national group could also claim a sense of belonging to another, navigating intersecting identities and personal biographies as well as merging and converging cultures associated with different regions and communities.[19] Often labelled transculturation, this process of the gathering and coming together of various forms of cultural expression—first identified by Cuban anthropologist Fernando Ortiz (1881–1969)—results in transformative changes that alter societies as they adopt new kinds of objects and materials into their ways of life.[20] These transcultural forms are subject to cultural recontextualizations; they often take up other forms, acquire new uses, and change meanings while reversing, upending, translating, surprising, and reappropriating local lifestyles and traditions.[21] If national heritage can be defined as 'items of historical or cultural significance handed down from generation to generation of a nation as a whole',[22] then this book addresses how these items began to signify as vernacular idioms in the first place, often through obscuring their foreign origin and tainting all subsequent discussions of the imagined purity of local and national culture as a result.

Addressed from this transcultural perspective, foreign things such as coffee introduced to Vienna by Kolschitzky—once considered external to the community they came to shape but later deemed part and parcel of the local way of life—might serve as a model for de-ethnifying culture, emphasizing its entangled character and weakening its ability to signify as an unalterable, cohesive whole. Kolschitzky's biographical details support this premise, highlighting how identity—be it national, regional, or local—is a fluid and multi-faceted process; not a fixed and immutable personal characteristic but a relational, lifelong undertaking contingent upon multiple contexts and subject positions that articulate historical alternatives to monolithic notions of culture.[23] For starters, it is impossible to define someone like Kolschitzky along ethnic lines. Several modern Polish scholars deem him a Catholic and thus an ethnic Pole, referring to him as Jerzy Franciszek Kulczycki;[24] their Ukrainian counterparts in contrast insist on his Orthodox and Ruthenian roots, calling him by his Ukrainian name Yuriy Frants Kulchytsky.[25] There is no evidence to support any of these claims, however, including Kulczycki/Kulchytsky's alleged admission to the Zaporozhian Cossacks, a *de facto* autonomous political entity in the south-eastern corner of the Kingdom of Poland that has often been seen as a nucleus for the sovereign Ukrainian nation in the modern era.[26] Even these anecdotal details of his youth fail to provide a convincing account of Kulczycki/Kulchytsky's ethno-cultural background, not least because the

transcultural character of early modern Ruthenia—located at a crossroads of Latin, Orthodox, and Muslim cultures—would have exposed him to various Polish, Ottoman, Vlach, and Tatar customs besides his native Ruthenian tradition, which was by no means pure, coherent, or self-contained in any case.

Adding further confusion, at some point Kulczycki/Kulchytsky is believed to have been captured by Ottoman forces and held captive in Constantinople (today's Istanbul) for several years, where he is said to have mastered the Turkish language and become acquainted with Ottoman society.[27] Then, in unexplained circumstances, he moved to Belgrade, finding employment as an interpreter with the Vienna-based Oriental Company (Orientalische Handelskompagnie). He eventually ended up in the Habsburg capital city of Vienna in 1678, where he is believed to have opened his own business in the trade of Oriental wares. It was there that he came to be known as Kolschitzky. Most of his biography before the move to Belgrade is apocryphal, as its components derive from eighteenth- and nineteenth-century sources without any documentary evidence.[28] What is certain is that, by the time of the Siege of Vienna, Kolschitzky had already lived in the Habsburg imperial city for at least five years, likely thinking of himself as a local, and thus—intentionally or not—transgressing the idea of cultural identity as a fixed, static attribute carried across a range of contexts and environments. The latter is a modern and nationalist definition of cultural identity that should not be imposed on early modernity.

We learn about Kolschitzky's transcultural performances of self during the 1683 siege from a near-contemporaneous account written by the Silesian historian and poet Johann Constantin Feige (1658–99) and published nine years later, in 1694.[29] Feige presents Kolschitzky as the man who accomplished nothing less than saving Christendom from falling into the hands of the Turks. In this narrative, Kolschitzky—who is said to be fluent in Turkish—clad himself in Ottoman costume and, unidentified as a pro-Habsburg emissary, crossed the enemy lines carrying important missives to Duke Charles V of Lorraine (1643–90), generalissimo of the Habsburg-led rescue army. So as to convince the city leaders to continue their defence efforts, Kolschitzky was given letters to carry back to beleaguered Vienna. Upon learning of the imminent relief force, the city leaders declined to surrender (their earlier plan) and continued fighting until the combined Habsburg and Polish–Lithuanian armies chased the Ottoman troops away from the walls of the imperial capital.[30]

Feige's account of Kolschitzky's adventures takes only three pages in a hefty volume that is over seven hundred pages long. But the author and the publisher clearly viewed Kolschitzky as an important contributor to the success of the Vienna rescue campaign: they included a full-page graphic portrait of Kolschitzky (Figure 0.3), one of only a few prints in the book. The image depicts him in Turkish attire and with other Ottoman paraphernalia, including a sabre

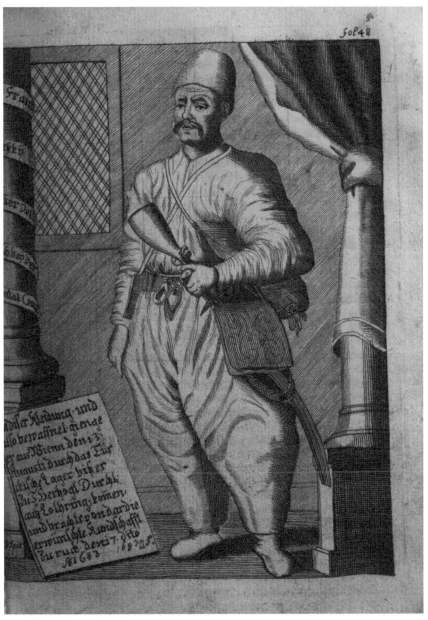

Martin Dichtl (attributed), *Georg Franz Kolschitzky as Scout in Ottoman Dress, 13 August 1683*, from Johann Constantinus Feigius, *Wunderbahrer Adlers-Schwung, oder fernere Geschichts-Fortsetzung Ortelii redivivi et continuati: das ist eine aussfuerliche Historische Beschreibung dess noch anhalten den Tuerchen-Kriegs*, Vienna: Voigt, 1694, vol. 2, fol. 48, engraving. Munich, Bayerische Staatsbibliothek, Eur. 914 0-1/2

0.3

and a fez. It is so similar in appearance to the street statue in Vienna by Pendl (Figure 0.1) that the print may have acted as a source of inspiration for the later representation. An inscription at the bottom left makes claims to the image's documentary status, proclaiming Kolschitzky's ability to emulate Turkishness as the driving force behind the success of the 1683 Vienna rescue mission:

> In this dress, and armed like this, [he] left Vienna on 13 August, and passing through the Turkish encampment he reached His Grace Duke Ch[arles] L[eopold] of Lorraine, and brought back the eagerly awaited news, on the 17th day of said month, AD 1683.[31]

The inscription reasserts that it was Kolschitzky's ability to pass for an Ottoman soldier that made possible the crucial exchange of intelligence between the imperial army and the city defence troops. Both the main body of Feige's text and the inscription acknowledge Kolschitzky's aptitude for shifting back and forth between cultural conventions, making manifest an environment in which the reappropriation of foreign cultural forms went hand-in-hand with confusion about their meaning. Kolschitzky was able to impersonate an Ottoman soldier, thereby deceiving the Turks, but as the main body of the text recounts, he was also, in reverse fashion, mistaken for a Turk by Austrian peasants who thought his camouflage an infallible sign of Turkishness and only let him through when shown 'something written from Vienna' (*etwas schrifftliches auß Wienn*).[32] The unsuspecting locals profiled Kolschitzky as an Ottoman soldier because of the material properties of his appearance, and it took material counter-evidence to convince them otherwise. Both the text and the engraved portrait insist on interpreting Kolschitzky's mission as a masquerade (he only dons Turkish costume temporarily to deceive the enemy), yet this masquerade is precisely how we remember the protagonist: he is perennially celebrated as an impostor Ottoman soldier, an identity nested within his status as a Central and Eastern European immigrant turned Viennese celebrity. As an image and as a literary construct, Kolschitzky reminds us that ethnicity, confession, and even language are not fixed categories guarded by impenetrable firewalls but rather a nexus of performative and descriptive utterances that are meaningful and relevant only insofar as they are perceived as such.[33]

Later sources reveal Kolschitzky as an adaptable historical character capable of embracing foreign cultural traditions with ease and comfort. Even though Feige's narrative makes no mention of it, eighteenth- and nineteenth-century variations on Kolschitzky's exploits during the Siege of Vienna make him still more amenable to transcultural analysis.[34] In these modern accounts, Kolschitzky is said to have come into possession of several sacks of green beans that had been left behind by the retreating Ottoman army. Because of the years he had spent in Constantinople, Kolschitzky recognized these beans as unroasted coffee and was granted an imperial privilege to open the first

coffeehouse in Vienna in recognition of his service to the city. The rest is history. Foreign to begin with, coffee soon became an inseparable aspect of local Viennese life. Who could now imagine Vienna without its omnipresent *Kaffeehäuser*?

But this story, too, is likely fiction. Kolschitzky, even if he ever ran a coffeehouse, was certainly not the first coffeehouse owner. Coffee had been known in Vienna prior to 1683, and its earliest coffeehouses were probably run by Syrians from Aleppo and Armenians.[35] By the 1880s—when Zwirina was commissioning the Kolschitzky statue above his coffeehouse—the story had come to function as an alluring urban myth. It perpetuated assumptions about local history not because there was any particularly strong historical evidence to confirm Kolschitzky's role as the first Viennese coffeehouse owner, but because the story appeared plausible by virtue of its apparent match with the available 'facts' about his life: captivity in Constantinople, rescue of Vienna, and circulating depictions of Kolschitzky in Ottoman costume. Tellingly, there is mutual dependency between localness and foreignness in this celebration of Viennese history. By acknowledging that the Ottoman custom of coffee drinking was brought to Vienna by a foreigner (a Ruthenian or a Pole) and profoundly changed the cultural landscape of the Austrian city, the story obscures the distinction between 'us' and 'them'. The man who was said to transform how Viennese spent their intellectual and leisure time and lead them to think of themselves as a city of coffeehouse culture is not celebrated as a foreigner after all but as a famous Viennese himself. He who gave Vienna its most beloved pastime became one of its most beloved children.

Kolschitzky's integration into Viennese lore is at least partly explicable by the fact that parts of Poland and Ruthenia were Austrian crownlands in the nineteenth century (the latter increasingly called Ukraine). Deeply engrained within Viennese self-perceptions, Kolschitzky's association with the city, however, does not prevent Polish historians from claiming him for Poland, citing undisclosed 'period sources' that allegedly reveal that he considered himself 'a native Pole'.[36] Yet such essentializing understanding of cultural belonging may prove meaningful only to a nativist who must untangle Kolschitzky's messy, untraceable life and situate it upon a linear historical path, pinning down his ethnicity, confession, and even his self-declared identity. Endeavours to naturalize these uncorroborated accounts notwithstanding, Kolschitzky's itinerant life experience makes it implausible that he would have defined himself along any clear-cut ethno-cultural lines. If anything, he might be described using Natalie Rothman's phrase: a 'trans-imperial subject' acting as a bridge between different societies rather than adhering to a single cultural tradition.[37] Adaptability to circumstances turns Kolschitzky into a confusing historical figure for a modern nativist who seeks to narrow ethnicity, insisting on a coherent national self-consciousness that persists throughout life.

Ongoing attempts to delimit Kolschitzky's cultural identity exclusively as Polish run parallel with past and present ethno-nationalist goals to make the nation visible, tangible, and experienceable as a unique, one-of-a-kind formation. All national communities have seemingly inimitable soundtracks, sights, and tastes that harvest emotions necessary for creating and sustaining each nation's alleged distinctiveness and autonomous existence.[38] The impact of visual and material culture on the rise of national sentiment is well examined, particularly in relation to how various images and objects have helped make abstract ideas of 'nation' and 'national identity' palpable and accessible to target audiences.[39] Eric Hobsbawm has called these formal paraphernalia of nationhood 'invented tradition', a term that describes rituals and practices such as, among others, donning the national costume, flying the national flag, and carrying the national emblem.[40] While it implies continuity with the past, these artefacts' significance tends in fact to be relatively recent and often largely fabricated. The mechanism of this socio-political constructionism has lately received much attention,[41] but the once foreign derivation of many of the material and visual forms that now make a given nation feel whole and complete is, with some notable exceptions, nearly absent in the literature on nationalism.[42]

This book seeks to redress this imbalance by investigating well-known foreign things that became vessels of vernacular tradition in early modernity, a process that can be traced through a wealth of published and archival sources. Taking the Polish–Lithuanian Commonwealth, Kolschitzky's birthplace, as a provocative repository of case studies, *Transcultural Things* examines artefacts such as maps that point to Poland–Lithuania's roots in the ancient land of Sarmatia (Chapter 1); shared clothing fashions that—despite their relative novelty and Ottoman provenience—purport to trace Polish culture back to a distant past (Chapter 2); costume used by Polish ambassadors as a visual emblem of their commonwealth (Chapter 3); and carpets described as Polish regardless of their foreign origin (Chapter 4). All of these material objects played a significant role in visualizing the shared cultural landscape of Polish–Lithuanian elites. But while modern scholarship defines these things as exemplary of a national heritage long understood as inherently Polish, early modern beholders treated them with more flexibility, seeing no contradiction in framing them as local cultural forms while simultaneously acknowledging their external provenience. Just as Kolschitzky swiftly moved among different cultural worlds, merging aspects of them into an admissible synthesis, so the men and women of the Polish–Lithuanian Commonwealth accepted foreign customs as native tradition without encountering a paradox.

A demi-Oriental place?

Given its location in Central and Eastern Europe, was Poland–Lithuania unusually susceptible to merging foreign and vernacular elements in its cultural

landscape? Established on 1 July 1569 by the nobilities of two territorial states, Poland and Lithuania, the Polish–Lithuanian Commonwealth superseded a looser union first forged in 1385 and lasted until 1795, when it was ultimately dissolved by neighbouring powers.[43] The act of union signed in Lublin states that 'the Kingdom of Poland and the Grand Duchy of Lithuania are one, indivisible and identical body; and thus identical, one and indivisible is the Commonwealth that has bonded and merged from two states and nations to one people'.[44] Despite this unifying rhetoric, however, Poland–Lithuania was a multi-ethnic, multi-lingual, and multi-confessional confederate polity with separate legal systems, treasuries, and armies. Located at the juncture of Central Europe, the lands of Eastern Orthodoxy, and the Ottoman Empire, it was a vast, culturally heterogeneous community of different peoples, traditions, and regional identities, roughly the size of today's France and Germany combined; its geographical position between worlds promoted interregional links, connections, and entanglements of various kinds. The Kingdom of Poland and the Grand Duchy of Lithuania were themselves ethnically, linguistically, and religiously polymorphous realms united through common political attitudes and participatory institutions rather than shared race, confession, or language (even though by the seventeenth century Polish had become the main mode of communication).

Poland–Lithuania was a civic not an ethnic idea—a community of the realm rather than of bloodlines—and it maintained sustained cultural differences as a Commonwealth.[45] Poles, Ruthenians, Lithuanians, and Germans constituted the majority of enfranchised citizens in the shared body politic, but both territorial states had economically vital minorities of Jews, Armenians, and Tatars, as well as Scots, Italians, and Dutchmen, to mention only the most populous groups.[46] While Roman Catholicism enjoyed privileges far greater than did other religions, Eastern Orthodoxy (since 1595 together with the Greek Catholic Church), various Protestant denominations of Christianity, Judaism, and even Islam could, too, claim adherents in these lands.[47] The union was also linguistically diverse: Polish, Ruthenian, and German were most commonly spoken, with Lithuanian, Yiddish, and Turkic languages also in use, though not among the nobles.[48] While the Polish nobility (*szlachta*) were the Commonwealth's dominant force, they were not in a position to ignore their social peers in Lithuania, Prussia, and Ruthenia.

Given this pluralist context, it should not come as a surprise that many citizens claimed to belong simultaneously to several nations within Poland–Lithuania—as did, for example, the political theorist Stanisław Orzechowski (Ukrainian: Stanislav Orikhovskii, 1513–66) who famously described himself as 'of the Scythian people and of the Ruthenian nation' (*gente Scytha, natione Ruthena*) and elsewhere as 'of the Ruthenian people but of the Polish nation' (*gente Roxolanus, natione vero Polonus*).[49] Both 'gens' and 'natio' could signify a community of the realm that today we would call a nation, but these

terms could also indicate descent from a noble estate, linguistic community, or confessional affiliation, in no way necessitating conflict with a larger 'multi-national' commonwealth.[50] Poland–Lithuania contained many parallel traditions and heritages that were constantly in flux; neither language nor confession nor place of birth would have given rise to, let alone secure, a fixed identity.[51] Still, there were things that the union's elites had in common.

The years around the Union of Lublin marked a period of notable political and cultural change facilitating the formation of a body politic that nationalism theorist Benedict Anderson would describe as an 'imagined political community'.[52] Often referred to in historiography as the 'Commonwealth of Both Nations', the renewed union of Poland and Lithuania established a single parliament, a common coin, and a shared defence policy (enforced by two separate armies), thereby transforming a dynastic union that had lasted for nearly two centuries into an entity that was effectively a confederation.[53] All adult male nobles were legal citizens in post-1569 Poland–Lithuania; they constituted a large class that, according to various estimates, included 5–10 per cent of the population.[54] Although demographically heterogeneous, many members of the nobility increasingly claimed a shared identity built on mutual participation in the affairs of the Commonwealth, the kind of group self-identification that historians call a 'political nation', meaning a community of citizens with shared rights and responsibilities.[55] We must recall, however, that confessional and linguistic parameters of identity were central for others in the Commonwealth, including some members of the Orthodox nobility—who could not sit in the Senate—and the Ukrainian Cossacks—who unsuccessfully sought legal inclusion in the noble estate.[56] In fact, the inability to address systemic inequities suffered by the Orthodox subjects of the Commonwealth contributed to its erosion in the mid-seventeenth century and to its ultimate downfall in the eighteenth. But for those with unrestricted access to civic and political life, ethnic, linguistic, and confessional differences were not strong enough to prevent them from imagining themselves as an entangled community of the realm. And as politics brought people together, some aspects of their material culture also began to converge.

Given the majority-Christian character of the Commonwealth, it is perhaps surprising that many of the shared elements of material culture in this vast political union resemble, in style, Ottoman objects and forms. This is especially true of the variety of garments worn in Poland–Lithuania, which would have appeared exotic to Western European observers, not unlike that of Kolschitzky in the descriptions and images above. The shift in sartorial preferences away from Italian and German towards Ottoman fashions—which occurred, among Poles and other Commonwealth subjects, during the late sixteenth century—has been interpreted as a form of 'self-Orientalization', an embrace of 'Eastern' material culture by a 'European' people.[57] Art and culture historian Tadeusz

Mańkowski (1878–1956), one of the earliest proponents of this theory, goes so far as to assert that Poles 'looked to the East as the cradle of their nation'.[58] This narrative summons the spectre of Orientalism, a fantasy of essentialized and exoticized otherness only loosely related to the actual places that the term 'East' has denoted since the emergence of Orientalist scholarship during the eighteenth century.[59] Did the Poles really 'look to the East' for cultural references as they absorbed elements of Ottoman fashion? Was their adaptation of costume to a new context an imitative practice, an aping of another culture's customs with no noteworthy change in intended purpose or any modification of design?

Charges of imitation and lack of agency are frequent elements of Orientalist discourse, which tends to draw a line between 'civilized' Europe and its negative 'other' in the East.[60] Central and Eastern Europe has itself fallen victim to this binary vision: historians of the region, most notably Larry Wolff and Maria Todorova, have argued that we tend to think of places like Poland, Ukraine, and Lithuania as 'European' only in a qualified sense (i.e., as 'Eastern European') and that this is a notional extension of the Orient into the region along the Continent's eastern rim.[61] Wolff even coined the term 'demi-Orientalism' to describe the region's status as a complementary 'other half' of Europe:—a backward, semi-barbaric realm, doomed to copy ideas and models developed elsewhere and thus to remain unable to define itself, always only reacting to Western European imaginings.[62] Admittedly, both Wolff and Todorova were examining the region's modern history, which raises the issue of using a term like 'demi-Orientalism' in relation to early modern societies, which did not yet strictly demarcate Europe's western and eastern halves.[63] Early modern Polish costume in particular can illustrate the point, as textual sources written in the Commonwealth invariably frame it as comfortably familiar, no matter how exotic the attire appeared to Western Europeans at the time—or to us today. While deemed strange outside Poland, such fashion was rarely defined as 'Eastern' by sixteenth- and seventeenth-century commentators. Crafted locally and seen by those abroad as typical of a kingdom that was a bastion of Christendom, Polish costume was nonetheless intertwined with Ottoman design, further material evidence that the inhabitants of the two heterogenous polities—Poland–Lithuania and the Ottoman Empire—were in continual contact enabled by cross-regional commerce and travel that straddled religious, political, and cultural lines.[64] As they were adapted to local contexts, Ottoman-style articles of clothing were not considered imitative but uniquely Polish—native rather than foreign. In its attention to how these things originally signified, this book zeroes in on their cultural multivalence with the aim of redressing the application of what have become commonplace terms like 'demi-Orientalism' and 'self-Orientalization' to interpretations of early modern Polish–Lithuanian culture and identity.

Things

Objects of material and visual Commonwealth culture—including maps of the union's territory, images of ancestors, clothing and decorative textiles, and representations of ambassadors' missions abroad—surrounded early modern beholders in their daily lives and during their social activities. Such objects were catalysts for imagining oneself as a member of a wider community of Poles, Lithuanians, Ruthenians, and Prussians—nations of the Commonwealth that, although distinct, generally shared similar tastes and ways of life. In embracing the agency of material forms, *Transcultural Things* follows the recent turn to materiality in art history, which acknowledges that artistic media and cultural forms have properties and affordances that shape human subjectivity and activity.[65] The defining characteristic of the new material studies—first expressed in the work of anthropologists and philosophers like Alfred Gell, Bruno Latour, Jane Bennett, and Graham Harman, to name a scant few—is that material forms should not be dismissed as inert lumps of matter waiting to be acted upon by human agents.[66] When objects and artefacts make a real impact on entire nations and peoples, they are better described as 'things': material forms with the capacity to act upon the world; active movers and shapers rather than passive carriers of tradition.[67] As they asserted themselves as things, the maps, prints, paintings, clothes, and carpets examined in this book together shaped their users' understanding of the world, in turn giving new meaning to material forms. To engage with materiality is thus to participate in what Martin Heidegger calls 'thinging': a process of moving beyond cerebral reference, of losing control over an object's fixed signification in the weight and bulk of its physical presence that defies language and buries itself in the world of lived experience.[68]

Accepting that the meaning of things is relational—subject to changes of context and reference—this book explores their impact on emerging self-identifications of the Commonwealth's Polish, Ruthenian, Lithuanian, and Prussian nobilities as they began to project their agricultural estates on the wider cartographic image of Poland–Lithuania; compare themselves to images of their alleged forefathers; dress in a manner resembling their fellow citizens; and furnish their houses with similar goods. Each chapter takes up a specific cultural form—Chapter 1, maps of Poland–Lithuania; Chapter 2, local costume; Chapter 3, images of Polish ambassadors; and Chapter 4, so-called Polish carpets—to examine how these artefacts became nexus of real and imagined commonalities among the otherwise heterogeneous Commonwealth elites, who increasingly found themselves searching for a convincing story about their shared place in the world. One of the central questions of this book is: How were the objects of Polish–Lithuanian material and visual culture able to frame such commonalities in the first place, given many Commonwealth things' foreign origins?

Chapter 1 begins to address this question by asking what it meant for Poland–Lithuania to emerge as a cartographic image associated with an ancient barbaric people from the Eurasian steppe—the Sarmatians. Like those of many other early modern nations, Polish–Lithuanian elites (and the scholars for whom they were patrons) creatively adapted classical philology and geography to trace the alleged historical continuity of their confederate polity back to classical antiquity. Drawing on authorities such as Ptolemy, Tacitus, Strabo, and Pliny, elites embraced an association of their native land with the Sarmatia of classical geographers—a borderland located between the known world of Europe and the unknown realms of Asia. This chapter tracks how the visual practices of charting the Commonwealth's geographical outline created not only a shared identity for the otherwise diverse nobility of the Polish–Lithuanian union but also a sense of the polity's longstanding connections to other European peoples. Modern historians and archaeologists have identified the Sarmatians as an Iranian people,[69] but this Orientalizing notion was absent from Polish–Lithuanian epistemologies. Thus what we might call the Sarmatization of Polish–Lithuanian historical geography in fact supported the Europeanization of the polity's invented tradition: allegedly its past was as old and rich as that of the Latin and Germanic peoples and was recorded by the same venerable classical authorities who confirmed its unchanged location. This chapter explores how this substitution of an early modern heterogenous society for a mysterious, ancient, and—reportedly—foreign and barbaric people came into being.

Chapter 2 continues this inquiry into Polish–Lithuanian self-perceptions via Commonwealth elites' adoption of Ottoman costume. Tracing clothing's dissemination across the region, this section of the book explores processes of transculturation, highlighting how sustained contact with other traditions changed the way recipient communities defined their own cultural milieus. While indebted to previous studies,[70] this chapter shows how new questions continue to emerge about stylistic Ottomanization of costume in Poland–Lithuania: How are we to understand the seeming paradox of adapting Islamic fashions for the needs of a predominantly Christian noble society? How could the exotic be identified as native without raising the eyebrows of this early modern nobility? The adaptation of Ottoman fashion was more than simply a projection of Ottoman sartorial style onto the material culture of Poland–Lithuania. Highlighting the popularity of Ottomanesque material forms in the Commonwealth, this chapter points beyond the dichotomy of Orient and Occident, revealing the process of inventing a self-avowedly Occidental sartorial tradition that was deeply embedded in 'Oriental' models, however inappropriately termed.

Chapter 3 focuses specifically on the ambassadorial entries of Jerzy Ossoliński into Rome (1633) and Łukasz Opaliński into Paris (1645), framing them as

performances in which the idea of Poland–Lithuania had to be pinned down and manifested in material and visual terms, particularly through the flamboyant display of costume. These two events are no random choice of materials for study. Indeed, they generated a profusion of textual and visual representations that circulated across Europe, propagating the notion of Poland–Lithuania as a mighty military power, victorious against the Turks and committed to the defence of Christendom. Simultaneously, however, European commentators pointed to the Ottoman overtones of Polish costume, comparisons that would later be used by modern historians to support interpretations of early modern Polish culture as a unique, quasi-Oriental formation, on the whole distinct from the rest (i.e., the West) of Europe. Albeit an attentive study of primary sources, this chapter does not undertake the antiquarian scrutiny of lesser-known material but rather examines critically the visual, material, and textual expressions embraced by Polish ambassadors as they embodied their monarch's realm. The aim is to redress the validity of 'Orientalism' as an analytical model for studying the transcultural aspects of early modern Polish culture.

Chapter 4 concludes this exploration by examining the group of carpets termed *tapis polonais* (French for 'Polish carpets'), which were mistakenly given this name in the nineteenth century despite their Iranian provenience. Today, these artefacts are often described as the 'so-called Polish carpets', emphasizing the historical confusion that led to the epithet. Relying on evidence from both early modern and modern archival and literary sources, this chapter argues that to uncover the significance of *tapis polonais*, however, we must embrace their transcultural contexts. Woven on Iranian looms, the carpets were often commissioned by Poles, Ruthenians, and Lithuanians; until the late nineteenth century, these objects were held in Central and Eastern European collections. Carpets based on similar designs were even produced in Poland–Lithuania, further complicating the discussion of these objects' cultural status. *Tapis polonais* effectively challenge outdated assumptions that the origin of an artform must be linked to a single nation or geography. These woven things engender a more horizontal narrative that treats with equal interest the many entangled places where *tapis polonais* were made, traded, consumed, and reinterpreted. Stressing the recontextualizations and reappropriations of these artistic objects, this chapter accordingly foregrounds the ongoing creation (and re-creation) of cultural forms that cannot be simply assigned to a single cultural region and its historical traditions.

As it probes how foreign visual and material forms could become the building blocks of vernacular tradition in Poland–Lithuania, *Transcultural Things* not only renders these artefacts more transnational than is conventionally acknowledged but also reveals their relevance to contemporary public history by exposing the role of things in engendering cultural memory. This is especially noteworthy today, when champions of nativism in Europe and North

America are increasingly embracing a false vision of the West's historical monoculturalism, allegedly rooted solely in Christian values.[71] In these delusional master narratives, artefacts often serve as representatives of national identities and cultural distinctiveness precisely because of their alleged historical association with a particular place.[72] But there is something paradoxical about discourse on cultural distinctiveness because, despite its exclusionary and insular rhetoric, the alleged uniqueness of a cultural community is often built on the adaptation (not only the rejection) of foreign elements. Once considered exotic, by the late sixteenth century the material forms examined in this study had begun to signify as local, and by the nineteenth century as native. With historical documents as its primary evidence, then, this book argues that the very idea of the 'origin' of artforms is misguided. After all, how can we ever determine what is 'native' and what 'foreign'; what is 'ours' and what 'theirs' in the context of culturally ambiguous artefacts that were in fact commissioned, produced, and consumed in transcultural contexts? *Transcultural Things* brings this epistemic incertitude to the fore, unfolding how an artefact can simultaneously belong to several cultural worlds, rendering cultural distinctiveness the domain of storytelling.

Towards a transcultural history of Poland–Lithuania

While cultural forms have traditionally been classified as originating in a particular location,[73] scholars have recently begun to embrace a multi-directional approach that acknowledges multiple antecedents of things, the possibility of provenience from more than one place, and a general cultural multivalence beyond the strict confines of national space.[74] Michel Espagne and Michael Werner were among the first to challenge outmoded emphases on the origins of cultural forms, considering instead how they circulated across geographies, undergoing transformations as things crossed borders and altered the contexts that embraced them.[75] This model frames so-called 'national cultures' not as autonomous and stable entities but as the result of ongoing processes of ebb and flow among societies. Blending and traversing different—although interconnected—cultural contexts, material and visual forms are transcultural rather than monocultural. This pluralist approach, often termed *histoire croisée* (intersectional history) in French, or entangled/connected history in English, challenges nationalist assumptions about cultural distinctiveness, pointing instead to the ongoing phenomena of adaptation and reappropriation of forms, media, and practices.[76] As cultural entanglement theorist Nicholas Thomas has aptly remarked: 'Objects are not what they were made but what they have become.'[77] Their circulation across geographical contexts suggests that the meanings and cultural valences of artefacts are never stable or fully formed. Instead, they are always changing and developing in dialogue with

other cultural forms and practices, bringing societies together as they cross paths, intersect, and become increasingly entangled.

Beginning with Claire Farago's pioneering work, historians of early modern art, too, have been expanding their understanding of visual and material culture beyond the context of artefact production and consumption, looking instead for signs and patterns of transculturation and examining histories that connect and converge.[78] But amid this recent surge of interest in Europe's links to the world, the role of often-overlooked parts of the continent, including Central and Eastern Europe, is being marginalized still further. Anglophone art history focuses predominantly on the economic hubs of early modern colonial power—Madrid, Lisbon, Amsterdam, London, and Paris—as the major players engaged with the world beyond Europe.[79] More recently, the non-colonial contexts of Italy and Germany have been added to the discussion,[80] but the global links of places like Poland–Lithuania are puzzlingly missing from the picture.[81] By concentrating on Latin Christendom's easternmost polity, this book aims to expand our framing of transculturation beyond Western Europe and its colonial possessions and trading posts, putting to the test the binaries of colony and metropole, foreign and local, self and other.[82]

Here it is important to emphasize that the historiography of Commonwealth art had been shaped by interest in transcultural narratives decades before the global turn gained momentum in Anglo-American art history. Thus it is admittedly somewhat misleading to claim to 'introduce' Poland–Lithuania to this discourse: already in the 1900s Polish scholars were considering the effects of Poland–Lithuania's proximity to the Ottoman Empire and the consequences of that nearness for local self-perceptions.[83] The most notable contributions are those by Mańkowski, who was among the first to study the reception of Ottoman and Persian costume, textiles, and metalwork in Poland–Lithuania. This reception, according to him, was possible because the Commonwealth 'became the territory where East and West met, where their cultural and artistic influences came into touch and intermingled, very often creating new, mediate forms of an interesting and peculiar kind'.[84] In his oft-cited monograph *Genealogia sarmatyzmu* (The Genealogy of Sarmatism, 1946), Mańkowski took an even stronger stance on the Commonwealth's connections with the 'East', as he framed it, asserting that the Polish–Lithuanian nobility traced its origin from the ancient Sarmatians, who were an Iranian people. It is because of this 'Eastern' origin, Mańkowski explained, that a Polish–Lithuanian predilection for Ottomanesque material culture endured.[85]

Mańkowski's general assumption about the eastward orientation of Polish–Lithuanian costume, textiles, and metalwork became a research paradigm for historians of art and material culture in Poland. Historians of costume have spoken of the 'Orientalization' of Polish dress in the sixteenth century;[86] art historians have explored the high demand for so-called 'Eastern' textiles in all

corners of the Commonwealth.[87] Several monographs and edited volumes are devoted to the expression of Polish–Lithuanian identities in costume, noticing that the Commonwealth's nobility saw no contradiction in priding themselves on their Christian virtue while wearing clothes with Ottoman—and hence Muslim—provenience.[88] This seeming paradox has never been resolved, and because most scholarship on Polish–Lithuanian visual and material culture has been published in Polish, Lithuanian, Belarussian, and Ukrainian, art historians elsewhere have not had the opportunity to consider deeply the theoretically generative possibilities that the study of Poland-Lithuania might offer a discerning scholar willing to venture into the lesser-known areas of art history.

Only recently has there been significant progress towards reaching a wider international audience for the history of Polish–Lithuanian art. Thomas DaCosta Kaufmann must be credited with making the field accessible to an English-speaking readership, with his *Court, Cloister, and City* (1995) serving as the first major study of the art of this geographical area since Jan Białostocki's *Art of the Renaissance in Eastern Europe* (1976).[89] While Białostocki's monograph sought (the allegedly) vernacular elements of art in Poland and was written from a nationalist point of view, Kaufmann foregrounded the polity's transcultural makeup and emphasized its artistic connections with other regions. He revisited Polish–Lithuanian art and culture in *Toward a Geography of Art* (2004), which pointed out the contradictions in seeing the Ottomanesque costume popular in Poland-Lithuania as an expression of ethnic lineage going back to the Sarmatians.[90] Rather than searching for the roots of ethnic identity, Kaufmann argued, it might be more fruitful to accept that the community of the realm had the capacity to imagine itself through material forms that were external to its historical heritage—especially as the Commonwealth contained several different proto-national communities within its borders. This is a vision of inclusive civic nationhood composed of multiple identities, languages, heritages, and cultures.

Kaufmann's uncompromised critique of monoculturalism paved the way for other art historians to present the Commonwealth as a medium for discussions of cultural pluralism and hyphenated identities, calling for a more inclusive and expansive approach in the study of Polish–Lithuanian visual and material culture.[91] The present study builds and expands upon this transcultural reassessment of art and culture in Poland-Lithuania, practising and advocating an approach attentive to the Commonwealth's internal heterogeneity and its external relations with other peoples, both in Europe and in West Asia. In James Clifford's famous terms, I am interested in routes rather than roots as I trace cultural entanglements, networks, and mobilities that challenge the conception of local, regional, and national histories as either immutable or self-contained.[92] This book focuses on foreign things that came to be recognized as local and native—or, 'traditional'—precisely because they allow

us to dispense with the tendency to treat the (modern) nation-state as the most fundamental unit of art-historical investigation.[93] As Eric Hobsbawm has emphatically remarked, all tradition is invented tradition and requires rules, rituals, and symbols that inculcate values and norms of behaviour by repetition, until they are taken for granted as timeless and inescapable.[94] But while some scholarship has examined the intersections between visual and material culture and the pursuit of often imaginary national heritage,[95] such forays into the transcultural makeup of artefacts and their complicity in nation-building have been conducted separately, focusing on either movement of artefacts across borders alone or the impact of artefacts considered local on nation-building, thus missing the opportunity to fully examine the paradox of nativism's reliance on foreign elements. The complex pathways and genealogies of artefacts flowing in and out of Poland–Lithuania are thus central to this book's argument as correctives to faulty theories and assumptions about geographical determinism and the unity of national culture that entrench the idea of cultural origin as particular to a specific location.

Transcultural Things builds on work by the few scholars who have actively sought to blur the foreign–local binary,[96] taking their approach one step further to argue that the idea of cultural distinctiveness can only emerge in a context where various objects of material and visual culture with many different origins are flowing freely across regions and polities. Like the representations of Kolschitzky/Kulczycki/Kulchytsky that open this introduction, the images and objects analysed in this book acted as signifiers of localness—but only insofar as they generated confusion regarding their origins. Although these artefacts originally had little to do with the places whose 'essence' they are often thought to represent, they were eventually co-opted into national agendas and cultural practices. Just as Kolschitzky has been reduced to the name of a coffee blend that allegedly captures the spirit of Vienna, these artefacts have been relegated to the confines of narrowly defined national traditions, most notably in Poland, a diminution that overlooks their wider significance as products of complex interactions and interdependencies among various material and visual cultures. A transcultural history of these artefacts' role as manifestations of national identity is necessary to pursue in a world that, as I write, is on the brink of turning once more towards nativism and cultural essentialism. Facile solutions to perceived problems of social cohesion poison public discourse when we confront the challenges of shifting world order, human migration across borders, and political polarization at home. Rather than a retreat from transcultural things, we need them more than ever in the fight against toxic myths of national purity, which often underpin atavistic ethno-nationalisms that purge the imagined community of dissenting views and petrify retrogressive ideas of national tradition. This book demonstrates how these misconstrued, historically inaccurate ideas can be defied.

Notes

1. Yann Mounir Demange, 'The Long Answer', in *The Good Immigrant: 26 Writers Reflect on America*, ed. Nikesh Shukla and Chimene Suleyman (New York: Little, Brown and Company, 2019), 178–96.
2. James Clifford, *Routes: Travel and Translation in the Late Twentieth Century* (Cambridge, MA: Harvard University Press, 1997), 344.
3. Daniel Unowsky, 'Stimulating Culture: Coffee and Coffeehouses in Modern European History', *Journal of Urban History* 42, no. 4 (2016): 806; Tag Gronberg, 'Coffeehouse Orientalism', in *The Viennese Café and Fin-de-Siècle Culture*, ed. Charlotte Ashby, Tag Gronberg, and Simon Shaw-Miller (New York: Berghahn Books, 2013), 63.
4. Gronberg, 'Coffeehouse Orientalism', 60.
5. On vernacular, see Stephanie Porras, *Pieter Bruegel's Historical Imagination* (University Park, PA: Pennsylvania State University Press, 2016), 27–35.
6. Zygmunt Abrahamowicz, 'Jerzy Franciszek Kulczycki', in *Polski Słownik Biograficzny*, vol. 16, 1971, 128–29.
7. See, for example, https://kolschitzky.at, and https://restaurantguru.com/Kolschitzky-Wiener-Neustadt.
8. www.meinlcoffee.com/gb/products/kolschitzky-coffee-ground-250g.
9. I use terms such as 'foreign' and 'exotic' in this volume not at face value but as arbitrary signifiers contingent upon the historical context of their utterance, always open to renegotiation and reinvention. See Peter Mason, *Infelicities: Representations of the Exotic* (Baltimore: Johns Hopkins University Press, 1998); Benjamin Schmidt, *Inventing Exoticism: Geography, Globalism, and Europe's Early Modern World* (Philadelphia: University of Pennsylvania Press, 2015).
10. www.tasteofaustria.org/coffee.
11. Ivan Krastev and Stephen Holmes, *The Light That Failed: A Reckoning* (London: Allen Lane, 2019); Anne Applebaum, *Twilight of Democracy: The Seductive Lure of Authoritarianism* (New York: Doubleday, 2020); Daniel Denvir, *All-American Nativism: How the Bipartisan War on Immigrants Explains Politics as We Know It* (London: Verso, 2020). For a recent example of this nativist attitude, see Shaun Walker and Flora Garamvolgyi, 'Viktor Orbán Sparks Outrage with Attack on "Race Mixing" in Europe', *The Guardian*, 24 July 2022, www.theguardian.com/world/2022/jul/24/viktor-orban-against-race-mixing-europe-hungary?mc_cid=5e947248cb&mc_eid=cd1f92f96c.
12. The idea of origin is currently being interrogated by art historians. See, for example, Maria H. Loh, *Titian Remade: Repetition and the Transformation of Early Modern Italian Art* (Los Angeles: Getty Research Institute, 2007); Christopher S. Wood, *Forgery, Replica, Fiction: Temporalities of German Renaissance Art* (Chicago: Chicago University Press, 2008); Alessandra Russo, *The Untranslatable Image: A Mestizo History of the Arts in New Spain*, trans. Susan Emanuel and Joe R. Teresa Lozano (Austin: University of Texas Press, 2014).

13 Geneviève Zubrzycki, ed., *National Matters: Materiality, Culture and Nationalism* (Stanford, CA: Stanford University Press, 2017).
14 T. Douglas Price and James H. Burton, *An Introduction to Archaeological Chemistry*, (New York: Springer, 2011), 213–42.
15 Brian Porter, *When Nationalism Began to Hate: Imagining Modern Politics in Nineteenth-Century Poland* (Oxford: Oxford University Press, 2000).
16 John A. Armstrong, *Nations before Nationalism* (Chapel Hill: University of North Carolina Press, 1982).
17 For the contrast of civic and ethnic nationalisms, see Hans Kohn, *The Idea of Nationalism: A Study in Its Origins and Background* (London: Routledge, 2005); Yael Tamir, *Why Nationalism* (Princeton: Princeton University Press, 2019).
18 Caspar Hirschi, *The Origins of Nationalism: An Alternative History from Ancient Rome to Early Modern Germany* (Cambridge: Cambridge University Press, 2011).
19 Frank E. Sysyn, *Between Poland and the Ukraine: The Dilemma of Adam Kysil, 1600–1653* (Cambridge, MA: Harvard Ukrainian Research Institute, 1985).
20 Fernando Ortiz, *Cuban Counterpoint, Tobacco and Sugar* (Durham: Duke University Press, 1995), 32–33.
21 Wolfgang Welsch, 'Transculturality: The Puzzling Form of Cultures Today', in *Spaces of Culture: City, Nation, World*, ed. Mike Featherstone and Scott Lash (London: Sage, 1999), 194–213; Julie F. Codell, ed., *Transculturation in British Art, 1770–1930* (Farnham: Ashgate, 2012).
22 'National heritage'. OED Online. September 2020. Oxford University Press. www-oed-com.proxy3.library.mcgill.ca/view/Entry/125287?redirectedFrom=national+heritage (accessed 18 October 2020).
23 John Jeffries Martin, *Myths of Renaissance Individualism* (Basingstoke: Palgrave Macmillan, 2005); Claire Farago, 'The "Global Turn" in Art History: Why, When, and How Does It Matter?', in *The Globalization of Renaissance Art: A Critical Review*, ed. Daniel Savoy (Leiden: Brill, 2017), 302.
24 Jerzy S. Kulczycki, 'Prawdziwa legenda wiedeńskiej wiktorii', *Wspólnota Polska*, no. 6 (2007), http://wspolnotapolska.home.pl/swp2/index3fe9.html?id=kw7_6_13.
25 Ostap Hryzaj, *Die Ukrainer und die Befreiung Wiens 1683* (Vienna: Literarische Sektion des Exekutiv-Komitees der ukrainischen Vereine in Österreich, 1934).
26 Abrahamowicz, 'Jerzy Franciszek Kulczycki', 128.
27 Abrahamowicz, 'Jerzy Franciszek Kulczycki', 128.
28 Gronberg, 'Coffeehouse Orientalism', 61.
29 Johann Constantin Feige, *Wunderbahrer Adlers-Schwung, oder fernere Geschichts-Fortsetzung Ortelii redivivi et continuati*, vol. 2 (Vienna: Leopold Voigt, 1694).
30 Feige, *Wunderbahrer Adlers-Schwung*, 2:48, 2:50–52.
31 'In dieser Kleidung und also bewaffnet gienge et aus Wienn den 13. Augusti durch das Türckische Läger biss er zu J. Hertzogl. Dux Ch. L. auss Lothring komen und brachte von dar die erwünschte Kundschaft wegen des Einsatzes zurück, den 17. dito Aō. 1683.' In Feige, *Wunderbahrer Adlers-Schwung*, 2:48.
32 Feige, *Wunderbahrer Adlers-Schwung*, 2:51.

33 For a good overview of the concept of performativity, see Amelia Jones, *In Between Subjects: A Critical Genealogy of Queer Performance* (New York: Routledge, 2020), 34–82.
34 Abrahamowicz, 'Jerzy Franciszek Kulczycki', 128.
35 Helmut Kretschmer, *Kapuziner, Einspänner, Schalerl Gold: zur Geschichte der Wiener Kaffeehäuser* (Vienna: Wiener Stadt- und Landesarchiv, 2006); Karl Teply, 'Kundschafter, Kuriere, Kaufleute, Kaffeesieder: Die Legende des Wiener Kaffeehauses auf dem Röntgenschirm der Geschichte und Volkskunde', *Österreich in Geschichte und Literatur* 22, no. 1 (1978): 1–17; Anthony T. Quickel, 'Cairo and Coffee in the Transottoman Trade Network', in *Transottoman Matters: Objects Moving through Time, Space, and Meaning*, ed. Arkadiusz Blaszczyk, Robert Born, and Florian Riedler (Göttingen: V&R Unipress, 2022), 87.
36 Hanna Widacka, 'Jerzy Franciszek Kulczycki: The Founder of the First Café in Vienna', *Silva Rerum*, 4 February 2011, www.wilanow-palac.pl/jerzy_franciszek_kulczycki_the_founder_of_the_first_caf_in_vienna.html.
37 E. Natalie Rothman, *Brokering Empire: Trans-Imperial Subjects between Venice and Istanbul* (Ithaca, NY: Cornell University Press, 2012), 3–15.
38 Karen A. Cerulo, *Identity Designs: The Sights and Sounds of a Nation* (New Brunswick, NJ: Rutgers University Press, 1995); Michaela DeSoucey, 'Gastronationalism: Food Traditions and Authenticity Politics in the European Union', *American Sociological Review* 75, no. 3 (2010): 432–55; Atsuko Ichijo and Ronald Ranta, *Food, National Identity and Nationalism: From Everyday to Global Politics* (London: Palgrave Macmillan, 2015).
39 Anthony D. Smith, *The Nation Made Real: Art and National Identity in Western Europe, 1600–1850* (Oxford: Oxford University Press, 2013).
40 Eric Hobsbawm, 'Inventing Traditions', in *The Invention of Tradition*, ed. Eric Hobsbawm and Terence Ranger (Cambridge: Cambridge University Press, 1983), 1–14.
41 Zubrzycki, *National Matters*.
42 For one of these exceptions, see Hugh Trevor-Roper, 'The Invention of Tradition: The Highland Tradition of Scotland', in *The Invention of Tradition*, ed. Eric Hobsbawm and Terence Ranger (Cambridge: Cambridge University Press, 1983), 15–42.
43 Robert I. Frost, 'Union as Process: Confused Sovereignty and the Polish–Lithuanian Commonwealth, 1385–1796', in *Forging the State: European State Formation and the Anglo-Scottish Union of 1707*, ed. Andrew Mackillop and Micheál Ó Siochrú (Dundee: Dundee University Press, 2009), 69–92.
44 'Iż już Krolestwo polskie i Wielgie Księstwo litewskie jest jedno nierozdzielne i nierożne ciało, a także nierożna ale jedna a spolna Rzeczpospolita, ktora się z dwu państw i narodow w jeden lud zniosła i spoiła.' In Stanisław Kutrzeba and Władysław Semkowicz, eds., *Akta unii Polski z Litwą 1385–1791* (Cracow: Nakł. Polskiej Akademji Umiejętności, 1932), 358.
45 Anna Grześkowiak-Krwawicz, 'Respublica and the Language of Freedom: The Polish Experiment', in *A Handbook to Classical Reception in Eastern and Central*

Europe, ed. Zara Martirosova Torlone, Dana LaCourse Munteanu, and Dorota Dutsch (Oxford: Wiley-Blackwell, 2017), 179–89; Dorota Pietrzyk-Reeves, *Polish Republican Discourse in the Sixteenth Century* (Cambridge: Cambridge University Press, 2020).

46 Michał Kopczyński and Wojciech Tygielski, eds., *Under a Common Sky: Ethnic Groups of the Commonwealth of Poland and Lithuania* (New York: PIASA Books, 2017).

47 Henryk Wisner, *Rozróżnieni w wierze* (Warsaw: Książka i Wiedza, 1982).

48 Bogdan Walczak and Agnieszka Mielczarek, 'Prolegomena historyczne: Wielojęzyczność w Rzeczypospolitej Obojga Narodów', *Białostockie Archiwum Językowe* 17 (2017): 255–68.

49 'Sum gente Scytha, natione Ruthena utroque autem modo Sarmata, quod ea Rusia, quae mihi patria est, in Sarmatia Europae sit posita dextra habens Daciam, sinistra Poloniam, ante illam est Ungaria, post vero Scythia vergit ad orientem solem.' Letter of Stanisław Orzechowski to Pope Julius III, 1551, in Ignacy Chrzanowski and Stanisław Kot, eds., *Humanizm i Reformacja w Polsce: Wybór źródeł dla ćwiczeń uniwersyteckich* (Lviv, Warsaw, and Cracow: Wydawnictwo Zakładu Narodowego im. Ossolińskich, 1927), 328. See also Althoen, 'Natione Polonus and the Naród Szlachecki', 494.

50 David A. Frick, 'Meletij Smotryc'kyj and the Ruthenian Question in the Early Seventeenth Century', *Harvard Ukrainian Studies* 8, no. 3/4 (1984): 351–75.

51 Stanisław Roszak, 'Forms of Patriotism in the Early Modern Polish–Lithuanian Commonwealth', in *Whose Love of Which Country? Composite States, National Histories and Patriotic Discourses in Early Modern East Central Europe*, ed. Balázs Trencsényi and Márton Zászkaliczky (Leiden: Brill, 2010), 443–60.

52 Benedict Anderson, *Imagined Communities: Reflections on the Origin and Spread of Nationalism* (London: Verso, 1991).

53 Robert I. Frost, *The Oxford History of Poland–Lithuania*, vol. 1 (Oxford: Oxford University Press, 2015); Frost, 'Union as Process'.

54 Urszula Augustyniak, *Historia Polski, 1572–1795* (Warsaw: PWN, 2008), 256.

55 Krzysztof Łazarski, 'Freedom, State and "National Unity" in Lord Acton's Thought', in *Citizenship and Identity in a Multinational Commonwealth: Poland–Lithuania in Context, 1550–1772*, ed. Karin Friedrich and Barbara M. Pendzich (Leiden: Brill, 2009), 269.

56 Serhii Plokhy, *The Origins of the Slavic Nations: Premodern Identities in Russia, Ukraine, and Belarus* (Cambridge: Cambridge University Press, 2010), 161–202; Natalia Jakowenko, *Historia Ukrainy do 1795 roku*, trans. Anna Babiak-Owad and Katarzyna Kotyńska (Warsaw: Wydawnictwo Naukowe PWN, 2011); Serhii Plokhy, *The Cossack Myth: History and Nationhood in the Age of Empires* (Cambridge: Cambridge University Press, 2014), 28–46.

57 Tadeusz Chrzanowski, 'Orient i orientalizm w kulturze staropolskiej', in *Orient i orientalizm w sztuce*, ed. Elżbieta Karwowska (Warsaw: PWN, 1986), 43–69; Przemysław Mrozowski, 'Orientalizacja stroju szlacheckiego w Polsce na przełomie XVI i XVII w.', in *Orient i orientalizm w sztuce*, ed. Elżbieta R. Karwowska (Warsaw: PWN, 1986), 243–61.

58 Tadeusz Mańkowski, *Genealogia sarmatyzmu* (Warsaw: Towarzystwo Wydawnicze 'Łuk', 1947), 97.
59 Edward W. Said, *Orientalism* (New York: Pantheon Books, 1978), 60.
60 Said, *Orientalism*.
61 Larry Wolff, *Inventing Eastern Europe: The Map of Civilization on the Mind of the Enlightenment* (Stanford: Stanford University Press, 1994); Maria Todorova, *Imagining the Balkans* (Oxford: Oxford University Press, 1997).
62 Wolff, *Inventing Eastern Europe*, 6–7.
63 Jan Kieniewicz, 'Polish Orientalness', *Acta Poloniae Historica* 49 (1984): 67–103.
64 Michael Połczyński, 'Seljuks on the Baltic: Polish-Lithuanian Muslim Pilgrims in the Court of Ottoman Sultan Süleyman I', *Journal of Early Modern History* 19, no. 5 (2015): 409–37; Gábor Kármán, 'The Polish-Ottoman-Transylvanian Triangle: A Complex Relationship in the Sixteenth and Seventeenth Centuries', in *Türkiye-Polonya İlişkilerinde 'Temas Alanlari' (1414-2014)*, ed. Natalia Królikowska and Hacer Topaktaş (Ankara: Türk Tarih Kurumu Yayınları, 2017), 293–321; Michał Wasiucionek, *The Ottomans and Eastern Europe: Borders and Political Patronage in the Early Modern World* (London: I.B. Tauris, 2021); Stefan Rohdewald, Albrecht Fuess, and Stephen Conermann, 'Transottomanica: Eastern European-Ottoman-Persian Mobility Dynamics', *Diyâr* 2, no. 1 (2021): 5–13.
65 Michael Cole, 'The Cult of Materials', in *Revival and Invention: Sculpture through Its Material Histories*, ed. Sébastien Clerbois and Martina Droth (Oxford: Peter Lang, 2011), 1–15; Ulinka Rublack, 'Matter in the Material Renaissance', *Past and Present* 219 (2013): 41–85; Veerle Thielemans, 'Beyond Visuality: Review on Materiality and Affect', *Perspective* 2 (2015), https://doi.org/10.4000/perspective. 5993; Jennifer L. Roberts, 'Things: Material Turn, Transnational Turn', *American Art* 31, no. 2 (2017): 64–69; Sean Roberts and Timothy McCall, 'Object Lessons and Raw Materials', in *The Routledge History of the Renaissance*, ed. William Caferro (New York: Routledge, 2017), 105–24.
66 Bruno Latour, *Reassembling the Social: An Introduction to Actor-Network-Theory* (Oxford: Oxford University Press, 2005); Alfred Gell, *Art and Agency: An Anthropological Theory* (Oxford: Clarendon Press, 1998); Jane Bennett, *Vibrant Matter: A Political Ecology of Things* (Durham, NC: Duke University Press, 2010); Graham Harman, *Object-Oriented Ontology: A New Theory of Everything* (London: Pelican Books, 2018).
67 Martin Heidegger, 'The Thing', in *Poetry, Language, Thought*, trans. Albert Hofstadter (Harper & Row, 1971), 161–83; Bill Brown, 'Thing Theory', *Critical Inquiry* 28, no. 1 (2001): 1–22.
68 Brown, 'Thing Theory'.
69 Tadeusz Sulimirski, *The Sarmatians* (London: Thames and Hudson, 1970).
70 See, for example, Irena Turnau, *Ubiór narodowy w dawnej Rzeczypospolitej* (Warsaw: Semper, 1991); Beata Biedrońska-Słota, *Polski ubiór narodowy zwany kontuszowym: Dzieje i przemiany opracowane na podstawie zachowanych ubiorów zabytkowych i ich części oraz w świetle źródeł ikonograficznych i literackich* (Cracow: Muzeum Narodowe w Krakowie, 2005).

71 Marinus Ossewaarde, 'The National Identities of the "Death of Multiculturalism" Discourse in Western Europe', *Journal of Multicultural Discourses* 9, no. 3 (2014): 173–89.

72 For a rebuttal of this presumption, see Zubrzycki, *National Matters*.

73 For a good overview of the problem, see Avinoam Shalem, 'Histories of Belonging and George Kubler's Prime Object', *Getty Research Journal* 3 (2011): 1–14; Béatrice Joyeux-Prunel, 'Art History and the Global: Deconstructing the Latest Canonical Narrative', *Journal of Global History* 14, no. 3 (2019): 413–35.

74 See, for example, Eva R. Hoffman, 'Pathways of Portability: Islamic and Christian Interchange from the Tenth to the Twelfth Century', *Art History* 24, no. 1 (February 2001): 17–50; Shalem, 'Histories of Belonging'; Elizabeth Rodini, 'Mobile Things: On the Origins and the Meanings of Levantine Objects in Early Modern Venice', *Art History* 41, no. 2 (2018): 246–65; Anna Grasskamp and Monica Juneja, eds., *EurAsian Matters: China, Europe, and the Transcultural Object, 1600–1800* (Cham: Springer, 2018).

75 Michel Espagne and Michael Werner, 'Deutsch-französischer Kulturtransfer als Forschungsgegenstand: Eine Problemskizze', in *Transferts: Les relations interculturelles dans l'espace franco-allemand, XVIIIe et XIXe siècle*, ed. Michel Espagne and Michael Werner (Paris: Editions recherche sur les civilisations, 1988), 11–34; Michel Espagne, *L'histoire de l'art comme transfert culturel: L'itinéraire d'Anton Springer* (Paris: Belin, 2009); Michel Espagne, 'Cultural Transfers in Art History', in *Circulations in the Global History of Art*, ed. Thomas DaCosta Kaufmann, Catherine Dossin, and Béatrice Joyeux-Prunel (Farnham: Ashgate, 2015), 97–112; Michael Werner, 'Kulturtransfer und Histoire croisée: Zu einigen Methodenfragen der Untersuchung soziokultureller Interaktionen', in *Zwischen Kahlschlag und Rive Gauche: Deutsch-französische Kulturbeziehungen 1945–1960*, ed. Stephan Braese and Ruth Vogel-Klein (Würzburg: Königshausen & Neumann, 2015), 21–42.

76 Michael Werner and Bénédicte Zimmermann, 'Beyond Comparison: Histoire Croisée and the Challenge of Reflexivity', *History and Theory* 45 (February 2006): 30–50; Sanjay Subrahmanyam, 'Connected Histories: Notes towards a Reconfiguration of Early Modern Eurasia', *Modern Asian Studies* 31, no. 3 (1997): 735–62.

77 Nicholas Thomas, *Entangled Objects: Exchange, Material Culture, and Colonialism in the Pacific* (Cambridge, MA: Harvard University Press, 1991), 4.

78 See, for example, Claire J. Farago, ed., *Reframing the Renaissance: Visual Culture in Europe and Latin America, 1450–1650* (New Haven: Yale University Press, 1995); Daniela Bleichmar and Peter C. Mancall, eds., *Collecting across Cultures: Material Exchanges in the Early Modern Atlantic World* (Philadelphia: University of Pennsylvania Press, 2011); Meredith Martin and Daniela Bleichmar, 'Introduction: Objects in Motion in the Early Modern World', *Art History* 38, no. 4 (2015): 604–19; Thomas DaCosta Kaufmann et al., eds., *Circulations in the Global History of Art* (Farnham: Ashgate, 2015); Leah R. Clark and Nancy Um, 'Introduction The Art of Embassy: Situating Objects and Images in the Early Modern Diplomatic Encounter', *Journal of Early Modern History* 20,

no. 1 (2016): 3–18; Daniel Savoy, ed., *The Globalization of Renaissance Art: A Critical Review* (Leiden: Brill, 2017); Bronwen Wilson and Angela Vanhaelen, 'Introduction: Making Worlds: Art, Materiality, and Early Modern Globalization', *Journal of Early Modern History* 23, no. 2/3 (2019): 103–20; Anna Grasskamp, 'Unpacking Foreign Ingenuity: The German Conquest of Artful Objects with "Indian" Provenance', in *Ingenuity in the Making: Matter and Technique in Early Modern Europe*, ed. Richard J. Oosterhoff, José Ramón Marcaida, and Alexander Marr (Pittsburgh: University of Pittsburgh Press, 2021), 213–28; Anna Grasskamp, *Art and Ocean Objects of Early Modern Eurasia: Shells, Bodies, and Materiality* (Amsterdam: Amsterdam University Press, 2021).

79 To verify the accuracy of this statement, one only has to review the curent catalogues of major academic presses publishing in the field of early modern art and architcture, including Princeton University Press, Penn State University Press, and Yale University Press.

80 Bronwen Wilson, *The World in Venice: Print, the City and Early Modern Identity* (Toronto: University of Toronto Press, 2005); Lia Markey, *Imagining the Americas in Medici Florence* (University Park, PA: Penn State University Press, 2016); Ulinka Rublack, *Dressing Up: Cultural Identity in Renaissance Europe* (Oxford: Oxford University Press, 2010); Stephanie Leitch, *Mapping Ethnography in Early Modern Germany: New Worlds in Print Culture* (Basingstoke: Palgrave Macmillan, 2010); Carina L. Johnson, *Cultural Hierarchy in Sixteenth-Century Europe: The Ottomans and Aztecs* (Cambridge: Cambridge University Press, 2011); Jessica Keating, *Animating Empire: Automata, the Holy Roman Empire, and the Early Modern World* (University Park, PA: Pennsylvania State University Press, 2018).

81 Some notable exceptions include Laura Lisy-Wagner, *Islam, Christianity and the Making of Czech Identity, 1453–1683* (Farnham: Ashgate, 2013); Robert Born, Michał Dziewulski, and Guido Messling, eds., *The Sultan's World: The Ottoman Orient in Renaissance Art*, exh. cat. (Brussels, Cracow, and Ostfildern: Centre for Fine Arts, Brussels; and the National Museum in Kraków, in association with Hatje Cantz, 2015).

82 I take up Dipesh Chakrabarty's challenge to 'provincialize Europe' from within, exploring its articulation not only in relation to the exotic locales outside of Europe's boundaries, but also to sites at the continent's own margins. Dipesh Chakrabarty, *Provincializing Europe: Postcolonial Thought and Historical Difference* (Princeton: Princeton University Press, 2000).

83 Władysław Łoziński, *Patrycjat i mieszczaństwo lwowskie w XVI i XVII wieku* (Lviv: H. Altenberg, 1902).

84 Tadeusz Mańkowski, 'Influence of Islamic Art in Poland', *Ars Islamica* 2, no. 1 (1935): 93.

85 Mańkowski, *Genealogia sarmatyzmu*. Mańkowski expanded on his theory in two subsequent monographs: Tadeusz Mańkowski, *Polskie tkaniny i hafty XVI-XVIII wieku* (Wrocław: Zakład im. Ossolińskich, 1954); Tadeusz Mańkowski, *Orient w polskiej kulturze artystycznej* (Wrocław: Zakład Narodowy im. Ossolińskich, 1959).

86 Maria Gutkowska-Rychlewska, *Historia ubiorów* (Wrocław: Zakład Narodowy im. Ossolińskich, 1968), 375–422; Mrozowski, 'Orientalizacja stroju szlacheckiego'; Biedrońska-Słota, *Polski ubiór narodowy zwany kontuszowym*; Turnau, *Ubiór narodowy w dawnej Rzeczypospolitej*; Chrzanowski, 'Orient i orientalizm w kulturze staropolskiej'.

87 Beata Biedrońska-Słota, 'Kobierce z polskich manufaktur (próba podsumowania)', in *Tkaniny artystyczne z wieków XVIII i XIX*, ed. Beata Biedrońska-Słota (Cracow: Zamek Królewski na Wawelu, 1997), 151–63; *Tkanina turecka XVI-XIX w. ze zbiorów polskich*, exh. cat. (Warsaw: Muzeum Narodowe w Warszawie, 1983).

88 Stanisław Wiliński, *U źródeł portretu staropolskiego* (Warsaw: Arkady, 1958); Tadeusz Dobrowolski, 'Cztery style portretu "sarmackiego"', *Zeszyty Naukowe Uniwersytetu Jagiellońskiego* 45 (1962): 83–101; Tadeusz Chrzanowski, *Portret staropolski* (Warsaw: Interpress, 1995).

89 Thomas DaCosta Kaufmann, *Court, Cloister, and City: The Art and Culture of Central Europe, 1450–1800* (Chicago: University of Chicago Press, 1995); Jan Białostocki, *The Art of the Renaissance in Eastern Europe: Hungary, Bohemia, Poland* (London: Phaidon, 1976).

90 Thomas DaCosta Kaufmann, *Toward a Geography of Art* (Chicago: University of Chicago Press, 2004), 144–53.

91 See, for example, Paulina Banas, 'Persische Kunst und polnische Identität', in *Sehnsucht Persien: Austausch und Rezeption in der Kunst Persiens und Europas im 17. Jahrhundert & Gegenwartskunst aus Teheran*, ed. Axel Langer (Zürich: Scheidegger & Spiess, 2013), 123; Aleksandra Koutny-Jones, 'Echoes of the East: Glimpses of the Orient in British and Polish–Lithuanian Portraiture of the Eighteenth Century', in *Britain and Poland-Lithuania: Contact and Comparison from the Middle Ages to 1795*, ed. Richard Unger (Leiden: Brill, 2008), 401–19; Adam Jasienski, 'A Savage Magnificence: Ottomanizing Fashion and the Politics of Display in Early Modern East-Central Europe', *Muqarnas* 31 (2014): 173–205; Carolyn C. Guile, 'Circulations: Early Modern Architecture in the Polish–Lithuanian Borderland', in *Circulations in the Global History of Art*, ed. Thomas DaCosta Kaufmann, Catherine Dossin, and Béatrice Joyeux-Prunel (Farnham: Ashgate, 2015), 79–96; Andrzej Piotrowski, *Architecture of Thought* (Minneapolis: University of Minnesota Press, 2011), 93–151; Olenka Z. Pevny, 'The Encrypted Narrative of Reconstructed Cossack Baroque Forms', *Harvard Ukrainian Studies* 31, no. 1/4 (2010 2009): 471–519; Alexandr Osipian, 'Between Mercantilism, Oriental Luxury, and the Ottoman Threat: Discourses on the Armenian Diaspora in the Early Modern Kingdom of Poland', *Acta Poloniae Historica* 116 (2017): 171–207; Alexandr Osipian, 'Uses of Oriental Rugs in Early Modern Poland-Lithuania: Social Practices and Public Discourses', in *Transottoman Matters: Objects Moving through Time, Space, and Meaning*, ed. Arkadiusz Blaszczyk, Robert Born, and Florian Riedler (Göttingen: V&R Unipress, 2021), 173–217; Jan K. Ostrowski, ed., *Land of the Winged Horsemen: Art in Poland, 1572-1764* (New Haven: Yale University Press, 1999); Born, Dziewulski, and Messling, The Sultan's World. See also Robert Born and Michał Dziewulski, eds., *The Ottoman Orient in Renaissance Culture: Papers*

from the International Conference at the National Museum in Krakow, June 26–27, 2015 (Cracow: National Museum in Cracow, 2015).

92 Clifford, *Routes*, 1–13.

93 Sebastian Conrad, *What Is Global History?* (Princeton: Princeton University Press, 2016); David Carrier, *A World Art History and Its Objects* (University Park, PA: Pennsylvania State University Press, 2008).

94 Hobsbawm, 'Inventing Traditions', 1.

95 Anderson, *Imagined Communities*; Kristoffer Neville, 'History and Architecture in Pursuit of a Gothic Heritage', in *The Quest for an Appropriate Past in Literature, Art and Architecture*, ed. Karl A. E. Enenkel and Konrad Adriaan Ottenheym (Leiden: Brill, 2018), 619–48; Barbara Arciszewska, 'The Role of Ancient Remains in the Sarmatian Culture of Early Modern Poland', in *Local Antiquities, Local Identities: Art, Literature and Antiquarianism in Europe, c. 1400–1700*, ed. Kathleen Christian and Bianca de Divitiis (Manchester: Manchester University Press, 2019), 286–304.

96 Mason, *Infelicities*; Schmidt, *Inventing Exoticism*; Anne Gerritsen, 'Domesticating Goods from Overseas: Global Material Culture in the Early Modern Netherlands', *Journal of Design History* 29, no. 3 (2016): 228–44; Lisy-Wagner, *Islam, Christianity and the Making of Czech Identity*; Rodini, 'Mobile Things'; Anna Grasskamp, *Objects in Frames: Displaying Foreign Collectibles in Early Modern China and Europe* (Berlin: Reimer, 2019).

1 Where is Sarmatia?

> Polish society looked to the East as the cradle of their nation.
> Tadeusz Mańkowski, *Genealogia sarmatyzmu*[1]

> Culturally plural societies often worked well in the past: so well, in fact, that cultural plurality was sometimes invented where it was previously lacking.
> Ernest Gellner, *Nations and Nationalism*[2]

Poland–Lithuania was not a state, but a union of two composite realms, each of them confessionally, linguistically, and ethnically diverse. There was, however, a sense among the union's elites—even if contested at times—of fostering a shared political project, the evolution of which may be traced by investigating the power of maps to inform, persuade, and inspire the imagination. The map of European Sarmatia (Figure 1.1) by Polish physician and cartographer Andrzej Pograbka (d. 1602), published in Venice in 1570, offers a good starting point. Just one year previously, on 1 July 1569, the nobilities of the Kingdom of Poland and the Grand Duchy of Lithuania had agreed to bind together their composite polities 'in perpetuity', forming a confederated political entity that replaced the looser union first forged in 1385. The new body politic is known in English-language scholarship as the Polish–Lithuanian Commonwealth, but in the original Polish-language document it was called Rzeczpospolita,[3] meaning both a well-ordered political community and 'something held in common by a wider public', *shared thing—res publica* in the classical Latin rendering, and 'common wealth' in early modern English translation.[4] Strictly speaking, the two autonomous polities remained, but each ceded aspects of its sovereignty to the Commonwealth, establishing a common sejm (legislative assembly) and currency. Pograbka's map was the first to appear after the forging of this momentous political alliance; it thus marks an important milestone in representing the newly formed Commonwealth as an integrated entity.

Pograbka needed to tackle several issues to render his cartographical representation of Polish–Lithuanian territories legible and indelible. How to depict a confederated polity on a map with only mountain ranges and rivers acting as subdivisions of land, no visible internal or external borders? What

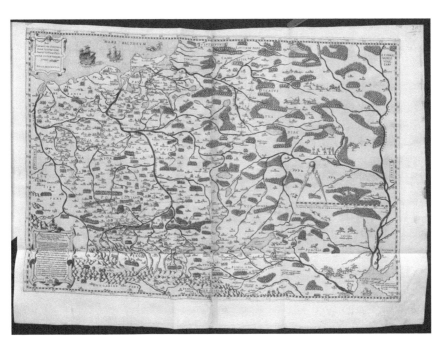

Andrzej Pograbka, *Partis Sarmatiae Europeae quae Sigismundo Augusto Regi Poloniae Potentissimo subiacet, nova descriptio*, 1570, printed in Venice, 68 × 46 cm. Munich, Bayerische Staatsbibliothek, 2 Mapp. 464

1.1

to call this polity if its self-proclaimed name referred simply to an idealized system of governance? 'Commonwealth' (and its cognates, such as 'Republic') does not unambiguously convey the composite character of the Polish–Lithuanian union; given that most maps of Poland–Lithuania were produced and consumed in Western Europe,[5] there was always a danger that the toponym 'Commonwealth' might be too vague to be useful. Map makers tended to use Poland, the name of the more powerful partner in the union, to refer to the entire confederated polity—as is evident, for example, in the 1570 edition of Abraham Ortelius's *Theatrum orbis terrarum* (Theatre of the Orb of the World). Less frequently, they included the names of both territorial states, as in various editions of Sebastian Münster's *Cosmographia*.[6] For map readers in Poland–Lithuania, the former solution risked irritating the Lithuanian nobility, who continued to insist on the legal distinctiveness of the Grand Duchy within the Commonwealth; the latter accommodation ignored the convergent aspect of the union.

Pograbka's choice to call the Commonwealth 'European Sarmatia' was an answer to both concerns. Rather than drawing on the potentially contentious politics of his day, marked by often bitter disagreements over the nature of

the union,⁷ Pograbka offered a simultaneously less politicized and more inclusive vision of Polish–Lithuanian lands by mapping them onto cartographical divisions from Ptolemy's treatise *Geographia*, an ancient text written around 150 CE, first printed as a modern illustrated edition with maps in 1477, and still widely read in the sixteenth century.⁸ Backed by the authority of this celebrated Greco-Roman geographer, European Sarmatia served as an ancient denomination for the lands that lay between the Vistula and the Don rivers, which in early modernity were inhabited by Poles, Lithuanians, Ruthenians, and Prussians. The term was not only meant to give these otherwise distinct peoples a sense of historical continuity and an impetus for closer association but also to firmly mark their place among all other Europeans with a claim to classical heritage. By applying ancient geography to an early modern context, Pograbka solved the problem of naming the new commonwealth while also claiming for it an allegedly unbroken history anchored in Sarmatian antiquity.

As literary historian Tadeusz Ulewicz (1917–2012) observes in his pioneering study *Sarmacja* (Sarmatia, 1950), a scholarly monograph on the uses and abuses of Ptolemy in premodern Polish historical discourse, Sarmatia is a concept intimately linked to cartographical representation and philological antiquarianism.⁹ The term's embrace by Polish-based humanists and their patrons from the late fifteenth century onward was an element of the pan-European revival of classical learning fuelled in some measure by early modern elites who attempted to locate their origins in antiquity, vying with each other for the most impressive lineage from an ancient people, ideally as recorded by Herodotus, Ptolemy, Tacitus, Julius Caesar, or another Graeco-Roman authority. The French, for example, had stories of their supposed descent from the Gauls,¹⁰ Swedes from the Goths,¹¹ and the Dutch from the Batavians.¹²

Although Ulewicz is mostly interested in early modern perceptions of Sarmatia as a geographical concept flexible enough to include various Central and Eastern European peoples and places, he nonetheless asserts that the region's inhabitants were united in 'the peculiar, highly characteristic, and unique style of life and a way of thinking' that he refers to as 'Sarmatism', an elusive term of eighteenth-century origin used in the 1950s primarily as a synonym for Polish Baroque culture.¹³ Ulewicz borrows this definition from art historian Tadeusz Mańkowski (1878–1956), who reintroduced Sarmatism to scholarly attention in a series of studies that culminated in *Geneaologia Sarmatyzmu* (A Genealogy of Sarmatism), one of the most influential works of Polish historiography, published three years before *Sarmacja*, in 1947.¹⁴ For Mańkowski, Sarmatism is a worldview, a style of living, and a specific set of attitudes and conventions typified by the formal 'Orientalization' of Polish material culture during the sixteenth through eighteenth centuries. In his model, the denizens of Sarmatia are not merely interconnected peoples sharing a historical territory, but are explicitly a community with shared historical

experience, united by and living with the same purpose and values, and recognizable by the 'Oriental' mode of their clothing and apparel. There is, then, an important distinction between Ulewicz's Sarmatia as a historical location and Mańkowski's Sarmatism as a cultural formation.

While Ulewicz's Sarmatia is a transnational spatial unit, Mańkowski's Sarmatism is a genealogical account of a specific (modern) nation—Poland—and its direct ancestry in the Sarmatians, an ancient Iranian people originally inhabiting the Pontic Steppe.[15] According to this interpretation, Poland is not only genealogically coherent but also an analogue for the entire Polish–Lithuanian Commonwealth. And the Commonwealth, in turn, is thus a larger version of Poland—a reputedly coherent society with one indivisible culture consisting of Poles and assimilated (Polonized) Lithuanians, Ruthenians, and Prussians, peoples who, as a result of Sarmatism's hold over historians' imaginations, become, more or less, regional versions of Poles. Their culture is shared because—as is argued in a truly circular manner—it is Polish, and therefore Sarmatian, and therefore 'a feature of Old Poland's life and thought.'[16] Mańkowski's followers have mostly accepted this notion of Sarmatism's assimilatory quality, imbuing the Commonwealth with a coherent cultural identity allegedly shared among the noble citizens who partook in 'Sarmatian culture,'[17] 'Sarmatian art,'[18] 'Sarmatian portraiture,'[19] 'Sarmatian ideology,'[20] and many other things 'Sarmatian.'[21] Sarmatia in this assimilatory projection is a nation in the making, with a teleological arc of collective memory rooted in self-avowedly shared traditions, contexts, and historical experiences.

An important aspect of this narrative is how it summons the spectre of Orientalism via an assumption that Polish nobles were aware of the Sarmatians' origins in the 'East', somewhere on the Eurasian Steppe, and how the outpouring of stories supposedly promoting Poland's Sarmatian lineage triggered the Orientalization of Polish costume and material culture in the sixteenth century.[22] This seemingly Oriental mode of Sarmatism was, as stated in the catalogue of the 1980 exhibition of 'Sarmatian' decorative arts held, as a primer for the general public, at Warsaw's National Museum, 'a specific style of living and its physical manifestation serving as the external expression of Polishness.'[23] Sarmatism (a modern analytical concept) is not simply a tool of diachronic inquiry into Sarmatia (a land) and the Sarmatians (a people); it is, more exactly, a deterministic account of Polish culture that locates its alleged uniqueness (i.e., its 'Orientalism') in the elusive realm of genealogy—that is, the early modern inhabitants of Sarmatia looked and behaved the way they did because their ancestors came from the 'East'.

Enticing as it is (at least for Polish ethno-nationalists), such a deterministic account of Commonwealth culture is ahistorical, since no citizen of Poland–Lithuania (of which fewer than half were Catholic Poles) would have spoken specifically of Sarmatia or the Sarmatians to describe the art, portraiture, music,

theatre, or belief systems of this vast political union. Nor were these cultural forms homogenous across Polish–Lithuanian lands. Certainly cartography—which provided the impetus for associating Poland–Lithuania with Sarmatia—offers no grounds for an assimilatory reading. In the Pograbka map (Figure 1.1), Sarmatia is a projection, not a fact. It is a collection of different political units rather than a single territorial state. 'Ducatus Lithuaniae' ([Grand] Duchy of Lithuania) is marked as separate from 'Polonia Maior' (Greater Poland) and 'Polonia Minor' (Lesser Poland), with Prussia, Samogitia, Volhynia, Podolia, and 'Russia' (the Ruthenian province) also added to the picture. Thus, while forming the Polish–Lithuanian Commonwealth (i.e., early modern Sarmatia), these historically distinctive provinces are captioned on the map as discrete entities. Pograbka's Sarmatia is not a single nation but a union of different Sarmatian lands. It is first and foremost a geographical container, more akin to Ulewicz's spatial continuum than to Mańkowski's account of Sarmatia's genealogically related constituent peoples.

This chapter hence proposes to redirect the discussion of Sarmatia from genealogy to cartography, whence it originated, in order to yield a new interpretation of this contentious toponym—not as a synonym for a Polish-led Commonwealth with a shared language and culture but rather as a place name acknowledging the heterogeneous character of the Polish–Lithuanian union. The term Sarmatia is more capacious than is currently acknowledged; it certainly does not denote a monocultural nation moving towards an ever-increasing degree of uniformity. Instead, and more accurately, Sarmatia is the result of ongoing renegotiations of the union's purpose among its citizens. While the former approach assumes the full cultural assimilation of the Commonwealth's various ethno-linguistic and confessional communities into the dominant Polonizing model, the latter recognizes that the Commonwealth was always a pluralistic realm distinguished by the heterogeneity of its constituent peoples—who needed to be continually convinced of the union's relevance so as to keep the Sarmatian historico-geographical nomenclature meaningful and consequential. Cartography projected a coherent, classically inspired vision for Poland–Lithuania while simultaneously guarding its composite character. Early modern maps of Sarmatia, therefore, did not only reflect a transcultural commonwealth in the making but also actively participated in its creation and sustenance.

What's in a name?

The nature of Sarmatian identity has lately become a subject of debate. While many scholars continue to uphold received wisdom maintaining that Sarmatism existed in early modernity as a real cultural formation,[24] Jakub Niedźwiedź has pointed to the questionable foundations of this claim.[25]

Sarmatism, he argues, is an invented tradition—a discourse of Romantic identity that developed in the nineteenth century as a response to lost political sovereignty and that attempted to essentialize Polishness through the lens of an idealized past.[26] It is hard to disagree with Niedźwiedź's reading of Sarmatism as an epistemic construct. Although it might appear to be an age-old cultural paradigm, Sarmatism is more accurately a grand narrative of Polish culture that emerged only after the confederate state formation that early modern cartographers described as 'European Sarmatia' had disappeared from the map in 1795.

Sarmatia, the land, is a geographical category of classical origin. The emergence of Sarmatism as an analytical concept, however, can only be attributed to the Age of Enlightenment, when the term served as a slur against the traditionalist nobility, whose members wanted to preserve the political system that favoured their interests over those of other social groups—and who displayed their conservatism in, among other things, the Ottomanesque costume once popular in Poland–Lithuania, which by the late eighteenth century had become a historical relic.[27] It was at this same time that *Monitor*, the newspaper supporting the reformist agenda of King Stanislaus Augustus (r. 1765–95), called the traditionalists 'thickheads of sarmatism' (*bałwany sarmatyzmu*), and Franciszek Zabłocki's comedy *Sarmatyzm* (1784) labelled them as a bunch of degenerates stuck in the past.[28] But what the Enlightenment-era critics mock is not so much a particular cultural profile or stylistic predilection as the social and political reactionism of the period, which manifested itself in, among other things, an outdated (early modern) overreliance on classical sources that were uncritically repeated and went unchallenged in their supposed championing of tradition over progress. The anonymous *Monitor* critic is particularly animated when announcing that Polish has replaced allegedly unscientific Latin as the language of scholarship in the Enlightenment-era Commonwealth. In doing so, he seems to ignore that Latin had once been the *lingua franca* of European humanism and science.[29] However, it was the Romantic and post-Romantic writers, particularly Henryk Sienkiewicz (1846–1916), who wrote most vividly of Sarmatism as a cultural formation in their literary descriptions of Old Poland, outlining the country's flamboyant manners, Ottomanesque costume, and bellicose character. These authors constructed a positive, glorifying vision of a lost Commonwealth, and indeed Sienkiewicz himself was unafraid to confess that he, too, was 'a Sarmatian child'.[30]

While literature framing early modern Poles as Sarmatians enjoyed its greatest success in the nineteenth century, it was not until the twentieth that the idea of Sarmatism received its first scholarly study. It all began with Mańkowski's *Genealogia sarmatyzmu* (1947), notably the first monograph to conflate the formal Ottomanization of Polish–Lithuanian fashions with the emergence and spread of belief in the Commonwealth's genealogical lineage

from ancient Sarmatia. His book converged these historical processes—neither of which he analysed critically—into a teleological model of Polish history, tellingly treating Lithuania as a Polish province, nearly entirely ignoring Ruthenia, and paying no attention to Prussia. This model casts the Commonwealth as an 'Eastern' land inhabited by a quintessentially 'Eastern' people. Mańkowski even asserts, as quoted in the epigraph to this chapter, that Poles 'looked to the East as the cradle of their nation'.[31] Seeking reasons for the nobles' self-labelling as descendants of the Sarmatians, he assumed that the cultural character of the Commonwealth had been determined by its citizens' genealogical predispositions.

This is, however, a specious claim: Mańkowski's argument relies upon many assumptions that find no confirmation in historical sources. Presupposing that early modern Poles had his modern understanding of the ancient Sarmatians as an Iranian people, and caring little about other Commonwealth citizens, Mańkowski in fact anachronistically applied the philological and archaeological knowledge of his own day to early modern Polish–Lithuanian epistemologies.[32] Although according to Herodotus and Strabo, the Sarmatians were related to the Scythians and inhabited the Pontic Steppe,[33] and while Tacitus compares them to the Persians,[34] none of the key early modern Polish–Lithuanian historical narratives explicitly states the Iranian extraction of these peoples.

Instead, early modern chroniclers understand Sarmatia in terms of geography rather than lineage. They emphasize Poles' long-term presence, traced back to antiquity, in Sarmatia, arguing that they were Slavs who cohabited Sarmatia with other peoples. While employing various literary modes of vernacular self-expression to convey the historical uniqueness of the land they portray and its inhabitants, these writers are interested not in taxonomic classification of Sarmatian origins but rather in a people's connection to a place. Maciej Miechowita (1457–1523, Latin: Matthias de Miechow), for example, asserts in the *Chronica Polonorum* (Chronicle of the Poles, 1519) that Poles have always inhabited the same realm: 'Poles and all other Slavs have been living in this kingdom, making their permanent home here, and nowhere else'.[35] Marcin Kromer (1512–89, German: Martin Cromer), author of the geographical treatise *Polonia* (Poland, 1577) is of a similar opinion: 'Poles are a Slavic and Sarmatian people'—they are related to other Slavic peoples and they live in Sarmatia.[36] There is no self-Orientalizing genealogical rhetoric in this statement because Kromer's focus is on Sarmatia as a place eternally located in Central and Eastern Europe, not a land that was at some point in history settled by an Oriental people. The author of the often reissued Polish-language *Kronika świata* (World Chronicle, 1550), Marcin Bielski (1495–1575), dates the presence of (loosely defined) Sarmatians in Polish–Lithuanian lands to a far more distant past, tracing their origins to one of the sons of Noah: '[Japheth] our Christian father [...] came to this northern country in Europe after the Deluge and multiplied his

offspring by the Lord's will'.³⁷ The *Kronika polska, litewska, zmodźka y wszystkiej Rusi* (Chronicle of Poland, Lithuania, Samogitia and all of Ruthenia, 1582) by Lithuania-based Pole and Catholic priest Maciej Stryjkowski (1547–93) maintains this same account, qualifying (after, most notably, Jan Długosz) that the Lithuanian nobles were descendants of the Roman duke Palemon and his five hundred companions, who settled in Lithuania—a Sarmatian land—and gradually adopted the Sarmatian customs and language.³⁸ The term 'Sarmatian' in this context describes the customs and language of the local people; it is an inclusive, transcultural concept that embraces all of Sarmatia's historical settlers and effectively contributes to a pluralist reading of the Polish–Lithuanian past, circumscribed however by the geography of Central and Eastern Europe. No self-identification with the 'Orient' is implied. As early modern Poles and Lithuanians did not yet know of modern archaeology or historical linguistics, relying instead on the interpretation of biblical and classical sources, it is unlikely that they would have identified the Sarmatians as Middle Eastern or Central Asian peoples.³⁹ Mańkowski's Sarmatism is thus not only an anachronism but also a catalyst for erroneous interpretations of Polish history.

Historical sources before the eighteenth century—including the most 'Sarmatian' of them all, the *Pamiętniki* (Memoirs) of petty nobleman Jan Chryzostom Pasek (1636–1701)—do not ever use the term,⁴⁰ and Polish historians have an abundance of other designations to describe the Commonwealth's culture, including 'early modern', 'transcultural', 'preindustrial', and even the outmoded 'Renaissance' and 'Baroque'. While eighteenth-century critics bequeathed us the word 'Sarmatism', they did not see it as a useful analytical category for making sense of the Commonwealth's historical trajectory. To them, Sarmatia—whence the *-ism* derived—was not an ethnic or national community but a holdover of Renaissance philological discourse. It is unclear whether they understood Sarmatism's cartographical origins, but Enlightenment-era critics certainly read the concept through the prism of its classical starting point—as a relic of a bygone era unsuitable to serve their own modernizing goals. Sarmatism was to these critics an unwanted inheritance, a cultural formation that had run its course. It is therefore important to recall that the original (early modern) rationale for Sarmatia was not cultural but spatial—it served as a rhetorical conceit alluding to the continuity of the Commonwealth's ancient borders. The term was picked up by early modern chronicle writers from cartography. Maps preceded historical narratives of Sarmatia, not the other way around.

What about Sarmatia's heterogeneity?

The exploration of Sarmatia as a classical analogue for early modern realms took shape at a particularly momentous time: when Renaissance humanists

started to think, for the first time, with maps in mind.⁴¹ Pograbka was not the first to claim European Sarmatia as a predecessor of Poland–Lithuania. He was following in the footsteps of previous map makers and antiquarians, mostly Italian and German, who invoked Tacitus, Strabo, Pliny, Pomponius Mela, and, above all, Ptolemy in referring to most of Central and Eastern Europe as European Sarmatia.⁴² Ptolemy's *Geography* (150 CE), in particular, was becoming the standard reference in the fifteenth and sixteenth centuries; it contained both textual and cartographical descriptions of the world known to the ancients.⁴³ Brought to Florence, probably from Constantinople, under undocumented circumstances in the early fifteenth century,⁴⁴ the work served as a catalyst for geometrically inspired representations of the known world by providing a method for charting the linear depiction of land on a gridded and uniformly scaled surface.⁴⁵ But while changing how land, distance, and location were conceptualized, the translation of Ptolemy also reinforced classical nomenclature in early modern political geography and established 'European Sarmatia' as a standard geographical reference for combined Polish and Lithuanian lands.⁴⁶ That twenty-six editions were printed in various European cities by 1550 emphasizes how much the diffusion of the idea of 'European Sarmatia' owes to the popularity of Ptolemy's *Geography*.⁴⁷

The first early modern rendition of Ptolemy's map covering the territories of the Kingdom of Poland and the Grand Duchy of Lithuania was designed by Cardinal Nicholas of Cusa (1401–64), often referred to by his Latinized name Cusanus. We only know his version, however, through a later one (Figure 1.2) that was created by the Benedictine friar Nicolaus Germanus (c. 1420–c. 1490) and later used in the printed editions of Ptolemy's atlases. The Cusanus-Germanus map depicted a territory roughly corresponding with early modern Poland–Lithuania but described as 'Sarmatia Europea' in direct adherence to Ptolemy's toponymy.⁴⁸ Thus European Sarmatia borders the Roman province of Dacia in the south, the Vistula River in the west, the Baltic Sea (Oceanus Sarmaticus) in the north, and the Don (Tanais) and the Black Sea (Palus Meotis) in the east. Although these are the coordinates from Ptolemy's treatise, Cusanus was likely assisted by a Polish scholar who would have supplied town locations on a grid of parallels of latitude and meridians of longitude. This scholar probably came from Lesser Poland or the Ruthenian province (also referred to as Galicia, Halych, and Red Ruthenia), given that the urban centres from these lands predominate on the map. A likely candidate is Jan Długosz (1415–80), canon at Cracow, who met Cusanus in Rome. This hypothesis is further strengthened by the map's inclusion of two localities, Brzeźnica and Oleśnica, the former Długosz's birthplace and the latter the family seat of his patron, Zbigniew Oleśnicki (1389–1455), bishop of Cracow.⁴⁹

Długosz is best known for his *Annales seu cronicae incliti regni Poloniae* (Annals or Chronicles of the Famous Kingdom of Poland), one of the earliest

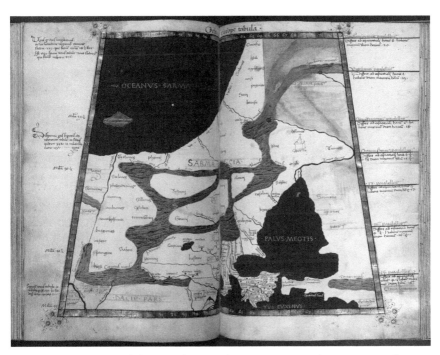

Nicolaus Germanus, Eighth Map of Europe (Sarmacia Europea) in *Cosmographia Claudii Ptolomaei Alexandrini*, c. 1460.

1.2

chronicles of Polish history. The volume was written in the mid-fifteenth century, concurrently with the creation of Cusanus's map,[50] and is one of the earliest to bring the Ptolemaic idea of Sarmatia into a historical narrative of the Polish state. But while he uses the term to delimit the land, Długosz did not understand Sarmatia in ethnic terms. The text treats Sarmatia not as a precise equivalent for the early modern Polish kingdom but rather as a historical description that ancient Romans used to reference the ethnically diverse ancestors of the fifteenth-century inhabitants of the realm. The author simply states that Poles and Ruthenians already inhabited their respective lands in antiquity, and since classical writers called this region European Sarmatia, the proper name 'Sarmatians' is a demonym under which these Slavic peoples were known in Greek and Roman times.[51] Sarmatia is, in this reading, a cosmopolitan rendering of an unknown ancient vernacular; while names change, the land remains constant.

Długosz does not specify when exactly Poles and Ruthenians settled in Central and Eastern Europe, though he hints that before the arrival of Lech and Rus—legendary leaders of each people, respectively—these populations had dwelt in Pannonia and later Slavonia.[52] Despite this acknowledgement of

intermingling and coexistence in prehistoric times, Długosz is Polonocentric in his narrative, treating Ruthenians as the younger cousins of Poles—Rus was not Lech's brother, as in other accounts, but his son. The chronicler treats Lithuanians as a people who arrived in Sarmatia after the Slavs, allegedly descended from the Romans.[53] In general, however, he renders Sarmatia as a space of different peoples' coexistence. It might have been a space destined to be dominated by Poles, but it was certainly not an ethnically delineated, closed-off community. In reading his chronicle, then, it is important to keep in mind that Długosz actively participated in the creation of maps and was likely surrounded by them when writing the *Annales*.[54] As the image of a territory encompassing most of Central and Eastern Europe—largely exceeding the confines of Długosz's Poland and including not only the Grand Duchy of Lithuania but also Bohemian, Hungarian, Muscovite, and Tatar lands—Sarmatia needed to remain heterogeneous if the land's historical integrity were to be preserved.

Cartography played a role in propagating this intercultural image of Sarmatia. That the term did not originally denote an ethnic or political community is evident in two woodcut maps from 1526 by Bernard Wapowski (1450–1535), secretary to King Sigismund I (r. 1506–48). Published in Cracow by the printer Florian Ungler (d. 1536), these were the first printed cartographical images of Sarmatia produced in Poland, possibly serving as companion maps to Długosz's *Annales*.[55] The originals had long been thought to have perished until they were discovered in the Central Archive of Old Records in Warsaw in 1932 by Polish librarian Kazimierz Piekarski (1893–1944), who found three fragments in the bindings of accounting books, where the maps had been used as scrap paper.[56] They were later lost during the near-complete destruction of Warsaw in 1944, but from descriptions and photographic reproductions (for example, Figure 1.3), we know that the size of the two maps put together was 60 × 90 cm without margins; we also know that they featured a grid of latitudes and longitudes, thus implying Ptolemy's influence. The now-lost fragments depicted southern and central Poland, Hungary and the northern Balkans, the Grand Duchy of Lithuania, Crimea, and parts of Muscovy. Clearly, Wapowski's Sarmatia was not a map of the Polish state.

We can further infer what territories the maps covered from a privilege dated 18 October 1526 that was granted to Ungler by Sigismund I. The following lands are listed: Poland, Hungary, Wallachia, 'Turkey' (likely only the European parts of the Ottoman Empire), 'Tartaria' (likely Crimea and its environs), Muscovy, Prussia, Pomerania, Samogitia, and Lithuania.[57] Another archival clue comes from a letter written by Lutheran theologian Johann Hess (1490–1547), a resident of Breslau (today Wrocław), on 11 May 1529. In the letter, which was sent to the Nuremberg humanist Willibald Pirckheimer (1470–1530), Hess reports that 'two maps of Sarmatia and Scythia have been

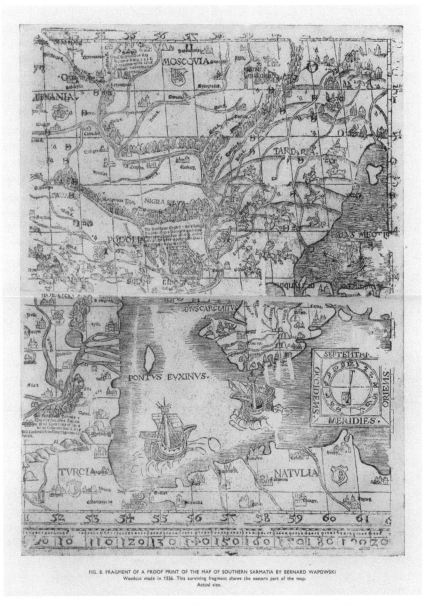

Bernard Wapowski, fragment of a proof print of the map of Sarmatia, facsimile (original woodcut made in 1526; lost during World War II), from Karol Buczek, *The History of Polish Cartography from 15th to the 18th Century*, Wrocław: Zakład Narodowy im. Ossolińskich, 1966

1.3

recently published in Cracow; although they are inelegant, they seem useful'.[58] Two months later, on 13 July, Hess dispatched another missive informing Pirckheimer that he was sending 'the second map of Sarmatia' and that he had requested the 'first map' from friends in Cracow, presumably to send to Nuremberg at a later time.[59] Lutheran reformer Philip Melanchthon (1497–1560) was another recipient of Wapowski's 'maps of Sarmatia distributed by Hess', evidence of which we find in a letter sent by Melanchthon to his 'friend' Andrzej Trzecieski the Elder (1497–1547) in October 1529.[60] Wapowski himself calls these lands 'Sarmatia' in a letter sent on 1 December 1530 to Prince-Bishop of Ermland (Warmia) Johannes Dantiscus (1485–1548, Polish: Jan Dantyszek), assuring his addressee that he had shipped 'two chorographies [descriptions of regions] of Sarmatian lands' to Catholic theologian Johannes Eck (1486–1543), as requested.[61] Given his use of the plural form 'lands' in describing Sarmatia's transterritorial ambit, it is clear that Wapowski treats the region in geographical rather than political terms. After all, his cartographical projections are first and foremost early modern editions of Ptolemaic atlases that impose a classical toponym upon the borders of sixteenth-century territorial states.

For Polish humanist scholar Maciej Miechowita (1457–1523), writing around the same time, divisions among different lands within Sarmatia remained self-evident. His widely circulated *Tractatus de duabus Sarmatiis Asiana et Europiana et de contentis in eis* (Treatise on the Two Sarmatias, Asian and European, and What is Found in Them), first printed in Cracow in 1517, firmly distinguished between the Poles, Lithuanians, Ruthenians, and Muscovites who inhabited the land called Sarmatia Europea, and the various Turkic peoples (whom he calls Scythians), who lived east of the Don in the area known as Sarmatia Asiatica.[62] Miechowita is often cited as the first to equate European Sarmatia with Poland,[63] but in fact he describes a much wider territorial expanse. His use of the term is not synonymous with the Polish kingdom but rather alludes to its potential future expansion to the east and south.[64] As Miechowita was a noted map collector whose understanding of history and current affairs was shaped by cartography,[65] he was well placed to recount the ethnic diversity of early modern Sarmatia.

This multi-cultural framing appears in other treatises, even as they employed the idea of Sarmatia as a potential unifier of the diverse peoples inhabiting the lands of the Polish–Lithuanian union.[66] As early as 1521, in his *De vetustatibus Polonorum* (On the Ancient Origins of the Poles), Iodocus Ludovicus Decius (1485–1545, German: Jost Ludwig Dietz, Polish: Justus Ludwik Decjusz), secretary to King Sigismund I, maintained in tautological fashion that Poles, Prussians, Lithuanians, and Ruthenians were all defined as Sarmatians because they inhabited the lands of Sarmatia. Sigismund was thus king of both Sarmatia as a whole, and Poland as its constituent part.[67] A perfect example of cartographically inspired imagination shaping real interactions

among peoples, Sarmatia offered new potential for connecting regions and integrating its inhabitants.[68] This humanistic interpretation of the coexistence of the four major peoples of Poland–Lithuania was thus paving the way for a shared self-identification among the otherwise distinct nobilities of the Polish and Lithuanian realms. That royal secretary Decius should embrace the notion of an uninterrupted historical cohabitation by all Polish–Lithuanian peoples is not surprising. After all, he worked for a Jagiellonian monarch who reigned over all these lands and had a dynastic interest in tying them more closely together.

As maps circulated across Poland–Lithuania and the rest of Europe, their use as a visual counterpart to text-based chronicles and pamphlets was becoming more widespread. The first update to Wapowski's map covering Poland and Lithuania was completed around 1558 by Wacław Grodecki (c. 1535–91), a nobleman of Teschen in Silesia (now Cieszyn), who was then still a student at Leipzig.[69] Perhaps due to anxieties over the development of a cohesive ethnic and religious identity for the emerging polity, the map was more overtly Polonocentric than Wapowski's version, assuming Poland's dominion over all the lands of the union. After all, the map—first printed in Basel in 1562 by Johann Oporinus (Figure 1.4)—is captioned 'in praise of Poland' (*in Poloniae laudem*) in the cartouche at the bottom left, thus claiming the historical lands included in Wapowski's apolitical representation as subordinate to the Polish Crown. Grodecki used Długosz's *Chorografia* and Wapowski's designs, either in the original or a copy, to create the most accurate map of Poland and Lithuania to date,[70] but he departed from the more inclusive logic of Sarmatia. The first practical application of the map, however, went against Grodecki's Polish-centred rhetoric. Printed with neither the name of the author nor a date, it was incidentally used as a cartographical counterpart to Philip Melanchthon's short treatise on the origin of the Slavs, published in 1558.[71] Given the context, this version of the map made much wider claims—none other than about the history of all Slavic peoples—than did the standalone Basel map printed four years later by Oporinus, which was described in the cartouche as 'Poland claiming dominion over various peoples' (*Poloniae variarum dominae gentium*).

As the same map could be employed in different written chorographies, it thereby served different purposes. The publication of Grodecki's map at Oporinus's Basel printing house is not without significance: at the time, Oporinus was likely also thinking about publishing the first authorized edition of *Polonia* (Poland), a treatise on the history and geography of Poland–Lithuania by Marcin Kromer, royal secretary and prince-bishop of Ermland.[72] Like Decius's *De vetustatibus Polonorum*, Kromer's *Polonia* naturalized Jagiellonian rule by asserting that Poles, Lithuanians, and Prussians were all Sarmatians—a claim laid with the help of cartography.[73] While Oporinus

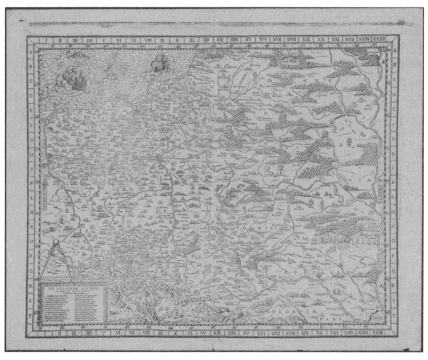

1.4 Wacław Grodecki, *In Poloniae laudem, et tabulae huius commendationem*, facsimile (original printed in 1562 by Johann Oporinus in Basel), from *Monumenta Poloniae Cartographica*, ed. Karol Buczek, vol. 1, Cracow: Polska Akademia Umiejętności, 1939

never did publish the book—which eventually came out in Cologne in 1577—there is surviving correspondence between Kromer and Oporinus as well as between Jan Grodecki (Wacław's brother) and Kromer that confirms he thought about including a version of Grodecki's map as an illustration to his work.[74] It was only the third authorized edition of *Polonia* (Cologne, 1589) that included a map to help the reader make sense of the text. Recycled from the 1570 edition of Abraham Ortelius's atlas *Theatrum orbis terrarum*, which itself was based on Grodecki's version published earlier by Oporinus, the map served as a visual tool to derive geographical information.[75] His commissioning of a map to accompany a historical chronicle demonstrates that Kromer saw cartography as indispensable for contextualizing his written descriptions of the land and its history; in other words, an account of 'Polonia' without its visual counterpart was seen as insufficient in communicating chorographical ideas clearly and effectively.

This brings us back to Pograbka, who—despite heavy reliance on Grodecki's designs for the 1570 map (Figure 1.1)—nonetheless refrained from calling the

lands of the union 'Polonia', preferring instead to refer to them by the classical designation 'European Sarmatia'. According to the dedication in the cartouche, Pograbka created this representation to address inaccuracies in the maps of Poland available in Venice at the time. He was probably referring to a 1562 map by Giacomo Gastaldi (1500–66) based on maps by Wapowski and Gerardus Mercator (1512–94). Pograbka's map was not innovative from a purely cartographical viewpoint—as Kazimierz Kozica has demonstrated, Pograbka merely revised Grodecki's 1562 map by adding 161 new localities.[76] Instead, Pograbka's key contribution lay in his marrying of the Ptolemaic idea of Sarmatia with the cartographical projection of Poland in Grodecki's map, thereby transforming a previously non-partisan idea into a platform for political integration.

Printed after the 1569 union, Pograbka's map offers a different perspective on the Polish–Lithuanian realms. His map of the union no longer depicts a collection of territories that forgo their individual identity 'in praise of Poland', as proclaimed by the cartouche in Grodecki's map. Rather, the later map visualizes a community of historic lands that together form the 'parts of European Sarmatia, which are under the control of the powerful Polish king Sigismund [II] Augustus'.[77] While the textual rhetoric of this formulaic account of sovereignty underlines the king's dominion over the Commonwealth, it simultaneously proposes to spread the value-neutral, classically sanctioned umbrella of European Sarmatia over the newly confirmed Polish–Lithuanian union. After all, Sigismund II was—from a legal point of view—not simply the king of Poland, his most prestigious regal title, but also 'by the grace of God, Grand Duke of Lithuania, Ruthenia, Prussia, Masovia, Samogitia, Livonia, Smolensk, Siveria, and Chirnihiv'. The visual language of the map is admittedly Polonocentric, with its western parts being richer in detail compared to the predominantly forest-covered Lithuanian and Ruthenian territories. Nonetheless, the map maintains a profound respect for the legal identity of all the lands of the union, each possessing their own historic names and distinct characters. The Commonwealth's visual identity is thus celebrated not as a coherent state inhabited by Polonized citizens but as a geographical entity consisting of separate units that together fill in the time-honoured contours of European Sarmatia. This is not yet a fully united realm but rather a projected vision of a polity inhabited by diverse peoples whose shared identity is based on living in a commonwealth whose roots go back to antiquity. Looking at this cartographical representation, early modern Polish–Lithuanian viewers of different linguistic and cultural backgrounds would have seen their regional distinctiveness simultaneously reinforced and open to reconfiguration, and would possibly even have grown stronger emotive ties with their fellow 'Sarmatians'. To paraphrase Richard Helgerson, Pograbka's map would have allowed them to see the Commonwealth for the first time.[78] Through

this and similar images, an imagined community of 'Sarmatia' was effectively coming into being.[79] Importantly, however, this casting of political sentiment in cartographical abstraction was merely the beginning of a process that had still not been completed by the time of the Commonwealth's partition in the late eighteenth century. In this sense, cartographical representation was not a reflection of reality.

It is difficult to gauge the impact of early modern images on collective identity, but soon after Pograbka's map was published, a change in the conception of Sarmatia began to take shape. While Marcin Bielski's earlier *Kronika świata* (1551) links Sarmatia only with Poland and Ruthenia (like Długosz's *Annales*), removing Lithuania from the picture altogether,[80] chronicles published in the 1580s promote a different narrative. For example, Stryjkowski's *Kronika polska, litewska, zmodźka y wszystkiey Rusi* (1582) provides the first detailed account of Lithuanian history as intimately related to the histories of Poland and Ruthenia. Funded not by the court but by over thirty Polish– Lithuanian noblemen,[81] Stryjkowski's volume blends Polish historiography with Lithuanian–Ruthenian chronicles (omitting their anti-Polish character) to claim that the Polish–Lithuanian union connected all the Sarmatian peoples under the aegis of a single polity.[82] Accordingly, Stryjkowski recounts the entangled past of all the Sarmatian nations, focusing on shared heritage and points of historical intersection. *Kronika polska* enjoyed wide reception in the Commonwealth and was popularized throughout Europe by the work of Alessandro Guagnini (1538–1614, Polish: Aleksander Gwagnin), an Italian soldier and writer active in Poland who in 1578 published *Sarmatia Europae descriptio* (A Description of European Sarmatia), a plagiarized version of Stryjkowski's manuscript, then still unpublished.[83] Like Stryjkowski, Guagnini included previously separate Polish, Lithuanian, and Ruthenian histories, uniting them under Sarmatian auspices.

Stryjkowski's account of the connections among all the nations inhabiting the Polish–Lithuanian Commonwealth quickly became a conventional mode of recounting the histories of its—by then—united realms. To give a notable example, Calvinist nobleman Stanisław Sarnicki (1532–97), who in 1587 published the Latin *Annales, sive de origine et rebus gestis Polonorum et Lituanorum* (Annals, or, On the Origins and Deeds of Poles and Lithuanians), described the principal peoples of the Commonwealth as having coexisted since the fourteenth century. Although he calls them Sarmatians and claims that Sarmatians had always inhabited the same lands in Central and Eastern Europe (which would later become Poland–Lithuania),[84] Sarnicki nonetheless treats Polish, Lithuanian, Ruthenian, and Prussian histories separately. This, then, is not a coherent narrative of one Sarmatian people but rather a history of neighbouring Sarmatian nations that had interacted with one another for generations and had only recently united. In Ruthenia and Prussia, similar

integrative processes materialized in historical writing, as local chroniclers began to update their nations' histories as distinct but not detached from those of their neighbours.[85] Nonetheless, despite the success of the Sarmatian narrative, the competing discourses of Lithuanians as allegedly descending from Romans, Prussians as heirs to Goths, and Ruthenians as the successors of Kyivan Rus' were never fully displaced.[86]

One Sarmatia, many Sarmatians

Poland–Lithuania would remain a composite polity throughout its existence. It was possible to add Sarmatia to one's sense of self without causing identity dissonance, since it was a geographical, historiographical, and (only implicitly) political designation that set the grounds for a shared vision of the union—not an exclusionary national category. Thus, when Ruthenian nobleman Adam Kysil (d. 1653, Polish: Kisiel) delivered a list of Ruthenian grievances at the sejm of 1641, he called his fellow nobles 'Ruthenian Sarmatians', and addressed his grievances to the 'Polish Sarmatians'.[87] The rhetoric of his speech foregrounds the nature of the transcultural polity that was shared between Poles and Ruthenians, while also revealing differences between these two groups. They are not a single, united people but rather two separate peoples who inhabit a connected geographical, political, and cultural space. Sarmatia in this account is a space of interconnectivity—a transcultural realm par excellence.

A similar use of the Sarmatian trope occurs in the oft-cited letter to Pope Julius III (r. 1550–55) written by Catholic clergyman Stanisław Orzechowski (1513–66, Ukrainian: Stanislav Orikhovskii, Latin: Stanislaus Orichovius), in which he argues against the Church's rule of celibacy for priests (just after his own marriage and subsequent excommunication). As he delivers his tirade, Orzechowski gives the following autobiographical details:

> I am of the Scythian people and of the Ruthenian nation [*gente Scytha, natione Ruthena*]. But I am also of the Sarmatian kind [*modo*], for Ruthenia [*Rusia*], which is my *patria*, is located in European Sarmatia. To the right [of Ruthenia] there is Dacia, and to the left is Poland. Before [Ruthenia] is Hungary, and indeed behind it is the actual Scythia that turns towards the rising sun.[88]

Orzechowski's self-identification is nothing if not complex. He feels simultaneously Scythian, Ruthenian, and Sarmatian, apparently seeing no conflict among what we might consider inconsistent identity claims. But while the first two appellations refer to genealogy, it is clear that Orzechowski uses Sarmatia in a geographical sense. He speaks explicitly of location when addressing Sarmatia, while he is Ruthenian 'by descent' or 'by birth' (Latin *natione*). Just like Kysil, then, Orzechowski sees himself as a Ruthenian Sarmatian.

There were also, of course, other types of Sarmatians. Prussian historian and educator Christoph Hartknoch (1644–87) asserts in his history of Prussia (*Alt- und neues Preussen*, 1684) that 'one European Sarmatia, as one common mother, nurtured the Poles and the Lithuanians and the Prussians'.[89] These peoples are distinct nations among the denizens of Sarmatia, yet by virtue of living in the same long-inhabited land they are, respectively, Polish, Lithuanian, and Prussian Sarmatians. History affects the present in this account, as current residents owe their country to different Sarmatian ancestors, who are identified as such based on their historical inhabitation of Sarmatia. While Hartknoch's reasoning is circular in nature, he does not seem to see a logical fallacy in his account. He simply takes the Ptolemaic notion of Sarmatia for granted—and, just like his Polish, Lithuanian, and Ruthenian counterparts, he treats the appellation 'Sarmatian' as a cartographical reference. Even if the Ptolemaic map of Sarmatia itself did not directly influence his ideas, Hartknoch assumed an epistemic position that naturalized Ptolemy's taxonomy into the default mode of investigating the Commonwealth's historical geography. The increased circulation of maps in this period promoted an image of Poland–Lithuania—both as a whole and as its constituent lands—that could be shared among the inhabitants of all the historically self-governing lands of this vast political union, giving rise to a sense of collective belonging that coexisted with local forms of self-identification. There was one Sarmatia—a geo-body that appeared real, even historical to its diverse inhabitants—but there were many different kinds of Sarmatians, and it would have crossed no one's mind to see this as a contradiction.[90]

The repeated self-identification of different inhabitants of the Commonwealth as Sarmatians raises the question of this chapter's purpose. If there was a Sarmatia and even Sarmatians, then why question the relevance of 'Sarmatism' for the study of identity and culture in the Commonwealth? Is there any point to this revisionism? The answer lies in the modern capture of Sarmatian discourse away from cartography to genealogy, and thus from a transcultural to a homogenizing perspective. It is imperative to reveal the anachronism of this modern reading because 'Sarmatism' is not merely an idiosyncratic account of Polish history but more markedly a larger metanarrative of Polish culture that reinforces Polonocentric interpretations of the Commonwealth, which is cast by this modern historiographical model as a 'Polonized' realm.[91] But although much twentieth-century scholarship on Sarmatism has (unwittingly) reproduced the Romantic bias of nineteenth-century national ideology and ignored the inherent diversity of both ancient and early modern Sarmatia, real and imagined, the diachronic study that the present chapter has undertaken of this cartographical construct reveals an unexplored archive of cosmopolitan thought in Sarmatian discourse itself.

A critical rereading of early modern accounts of Sarmatia through the lens of cartography makes a positive case for an entangled history of Poles, Lithuanians, Ruthenians, and Prussians as separate but interconnected nations within the Commonwealth. Although Sarmatia was a phantasm conjured up by the early modern followers of Ptolemy and other Greco-Roman geographers, it nonetheless provided a useful, classically sanctioned moniker for conceptualizing connections among the elites of Poland–Lithuania in spatial terms. Cartography, then, not only reproduced reality as it appeared in the light of day but also reordered it, constituting a means of thinking about and transforming reality through the visual representation of territory. Maps served as transcultural things in this respect, merging and converging peoples while visualizing and naturalizing their connected histories. Poland–Lithuania appeared in these symbolic depictions as the early modern equivalent of an ancient land with a similarly heterogeneous population, thus offering a base for political projections: since there was a shared past, there may also be a shared future.

While the Commonwealth did not need an ethnic common denominator to function, it was desirable to have a spatial metaphor and a visual trope that could embrace the whole territory without homogenizing or dividing its constituent peoples. The rhetoric of Sarmatia, which reinforces but does not supplant ideas of the Republic or the Commonwealth,[92] foregrounds a polity that is shared among these peoples, simultaneously revealing differences among them, including different ancestors. Polish-Lithuanian 'Sarmatians' saw themselves as connected not through lineage and shared ethnic origins, as is traditionally assumed (at least by some Polish scholars), but rather through the exigencies and expectations of living together in a shared polity. This is the precise rhetorical function of Sarmatia: to act as the spatial container of a dualistic polity comprising two composite states and at least four different peoples who all—at least at times—called themselves Sarmatians. The Commonwealth was not a nation-state in-the-making.[93] Instead, it was a union of diverse peoples who often disagreed (just as Adam Kysil disagreed with the Polish nobility at the sejm of 1641), but who still saw value in a shared political project that could be mapped onto the geographical contours of ancient Sarmatia, a transcultural realm.

Notes

1 Mańkowski, *Genealogia sarmatyzmu*, 97.
2 Ernest Gellner, *Nations and Nationalism* (Ithaca, NY: Cornell University Press, 1983), 55.
3 Kutrzeba and Semkowicz, *Akta unji Polski z Litwą*, 358.

4 Felicia Rosu, *Elective Monarchy in Transylvania and Poland–Lithuania, 1569–1587* (New York: Oxford University Press, 2017), 8–9; Grześkowiak-Krwawicz, 'Respublica and the Language of Freedom'.
5 Pograbka's map, for example, was printed in Venice, the unquestioned epicentre of European cartography in the 1560s and 1570s. See Karol Buczek, *The History of Polish Cartography from the 15th to the 18th Century*, trans. Andrzej Potocki (Amsterdam: Meridian, 1982); Michael J. Mikoś, 'Monarchs and Magnates: Maps of Poland in the Sixteenth and Eighteenth Centuries,' in *Monarchs, Ministers, and Maps: The Emergence of Cartography as a Tool of Government in Early Modern Europe*, ed. David Buisseret (Chicago: University of Chicago Press, 1992), 168–81; Maria Juda, 'Mapy ziem polskich w dawnej typografii europejskiej,' *Studia Źródłoznawcze* 41 (2003): 45–63; Jarosław Łuczyński, 'Ziemie Rzeczypospolitej w kartografii europejskiej XVI wieku (Próba ustalenia filiacji map wydanych drukiem),' *Polski Przegląd Kartograficzny* 41, no. 2 (2009): 128–144; Kazimierz Kozica, 'The Map of the Polish–Lithuanian Commonwealth by Andrzej Pograbka Published in Venice in 1570 in the Niewodniczański Collection 'Imago Poloniae' at the Royal Castle in Warsaw – Museum,' in *Proceedings 12th ICA Conference Digital Approaches to Cartographic Heritage, Venice, 26–28 April 2017*, ed. Evangelos Livieratos (Thessaloniki: AUTH CartoGeoLab, 2017), 10–14; David Woodward, *Maps as Prints in the Italian Renaissance: Makers, Distributors and Consumers* (London: The British Library, 1996), 4–5.
6 Peter van der Krogt, 'The Map of Russia and Poland in Dutch Atlases of the Sixteenth and Seventeenth Centuries,' in *Maps in Books of Russia and Poland Published in the Netherlands to 1800*, ed. Paula van Gestel-van het Schip et al. (Houten: Hes & De Graaf, 2011), 113–31; Andrzej Michał Kobos, 'Tomasz Niewodniczański (1933–2010) i jego zbiory,' *Prace Komisji Historii Nauki PAU* 11 (2012): 149–97.
7 Frost, *The Oxford History of Poland–Lithuania*, 405–94.
8 Benjamin Weiss, 'The *Geography* in Print, 1475–1530,' in *Ptolemy's 'Geography' in the Renaissance*, ed. Zur Shalev and Charles Burnett (London: The Warburg Institute, 2011), 91–120.
9 Tadeusz Ulewicz, *Sarmacja: Studium z problematyki słowiańskiej XV i XVI w.* (Cracow: Wydawnictwo Studium Słowiańskiego Uniwersytetu Jagiellońskiego, 1950).
10 Henri Estienne, *Traité de la conformité du langage françois avec le grec* (Geneva, 1565).
11 Neville, 'History and Architecture in Pursuit of a Gothic Heritage'.
12 K. A. E. Enenkel and Koen Ottenheym, *Ambitious Antiquities, Famous Forebears: Constructions of a Glorious Past in the Early Modern Netherlands and in Europe*, trans. Alexander C. Thomson (Leiden; Boston: Brill, 2019).
13 Ulewicz, *Sarmacja*, 136.
14 Tadeusz Mańkowski, *Genealogia sarmatyzmu*.
15 Mańkowski, *Genealogia sarmatyzmu*, 18.
16 Aleksander Brückner, 'Sarmatyzm,' in *Encyklopedia staropolska*, vol. 2 (Warsaw: Trzaska, Evert i Michalski, 1939), 451–53.

17 Tadeusz Chrzanowski, *Wędrówki po Sarmacji europejskiej: Eseje o sztuce i kulturze staropolskiej* (Cracow: Znak, 1988); Janusz Tazbir, *Kultura szlachecka w Polsce: rozkwit – upadek – relikty* (Poznań: Wydawnictwo Poznańskie, 1998), 132–52.
18 Mariusz Karpowicz, *Sztuka oświeconego sarmatyzmu: Antykizacja i klasycyzacja w środowisku warszawskim czasów Jana III*, 2nd ed. (Warsaw: PWN, 1986).
19 Dobrowolski, 'Cztery style portretu "sarmackiego"', 83–85.
20 Janusz Tazbir, 'Polish National Consciousness in the Sixteenth to the Eighteenth Century,' *Harvard Ukrainian Studies* 10, no. 3/4 (1986): 318.
21 Stanisław Cynarski, 'Sarmatyzm – ideologia i styl życia,' in *Polska XVII wieku: państwo, społeczeństwo, kultura*, ed. Janusz Tazbir (Warsaw: Wiedza Powszechna, 1969), 220–43; Władysław Tomkiewicz, 'W kręgu kultury sarmatyzmu,' *Kultura* 30 (1966); Maria Bogucka, *The Lost World of the 'Sarmatians': Custom as the Regulator of Polish Social Life in Early Modern Times* (Warsaw: Polish Academy of Sciences, Institute of History, 1996); Krzysztof Koehler, *Palus sarmatica* (Warsaw: Muzeum Historii Polski, 2016).
22 Chrzanowski, 'Orient i orientalizm w kulturze staropolskiej'; Banas, 'Persische Kunst und polnische Identität.'
23 *Decorum życia Sarmatów w XVII i XVIII wieku: Katalog pokazu sztuki zdobniczej ze zbiorów Muzeum Narodowego w Warszawie* (Warsaw: Muzeum Narodowe, 1980), 7.
24 Jacek Kowalski, *Sarmacja, obalanie mitów: Podręcznik bojowy* (Warsaw: Zona Zero, 2016); Ewa Thompson, 'Sarmatism, or the Secrets of Polish Essentialism,' in *Being Poland: A New History of Polish Literature and Culture since 1918*, ed. Tamara Trojanowska, Joanna Niżyńska, and Przemysław Czapliński (Toronto: University of Toronto Press, 2018), 3–29; Jan Sowa, 'Spectres of Sarmatism,' in *Being Poland: A New History of Polish Literature and Culture since 1918*, ed. Tamara Trojanowska, Joanna Niżyńska, and Przemysław Czapliński (Toronto: University of Toronto Press, 2018), 30–47.
25 Jakub Niedźwiedź, 'Sarmatyzm, czyli tradycja wynaleziona,' *Teksty Drugie* 1 (2015): 46–62.
26 After Eric Hobsbawm, 'Inventing Traditions,' in *The Invention of Tradition*, ed. Eric Hobsbawm and Terence Ranger (Cambridge: Cambridge University Press, 1983), 1–14.
27 Dirk Uffelmann, 'Importierte Dinge und imaginierte Identität: Osmanische 'Sarmatica' im Polen der Aufklärung,' *Zeitschrift für Ostmitteleuropa-Forschung* 65, no. 2 (2016): 193–214.
28 *Monitor Warszawski*, no. 30, 1765, 234; Franciszek Zabłocki, *Sarmatyzm: Komedya w pięciu aktach* (Lviv: Nakł. dr. Wilhelma Zukerkandla, 1905).
29 *Monitor Warszawski*, 30: 234.
30 Maciej Gloger, 'Teologia Polityczna Henryka Sienkiewicza,' in *Sienkiewicz Ponowoczesny*, ed. Bartłomiej Szleszyński and Magdalena Rudkowska (Warsaw: Wydawnictwo IBL PAN, 2019), 372.

31 Mańkowski, *Genealogia sarmatyzmu*, 97.
32 For a modern account, see Sulimirski, *The Sarmatians*.
33 Herodotus, *Histories*, ed. Carolyn Dewald, trans. Robin Waterfileld (Oxford: Oxford University Press, 1998), 4.110–117; Strabo, *Geography*, trans. Horace Leonard Jones, vol. 7 (Cambridge, MA: Harvard University Press, 1995), 3.17.
34 Tacitus, *La Germanie*, trans. Jacques Perret (Paris: Société d'Édition Les Belles Lettres, 1983), chap. 17.
35 'Poloni [...] et omnia genera slavorum, post diluvium in hanc aetatem in suis sedibus et connatis regnis permanent, et non aliunde supervenerunt'. Quoted in Ulewicz, *Sarmacja*, 59.
36 Marcin Kromer, *Polska: czyli o położeniu, ludności, obyczajach, urzędach i sprawach publicznych Królestwa Polskiego księgi dwie*, trans. Stefan Kazikowski (Olsztyn: Pojezierze, 1977), 15.
37 'Ociec nasz krześcijański [...] w ten tu kraj północny przyszedł do Europy po potopie i rozmnożył potomstwo swoje według Pańskiej wolej'. Marcin Bielski, *Kronika polska* (Cracow, 1551), 154v.
38 Maciej Stryjkowski, *Kronika polska, litewska, zmodźka, y wszystkiej Rusi* (Königsberg, 1582), 74.
39 Even Wojciech Dembołęcki, a Franciscan who conflates ancient Poles with the Scythians, reduces Polish antiquity to a necessary ethnographic prelude for the Christian era. In his account, the Eastern past has no bearing on the present, however, and is implied only to deduce the Poles' alleged descent from Seth (whom Dembołęcki calls 'Scyth'), the third son of Adam and Eve, and thus to claim that Polish was the language spoken in the Garden of Eden. See Wojciech Dembołęcki, *Wywod iedynowłasnego panstwa swiata, w ktorym pokázuie X.W. Debolecki ... ze nastárodawnieysze w Europie Krolestwo Polskie, lubo Scythyckie ... y ... ze język słowieński pierwotny jest ná świećie* (Warsaw: J. Rossowski, 1633), 27–45.
40 Jan Chryzostom Pasek, *Pamiętniki*, ed. Jan Czubek (Cracow: Polska Akademia Nauk, 1929), http://wolnelektury.pl/katalog/lektura/pamietniki.
41 Katharina N. Piechocki, *Cartographic Humanism: The Making of Early Modern Europe* (Chicago: University of Chicago Press, 2019), 12.
42 Pomponius Mela, *Description of the World*, trans. Frank E. Romer (Ann Arbor: University of Michigan Press, 1998), 110.
43 Patrick Gautier Dalché, 'The Reception of Ptolemy's Geography (End of the Fourteenth to Beginning of the Sixteenth Century),' in *Cartography in the European Renaissance*, ed. David Woodward, vol. 3 (Chicago: University of Chicago Press, 2007), 320–21; Buczek, *The History of Polish Cartography*, 25–27.
44 Dalché, 'The Reception of Ptolemy's Geography', 285–90.
45 Zur Shalev, 'Main Themes in the Study of Ptolemy's Geography in the Renaissance,' in *Ptolemy's Geography in the Renaissance*, ed. Zur Shalev and Charles Burnett (London: The Warburg Institute, 2011), 7–9; Alexander Jones, 'Ptolemy's Geography: A Reform That Failed,' in *Ptolemy's Geography in the Renaissance*, ed.

Zur Shalev and Charles Burnett (London: The Warburg Institute, 2011), 15–30; Katharina N. Piechocki, 'Erroneous Mappings: Ptolemy and the Visualization of Europe's East,' in *Early Modern Cultures of Translation*, ed. Karen Newman and Jane Tylus (Philadelphia: University of Pennsylvania Press, 2015), 81. For a recent critique of the notions of improved cartographic projection and the supposed novelty of the coordinate system, which were traditionally associated with the so-called Ptolemaic revolution, see Sean Roberts, *Printing a Mediterranean World: Florence, Constantinople, and the Renaissance of Geography* (Cambridge, MA: Harvard University Press, 2013), 36–44.

46 Bożena Modelska-Strzelecka, *Odrodzenie Geografii Ptolemeusza w XV w.: Tradycja kartograficzna* (Wrocław: Polskie Towarzystwo Geograficzne, 1960); Jadwiga Bzinkowska, *Od Sarmacji do Polonii: Studia nad początkami obrazu kartograficznego Polski* (Cracow: Nakł. Uniwersytetu Jagiellońskiego, 1994), 13–25; Lucyna Szaniawska, *Sarmacja na mapach Ptolomeusza w edycjach jego 'Geografii'* (Warsaw: Biblioteka Narodowa, 1993); Anthony Grafton, *New Worlds, Ancient Texts: The Power of Tradition and the Shock of Discovery* (Cambridge, MA: Belknap Press, 1992), 1–10.

47 See Henry Newton Stevens, *Ptolemy's Geography: A Brief Account of All the Printed Editions down to 1730* (Amsterdam: Meridian, 1973), 14–25, 106–8.

48 Claudius Ptolemy, *Geography*, trans. Edward Luther Stevenson (New York: The New York Public Library, 1932), book 3, chap. 5.

49 Buczek, *The History of Polish Cartography*, 26.

50 The work was never published in full but it circulated widely throughout early modernity. Hans-Jürgen Bömelburg, *Polska myśl historyczna a humanistyczna historia narodowa (1500–1700)*, trans. Zdzisław Owczarek (Cracow: Universitas, 2011), 64.

51 Jan Długosz, *Roczniki czyli kroniki sławnego Królestwa Polskiego* (Warsaw: PWN, 1961), 137.

52 Długosz, *Roczniki czyli kroniki sławnego Królestwa Polskiego*, 94, 164–65.

53 Długosz, *Roczniki czyli kroniki sławnego Królestwa Polskiego*, 286.

54 Bzinkowska, *Od Sarmacji do Polonii*, 23–24.

55 Bzinkowska, *Od Sarmacji do Polonii*, 34.

56 Buczek, *The History of Polish Cartography*, 32. These are, however, reproduced in Buczek's book from pre-WWII facsimiles.

57 'Sigismundus etc. Manifestum facimus tenore praesentium universis, quia cum famatus Florianus, civis et calcographus Cracoviensis, duas tabulas cosmographiae, particulares, alteram videlicet nonnulla loca regni nostri Poloniae et etiam Hungariae ac Valachiae, Turciae, Tartariae, et Masoviae [Moscoviae?], alteram vero ducatus Prussiae, Pomeraniae, Samogithiae et magni ducatus nostril Lithuaniae continentem, per venerabilem Bernardum Vapowski, cantorem ecclesiae cathedralis Cracoviensis, secretarium nostrum.' Published by Jan Ptaśnik, ed., *Monumenta Poloniae typographica XV et XVI saeculorum*, vol. 1 (Lviv: Ossolineum, 1922), 119–20, no. 287.

58 'Cracovia Poloniae nuper dedit tabulas duas Sarmatiae et Scythiae, licet inelegantes, tamen, me iudice, non inutiles. Si te illarum tenet ardot habendi, non deero tuo desiderio.' Johann Heumann, ed., *Documenta literaria varii argumenti* (Altorf, 1758), 119.

59 'Tabulam Sarmatiae secundo tibi mitto, nam hanc unicam ad manum nunc habui, pro prima scripsi Cracoviensibus amicis, habebis et illam. Quod Ptolemaeum viderit, fert graviter.' Heumann, Documenta literaria varii argumenti, 79.

60 Bernhard Willkomm, 'Beiträge zur Reformationsgeschichte aus Drucken und Handschriften der Universitätsbibliothek in Jena', *Archiv für Reformationsgeschichte* 9, no. 3 (1912): 246–47. See also Paweł Matwiejczuk, ed., *Melanchtoniana polonica* (Berlin and Warsaw: CBH PAN and Muzeum Historii Polski, 2022).

61 'D. Joannes Eckius, a me per literas poposcit, Corographias duas terre Sarmatiae, que opera mea in luce prodierunt, quas nunc in eo fasciculo transmitto.' Fragment of the letter published in Ludwik Birkenmajer, *Mikołaj Kopernik: Studya nad pracami Kopernika oraz materyały biograficzne* (Cracow: Akademia Umiejętności, 1900), 455.

62 Maciej Miechowita, *Opis Sarmacji Azjatyckiej i Europejskiej*, ed. Henryk Barycz, trans. Tadeusz Bieńkowski (Wrocław: Zakład Narodowy im. Ossolińskich, 1972), 28.

63 Mańkowski, *Genealogia sarmatyzmu*, 17.

64 Piechocki, *Cartographic Humanism*, 78.

65 Leszek Hajdukiewicz, *Biblioteka Macieja z Miechowa* (Wrocław: Zakład Narodowy im. Ossolińskich, 1960), 70, 154.

66 Kloczkowski, 'Polacy a cudzoziemcy w XV wieku', in *Swojskość i cudzoziemszczyzna w dziejach kultury polskiej*, ed. Zofia Stefanowska (Warsaw: PWN, 1973), 57; Chrzanowski, 'Orient i orientalizm w kulturze staropolskiej', 45; Mańkowski, *Genealogia sarmatyzmu*; Ulewicz, *Sarmacja*.

67 Jost Ludwig Dietz, *De vetustatibus Polonorum* (Cracow: Hieronymus Vietor, 1521), 2.

68 Kloczkowski, 'Polacy a cudzoziemcy w XV wieku', 57; Chrzanowski, 'Orient i orientalizm w kulturze staropolskiej', 45. See also Mańkowski, *Genealogia sarmatyzmu*; Tomas Venclova, 'Mit o początku', *Teksty* 4 (1974): 104–16; Ulewicz, *Sarmacja*.

69 Karol Buczek, 'Wacław Grodecki', *Polski Przegląd Kartograficzny* 11, no. 43 (1933): 80.

70 Łuczyński, 'Ziemie Rzeczypospolitej w kartografii europejskiej', 134.

71 Buczek, *The History of Polish Cartography*, 41.

72 Roman Marchwiński, 'Kromer a Grodecki: Podstawy kartograficzne kromerowskiej Polonii,' *Acta Universitatis Nicolai Copernici: Historia* 16, no. 114 (1980): 139.

73 Kromer, *Polska*, 15.

74 Buczek, 'Wacław Grodecki', 84–85.

75 Buczek, 'Wacław Grodecki', 83.

76 Buczek, *The History of Polish Cartography*, 45; Zsolt G. Török, 'Renaissance Cartography in East-Central Europe, ca. 1450–1650', in *Cartography in the European Renaissance*, ed. David Woodward, vol. 3 (Chicago: University of Chicago Press, 2007), 1816–20, 1833–34.

77 'Partis Sarmatiae Europeae quae Sigismundus Augusto Regi Poloniae Potentissimo subiacet.'
78 See Richard Helgerson, *Forms of Nationhood: The Elizabethan Writing of England* (Chicago: University of Chicago Press, 1992), 114.
79 The term 'imagined community' is Benedict Anderson's. See Anderson, *Imagined Communities*, 6.
80 Bielski, *Kronika Polska*, 155, 191–191r, 225–26. See also Bömelburg, *Polska myśl historyczna*, 178.
81 Bömelburg, *Polska myśl historyczna*, 589.
82 Maciej Stryjkowski, *Kronika*, vol. 1 (Warsaw, 1846), XV and XL.
83 Stryjkowski claims his manuscript was stolen by Guagnini. Bömelburg, *Polska myśl historyczna*, 590.
84 Stanisław Sarnicki, *Annales, sive de origine et rebus gestis Polonorum et Lituanorum libri octo* (Cracow: Aleksy Rodecki, 1587), Epistola praeliminaris, unpaginated. See also Bömelburg, *Polska myśl historyczna*, 239.
85 Bömelburg, *Polska myśl historyczna*, 594–655.
86 Albertus Koialovicius-Wijuk, *Lithuanae pars prior, de rebus Lithuanorum ante susceptam Christianam religionem conjunctionemque... cum regno Poloniae* (Danzig, 1650); Venclova, 'Mit o początku'; Tazbir, 'Polish National Consciousness'; Frank E. Sysyn, 'Concepts of Nationhood in Ukrainian History Writing, 1620–1690', *Harvard Ukrainian Studies* 10, no. 3/4 (1986): 393–423; Frank E. Sysyn, 'The Cossack Chronicles and the Development of Modern Ukrainian Culture and National Identity', *Harvard Ukrainian Studies* 14, no. 3/4 (1990): 593–607; Karin Friedrich, *The Other Prussia: Royal Prussia, Poland and Liberty, 1569–1772* (Cambridge University Press, 2006), 103–8; Oleksii Rudenko, 'The Myth, the Text, the Map: The Imaginary Homeland and Its Geographical Markers in Early Modern Poland and Lithuania', in *Crossing Borders, Contesting Boundaries: Proceedings of the 2020 14th MEMSA Annual Conference*, ed. Irini Picolou (Durham: MEMSA, 2021), 78–91.
87 After Frank E. Sysyn, 'Regionalism and Political Thought in Seventeenth-Century Ukraine: The Nobility's Grievances at the Diet of 1641', *Harvard Ukrainian Studies* 6, no. 2 (1982): Appendix, 186.
88 'Sum gente Scytha, natione Ruthena utroque autem modo Sarmata, quod ea Rusia, quae mihi patria est, in Sarmatia Europae sit posita dextra habens Daciam, sinistra Poloniam, ante illam est Ungaria, post vero Scythia vergit ad orientem solem.' Letter of Stanisław Orzechowski to Pope Julius III, 1551, in Ignacy Chrzanowski and Stanisław Kot, eds., *Humanizm i Reformacja w Polsce: Wybór źródeł dla ćwiczeń uniwersyteckich* (Lviv, Warsaw, and Cracow: Wydawnictwo Zakładu Narodowego im. Ossolińskich, 1927), 328.
89 Christophorus Hartknoch, *Alt- und neues Preussen* (Frankfurt and Leipzig, 1684), 101.
90 For the concept of 'geo-body', see Thongchai Winichakul, *Siam Mapped: A History of the Geo-Body of a Nation* (Honolulu: University of Hawaii Press, 1994), 16.

91 For recent examples, see Kowalski, *Sarmacja*; Thompson, 'Sarmatism, or the Secrets of Polish Essentialism'.
92 For recent studies in English on Polish–Lithuanian republicanism, see Frost, *The Oxford History of Poland–Lithuania*; Rosu, *Elective Monarchy in Transylvania and Poland–Lithuania*; Pietrzyk-Reeves, *Polish Republican Discourse*.
93 See Andrzej Sulima Kamiński, *Historia Rzeczypospolitej Wielu Narodów 1505–1795: Obywatele, ich państwa, społeczeństwo, kultura* (Lublin: Instytut Europy Środkowo-Wschodniej, 2000).

How do you dress like a Pole? 2

Imitation compromises the narratives of national distinction by emphasizing inconvenient similarities and shared heritages.

Barbara Fuchs, *Mimesis and Empire*[1]

We should not be misled by a curious, but understandable, paradox: modern nations and all their impedimenta generally claim to be the opposite of novel, namely rooted in the remotest antiquity, and the opposite of constructed, namely human communities so 'natural' as to require no definition other than self-assertion.

Eric Hobsbawm, 'Inventing Traditions'[2]

A young man gazes out from a portrait painted around 1560 (Figure 2.1), oozing the confidence and oomph often seen in such images. In a gesture typical of early modern monumental portraiture, the sitter rests his right arm on a table covered with patterned velvet fabric set before a classical column. The conventional *all'antica* palatial setting bespeaks wealth and respectability, clearly marking the young man as a person of high rank. To emphasize this distinction still further, he wears a silk doublet, velvet hose, silk stockings, a black satin cloak lined with golden thread, and leather duckbill shoes.[3] He also holds a handkerchief and a pair of gloves, garments associated with courtly manners and high society. A tall satin hat perches on the table, completing the picture of an opulent, aristocratic lifestyle in line with the latest elite European fashions. This is not surprising—after all, the portrait depicts Polish nobleman Sebastian Lubomirski (1546–1613), scion of a great fortune who later in life held many lucrative state offices, including the first senatorial appointment secured by the Lubomirski family.

There is nothing unusual about this painting. Many European noblemen of the day had similar portraits commissioned, in which they appear wearing similar dress. In the mid-sixteenth century, the upper nobility of Poland–Lithuania often followed the same fashion trends as did its counterparts elsewhere in Europe.[4] Yet things were soon to take a different turn. In a portrait of Lubomirski painted some forty years later (Figure 2.2), we see what looks

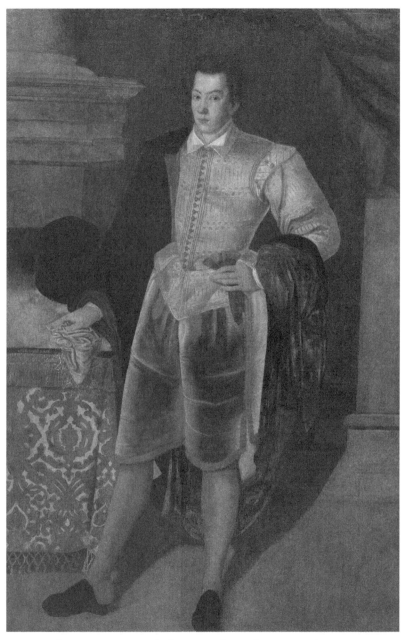

2.1 Giovanni de Monte, *Portrait of Sebastian Lubomirski*, c. 1560, oil on canvas, 173 × 113 cm. Warsaw, Muzeum Pałacu Króla Jana III w Wilanowie, Wil.1150

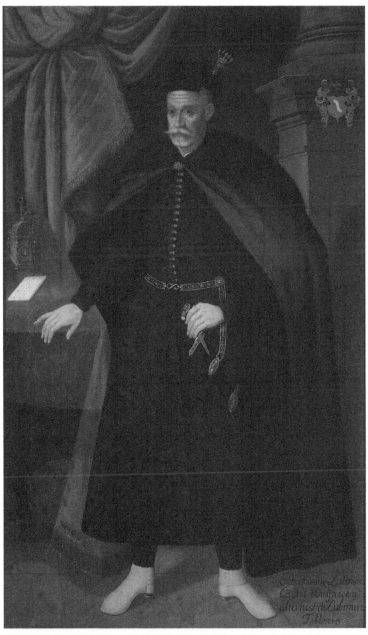

Anonymous (Poland?), *Portrait of Sebastian Lubomirski*, after 1603, oil on canvas, 200 × 120 cm. Warsaw, Muzeum Narodowe, MP 5510, provenance: the Potocki of Krzeszowice collection

2.2

to be an entirely different man, potentially from an entirely different place. An inscription at bottom right refers to the sitter as 'Castellan of Wojnicz', a senatorial office that Lubomirski acquired in 1603, marking his steady upward progression towards the highest echelons of the Polish–Lithuanian nobility. The *all'antica* background and the full-length confident pose have not changed, but the dress no longer corresponds to prevalent European fashions of the day. Instead of donning the doublet, cape, and hose that were still popular in many parts of Europe during this period, Lubomirski now wears an Ottoman-inspired silk undercoat (*żupan*), a fur-fitted overcoat (*delia*), also of Ottoman provenience, and a rounded felt hat of Hungarian origin (hence its Polish name *magierka*, 'a little Hungarian').[5] The hat is adorned with a silver pin (*szkofia*) plumed with a heron feather that likely came from Ruthenia or the Ottoman Empire.[6] Gone are the gloves, exchanged for a sabre hanging from a metal belt, both in Ottoman style. Courtly duckbill shoes have been replaced with yellow leather boots and their associations with hunting or military pastimes—this footwear, too, has parallels in Ottoman fashion.[7] In his Ottomanesque dress, the Pole appears out of sync with (Western) European sartorial codes of the day. Over the forty years that separate his portraits, Lubomirski not only grew old but also visibly abandoned his youthful tastes.

Lubomirski was by no means alone in changing the way he presented himself to the world. Other members of the Polish nobility undertook a similar makeover, evidence of which can be found in a legion of portraits, household inventories, and literary accounts.[8] This assimilation of Ottoman fashion into Polish dress—and into Polish–Lithuanian culture more broadly—has received ample scholarly attention.[9] Art historians and costume historians often point to the geographical location of Poland–Lithuania, its border with Ottoman tributary states encouraging mercantile and cultural exchanges with the Ottoman world.[10] Other scholars have argued that it was through confrontation with Ottoman and Crimean armies that Polish–Lithuanian nobility discovered their penchant for Ottomanesque fashions, which were better suited than Western European garments to the harsh climate of Central and Eastern Europe and campaign conditions in the Polish–Ottoman borderlands.[11] These foreign fashions were at first embraced only by those who took part in military operations, but the trend was soon followed by the nobility from other parts of the Commonwealth, especially as they fraternized at royal elections, sessions of the general diet (sejm), and regional legislative assemblies (*sejmiki*).[12] Still other scholars maintain that fifteenth- and sixteenth-century Polish, Lithuanian, and Ruthenian costume had already shared similarities with the Ottoman manner—a loose-fitting robe being the most common item of male attire until the more tailored Western European garments with their tighter fit gained popularity among Polish–Lithuanian elites in the sixteenth century.[13] This historical preference for loose-fitting fashions may

have proven relevant at the turn of the next century when the nobility were increasingly treating long robes and tunics as an element of vernacular tradition.[14] Be they Lithuanian, Polish, Prussian, or Ruthenian, the multi-lingual and multi-confessional nobilities of Poland–Lithuania began to look similarly Ottomanesque by the seventeenth century, particularly as images of men clad in żupans and delias circulated across the polity's territories in prints commemorating military victories, sejm sessions, and other official events, providing ample points of reference for the increasing familiarity of once foreign costume now treated as local.[15] Polish–Lithuanian nobles were coming to visually resemble not only Ottoman subjects but also each other, blurring the differences among the regional cultures of the multi-ethnic Commonwealth.[16] When Lubomirski commissioned the portrait that marks his ascendancy to the castellany of Wojnicz (Figure 2.2), adherence to Ottomanesque fashion was a commonplace practice.

The shift in sartorial preferences away from Italian and German types among Commonwealth subjects has been interpreted as a form of self-Orientalization—an embrace of 'Eastern' material culture by a 'European' people.[17] Though widely accepted, the logic of this interpretation is flawed, not least because it assumes a binary distinction between West and East, Europe and others but also because it blindly applies these reductive categories to a complex transcultural context. The border between Poland–Lithuania and the Ottoman Empire was porous and fluid; rather than demarcating strict cultural boundaries, this zone of exchange placed the inhabitants of heterogenous polities in continual contact enabled in large part by cross-regional patronage, commerce, and travel.[18] As a result, admiration, fear, and sometimes indifference by, of, and among peoples went hand in hand, co-shaping Polish and other Commonwealth perceptions of Ottoman culture without a sense of contradiction.[19] Sartorial codes, too, defied easy ethnic or geographical categorizations. While Poles originally saw Ottoman costume as alien, with time they became used to it, adapted it to fit local sensibilities and needs, and began to call it 'Polish'. Seventeenth-century household inventories are full of descriptions of garments identified as local, which at the time meant an assimilated version of Ottoman garments.[20] Their wearers naturalized these fashions so fully that they soon lost sight of the causal relationship between their own and Ottoman custom, effectively accepting a transcultural import as part of local, allegedly timeless tradition.

Of course all tradition is invented tradition. Historically embedded rather than timeless, it is only through naturalization, repetition, and everyday practice that material things like costume become culturally adopted as ancient, unchanging, and locally rooted.[21] The Ottomans, then, need to be both acknowledged as contributors to the history of Polish fashion and reintegrated into it in a way that defies binary cultural categories, connects not

divides, and—most importantly—embeds tradition with its transcultural underpinnings rather than appealing to nativist sentiment. The similarities between Polish and Turkish elite costume are too many to count—they create a striking sartorial idiom that confounded early modern observers from Western Europe, who sometimes mixed up the Polish–Lithuanian look with Ottoman fashion. For locals, however, Polish costume—as reinvented in its late sixteenth-century Ottomanesque form—felt unique, distinctive, and intimately linked to local culture.[22]

What should we call this costume, then? Is 'self-Orientalization' an accurate way of describing the material culture of a Central and Eastern European elite whose manners escaped clear definition, instead generating such contradictory epithets as 'bulwark of Christendom', 'neighbours of the Turks', or 'descendants of the Scythians [who] ape the grandeur and majesty of the [Ottoman] Seraglio'.[23] Polish costume paradoxically gave rise to exoticizing interpretations (particularly from abroad) while also acting as a marker of allegedly vernacular tradition (particularly at home). Declared unique and distinct by both local and foreign sixteenth- and seventeenth-century literary sources, Polish fashions were nonetheless intertwined with those in other parts of the world—East, West, and beyond. To understand this transcultural dimension of early modern Polish culture, tacitly embraced and yet ostensibly disavowed, we must approach it from a comparative perspective that dives into both external factors and internal causes. The disavowal of Polish costume's foreignness, which is particularly noticeable in the seventeenth century, followed from postulates assuming the historical integrity of local culture, however misconstrued. But how did such an openly deterministic notion of cultural integrity not collapse under its own contradictions? How could nativist sentiment find its most visible expression in what had once been seen as foreign garb? This chapter tackles these underexplored questions in order to examine what it meant to dress like a Pole in the sixteenth and seventeenth centuries, and what kinds of comparisons and references choice of dress evoked in a multi-ethnic Poland–Lithuania.

Inventing and reinforcing tradition

The chronology of how Ottomanesque fashion was adapted in Poland–Lithuania is well understood.[24] While, during the early sixteenth century, Ottoman costume was still considered foreign, by the seventeenth century its altered form had become a conventional expression of the main regional Commonwealth identities: 'Polishness', 'Lithuanianness', 'Ruthenianness', and even—in some cases—'Prussianness'. Ottomanesque dress first reached Poland via Hungary during the first half of the sixteenth century and later spread to

all the other lands of the vast polity.²⁵ Historians have emphasized the existence of trade routes with the Balkans, Anatolia, and West Asia that ran across Poland–Lithuania as one of the reasons for the adoption of Ottomanesque costume.²⁶ The Armenian diaspora in Poland's southeast, in particular, served as a vector of transmission.²⁷ In addition to these close commercial links—not to mention the high quality of Ottoman textiles, which made them particularly desirable—warfare with the Ottoman and Tatar armies provided plentiful opportunities for familiarizing Polish–Lithuanian nobles with Ottoman fashion. It is also possible that the strict regulation of dress for all ranks of the Ottoman military made a strong impression on Polish–Lithuanian observers during a period when choices about how to dress often gravitated towards visual displays of power and success—nobles' eyes would have been drawn to dress that implied high status.²⁸ The sight of finely clad, well-armed Ottoman soldiers thus left a lasting impression on Poles who saw them first-hand, and occasional war booty could entice those who lived further away from the theatre of war to broaden their fashion sense.²⁹ Removed from the realities of combat and trade, Ottoman fashions were at first a luxury but gradually became more accessible.³⁰

The shift from exotic to local was not, however, straightforward, nor was it without controversy. During the mid-sixteenth century, Ottomanesque costume was still considered foreign in Poland, even evoking hostile feelings towards the Turks. Catholic Ruthenian cleric and political theorist Stanisław Orzechowski (1513–66, Ukrainian: Stanislav Ozhekhovskii), to give a prominent example, rallied his readers against Turkish costume by insinuating its corrupting impact:

> Consider their costume; how cruel, how coarse, how intimidating: their heads shaved [...] their lips inhuman [...] and very stupid; not to mention the effeminate character of their clothing, too long, down all the way to the ankle; a Turk covers his entire body so as to not reveal any part that might give away his inhuman form.³¹

Orzechowski's description appears in a Latin-language pamphlet published in 1544 (and in Polish in 1590) that calls for a crusade against the Ottoman Empire, a goal that partly explains the passage's insults and exaggerated tone. The antagonistic, derogatory language suggests that in the 1540s, Ottoman dress was considered a barbaric oddity, at least by Orzechowski.³²

It is perhaps unsurprising, then, that two decades later many Polish writers still found Ottomanesque costume foreign and thus inappropriate for Polish nobles. Yet in the mid-sixteenth century, there was in fact no style that could be considered typically local. In the 1566 Polish-language adaptation of Baldassare Castiglione's *Il Cortegiano*, titled *Dworzanin polski* (The Polish

Courtier), for instance, humanist Łukasz Górnicki (1527–1603) worries about the disorienting coexistence of too many fashions:

> Today, there are so many different costumes here that it is hard to count them. Some fancy their clothes Italian, others like them Spanish, yet others prefer the Brunswick-style dress, or Hussar-style [Hungarian?], both the old and new fashions, either Cossack or Turkish; and there are still other styles that I cannot even name.[33]

Górnicki asserts that none of these fashions predominated, but the underlying issue is that 'traditional' Polish dress was no longer popular. Although clearly troubled by the surrender of a local tradition, he cannot specify what this old Polish fashion was actually like:

> We Poles do not have our own costume, but I guess it must have existed before, though it later became unappealing to us when we gave in to novelties.[34]

The danger of 'giving in' was that the Polish nation might fall prey to the ethnic groups whose customs they adopted. While Górnicki frets over sartorial appropriation in general, he is particularly wary of Ottoman influence:

> The Hungarians lost their kingdom when they adopted Turkish costume. Only God can know what harm the multitude of costumes in our dear old Poland could bring about. If all those whose dress we wear were to attack Poland, little would remain of the country. We must then pray to God so that our people put an end to this strange fancy of foreign costume.[35]

By warning the nobility that they might end up under the Ottoman yoke—just like the Hungarians did in 1526—if they acquire too strong an inclination for Turkish garments, Górnicki associates costume with a way of life, transforming material reality into an essentializing discourse of pure and bounded cultural identity. Criticism of Ottoman dress correlates with a wider distrust for foreign things and their real—as well as potential—impact on local custom, revealing a longing for older, simpler Polish ways. In this nostalgic rhetoric, Górnicki follows Castiglione who, too, worries about loss of identity (and sovereignty) should his fellow Italians continue adopting foreign fashions.[36] But while Castiglione can define a local style, albeit vaguely, Górnicki can only speak of traditional Polish costume in the hypothetical. From this conjectural description emerges a yearning for sartorial uniformity that admittedly never existed.

Mid-sixteenth-century household inventories bring further evidence of the wide variety of fashions worn by the Polish nobility. In the best explored sample from Greater Poland (Wielkopolska), garments described as Polish, Hungarian, Ruthenian, Lithuanian, Turkish, and Italian appear alongside each other in various property registers, suggesting not only a broad range of choice but also discernible differences between Polish costume and the fashions

predominant in Ruthenia and Lithuania.[37] One of many contemporaries who pointed to this divergence, Cracow University professor Maciej Miechowita (1457–1523, Latin: Matthias de Miechow) described Ruthenians as following Greeks rather than Poles in manner of dress.[38] Neither did the diversity of costume in Poland–Lithuania escape the attention of foreign visitors. Giulio Ruggieri, papal envoy to Poland from 1566 to 1567, instructed Pius V in a report that the locals 'like to dress sumptuously, enjoying Hungarian costume in particular, but they sometimes wear Italian clothes as well'.[39] Spanish lawyer and poet Pedro Ruiz de Moros (c. 1505–71), who spent most of his life in Poland and Lithuania, manifested this sartorial plurality in a particularly evocative manner:

> Germans, Greeks, Italians, or Spaniards—from the Phoenician Cádiz
> To the borders of India—you will recognise them everywhere
> By their uniform, relevant national dress,
> Only Poles wear clothes of such different fashions.[40]

Among the world's various nations, in other words, only the vacillating Poles are unable to decide on an appropriate form of dress that would mark them in the eyes of foreigners as a coherent people.

Around the time when Górnicki, Ruggieri, and Ruiz were recounting this multitude of sartorial codes, other writers were beginning to notice the growing popularity of Ottomanesque costume in the kingdom. In a report sent to Pius IV in 1560, Apostolic Nuncio to Poland Bernardo Bongiovanni (d. 1574) notes that King Sigismund II (r. 1548–72) switched between Hungarian (Ottomanesque) and Italian (Western European) fashions with ease and confidence.[41] The king may have felt pressure to perform publicly in Ottomanesque costume in order to appeal to Polish nobles, some of whom were already wearing this type of costume. But it was under the Hungarian-born King Stephen Báthory (r. 1576–86)—who wore Ottomanesque dress daily, according to witnesses—that the new fashion found its most ardent enthusiast.[42]

In a portrait painted in 1583 by court painter Martin Kober (Figure 2.3), King Stephen appears in a costume that exemplifies his preference for the new fashion. His red overcoat (*delia*) reveals a patterned silk tunic (*żupan*) worn underneath, with only the sleeves visible. Narrow trousers, yellow boots, black fur collar, and a fur-trimmed cap (*magierka*) plumed with an ornamental feather completes the outfit, which is clearly reminiscent of Ottoman fashions that Orzechowski had criticized some forty years earlier. Zdzisław Żygulski Jr. has read even the napkin that the king holds in his left hand as an attribute of royal sovereignty adapted from Ottoman custom, where an *ulatu* or *savluk* can be symbolic of a sultan's dignity and power.[43] Versions of the king's portrait circulated across the country in painted and printed copies: a replication of imagery that coincided and correlated with the growing demand for portraits

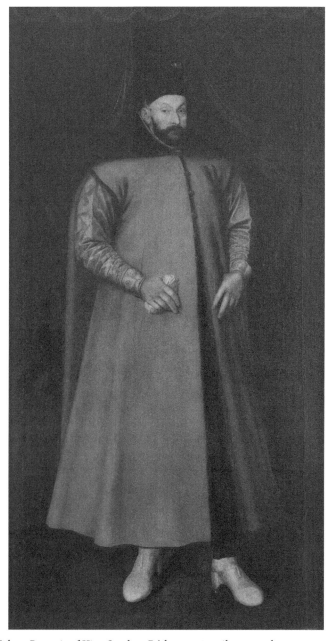

2.3 Martin Kober, *Portrait of King Stephen Báthory*, 1583, oil on panel, 236 × 122 cm. Cracow, Historical and Missionary Museum of the Congregation of the Mission

among noble citizenry and the increasing popularity of Ottomanesque costume, which had now received the royal stamp of approval.⁴⁴

By 1600, as we have seen, even magnates like Sebastian Lubomirski were finding it necessary to don the new fashion (Figure 2.2). Pietro Duodo (1554–1610), Venetian envoy to the court of King Sigismund III (r. 1587–1632), confirms the preponderance in Poland of Ottomanesque fashion in a speech that he delivered to the Venetian Senate upon his return in 1592, stating that 'Poles have their own costume similar to the Hungarian'.⁴⁵ Duodo thus broke with the older rhetoric of sartorial multitude, claiming instead that there *was* a costume that distinguished Polish nobles from their counterparts elsewhere. Márton Szepsi Csombor (1594–1623), a Hungarian pastor and educator who travelled to Poland in 1616, states matter-of-factly in his travel account *Europica varietas* (European Variety, Košice/Kassa/Kaschau, 1620) that 'Polish male garments once differed from the Hungarian, but today there is little difference, for both peoples delight in Turkish dress'.⁴⁶ The adoption of Ottoman fashion as Polish tradition is made to appear so self-evident in this pithy statement that it can be voiced seemingly without explanation.

To see this sense of local tradition expressed in a specific historical context, consider a painting in Lviv's Historical Museum (Figure 2.4). Perhaps a workshop copy of a scene commissioned from Tommaso Dolabella (1570–1650), court painter to Sigismund III, the image depicts the tribute paid to the king by the deposed Muscovite tsar Vasili IV Shuisky (r. 1606–10) accompanied by his brothers, Dmitry and Ivan. The event, which concluded a victorious Polish expedition against Muscovy, took place in the Senate Hall at Warsaw Castle on 29 October 1611; the original oil painting may have decorated either the ceiling of the same room or an antechamber elsewhere in the castle to commemorate the tribute.⁴⁷ Sigismund is seated at centre on the throne. Dressed in pink silk żupan and fur-trimmed delia, with a kalpak hat on his head, he receives the Muscovite tsar on behalf of the Commonwealth. On his left sits Crown Prince Ladislaus (future King Ladislaus IV, r. 1632–48), who wears similar dress. Most men gathered in the room are senators and sejm deputies who—with few exceptions—are seen in variations of the costume worn by the royals. Apart from the senator-bishops in Catholic clerical robes, only Marshal of the Sejm Jan Swoszowski (d. 1615) wears black-and-white Spanish costume. Its foreign mode is in plain sight, especially as Swoszowski appears in the foreground (at left), directly across from Grand Marshal of the Crown Zygmunt Gonzaga Myszkowski (1562–1615).⁴⁸ Both of them hold a marshal's staff and flank the Muscovites who stand between them, but Myszkowski is contrastingly dressed in the Ottomanesque Polish costume of nearly all the other figures—dress that at this point was already accepted as an indispensable and integral part of Polish culture. Among the proponents of the dominant fashion, we see Field Crown Hetman and Sigismund's sworn enemy Stanisław

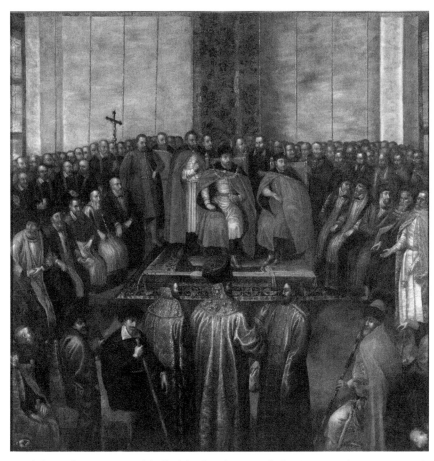

2.4　Workshop of Tommaso Dolabella (?), *Shuysky Czars before Sigismund III*, seventeenth century, restored in 2011–13, oil on canvas, 340 × 340 cm. Copy of a lost painting by Dolabella of c. 1611. Lviv Historical Museum, Pidhirtsi Castle Collection

Żółkiewski (1547–1620) who, as historical records stipulate,[49] presented the tsar and his brothers to the king, but in this royal commission is relegated to the right-hand side of the painting; even the golden mace, a symbol of his office, appears diminished. His costume, very like the king's, seems almost royal livery and acts to blend him in with the nobles assembled in the Senate Hall, thus completing the picture of sartorial uniformity.

The Muscovites, on the other hand, stand out from the crowd in their floral-patterned silk tunics with long collars. Visibly different from the nearly uniform Polish–Lithuanian outfits in the painting, these robes were tailored especially for the occasion, on the king's order—likely to amplify the differences between the warring nations' fashions.[50] In 1618, royal courtier

Jakub Sobieski (1591–1646), who took part in the Polish military expedition in Muscovy, compared the dress of the tsar's envoys to that of actors who 'according to their fashion [*more suo*] were tricked out and overdressed as in a comedy'.[51] But Sobieski's description of the Muscovites' long robes and richly layered fabrics sought not only to provoke odium for exaggerated luxury and over-ornamentation but also to draw a line between 'us' and 'them'. Both sameness and difference could be expressed by costume, and the Lviv painting drives this point home by visualizing the contrast in appearance between the familiar Polish self and the exotic Muscovite other.

Clothing distinguished a local from a foreigner so clearly that the non-negotiability of its visual code was taken for granted.[52] Costume was inseparably linked to cultural rules and expectations, and people of all social strata read their own dress and that of others as a marker of identity.[53] This outermost presentation of the body was thus precisely where the identity of an individual or a wider community was physically made manifest. Costume was synonymous with custom, or 'habit'—the latter term appears repeatedly in early modern costume books, illustrated albums that linked clothes to a people, conflating material culture with manners and morals.[54] A strategy of marking differences and similarities via a plethora of cued associations, 'habit' absorbed nation, region, religion, lineage, genealogy, mode of dress, and living into a teleological inevitability.[55]

But since early modern identity was expressed by surface appearances, there was always a danger that it could be counterfeited.[56] Articles of clothing were designed to serve as tools of authentication and guarantors of identity, but stories of dissimulation through costume abounded in early modernity: individuals dressed up (or down) to look like others (women as men; peasants as nobles), rendering dress and attire a potential agent of deception in both historical account and fictional rendering—often to comic effect, though with potentially disruptive ramifications for social stability.[57] One historical example is Sigismund III and his sons Ladislaus IV and John Casimir (r. 1648–68) of the House of Vasa, which originated in Sweden. Unlike King Stephen, these royals preferred Western European fashions in both their private and public lives, but at times they wore Ottomanesque Polish costume in an attempt to gain the trust of their subjects, particularly those beyond courtly circles. The 1611 Muscovite tribute and the images that publicized it provided one such opportunity. Yet as we know from historical sources, these staged performances of Polishness were not always viewed as genuine expressions of Vasa cultural affinities; rather, they were seen as counterfeit meant to downplay the Spanish, Italian, German, and later French manners espoused on many occasions by the court and its allies.[58] This led to an unsolvable problem for the Vasas: when they flaunted foreign (Western European) fashions, they were rebuked for introducing overseas customs, including—allegedly—Habsburg-style absolutism,

but when they donned local (Ottomanesque) costume, they were accused of falseness.⁵⁹ Costume thus acquired explicit political connotations.

The libel *Wojna czupryny z pontą* (The War Between Tuft of Hair and Pointed Beard, 1607), by an anonymous pamphleteer, exemplifies the nexus of politics and costume. Written during the two-year-long armed revolt (1606–8) against Sigismund III, which was led by his political rival, Lord-Palatine of Cracow Mikołaj Zebrzydowski (1553–1620),⁶⁰ the work metonymically reduces the king to his Spanish-style pointed beard and clothing, with żupan and shaven head with tuft of hair atop serving as a contrasting synecdoche for the recalcitrant nobility. Enumerating his reasons for civil disobedience, Tuft of Hair, clearly an antiroyalist, laments Pointed Beard's disrespect for local fashions:

> I nurse a grudge against Pointed Beard
> That he should promote foreign hairstyles,
> Favours doublet over the żupan,
> And thinks our delurka and delia are inferior.⁶¹

The rhetoric of 'us' versus 'them' evident in this polemical verse vividly paints a context in which the king was repeatedly charged with defying local cultural conventions—to the extent that he was eventually deemed unfit for rule due to his allegedly doubtful allegiance to his adopted country.

Critiques of Vasa sartorial preferences were recurrent. Even Samuel Twardowski (1600–61), author of several epic poems celebrating Ladislaus IV, complained about the king's penchant for foreign fashions. Seen as a fad, the need to conform to overseas customs allegedly 'prevented most locals from becoming a courtier; only enthusiasts of French and Italian costume would qualify'.⁶² An anonymous seventeenth-century diarist accused King John Casimir of the same perceived offence. Describing the king's August 1649 sojourn in Lviv, the diarist recounts that:

> before the King left [the city], he had taken off German costume, which he had fancied since childhood, and put on Polish dress in order to gain favours from the Poles. Everyone liked the gesture, but they also wished that the king would embrace not only Polish costume, but also customs.⁶³

In a similar vein, multiple sejm minutes record unsolicited advice cast at all Vasa kings: that they wear Polish dress.⁶⁴

While the Vasas often ignored the admonitions they were given, on some occasions they conformed, proving that sartorial code-switching was not an aberration but an integral component of Polish–Lithuanian high society. Costume provided a mechanism for framing cultural affiliation that escaped rigid self-definitions, and elites switched easily between local, German, French, and Spanish fashions, depending on social and political context.⁶⁵

There are many surviving portraits in which male members of the Denhoff, Radziwiłł (Radvila), and Zasławski-Ostrogski noble families, among others, appear in various Western European fashions. The same men, however, can be seen in local dress in other portraits, suggesting that there were always various clothing styles at nobles' fingertips.[66] As Jacek Żukowski has demonstrated, mixed costume with local and Western European elements was widespread in Poland–Lithuania.[67] This conflation of local and foreign modes of dress was anxiety-inducing for seventeenth-century moralists who often reprimanded noblemen for developing a penchant for imported garments.[68] Unease with sartorial code switching is nowhere more evident than in the recurrent critiques of the Grand Tour.[69] Krzysztof II Radziwiłł (1585–1640), Lord-Palatine of Vilnius and Grand Hetman of the Crown, exemplifies this anxiety when he frets that his son Janusz would be tempted to surrender Polish costume on his travels across the continent. He therefore urges Janusz's preceptor, in a handwritten instruction, 'to wear Polish habits [*jechać w polskich habitach*] in Berlin […] and to only take up foreign fashions in Leipzig'.[70] The less time an heir would spend parading in others' costumes, the better.

It is in the context of this multitude of sartorial models available to elites that we must understand the seventeenth century's constant eulogizing of Poland's allegedly unique and supposedly traditional costume. Polish moralists often claimed the superiority of Polish habits, juxtaposing their stabilizing effect on society against the inherent instability of Western European 'fads'—which, they believed, corrupted body and soul. In this manner, wealthy landowner, politician, and satirist Krzysztof Opaliński (1611–55) insisted that foreign customs be kept away from Polish youth to avert the country's moral decay. In the anonymously published *Satires* (1650), he advises against sending noble offspring on a Grand Tour to France so that they do not lose sight of Polish values. The argument goes that an unsuspecting young nobleman would not only:

> [learn] to speak French but also to walk
> And dress *alamode*, and do everything as if he were French.
> […] Now Poland is vulgar to him, and everything about it stinks.
> He boasts of France, its ladies, and ballets.
> Yet he knows nothing but lies and false appearances.
> He always looks in the mirror like an ape,
> Prettying up and shaving as often as twice a day.[71]

Opaliński was clearly disgruntled at the prospect of French fashions taking root in Poland. He deems them vain, superfluous, and, most worryingly, foreign—thus, completely at odds with the local Polish social order.

Writings on the threat of losing Polish traditions to foreign novelties employ unsurprising rhetoric. The passing down of cultural elements from

generation to generation, elements seen as eternal and unchanging, is here contrasted with the supposed transience and fluidity of French customs, described as 'false appearances'. Tradition was considered the glue that held society together; in the face of its unravelling, the argument went, confusion and loss would ensue, uprooting Poland from its historical grounding. In line with this thinking, costume assumed an important role in guarding traditional virtues and defending society against any putative loss of cultural identity and against foreign influence. But such sartorial traditionalism is mired in a deep contradiction: had it not been for foreign interactions and, indeed, influence, the supposedly native costume of Poland would have never emerged. How deep did this nativist rabbit hole go?

Historicizing fashion

Belief in the historical embeddedness of seventeenth-century Polish costume was not without any supporting evidence. Contemporaries' sense of sartorial nativism was in fact historicized through a variety of media widely accessible to the nobility. Take, for example, a seventeenth-century panel depicting a range of Polish ensembles worn by the nobility during the Vasa period (1587–1668), held today at the National Museum in Poznań (Figure 2.5).[72] Four men in the highest register wear żupans and delias, appearing united in their preference for long robes so unlike the short, closely fitted garments worn by most European men at the time. Women's bodies, too, are covered almost in their entirety (see the middle register), in contrast with the more revealing dress of their Italian and French counterparts of the same era. This modesty of costume does not accurately reflect the practices of the day, however, as household inventories from the period list many low-cut dresses.[73] The demure clothing in this image may therefore be seen as a proscriptive expectation of noblewomen's comportment that did not necessarily materialize in the real world. Taking shape before the viewer's eyes across the registers of this panel is thus a make-believe tradition that would doubtless have satisfied the puritanical longings of Polish moralists but that is coherent only as an effect of its own cause rather than being a true expression of lived experience. The rhetoric of the painting foregrounds the collective character of Polish fashions, yet their local specificity is premised on the idea that a wider group must accept these garments' status as traditional clothing in order to unlock their community-building potential.

For the men in the painting, a sense of shared belonging is created through emphasis on military prowess. All the full-figure men carry a sword; one even holds a general's staff (second to the left, upper register). The full-figure men depicted in the lower registers appear with their military equipment, including quivers, arrows, and a war hammer. The horses, in full tack and ready to

How do you dress like a Pole? 73

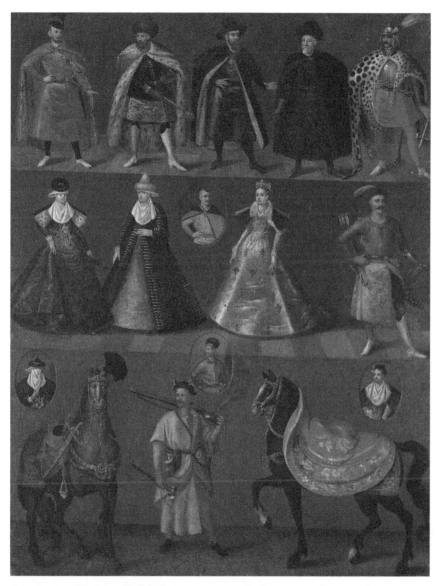

Anonymous, *Variety of Polish Costumes*, seventeenth century, oil on panel, 117 × 89.5 cm. Poznań, National Museum, Mp 841

2.5

be mounted, complete this picture of the expectations placed on Polish noblemen, who needed to be accomplished soldiers and riders.[74] But it is debatable whether such moralizing visual proclamations were reflected in practice. The *levée en masse* (Polish: *pospolite ruszenie*)—the obligation to take up arms and

defend the country that was imposed on the nobility by law—was only decreed four times by the king during the seventeenth century, underlining the landholding rather than military character of the noble estate.[75] The weapons in the painting, then, serve more a social than military function, presenting an upper-class masculinity dependent on external props, luxury weapons, and textiles—many of which were of Ottoman or Persian origin—that is, accessories for show, or 'male jewellery' (*männlicher Schmuck*), as Dirk Uffelmann has aptly called them.[76]

The painting not only details a shared sartorial convention but also historicizes it: the figures both present current fashions to the beholder and steep them in timeless tradition. The four oval portraits within the painting are crucial to this mechanism as they simultaneously provide additional examples of local dress and, in a rhetorically brilliant move, also recall the styling of a gallery of ancestors. This interior design feature of an increasing number of palaces and manor houses during the same period put on display ancient lineage and the prestige associated with it.[77] But although they give viewers the sense of a glimpse into the past, the historical characters in the bust portrait vignettes are virtually indistinguishable from the full-length figures who represent seventeenth-century Poles. The portraits thus convey a continuity between purported ancestors and their alleged descendants, not just imagining historical precursors in contemporary costume but, more importantly, opening a space for comparisons between past and present. This is not simply an 'actualization' (Polish: *aktualizacja*) of historical costume—the presentist term applied to early modern Polish portraiture by Władysław Tomkiewicz (1899–1982), who sought to define this anachronism in formalist terms.[78] More accurately, these images suggest a longer history for Polish dress—one that goes back several generations and is thus embedded in a deeper past—claiming its fixedness and stability across time. The association of tradition with historical constancy and resistance to change is, of course, a myth, but as Roland Barthes famously asserted, a myth works by making the historical seem natural precisely by downplaying the constant reworkings and reconfigurations involved in tradition building and maintenance.[79] Images like the Poznań panel evoke a comforting familiarity of history that downplays a wider range of cultural divergences as well as entanglements.

Other than depictions of noblemen in full armour on tombstones, not many portraits existed in Poland before the mid-sixteenth century, leaving early modern Poles with few material traces of what pre-sixteenth-century local costume would have looked like.[80] By providing images of 'ancestors', paintings like the Poznań panel served as evidence (however spurious) of links between historical dress and present-day fashions that texts could not convey. The sense of cultural durability we see here was replicated in myriad other pictures, including portraits of ancestors, funerary portraits, figures of

donors in votive images, and even images of the saved and the damned in the Last Judgement.[81] The local church and manor house, where these images were on display, thus told and repeated stories of real and imagined ancestors who donned clothes that resembled in style the fashion of contemporary beholders. Created after the adoption of Ottomanesque dress—and often imposing early modern fashion on historical individuals—these portrayals constructed a certain historical uniformity and linear continuity that assumed communion between past and present.[82] Costume in this sense functioned as a threshold of collective memory—a grouping of historical imaginaries that gained credibility via comparison to one's own body and the garments covering it. Creating a medium for common understanding, fashion became a vehicle for cultural remembrance.[83] As historian of collective memory Pierre Nora has demonstrated, the process of remembering and constructing shared heritage is often selective, virtual, inventive, and embodied.[84] Polish costume, though assembled from foreign components, helped shape an imagined community by providing a shared sartorial practice that visually marked Polish nobles as a connected society with traditions going back many generations.

Just how many generations back it went is uncertain, but the 1564 woodcut of Leszko II (Figure 2.6), a legendary eighth-century ruler of Poland here depicted with a mace and feathered cap in Marcin Bielski's *Kronika świata* (World Chronicle; first edition Cracow 1551), implies a long trajectory for Polish costume that harkens back to prehistoric times. Leszko's loose-fitting robe is not a mirror image of mid-sixteenth-century Polish dress, but its distinction from tailored Western European garments gives the impression of the sartorial particularism that was well embedded in Polish tradition. The woodcut hints that there existed a type of costume that was rooted within the geographical confines of the country and traced its origins back centuries. If an early modern Polish nobleman were to examine Leszko's overcoat and tunic, the beholder would have been able to compare it with his own delia and żupan, and walk away thinking that Polish costume had changed only slightly since the founding of the Polish state. Bielski's chronicle was reissued several times, including by his son Joachim; this meant that the image of Leszko enjoyed a long afterlife and wide reach, reinforcing the idea of the diachronic uniformity of Polish dress.[85]

Particularly telling examples of the invented continuity of Polish costume are the images of ancestors in *Gniazdo cnoty, zkąd herby rycerstwa slawnego Krolestwa Polskiego* (The Nest of Virtues, Whence the Coats of Arms of the Knights of the Polish Kingdom, Cracow 1578) by Bartosz Paprocki (1540/43–1614), often considered the father of Polish genealogy.[86] Dedicated to King Stephen, a Hungarian, the volume is a book of heraldry that purported to acquaint the foreign-born ruler with the armorial markings of Poland's noble families as well as their histories.[87] More than a thousand pages long,

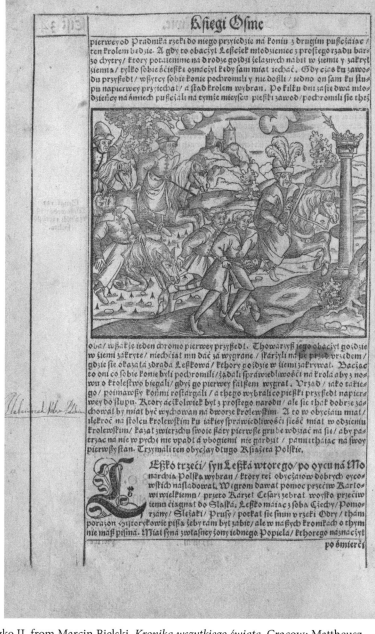

2.6 Leszko II, from Marcin Bielski, *Kronika wszytkiego świata*, Cracow: Mattheusz Siebeneycher, 1564, fol. 341v., woodcut. Cracow, Biblioteka Książąt Czartoryskich – Muzeum Narodowe w Krakowie, 22 III Cim

the volume includes woodcuts of 188 coats of arms and some 3,500 individual noblemen, both early modern and ancient, tracing the most prominent lines of the Polish nobility.[88] One of these illustrations is a chart dedicated to knight Stawisz and his descendants (Figure 2.7).[89] Stawisz, allegedly the first holder of the Półkozic (half-goat) coat of arms, received this honour in 1022, according to Paprocki—though this is inaccurate, as Polish heraldry only originated at the turn of the fourteenth century. In any case, the knight and his family line are depicted on a grid of small portrait vignettes scattered across three folios and spanning six centuries, from the eleventh to the sixteenth. Combining text and image, the vignettes list the virtues of Stawisz and his descendants while also attempting to individualize each personage through facial hair and costume. But these individual characteristics are illusive, not least because some of the portrait vignettes are repeated several dozen times throughout the volume, likely due to the difficulty of producing the number of woodcuts required to detail the distinct features of each family member. Any individualization attempts are further diminished by the depiction of the same type of costume regardless of an individual's century of birth. The woodcuts thus show generations of the most illustrious families to be united across centuries in their preference for fashions that we would describe as Ottomanesque today but that had begun to signify as Polish by the time of *The Nest of Virtues*.

Because costume functioned as a transhistorical sign, it had the ability to texture and contour the social body, a wide community of wearers, marking each one of them as kin to other present-day wearers as well as their ancestors.[90] Donning a żupan, despite its relatively short history of use in Poland, thus became an expression of Polish tradition reinforced by a feeling of the clothing item's 'naturalness'. After all, a wearer might conclude, previous generations had worn the same kind of dress, as evidenced by many commonplace portraits of ancestors, real and imagined, as well as expressed in different artistic forms and media formats. Leafing through the pages of *The Nest of Virtues* and other works of genealogy and historiography placed readers in line with their ancestors, blending past and present while subsuming the legacies of Poland's old and new fashions, which would have come to seem essentially one and the same. If costume felt timeless and native, this was due to its perceived ability to retain its form for generations—a form that, through visual representation in particular, appeared unaltered and therefore steeped in tradition and cultural significance. This is why, when reporting on his Ottomanesque-clad 1633 entry to Rome, Jerzy Ossoliński (1595–1650), ambassador of King Ladislaus IV, could quip in a speech to the Polish–Lithuanian sejm that he 'did not wish to forgo the dress of our forefathers' when explaining his decision to parade in Polish costume around the papal city.[91] Although it in fact constituted just a sliver of the vast cultural history timeline of Poland, Ossoliński believed, like other

2.7 Stawisz's family line, from Bartosz Paprocki, *Gniazdo cnoty zkad herby rycerstwa slawnego Krolestwa Polskiego … poczatek swoy maja*, Cracow: Andrzej Piotrkowczyk, 1578, f. 66, woodcut. Warsaw, Biblioteka Narodowa, SD XVI.F.64

Poles, that Ottomanesque costume—or, as he called it, 'Polish costume'—had had a far-reaching past.

As Alexander Nagel and Christopher Wood have convincingly argued, this conflation of past and present was not a series of incidental mistakes but rather a whole way of anachronic thinking about the historical age of artefacts that allowed for, and even made productive use of, temporal confusion.[92] Through costume, the past participated in the present, the latter stitching itself through time to pull two distinct historical realities together.[93] Antiquity could be foregrounded in early modern forms by engendering nativist thinking that desired to unearth deep histories for the objects of everyday life.[94] Europe abounded in similar cases of anachronism during this period, with many local sites and cultural forms reclaimed as native antiquities.[95] In this respect, costume not only gave early modern Poles a sense of historical coherence and continuity but also placed them firmly within a wider European trend. If Polish costume could be seen as antique—a living relic—it is because wearers saw dress as a reference point revealing a recursive characteristic of their culture, with long historical lineage projected onto the (early modern) present.

How Ottoman?

If from the late sixteenth century onwards Poles considered their costume to be part of local heritage and tradition, then why do we so often see it described as 'Oriental', 'Orientalized', and more recently 'Ottomanized'—exoticizing terms that evoke unresolved tensions and exogenous origins rather than a locally driven process of reinventing Polishness? As with modern readings of many other Polish–Ottoman encounters and interactions, real and imagined, it all began with Tadeusz Mańkowski, whose pioneering work in the early twentieth century foregrounded the adoption of Ottoman and Persian designs as a central leitmotif in Polish cultural history.[96] He termed this process 'Orientalization', by which he meant an imitative process of cultural transfer, a wholesale acceptance of what he called 'Oriental' men's fashions, and the increased popularity of Ottoman textiles in women's garments. He cites the example of Stanisław Krasiński (d. 1654), castellan of Płock, whose mid-seventeenth-century portrait (Figure 2.8) by royal court painter Daniel Schultz the Younger (1615–83) depicts a vermillion-coloured silk żupan fastened with precious buttons and girded with a red silk sash, complete with sleeveless fur overcoat. For Mańkowski, this is 'a nearly direct copy' of the dress donned by the Ottoman sultan Suleiman I (r. 1520–66) in a portrait by Titian from around 1530, and therefore 'Poles imitated the costumes of the highest social spheres in the East, like the sultan's dress in our example, although […] with significant delay'.[97] Polish costume was not only an imitation of 'Eastern'

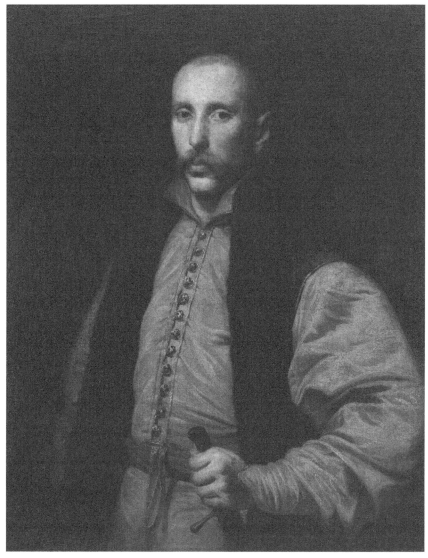

2.8 Daniel Schultz, *Portrait of Stanisław Krasiński*, c. 1653, oil on canvas, 93 × 77 cm. Warsaw, Muzeum Narodowe, MP 4312, provenance: the Krasiński Museum collection

fashions in Mańkowski's mind but also a development much delayed vis-à-vis its Anatolian prototypes.

The question of how to reconcile Ottomanesque Polish costume with its self-professed nativeness has long puzzled scholars, with no conclusions in sight. Despite the preliminary nature of Mańkowski's framing of early modern

Polish elite culture as characterized by self-Orientalization, subsequent generations of historians have accepted his perspective wholly and uncritically. Tadeusz Chrzanowski (1926–2006) embraced the idea of pre-modern Polish 'Orientalism' [sic] as 'acceptance of authentic exoticism'—an assimilation of foreign tastes so complete that it drove feelings of localness (*swojskość*) in Poland as well as consternation about the country's exotic habits elsewhere in Europe.[98] Janusz Tazbir (1927–2016) described this 'Orientalism' as an integral part of daily life, distinct from the superficial celebration of exotica in Western Europe, thus making Polish culture unique compared to the rest of Latin Christendom.[99] Przemysław Mrozowski (b. 1958) suggested that the shift in sartorial choices pushed the Polish nobility into the realm of 'Eastern tastes' and away from the West.[100] None of these scholars asked, however, what value-laden terms such as 'Orientalism' and 'exoticism' actually meant in an early modern Polish–Lithuanian context. While it is true that Poles and other Commonwealth subjects were often compared to Turks by early modern European writers, the binary distinction between European 'West' (Occident) and Ottoman 'East' (Orient) is too crude to be useful.

For one, the modern historiographical tendency to essentialize Europe into a coherent cultural bloc antithetical to the Ottoman Empire does not accurately reflect the dominant thinking in early modernity.[101] Alliances among European polities and the Ottomans were often forged against other Europeans; Armenian, Jewish, and Greek diasporas operated across regions and confessional divides; translators, scholars, diplomats, merchants, and various transimperial subjects, including dragomans, converts, and returnees from Ottoman captivity served as cultural brokers traversing political, confessional, and linguistic boundaries; and it was even easier for objects of material culture to mediate across worlds and places.[102] Recent scholarship has challenged the notion of Europe as a separate civilization divided from the rest of the world by an insurmountable firewall of Christian faith, instead focusing on encounters, coexistence, and ongoing renegotiations of identities.[103] To see Polish costume as the Orientalizing pastiche of a material culture created by a different civilization known as 'the East' or 'the Orient' is misleading because it posits a dichotomy between Latin and Ottoman Europe, and frames Poland as a hybrid culture that sits on the fault line bordering two distinctive worlds.

Exoticizing Polish material forms based on their visual affinity with Ottoman counterparts is equally dubious, relying too heavily on modern stylistic criteria and perceived appearances. In their critique of hybridity as an art-historical model of analysis, Carolyn Dean and Dana Leibsohn have highlighted that the visuality of an artwork can hide as much as it can reveal, and that therefore calling a thing 'hybrid' mostly brings into view the *beholder's* own experiences and expectations rather than the *artefact's* (allegedly) intrinsic status of belonging to a specific culture.[104] Others have argued that hybridity

foregrounds a model of cultural transmission that reifies difference, suggesting that two discrete and authentic cultures meet and blend to generate a new in-between formation; yet it is instead an act of recognition—or creation—of 'us' and 'them' that stems from such taxonomic pursuits.[105] Either way, hybridity describes exceptions within a cultural convention that are dependent upon the recognition of difference; in the case of Polish costume, its assumed divergence from Western European fashions. Both the presumption of the pre-existence of pure forms and the idea that distinct forms can appear gradually are potential pitfalls of thinking about culture along the lines of visibility.

To avoid the perils of cultural essentialism, the study of Polish costume is best undertaken with the acknowledgement that all cultures are inherently heterogeneous.[106] There is nothing special about Polish sartorial transculturalism in this scenario because original pure forms could not and did not exist in either the Ottoman Empire or in Western Europe. The appropriations of West Asian and North African fashions in places like Italy or Spain, and the general transcultural dimension of much of early modern Eurasia precludes talk of cultural authenticity in any given geographical location.[107] Thus, while on a formal level Polish dress diverted from other European fashions, particularly those west of the Danube, the mechanism for including foreign elements in a local sartorial idiom was a supra-European phenomenon, broad and wide, and in this respect Polish dress cannot be seen as unique. Culture is not a static ancestral property but an active, dynamic process of connection and affirmation that exists in relation to other cultures, equally a nexus of belonging and a series of creative adaptations and resourceful reappropriations.

Perhaps the reason why early modern Polish fashions appear different on the surface from other European dress is the development of new media that influenced regional European identities, especially costume books.[108] A genre situated at the intersection of text and image, costume books assigned particular types of attire to specific national, regional, and civic communities. In so doing, these volumes essentialized culture, localizing it in fashion as a visual embodiment of belonging.[109] While no costume books were published in the Kingdom of Poland outside of Danzig, where local *Trachtenbücher* focus predominantly on local Prussian dress,[110] the most widely read examples of the genre produced in places like Venice and Nuremberg catered to an international readership.[111] Through the inclusion of bookplates in the volumes that have survived in Polish libraries, we can trace several of them to early modern Polish collections,[112] suggesting that educated readers in Poland, just like other Europeans, were paying attention to different 'habits' and how they measured up to their own fashions. In these books, Poles saw themselves represented as a unique people with its own characteristic sartorial tradition, distinct from and yet comparable with that of other Europeans in how each community would demarcate its distinction from the rest of the world through dress.

How do you dress like a Pole? **83**

The function of clothing in costume books was, precisely, to construe difference through imagery that served as a relatively stable indicator of cultural identity at a time when political borders shifted frequently.[113] Viewed in this way, the 'Ottomanization' of Polish dress could be read as its ongoing Europeanization, fitting into the wider European trend of claiming cultural uniqueness.

There may have been no Polish costume books, but images of costumed bodies in Polish chronicles appeared around the same time as they did in Western Europe. The most evocative were depictions of Polish–Lithuanian sejm, which became a genre in its own right.[114] A variation on the theme is the woodcut in Alessandro Guagnini's *Sarmatiae Europeae descriptio* (A Description of European Sarmatia, Speyer 1581), which represents secular and ecclesiastical senators encircling King Stephen seated on his throne, with several lower chamber deputies added to the four corners of the print (Figure 2.9). Nearly all the laymen in the image wear Polish costume, creating a sense of

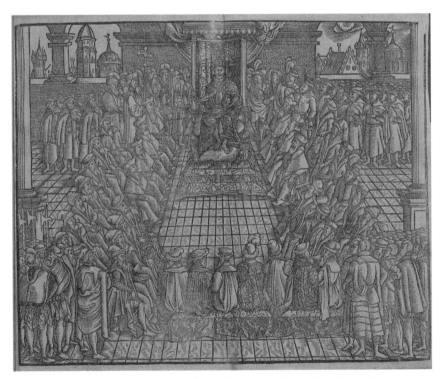

2.9 Polish–Lithuanian sejm in session, from Alessandro Guagnini, *Sarmatiae Europeae descriptio: quae regnum Poloniae, Lituaniam, Samogitiam, Russiam, Massoviam, Prussiam, ... et Moschoviae, Tartariaeque partem complectitur*, Speyer: Bernhard Albin, 1581, fol. Aiiii, woodcut by Jörg Brückner (blockcutter, attr.) and Wendel Scharffenberg (printmaker). Cracow, Biblioteka Jagiellońska, BJ St. Dr. Cim. 8138

visual unity among members of the republican body politic that marks this type of dress as the Commonwealth's shared heritage. At the time of its publication in Guagnini's *Sarmatiae Europeae descriptio*, the print had been circulating for over a decade, appearing in, among others, Jan Herburt's *Statuta i przywileje koronne* (Statutes and Privileges of Poland, Cracow 1570) and an earlier edition of Guagnini's chronicle published in Cracow in 1578,[115] evoking and reinforcing the longevity of Polish sartorial tradition. Whether this costume is 'Orientalized', as modern commentators continue to call it, is a moot point: the woodcut's purpose is to embody the *Rzeczpospolita* (Commonwealth, or literally '[our] shared thing'), a political community of citizens. The clothing worn on the collective body politic thus becomes an indexical sign of Polish–Lithuanian republicanism, and as such would not stand comparison with Ottoman fashion, which was often associated with tyranny and despotism in Polish moralist literature.[116]

Although Polish nobles resembled Turks on the surface, the former claimed no causal relationship between their costume and that of the Ottoman Empire. The listing of garments described as 'Turkish' in seventeenth-century household inventories suggests that notaries made important distinctions between local fashions and those imported from further afield. Locally made articles of clothing might look Ottoman to us (even as they did to early moderns from elsewhere), but they are distinct from actual Ottoman apparel, which was also worn by Commonwealth nobles but would not have been viewed as local Polish costume at the time. For example, the post-mortem inventory of Andrzej Firlej, Castellan of Lublin (d. 1661), records 'a Turkish sash embroidered with Turkish silver and gold', and several other 'Turkish' items of clothing, implying that the sourcing of clothing items was often known and deemed important.[117] Clearly, the difference was easy to tell for a trained eye, partly because Polish garments had distinct cuts and were tailored differently than their Ottoman counterparts.[118] A systematic study of Ottoman costume in seventeenth-century Polish notarial documents has still to be conducted, but fragmentary information from other available sources supports the argument that difference between Polish (however 'Ottomanesque') and Ottoman costume was discernible and discerned. Costume historian Beata Biedrońska-Słota enumerates several inventories that list garments like 'a Turkish delia', 'a Turkish żupan', 'a Turkish delurka', and, less specifically, 'Turkish costume', always marking them as distinct from Polish fashions.[119] Another inventory written in 1616 for Princes Ostrogski (Ostroz'kii) in Dubno also distinguishes between attire described as 'Turkish' and delias, żupans, and kopieniaks with no added geographical qualification, and thus possibly Polish—so familiar that their provenience was not deemed worthy of identifying.[120] The description of some of these garments as 'Turkish' despite their assumed similarities with

Polish designs—the same words used to denote both—suggests that although Polish and Ottoman apparel signified differently, the difference between them was not absolute. In the same way, Sefer Muratowicz (d. after 1631), Armenian merchant in the service of King Sigismund III, would use the Polish terms 'żupan' and 'delia' to describe the attire of the Persian shah Abbas I (r. 1588–1629) for the benefit of a Polish readership.[121] The predisposition to see similarities went hand in hand with the ability to discern differences.

But the distinction between Poles and Ottomans was always maintained, and Poles saw differences in their respective costumes even where other Europeans did not. King John III Sobieski (r. 1674–96), for example, needed to instruct his hussars to tie straw ropes around themselves as a sign of their Polishness in the 1683 Battle of Vienna, fought between pro-Habsburg and Ottoman forces.[122] These signature accessories were necessary to ensure that allied German imperial troops would not mistake John III's hussars for Turks, but they were not required for Poles, who would not, supposedly, have made the same mistake. An anecdote recounted by Polish diarist Jan Chryzostom Pasek (1636–1701) clearly illustrates this sartorial distinction. Describing the return of Commonwealth nobles to their homes after their victory at the Battle of Khotyn (1673), in which the Polish–Lithuanian army defeated the Ottomans and took spoils of war, apparently including clothes, Pasek tells the story of a particularly showy young nobleman:

> Approaching his family house, he wanted to greet his father in Turkish costume: and so he dressed as a Turk from top to bottom, mounted a camel, and, having made his servants wait in the village, left for the manor. His elderly father was on his way to the neighbours' house, leaning on a cane, when a strange monster ran into the yard. The old man crossed himself in terror and took to his heels. The son, noticing his father's panic, chased him, shouting: 'Wait, dear man! It's me, your son!' But this caused the father to run even faster. He then fell ill from trepidation, and soon after died.[123]

The old man's dramatic reaction and resulting death—sparked by his inability to recognize his own son, whom the father mistook for a Turkish warrior invading the family estate—certainly suggests that the Commonwealth nobility's alleged affinity with the Ottoman 'East' did not hold up in all instances.

This is perhaps because Polish costume was less 'Orientalized' than is often assumed. In the fashion glossary compiled by Polish dress historian Irena Turnau, out of 2,700 total entries, more than half are etymologically Slavic, over 300 derive from French, another 200 or so from German, but only 150 have West Asian origin.[124] From our modern perspective—and apparently from the early modern Western European perspective, too—Polish costume looks Ottomanesque. But only around 5 per cent of fashion vocabulary reflects

this internalized expectation, perhaps revealing that costume in Poland was shaped by a more multi-directional web of influences than the analytical lens of 'Orientalization' allows. The geographical sourcing and visual appearance of dress fabrics played a role in the development of Polish tastes. Even in the seventeenth century, during the heyday of Ottoman impact on Polish fashion, household inventories of nobles in Greater Poland (Wielkopolska) reveal that many żupans were made with Dutch, French, and Italian fabrics rather than their Ottoman (or 'Oriental') equivalents.[125] In fact, most textiles used for the production of Polish clothes—including those we would now describe as Ottomanesque—may have been made in Italy or elsewhere in Western Europe.[126] Indeed, Szymon Starowolski (1588–1656), the author of *Polonia* (Cologne, 1632), a Latin-language description of the Commonwealth, asserted that 'usually, we all use foreign fabrics, mostly German, Flemish, French, English, Spanish, and Italian'.[127] Clearly Starowolski is here highlighting Commonwealth affinities with Western Europe; the 'Eastern' provenance of Polish costume is overlooked entirely. This might, of course, be an exaggeration—and/or a purposeful omission. As Suraiya Faroqhi has suggested, high-ranking Polish dignitaries may have owned significant quantities of silk textiles produced in the Ottoman Empire.[128] Either way, the concept of the 'Orientalization' of Polish costume needs to be revisited.

Often cited as evidence of Poles' self-Orientalizing fervour is a passage from Jan Białobocki's short 1661 tract on the genealogy of Polish kings, which asserts that 'no robe is better for a Pole / than an eastern one / because it is his own: and especially for the man / while the white heads [women] tend to wear black cloth from the west'.[129] This passage can indeed be interpreted as praise for 'Eastern' fashion, but it can also be read simply as an acknowledgement of provenience: some fabrics originated in the Ottoman Empire and Persia, others in Western Europe. If we accept the latter as a possible interpretation, we cannot read Białobocki's statement as a purely self-Orientalizing claim. Rather, his words may also (or instead) indicate his acceptance of early modern Polish dress drawing on a whole gamut of inspirations. Such a reading finds support in the corpus of Polish garments increasingly described as transcultural: sashes used to secure at the waist a żupan and later a kontusz, for example, may have been imported from Anatolia or Iran, produced in a Polish–Lithuanian workshop called a *persjarnia* (Persian shop), or ordered from a European manufacturer—silk-weaving mills in Lyon being the best documented example.[130] So-called 'Orientalization', then, becomes only one aspect of the history of Polish costume; we are simultaneously reminded of the equally relevant Polonizing and Europeanizing elements of the puzzle. At any rate, early modern fashion ran along a spectrum and did not constitute a hardened set of rules defined by ethnic and geographical determinations.

Beyond Orientalism

Heuristically, Orientalization may simply describe a process of formal change in the realm of material culture—indeed, this is how the term is often used by Polish scholars. But in the Anglo-American historiographical tradition, the term inevitably evokes the 1978 critique of Orientalism by postcolonial scholar Edward Said (1935–2003), who defines it as a model of knowledge production that posits a civilizational difference and superiority of Europe vis-à-vis its neighbours to the (notional) 'East', in West Asia and North Africa.[131] Here it is important to note that there is no clear consensus on how the concept of Orientalism should be used in historical study, particularly of the premodern era. Some early modernists, invoking postcolonial aims and reading practices, follow Said in his deconstruction of the style of European scholarship that arose out of a need for the West to define itself as the opposite of a counterbalancing entity called the 'Orient'.[132] Others question the usefulness of postcolonial methodologies like Said's for reading textual sources—including travel accounts, ethnographic compendia, and early dictionaries—created prior to the age of Europe's imperial dominance. There are certainly elements of bias in earlier scholarly texts, some of whose authors knew the trans-Danubian regions very well, but their accounts do not necessarily reflect the notions and values of the European subject who essentializes a historical relationship of political and economic domination into 'civilizational' difference and superiority.[133] This is partly because the imbalance of power does not apply before the eighteenth century, when the Ottoman Empire was the leading state formation in the region, influential not only politically and economically but also culturally.[134] Lest we forget, some of the most important Ottoman territories—including the imperial capital of Constantinople—were in Europe; many early modern European maps marked them as 'Turkey in Europe'.[135] Of course, knowledge production and state formation are two separate matters, and both Said and his critics have been concerned with the former.[136] Nor can Said be accused of promoting cultural essentialism, as he later revised his framing of the dichotomies between Orient and Occident, stating that 'all cultures are involved in one another; none is single and pure, all are hybrid, heterogeneous, extraordinarily differentiated, and unmonolithic'.[137] But as Europe's relationship with the Middle East and North Africa remains fraught with anxiety, particularly in today's context of mass migration and economic instability, writing about earlier chapters of this complex historical relationship remains a difficult balancing act.[138]

The use of the term 'Orientalism' traditionally favoured by Polish culture historians is restricted to the reception of 'Oriental' material and visual forms.[139] The term thus completely bypasses the question of Poland's own ambivalent placing on the edges of Europe as theorized by both Polish and

Western European writers, from proponents of the idea of Poland–Lithuania as the 'bulwark of Christendom' to Enlightenment-era philosophers dividing the continent into zones of civilization and obscurantism, and then to Cold War ideologues reifying the East–West binary.[140] This is a missed opportunity. The early modern Commonwealth was a geopolitical unit that evades clear-cut categorization: its transcultural landscape contained elements from different traditions, including Ottoman fashion, that collectively defy essentialized, monolithic categories of separate European and Islamic worlds. Partly because of its visible difference, the Commonwealth—like many other Central and Eastern European places—has sometimes been seen as somewhat 'Eastern' and thereby 'European' only in a qualified sense. This is yet another reason not to gloss over the wider ramifications of a contentious term like 'Orientalization' in early modern Polish–Lithuanian context. As we see in the epigraph to Chapter 3, Larry Wolff has described the relegation of the Commonwealth to the edges of European civilization by Enlightenment-era philosophers as 'demi-Orientalism,' manifestly taking Said as inspiration.[141] This intra-European Orientalization is a discourse that creates, replicates, and legitimatizes the dependency and inferiority of the eastern half of Europe in relation to its alleged western core, consequently implying a double burden of Commonwealth dependency. Not only does the region borrow from the 'West' in this interpretative scenario; it also adopts fashions from the 'East', becoming in the process a twofold copy of other cultures deemed more attractive and potent. When portrayed as less European and more Oriental, Poland–Lithuania comes to reinforce the discourse of Central and Eastern Europe as a semi-exotic realm of second-hand culture, lost in its sense of direction. But Poland–Lithuania's transcultural condition does not need to be framed in terms of West versus East. Early modernity was a period of transition in world history, during which a sort of early globalization brought many Eurasian societies into contact with one another without—at least initially—creating a significant imbalance of power.[142] We would do better to speak of stimuli coming from different directions—all of which partook in the making of local culture—than to maintain the fiction of Commonwealth culture's (and cultures') rigid geographical taxonomy.

However it appears to a modern eye, Polish costume was first and foremost a local thing to its wearers—an indispensable part of vernacular tradition. A cross-dressing incident that French official and visitor to Poland Nicolas Payen included in the second edition of his *Voyages* (Paris, 1667) illustrates how strongly connected this tradition was to the sense of the Polish self. Payen describes a feast he reportedly attended in Danzig (Polish: Gdańsk) that included binge drinking resulting in an unexpected offer. An intoxicated Polish nobleman, who in a bout of alcoholic excess grew very fond of the visitor, offered him his own daughter as a wife, together with ten thousand French

livres (pounds) and two hundred serfs. The Polish nobleman then proclaimed Payen a Pole, and began dressing him accordingly:

> He began by putting on my head his hat, and then, carried away by fantasy, continued dressing me from top to bottom. He took off his coat, which was made of scarlet, with golden pins and fitted with martens, and put it over my clothes. He even made me wear his boots, and then detached his sabre from his side, made me kiss its hilt, and told me that it guarded the honour of his country; that this sabre defended more than one royal throne; that it made the Ottoman power tremble, and that all Poland owed it its freedom; he then buckled it to my side.[143]

While likely an exaggeration, Payen's narrative conveys a clear correlation between costume and custom. The Polish nobleman in the story is convinced that Payen can only become a Pole if he accepts local fashion. Costume appears here as the nation's shield and as a guardian of Polish freedoms that were allegedly threatened by the Ottomans. The Polish nobleman appears blissfully unaware of the formal similarities between Polish and Ottoman costumes. It is not implied Oriental influence but rather association with local custom that marked fashion as the material manifestation of a people, an attempt to fix Polish identity in tangible and visible form. At the same time, cultural belonging could be revised, if need be, by accepting the costume associated with a different culture. Sartorial signs solidified collective identity while simultaneously offering an easy way in or out for individuals.

Although, for Mańkowski and his followers, Polish costume reflected 'Eastern' influence—being like a Turk rather than being like a European—Polish sources from the seventeenth century onwards invariably described this costume as local and comfortingly familiar, no matter how exotic (Ottomanesque, Oriental, or Eastern) it might have appeared to other early moderns or can apparently appear to modern scholars. Poles were indeed adopting Ottomanesque fashions during the sixteenth century, but they were not doing so in a vacuum. Rather, this was a shift in trends occurring in the wider European context of sartorial redefinition, inspired in part by costume books and other new media such as illustrated chronicles, which projected allegedly unique fashions upon distinct European nations. By the seventeenth century, Poles looked at dress through the prism of comforting localness. After all, as this chapter has highlighted, costume in Poland was above all considered *Polish* costume: to dress like a Pole meant to don clothes deemed typical of the country, not to 'Orientalize' oneself. It is appropriate to speak of reinvented tradition—once costume changed, local tradition changed along with it—but to pinpoint the exact source of the tradition, be it a real or imaginary Orient or an equally elusive West, risks reinforcing binary clichés that did not exist for early modern Europeans.

Notes

1. Barbara Fuchs, *Mimesis and Empire: The New World, Islam, and European Identities* (Cambridge: Cambridge University Press, 2001), 4.
2. Hobsbawm, 'Inventing Traditions', 14.
3. *Portrety osobistości polskich znajdujące się w pokojach i w Galerii Pałacu w Wilanowie: Katalog* (Warsaw: Muzeum Narodowe w Warszawie, 1967), cat. no. 114, 110-11; Jan K. Ostrowski, *Portret w dawnej Polsce* (Warsaw: Muzeum Pałacu Króla Jana III w Wilanowie, 2019), 243-45; Przemysław Mrozowski, *Portret w Polsce XVI wieku* (Warsaw: Muzeum Pałacu Króla Jana III w Wilanowie, 2021), 249-50.
4. Aleksander Brückner and Karol Estreicher, *Ubiory w Polsce* (Cracow: Drukarnia Narodowa, 1939).
5. Janina Ruszczycówna, ed., *Portret polski XVII i XVIII wieku: Katalog wystawy* (Warsaw: Muzeum Narodowe, 1977), cat. no. 28, 32-33.
6. On feathers in European fashion, see Ulinka Rublack, 'Befeathering the European: The Matter of Feathers in the Material Renaissance', *The American Historical Review* 126, no. 1 (2021): 19-53.
7. Andrzej Dziubiński, *Na szlakach Orientu: Handel między Polską a Imperium Osmańskim w XVI-XVIII wieku* (Wrocław: Fundacja na Rzecz Nauki Polskiej, 1997), 174.
8. Dobrowolski, 'Cztery style portretu "sarmackiego"'; *Decorum życia Sarmatów*; Beata Biedrońska-Słota, 'The Art of Islam in the History of Polish Art', in *The Orient in Polish Art: Catalogue of the Exhibition*, ed. Beata Biedrońska-Słota, exh. cat. (Cracow: National Museum Cracow, 1992), 7-18; Andrzej Pośpiech, 'Szkic do portretu Sarmaty na podstawie wielkopolskich szlacheckich pośmiertnych inwentarzy mobiliów z drugiej połowy XVII w.', in *Ubiory w Polsce*, ed. Anna Sieradzka and Krystyna Turska (Warsaw: Stowarzyszenie Historyków Sztuki, 1994), 28-45; Jerzy Malinowski, ed., *Where East Meets West: Portrait of Personages of the Polish-Lithuanian Commonwealth, 1576-1763*, exh. cat. (Warsaw: National Museum, 1993); Jarosław Dumanowski, 'Inwentarze wielmożnych i urodzonych: Konsumpcja szlachty wielkopolskiej w XVIII w.', *Kwartalnik Historii Kultury Materialnej* 51, no. 2 (2003): 261-76.
9. Gutkowska-Rychlewska, *Historia ubiorów*, 394-422; Mrozowski, 'Orientalizacja stroju szlacheckiego'; Irena Turnau, 'Rozwój ubioru narodowego od około 1530 do 1795 roku', *Kwartalnik Historii Kultury Materialnej* 34, no. 3 (1986): 413-23; Turnau, *Ubiór narodowy w dawnej Rzeczypospolitej*; Przemysław Mrozowski, 'Ubiór jako wyraz świadomości narodowej szlachty polskiej w XVI-XVIII wieku', in *Ubiory w Polsce*, ed. Anna Sieradzka (Warsaw: Stowarzyszenie Historyków Sztuki, 1992), 19-27.
10. Mańkowski, *Orient*; Maria Szuppe, 'Un marchand du roi de Pologne en Perse, 1601-1602', *Moyen Orient & Ocean Indien* 3 (1986): 81-110; Dziubiński, *Na szlakach Orientu*; Selmin Kangal and Bartłomiej Świetlik, eds., *War and Peace: Ottoman-Polish Relations in the 15th-19th Centuries* (Istanbul: Museum of Turkish and Islamic Arts, 1999); Kármán, 'The Polish-Ottoman-Transylvanian Triangle'.

11 Gutkowska-Rychlewska, *Historia ubiorów*, 395–96; Zdzisław Żygulski Jr., 'The Impact of the Orient on the Culture of Old Poland', in *Land of the Winged Horsemen: Art in Poland, 1572–1764*, ed. Jan K. Ostrowski (New Haven: Yale University Press, 1999), 69–79; Mirosław Nagielski, 'Wpływ Orientu na staropolską sztukę wojenną XVI-XVII w.', in *Staropolski ogląd świata: Rzeczpospolita między Okcydentalizmem a Orientalizacją*, ed. Filip Wolański and Robert Kołodziej, vol. 1 (Toruń: Adam Marszałek, 2009), 77–96.

12 Maria Bogucka, 'Szlachta polska wobec Wschodu turecko-tatarskiego: Między fascynacją a przerażeniem (XVI–XVIII w.)', *Sobótka* 37, no. 3/4 (1982): 185–93; Marek Wrede, *Sejm i dawna Rzeczpospolita: Momenty dziejowe* (Warsaw: Wydawnictwo Sejmowe, 2005); Biedrońska-Słota, *Polski ubiór narodowy zwany kontuszowym*, 66–70.

13 Jan Horoszkiewicz, *Strój narodowy w Polsce* (Cracow: Spółka Wydawnicza Polska, 1900), 9–10; Gutkowska-Rychlewska, *Historia ubiorów*, 290–306; Biedrońska-Słota, *Polski ubiór narodowy zwany kontuszowym*, 49–65.

14 Janusz Tazbir, 'Sarmatyzm a barok', *Kwartalnik Historyczny* 76, no. 4 (1969): 815–30. Arguments have been made, however, that caution be taken against drawing this direct link; sartorial models in Poland changed too frequently to serve as a cultural qualifier before assuming their now familiar form in the late sixteenth century. See Przemysław Mrozowski, 'Portret Piotra Widawskiego i problem początków stroju narodowego w Polsce', in *Velis quod possis: Studia z historii sztuki ofiarowane Profesorowi Janowi Ostrowskiemu*, ed. Andrzej Betlej et al. (Cracow: Wydawnictwo Towarzystwa Naukowego Societas Vistulana, 2016), 244.

15 See papers in Lech Kalinowski, ed., *portret typu sarmackiego w wieku XVII w Polsce, Czechach, na Słowacji i na Węgrzech* (Cracow: Muzeum Narodowe w Krakowie, 1985).

16 Tazbir, 'Sarmatyzm a barok', 817.

17 Chrzanowski, 'Orient i orientalizm w kulturze staropolskiej'; Mrozowski, 'Orientalizacja stroju szlacheckiego'.

18 Połczyński, 'Seljuks on the Baltic'; Kármán, 'The Polish–Ottoman–Transylvanian Triangle'; Wasiucionek, *The Ottomans and Eastern Europe*; Rohdewald et al., 'Transottomanica'.

19 Dariusz Kołodziejczyk, 'Stosunki dawnej Rzeczypospolitej z Turcją i Tatarami: Czy naprawdę byliśmy Przedmurzem Europy', *Praktyka Teoretyczna* 26, no. 4 (2017): 16–36.

20 Pośpiech, 'Szkic do portretu Sarmaty'.

21 Hobsbawm, 'Inventing Traditions', 1.

22 Mrozowski, 'Ubiór jako wyraz świadomości narodowej'.

23 Paul Srodecki, *Antemurale Christianitatis: Zur Genese der Bollwerksrhetorik im östlichen Mitteleuropa an der Schwelle vom Mittelalter zur Frühen Neuzeit* (Husum: Matthiesen Verlag, 2015); Françoise Bertaut de Motteville, *Memoirs for the History of Anne of Austria, Wife to Lewis XIII. of France*, vol. 1 (London: J. Darby, 1726), 260–61.

24 Jan K. Ostrowski, 'Jeszcze o stroju polskim w malarstwie portretowym w XVII–XX wieku: Pomiędzy obrazami a źródłami', *Artifex Novus*, no. 4 (2020): 44–67.

25 Irena Turnau, *History of Dress in Central and Eastern Europe from the Sixteenth to the Eighteenth Century* (Warsaw: Institute of the History of Material Culture, Polish Academy of Sciences, 1991), 71; Gutkowska-Rychlewska, *Historia ubiorów*, 395.

26 Roman Rybarski, *Handel i polityka handlowa Polski w XVI stuleciu*, vol. 1 (Warsaw: PWN, 1958), 179; Biedrońska-Słota, *Polski ubiór narodowy zwany kontuszowym*, 86; Beata Biedrońska-Słota, 'Wpływ sztuki orientalnej na sztukę polską w okresie Sarmatyzmu', in *Portret typu sarmackiego w wieku XVII w Polsce, Czechach, na Słowacji i na Węgrzech*, ed. Ewa Zawadzka (Cracow: Muzeum Narodowe w Krakowie, 1985), 189.

27 Eleonora Nadel-Golobič, 'Armenians and Jews in Medieval Lvov: Their Role in Oriental Trade 1400–1600', *Cahiers du monde russe et soviétique* 20, no. 3/4 (1979): 345–88; Piotr Kondraciuk, "Sztuka ormiańska w Zamościu," in *Ars armeniaca: Sztuka ormiańska ze zbiorów polskich i ukraińskich* (Zamość: Muzeum Zamojskie, 2010), 11–25.

28 Kangal and Świetlik, *War and Peace*; Charlotte Jirousek, *Ottoman Dress and Design in the West: A Visual History of Cultural Exchange* (Bloomington: Indiana University Press, 2019), 132.

29 Uffelmann, 'Importierte Dinge und imaginierte Identität'.

30 The fact that the Jews of Poland–Lithuania adopted a version of this costume as a template for their own implies a wide spread of Ottomanesque Polish fashion across different regions and social strata. Irena Turnau, 'Ubiór żydowski w Polsce XVI–XVIII wieku', *Przegląd Orientalistyczny*, no. 3 (1987): 297–311.

31 'Wspomnijcie sobie co tam ... za ubiór; jako jest srogi i gruby, jako groźny: głowa ogolona ... usta nie człowiecze ... i bardzo głupie; nadto ubiór zniewieściały, długi aż po kostki, którym okrywa ciało wszystko swoje, by się snać która część ciała nie okazała bydź człowiecza.' Stanisław Orzechowski, *Mowy [o wojnie tureckiej; Turcyki]* (Sanok: K. Turowski, 1855), 12.

32 It is important to notice that the claim of barbarism—that is, the casting of foreigners as inferior, ill-bred ruffians who differed in their manners, gestures, clothes, and smells—was by no means aimed only at Turks. There are many examples of Muscovites, Scandinavians, and Germans being labelled as equally uncouth by the indiscriminately prejudiced Poles. See Zofia Stefanowska, ed., *Swojskość i cudzoziemszczyzna w dziejach kultury polskiej* (Warsaw: Państwowe Wydawnictwo Naukowe, 1973). Nor was this sentiment typical of Poles; other Europeans scolded foreigners and disparaged their manners and dress in a similarly discriminatory way. See Harald Hendrix, 'Imagining the Other: On Xenophobia and Xenophilia in Early Modern Europe', *Leidschrift* 28, no. 1 (2013): 7–20; Jan Hennings, *Russia and Courtly Europe: Ritual and the Culture of Diplomacy, 1648–1725* (Cambridge: Cambridge University Press, 2016), 35–44.

33 '[D]ziś u nas tak wiele jest strojów, iż im liczby nie masz. To po włosku, to po iszpańsku, po brunszwicku, po usarsku, dwojako, staro i nowo, po kozacku, po turecku drudzy: i drugie stroje są, których ja nie znam zaprawdę.' Łukasz Górnicki, *Dworzanin polski*, Wirtualna Biblioteka Literatury Polskiej (Gdańsk: NASK, 2003), 76.

34 'My Polacy nie mamy swego własnego ubioru; acz podobno musiał być pirwej, ale nam omierzł, jakeśmy sie nowinek chycili.' Górnicki, Dworzanin polski, 76.
35 'Węgrzy, gdy się tureckich strojów jęli, zginęli. I w Polszcze u nas ta rozliczność strojów, wie to Bóg, jeśli co dobrego przyniesie. A mieliby wszyscy ci Polskę szarpać, których strojów używamy, niewiem jakoby jej co zostało. Przeto Pana Boga trzeba prosić, aby, jako różne stroje, tak też i dziwne dumy w ludziech naszych ustały.' Górnicki, Dworzanin polski, 77.
36 Baldassare Castiglione, *Il Libro del Cortegiano*, ed. Ettore Bonora (Milan: Mursia, 1972), 133.
37 Jarosław Dumanowski, 'Orientalne i zachodnie wzory konsumpcji szlachty wielkopolskiej w XVI–XVIII w.', in *Między Zachodem a Wschodem: Studia z dziejów Rzeczypospolitej w epoce nowożytnej* (Toruń: Adam Marszałek, 2002), 157.
38 Miechowita, *Opis Sarmacji Azjatyckiej i Europejskiej*, 63.
39 Giulio Ruggieri, 'Relacya o stanie Polski złożona Papieżowi Piusowi V przez Julliusza Ruggieri, nuncyusza jego u dworu Króla Zygmunta Augusta roku 1568', in *Relacye nuncyuszów apostolskich i innych osób o Polsce od roku 1548 do 1690*, trans. Erazm Rykaczewski, vol. 1 (Poznań: Księgarnia B. Behra, 1864), 170.
40 'Niemiec, Grek, Włoch czy Hiszpan—od Kadyksu Tyryjczyków / Aż po Indów granice—wszędzie ich rozpoznasz / Po jednolitym, stosownym narodowym stroju, / Tylko Polak nosi szaty o tak różnym kroju.' In Jacek Żukowski, "W kapeluszu i w delii, czyli ewenement stroju mieszanego w dawnej Rzeczypospolitej," *Kwartalnik Historii Kultury Materialnej* 57, no. 1 (2009): 35.
41 Jan Gintel, ed., *Cudzoziemcy o Polsce: Relacje i opinie*, vol. 1 (Cracow: Wydawnictwo Literackie, 1971), 123.
42 Gutkowska-Rychlewska, *Historia ubiorów*, 400.
43 Zdzisław Żygulski Jr., 'Akcenty tureckie w stroju Batorego', *Folia Historiae Artium* 24 (1988): 62–63.
44 Stefan S. Komornicki, *Essay d'une iconographie du roi Etienne Batory* (Cracow: Imprimerie de l'Université des Jagellons, 1935); Chrzanowski, *Portret staropolski*, 21; Mrozowski, *Portret w Polsce XVI wieku*, 217–19.
45 In Gintel, *Cudzoziemcy o Polsce*, 1: 184.
46 Márton Szepsi Csombor, *Podróż po Polsce*, trans. Jan Ślaski (Warsaw: Czytelnik, 1961), 11.
47 Jerzy Lileyko, 'Z rozważań nad programem ideowym pokojów królewskich na Zamku Warszawskim za Wazów', *Rocznik Warszawski* 15 (1979): 191; Juliusz A. Chrościcki, *Sztuka i polityka: Funkcje propagandowe sztuki w epoce Wazów, 1587–1668* (Warsaw: PWN, 1983), 26, 72, 89; Jan K. Ostrowski and Jerzy T. Petrus, eds., *Podhorce: Dzieje wnętrz pałacowych i galerii obrazów* (Cracow: Zamek Królewski na Wawelu, 2001), 62, cat. no. A.94.
48 Identification of the two notables after Wawel Royal Castle, Pokaz specjalny: Prezentacia obrazu ze zbiorów Lwowskiego Muzeum Historycznego. Carowie Szujscy na sejmie w 1611 roku, Cracow, 30 November 2021–30 October 2023.
49 Dariusz Chemperek, 'Historiografia i literatura dawna o tryumfie Stanisława Żółkiewskiego i hołdzie Szujskich w roku 1611', *Res Historica* 37 (2011): 21–46; Justyna

Gałuszka, '"Akt sławny, wielki i nigdy w Polszcze niewidziany...": Warszawski triumf Stanisława Żółkiewskiego (1611) na tle uroczystości z 1583 roku', *Zapiski Historyczne* 84, no. 2 (2019): 171–203.

50 Jacek Żukowski, 'Kniaź Wielki Moskiewski Władysław Zygmuntowicz: Przegląd ikonografii w 400-setną rocznicę elekcji', *Acta Academiae Artium Vilnensis* 65–66 (2012): 189.

51 'Którzy more suo na komedyję jakąś upstrzyli się i postroili byli.' In Jakub Sobieski, *Peregrynacja po Europie (1607–1613); droga do Baden (1638)*, ed. Józef Długosz (Wrocław: Zakład Narodowy im. Ossolińskich, 1991), 8.

52 Daniel Defert, a historian of anthropology was among the first to suggest that costume books were proto-ethnologies. Daniel Defert, 'Un genre ethnographique profane au XVIe siècle: Les livres d'habits (Essai d'ethno-iconographie)', in *Histoires de l'anthopologie (XVIe-XIXe siècles)*, ed. Britta Rupp-Eisenreich (Paris: Klincksieck, 1984), 25–41.

53 Anne Rosalind Jones, 'Habits, Holdings, Heterologies: Populations in Print in a 1562 Costume Book', *Yale French Studies* 110 (2006): 94; Wilson, *The World in Venice*, 102.

54 Ulrike Ilg, 'The Cultural Significance of Costume Books in Sixteenth-Century Europe', in *Clothing Culture, 1350–1650*, ed. Catherine Richardson (Aldershot: Ashgate, 2004), 29–47.

55 Valerie Traub, 'Mapping the Global Body', in *Early Modern Visual Culture: Representation, Race, and Empire in Renaissance England*, ed. Peter Erickson and Clark Hulse (Philadelphia: University of Pennsylvania Press, 2000), 59.

56 Michael Gaudio, 'The Truth in Clothing: The Costume Studies of John White and Lucas de Heere', in *European Visions: American Voices*, ed. Kim Sloan (London: British Museum Press, 2009), 26.

57 Valentin Groebner, *Who Are You? Identification, Deception, and Surveillance in Early Modern Europe* (New York: Zone Books, 2007), 77–94.

58 Żukowski, 'W kapeluszu i w delii', 34–35.

59 Jasienski, 'A Savage Magnificence', 193–94; Stefania Ochmann-Staniszewska, *Dynastia Wazów w Polsce* (Warsaw: PWN, 2006), 263.

60 Edward Opaliński, 'Civic Humanism and Republican Citizenship in the Polish Renaissance', in *Republicanism: A Shared European Heritage*, ed. Martin van Gelderen and Quentin Skinner (Cambridge: Cambridge University Press, 2002), 165.

61 'To mnie do Ponty boli / Że strzyżą obcą tu wnosić woli / Chcąc, żeby habit miał nad żupany / Delurki a płaszcz za swoje many.' In Jan Czubek, ed., *Pisma polityczne z czasów rokoszu Zebrzydowskiego, 1606–1608*, vol. 1 (Cracow: Akademia Umiejętności, 1916), 284.

62 'I nikt się do prezentu dworskiego nie zgodzi / Tylko kto po francusku, kto po włosku chodzi.' In Czesław Lechicki, *Mecenat Zygmunta III i życie umysłowe na jego dworze* (Warsaw: Kasa im. Mianowskiego, 1932), 169.

63 'Nim krul ze Lwowa wyjechał, zrzuciwszy stroy niemiecki w ktorym w młodości chodził, ubrał się po Polsku przypodobac chconey się Polakom, podobało się to

wszystkim, lecz życzyli drudzy, żeby nietylo stroj, ale i obyczaje Polskie wdział na się, a bacznosc wienkszą miał na żołnierzow niż na dworskich swoich.' In Kazimierz Władysław Wójcicki, ed., *Pamiętniki do panowania Zygmunta III, Władysława IV i Jana Kazimierza*, vol. 2 (Warsaw: S. Orgelbrand, 1846), 100.
64 Turnau, *Ubiór narodowy w dawnej Rzeczypospolitej*, 135.
65 Kaufmann, *Toward a Geography of Art*, 148–49.
66 For this argument, see Kaufmann, *Toward a Geography of Art*, 146–53.
67 Żukowski, 'W kapeluszu i w delii'.
68 Turnau, *Ubiór narodowy w dawnej Rzeczypospolitej*, 13.
69 See, for example, Andrzej Maksymilian Fredro, *Przysłowia mów potocznych, albo przestrogi obyczajowe, radne, wojenne* (Sanok: Karol Pollak, 1855), 50; Wacław Potocki, *Moralia*, vol. 2 (Cracow: Akademia Umiejętności, 1916), 201.
70 'Do Berlina jechać w polskich habitach i lubo z wielu miar życzyłbym aby sprawowanie szat cudzoziemskich do Lipska odłożono.' In Maria Zachara and Teresa Majewska-Lancholc, 'Instrukcja Krzysztofa II Radziwiłła dla syna Janusza', *Odrodzenie i Reformacja w Polsce* 16 (1971): 175.
71 'Nauczył dyszkurować; więc i *alamode* / Chodzić, stroić, i wsztyko czynić po francusku. / … Już mu i Polska śmierdzi, i wszystko w niej gani. / O Francyi powiada, o damach, baletach. / Nic nie umie tylko łgać, a udawać rzeczy; / W zwierciadle ustawicznie ni tam małpa jaka / Muszcze się, goli brodę i dwa razy o dzień.' Krzysztof Opaliński, *Satyry* (Cracow: Nakł. K. Bartoszewicza, 1884) 7.
72 Joanna Dziubkowa, ed., *Szlachetne dziedzictwo czy przeklęty spadek: Tradycje sarmackie w sztuce i kulturze*, exh. cat. (Poznań: Muzeum Narodowe w Poznaniu, 2004), 68–69, cat. no. 53; Adam Soćko, *Galeria Malarstwa i Rzeźby Muzeum Narodowego w Poznaniu: Przewodnik* (Poznań: Muzeum Narodowe w Poznaniu, 2008), 74–75; Tomasz Torbus and Malgorzata Omilanowska, eds., *Tür an Tür: Polen – Deutschland, 1000 Jahre Kunst und Geschichte* (Cologne: DuMont, 2011), 391, cat. no. 11.3; Maria Gołąb, Ewa Hornowska, and Adam Soćko, eds., *Skarby sztuki: Muzeum Narodowe w Poznaniu* (Warsaw: Arkady, 2014), 116–18.
73 Turnau, *Ubiór narodowy w dawnej Rzeczypospolitej*, 26.
74 Wiesław Majewski, 'The Polish Art of War in the Sixteenth and Seventeenth Centuries', in J. K Fedorowicz (ed.), *A Republic of Nobles: Studies in Polish History to 1864* (Cambridge: Cambridge University Press, 1982), 179–97.
75 Karol Łopatecki, *Organizacja, prawo i dyscyplina w polskim i litewskim pospolitym ruszeniu do połowy XVII wieku* (Białystok: Instytut Badań nad Dziedzictwem Kulturowym Europy, 2013); Urszula Augustyniak, *History of the Polish–Lithuanian Commonwealth: State, Society, Culture* (Frankfurt am Main: Peter Lang, 2015), 151.
76 Uffelmann, 'Importierte Dinge und imaginierte Identität', 199–204.
77 Marta Pieniążek-Samek, ' "W honor domu i jego pamięć": Kilka uwag o dekoracji Pałacu Biskupów Krakowskich w Kielcach', *Rocznik Muzeum Narodowego w Kielcach* 25 (2010): 160.
78 Władysław Tomkiewicz, 'Aktualizm i aktualizacja w malarstwie polskim XVII wieku', *Biuletyn Historii Sztuki* 13, no. 1 (1951): 55–76.

79 Roland Barthes, 'Myth Today', in *Mythologies*, trans. Annette Lavers (New York: Hill and Wang, 1984), 109–59.
80 Mrozowski, 'Orientalizacja stroju szlacheckiego', 50.
81 Wiliński, *U źródeł portretu staropolskiego*; Tadeusz Dobrzeniecki, 'Średniowieczny portret w sakralnej sztuce polskiej', *Rocznik Muzeum Narodowego w Warszawie* 13, no. 1 (1969): 11–51; Ewa Łomnicka-Żakowska, 'Początki portretu polskiego: Adoranci w polskim malarstwie tablicowym, miniaturowym i ściennym w wieku XV i w pierwszych dziesięcioleciach wieku XVI', *Studia Źródłoznawcze* 14 (1969): 13–34; Chrzanowski, *Portret staropolski*, 73–80; Liliya Bereznaya and John-Paul Himka, *The World to Come: Ukrainian Images of the Last Judgment* (Cambridge, MA: Harvard University Press, 2014).
82 On creating a sense of linear continuity in a gallery of ancestors, see Krzysztof J. Czyżewski and Marek Walczak, 'Picturing Continuity: The Beginnings of the Portrait Gallery of Cracow Bishops in the Cloisters of the Franciscan Friary in Cracow', *Journal of Art Historiography* 17 (2017): 1–13.
83 On memory and history, see Paul Ricoeur, *Memory, History, Forgetting*, trans. Kathleen Blamey and David Pellauer (Chicago: University of Chicago Press, 2004), 44–55.
84 Pierre Nora, *Rethinking France: Les Lieux de Mémoire*, trans. Mary Seidman Trouille, vol. 1: The State (Chicago: University of Chicago Press, 1999), vii–xxii.
85 Marcin Bielski and Joachim Bielski, *Kronika polska* (Cracow, 1597), f. 36; Bömelburg, *Polska myśl historyczna*, 172–84. Early modern chronicles are full of images that depict historical personages in similar costume. For example, Alessandro Guagnini, *Sarmatiae Europeae descriptio: quae regnum Poloniae, Lituaniam, Samogitiam, Russiam, Massoviam, Prussiam, Pomeraniam, Livoniam et Moschoviae Tartariaeque partem complectitur* (Speyer, 1581), fol. 10r, 18r, 18v, 51r; Maciej Stryjkowski, *Rerum Polonicarum tomi tres* (Frankfurt, 1584), fol. i; Alessandro Guagnini, *Kronika Sarmacyey Europskiey: w ktorey sie zamyka Krolestwo Polskie ze wszystkiemi Państwy, Xięstwy y Prowincyami swemi* (Cracow, 1611), fol. 13.
86 Mariusz Kazańczuk, 'Wzorce osobowe w herbarzach Bartosza Paprockiego i Kaspra Niesieckiego', in *Wzorce osobowe w dawnej literaturze i kulturze polskiej*, ed. Elżbieta A. Jurkowska and Bernadetta M. Puchalska-Dąbrowska (Białystok: Wydawnictwo Prymat, 2018), 53–66.
87 Ewa Kurak, 'Autokreacja Bartłomieja Paprockiego (ok. 1543–1614) w świetle listów dedykacyjnych w "Gnieździe Cnoty" oraz "Herbach Rycerstwa Polskiego"', *Zeszyty Naukowe Towarzystwa Doktorantów UJ*, Nauki Społeczne, 14, no. 3 (2016): 39–53.
88 Agnieszka Tułowiecka, 'Herbarze i quasi-herbarze: Wokół konstrukcji genologicznych Bartosza Paprockiego' (PhD Thesis, Katowice, Uniwersytet Śląski, 2009), 75–77.
89 Bartosz Paprocki, *Gniazdo cnoty zkąd herby rycerstwa sławnego Krolestwa Polskiego … początek swoy maią* (Cracow, 1578), 66.
90 Margreta De Grazia, Maureen Quilligan, and Peter Stallybrass, eds., 'Introduction', in *Subject and Object in Renaissance Culture* (Cambridge: Cambridge University Press, 1996), 5.

91 'Nie chciałem ojczystego odmieniać stroju.' Quoted in Ludwik Kubala, *Jerzy Ossoliński* (Warsaw: Księgarnia Zakładu Nar. im. Ossolińskich, 1924), 482.
92 Alexander Nagel and Christopher S. Wood, 'What Counted as an Antiquity in the Renaissance?', in *Renaissance Medievalisms*, ed. Konrad Eisenbichler (Toronto: Centre for Reformation and Renaissance Studies, 2009), 53–74.
93 Alexander Nagel and Christopher S. Wood, *Anachronic Renaissance* (New York: Zone Books, 2010), 29–34.
94 There were other examples of such anachronism in Poland, including a pair of prehistoric mounds near Cracow, identified by chronicler Wincenty Kadłubek (c. 1150–1223) and rector of Cracow Academy Jan Dąbrówka (c. 1400–72) as the burial sites of the legendary king Krakus and his daughter Wanda. See Arciszewska, 'The Role of Ancient Remains'.
95 Edward Wouk, 'Reclaiming the Antiquities of Gaul: Lambert Lombard and the History of Northern Art', *Simiolus* 36, no. 1 (2012): 35–65; Kristoffer Neville, 'The Land of the Goths and Vandals: The Visual Presentation of Gothicism at the Swedish Court, 1550–1700', *Renaissance Studies* 27, no. 3 (2012): 435–59; Porras, *Pieter Bruegel's Historical Imagination*; Marisa Bass, *Jan Gossart and the Invention of Netherlandish Antiquity* (Princeton: Princeton University Press, 2016).
96 Mańkowski, 'Influence of Islamic Art in Poland'.
97 'W Polsce naśladowano stroje najwyższych sfer społecznych na Wschodzie, jak w naszym przykładzie strój sułtański, choć, jak raz jeszcze podkreślamy, ze znacznym opóźnieniem.' In Mańkowski, *Orient*, 196–97.
98 Chrzanowski, 'Orient i orientalizm w kulturze staropolskiej', 56.
99 Tazbir, 'Sarmatyzm a barok', 824.
100 Mrozowski, 'Orientalizacja stroju szlacheckiego', 260.
101 Lisy-Wagner, *Islam, Christianity and the Making of Czech Identity*; Born et al., *The Sultan's World*.
102 Gerald M. MacLean, ed., *Re-Orienting the Renaissance: Cultural Exchanges with the East* (Basingstoke: Palgrave Macmillan, 2005); Stefano Carboni, ed., *Venice and the Islamic World, 828–1797*, exh. cat. (New York and New Haven: Metropolitan Museum of Art; in association with Yale University Press, 2007); Eric Dursteler, 'On Bazaars and Battlefields: Recent Scholarship on Mediterranean Cultural Contacts', *Journal of Early Modern History* 15, no. 5 (2011): 413–34; Rothman, *Brokering Empire*; Rodini, 'Mobile Things'; Robyn D. Radway, 'Christians of Ottoman Europe in Sixteenth-Century Costume Books', in *The Dialectics of Orientalism in Early Modern Europe*, ed. Marcus Keller and Javier Irigoyen-García (London: Palgrave Macmillan, 2018), 173–93; Michał Wasiucionek, 'Introduction: Objects, Circuits, and Southeastern Europe', *Journal of Early Modern History* 24, no. 4/5 (2020): 303–16.
103 Eric Dursteler, *Venetians in Constantinople: Nation, Identity, and Coexistence in the Early Modern Mediterranean* (Baltimore: Johns Hopkins University Press, 2006); Eric Dursteler, *Renegade Women: Gender, Identity, and Boundaries in the Early Modern Mediterranean* (Baltimore: Johns Hopkins Press, 2011); Arkadiusz Blaszczyk, Robert Born, and Florian Riedler, eds., *Transottoman Matters: Objects Moving through Time, Space, and Meaning* (Göttingen: V&R Unipress, 2021).

104 Carolyn Dean and Dana Leibsohn, 'Hybridity and Its Discontents: Considering Visual Culture in Colonial Spanish America', *Colonial Latin American Review* 12, no. 1 (2003): 5–35.
105 Robert J. C. Young, *Colonial Desire: Hybridity in Theory, Culture, and Race* (London: Routledge, 1995); Annie E. Coombes and Avtar Brah, 'Introduction: The Conundrum of Mixing', in *Hybridity and Its Discontents: Politics, Science, Culture*, eds. Annie E. Coombes and Avtar Brah (London: Routledge, 2000), 1–16; Philipp W. Stockhammer, 'Questioning Hybridity', in *Conceptualizing Cultural Hybridization: A Transdisciplinary Approach*, ed. Philipp Wolfgang Stockhammer (Heidelberg: Springer, 2012), 1–3.
106 See Edward W. Said, *Culture and Imperialism* (New York: Knopf, 1993), xxix.
107 Jirousek, *Ottoman Dress and Design in the West*.
108 Ann Rosalind Jones, '"Worn in Venice and throughout Italy": The Impossible Present in Cesare Vecellio's Costume Books', *Journal of Medieval and Early Modern Studies* 39, no. 3 (2009): 511–44.
109 Guilia Calvi, *The World in Dress: Costume Books Across Italy, Europe, and the East* (Cambridge: Cambridge University Press, 2022).
110 Anton Möller, *Omnium statuum Foeminei sexus ornatus, et usitati habitus Gedanenses* (Danzig, 1601); August Bertling, *Anton Möller's Danziger Frauentrachtenbuch aus dem Jahre 1601 in getreuen Faksimile-Reprododuktionen: Neu herausgegeben nach den Original-Holzschnitten mit Begleitendem* (Danzig: Richard Bertling, 1886).
111 Stephanie Leitch, 'Cosmopolitan Renaissance: Prints in the Age of Exchange', in *The Globalization of Renaissance Art*, ed. Daniel Savoy (Leiden: Brill, 2017), 186–217.
112 For example, BJ St. Dr. Cim. 5875 (Jagiellonian Library); sygn. 31254 (PAN Biblioteka Kórnicka); Magazyn Starych Druków SD XVI.Qu.6556 (National Library).
113 Wilson, *The World in Venice*, 72.
114 Wrede, *Sejm i dawna Rzeczpospolita*.
115 Wrede, *Sejm i dawna Rzeczpospolita*, 82–83.
116 Bogucka, 'Szlachta polska wobec Wschodu turecko-tatarskiego'.
117 Jan Czubek, "Dwa inwentarze firlejowskie z XVII w.", *Sprawozdania Komisyi do Badania Historyi Sztuki w Polsce* 8, no. 3/4 (1912): 392.
118 Turnau, *Ubiór narodowy w dawnej Rzeczypospolitej*; Irena Turnau, 'Słownik nazw ubiorów używanych w Polsce od średniowiecza do początku XIX wieku: Źródła i koncepcja', *Kwartalnik Historii Kultury Materialnej* 45, no. 1 (1997): 72.
119 Biedrońska-Słota, *Polski ubiór narodowy zwany kontuszowym*, 86.
120 Tadeusz Lubomirski, 'Regestra skarbca Książąt Ostrogskich w Dubnie spisane w roku 1616', *Sprawozdania Komisyi do Badania Historyi Sztuki w Polsce* 6, no. 2/3 (1898): 206–21.
121 Sefer Muratowicz, *Relacya Sefera Muratowicza obywatela warszawskiego od Zygmunta III Krola Polskiego dla sprawowania rzeczy wysłanego do Persyi w roku 1602* (Warsaw: J. F. Minasowicz, 1777), 12.

122 Janusz Tazbir, 'Stosunek do obcych w dobie baroku', in *Swojskość i cudzoziemszczyzna w dziejach kultury polskiej*, ed. Zofia Stefanowska (Warsaw: Państwowe Wydawnictwo Naukowe, 1973), 102.

123 'Przyjeżdżając pod dom, chciał się też ojcu pokazać na powitaniu tureckim strojem: ustroił się w ubiór wszystek turecki [i] zawój, wsiadł na wielbłąda; kazawszy czeladzi zatrzymać się na wsi, pojechał przodem do dwora. Ociec staruszek idzie przez podwórze z laską do jakiegoą gospodarstwa, a owo straszy[d]ło wjeżdża we wrota. Starzec okrutnie uciekać począł, żegnając się. Syn widząc, że się ociec zaląkł, pobieży też za nim, wołając: „Stój, Dobrodzieju: ja to, syn twój!" Ociec tym bardziej w nogi. Potem rozchorował się z przelęknienia i niezadługo potem umarł.' Pasek, *Pamiętniki*, 185.

124 Irena Turnau, *Słownik ubiorów: Tkaniny, wyroby pozatkackie, skóry, broń i klejnoty oraz barwy znane w Polsce od średniowiecza do początku XIX w.* (Warsaw: Semper, 1999), 7–8.

125 Andrzej Pośpiech, *Pułapka oczywistości: Pośmiertne spisy ruchomości szlachty wielkopolskiej z XVII wieku* (Warsaw: Letter Quality, 1992), 119–20.

126 Adam Manikowski, *Toskańskie przedsiębiorstwo arystokratyczne w XVII wieku: Społeczeństwo elitarnej konsumpcji* (Warsaw: PWN, 1991).

127 Szymon Starowolski, *Polska albo opisanie Królestwa Polskiego*, trans. Antoni Piskadło (Cracow: Wydawnictwo Literackie, 1976), 124.

128 Suraiya Faroqhi, 'Ottoman Silks and Their Markets at the Borders of the Empire, c. 1500–1800', in *Threads of Global Desire: Silk in the Pre-Modern World*, eds. Dagmar Schäfer, Giorgio Riello, and Luca Molà (Woodbridge: Boydell Press, 2018), 127–47.

129 'Nieprzypada zaden stroy lepiey Polakowi / Jako wschodni / bo własny: a zwłaszcza Mezowi / Białogłowom záś káry pluza od Zachodu.' In Jan Białobocki, *Zegar w krótkim zebraniu czasów Królestwa Polskiego wiekiem królów idący* (Cracow, 1661), f. H4r.

130 Janina Poskrobko-Strzęciwilk, 'Polish Kontusz Sash and Its Cross-Cultural, Artistic and Technical Connections with the 17th–18th Century Silk Sashes from Safavid Persia and Ottoman Turkey' (PhD thesis, Toruń, Uniwersytet Mikołaja Kopernika, 2019); Katarzyna Połujan, *Kontusz Sashes: Collection Catalogue* (Warsaw: The Royal Castle in Warsaw – Museum, 2019).

131 Said, *Orientalism*.

132 Robert Clines, 'Edward W. Said, Renaissance Orientalism, and Imaginative Geographies of a Classical Mediterranean', Memoirs of the American Academy in Rome 65 (2020): 481–533.

133 Alexander Bevilacqua and Helen Pfeifer, 'Turquerie: Culture in Motion, 1650–1750', *Past and Present* 221 (2013): 75–118.

134 Kaya Şahin, Julia Schleck, and Justin Stearns, 'Orientalism Revisited: A Conversation across Disciplines', *Exemplaria* 33, no. 2 (2021): 196–207.

135 Todorova, *Imagining the Balkans*, 27; Diana Mishkova, 'Balkans/Southeastern Europe', in *European Regions and Boundaries: A Conceptual History*, ed. Diana Mishkova and Balázs Trencsényi (New York: Berghahn Books, 2017), 143.

136 Vassilis Lambropoulos, *The Rise of Eurocentrism: Anatomy of Interpretation* (Princeton, N.J: Princeton University Press, 1993); Susanne Zantop, *Colonial Fantasies: Conquest, Family, and Nation in Precolonial Germany, 1770–1870* (Durham, NC: Duke University Press, 1997); Suzanne L. Marchand, *German Orientalism in the Age of Empire: Religion, Race, and Scholarship* (Cambridge: Cambridge University Press, 2009).

137 Said, *Culture and Imperialism*, xxix.

138 On some of these difficulties, see James Clifford, 'On Orientalism', in *The Predicament of Culture: Twentieth-Century Ethnography, Literature, and Art* (Cambridge, MA: Harvard University Press, 1988), 255–76.

139 Chrzanowski, 'Orient i orientalizm w kulturze staropolskiej'; Mrozowski, 'Orientalizacja stroju szlacheckiego'.

140 See Katarzyna Murawska-Muthesius, *Imaging and Mapping Eastern Europe: Sarmatia Europea to Post-Communist Bloc* (New York: Routledge, 2021).

141 Wolff, *Inventing Eastern Europe*.

142 Giancarlo Casale, *The Ottoman Age of Exploration* (Oxford: Oxford University Press, 2010); Jerry H. Bentley, ed., *The Oxford Handbook of World History* (Oxford: Oxford University Press, 2011); Maxine Berg, ed., *Goods from the East, 1600–1800: Trading Eurasia* (Basingstoke: Palgrave Macmillan, 2015); Krishan Kumar, *Visions of Empire: How Five Imperial Regimes Shaped the World* (Princeton: Princeton University Press, 2017).

143 'il commença à me coëffer de son bonnet; & puis la phantaisie luy pregnant de m'habiller de pied en cap, il se dépoüilla de sa premiere robbe, qui estoit d'écarlate, avec des agraffes d'argent, & fourrée de Martres, & m'en reuestit par dessus mes habits: Il me fit mesme chausser ses brodequins. En suite de cela il tira son sabre de son costé; & apres m'en avoir fait baiser avec respect la garde, me dit que c'estoit là l'honneur de son pays; que ce sabre avoit soûtenu plus d'une fois le Trosne de son Roy; qu'il avoit fait trembler la puissance Ottomane, & que toute la Pologne luy devoit sa liberté, & me le mit au costé.' Nicolas Payen, *Les voyages de Monsieur Payen: où sont contenues les descriptions d'Angleterre, de Flandre, de Brabant, d'Holande, de Dennemarc, de Suede, de Pologne, d'Allemagne & d'Italie* (Paris, 1667), 130.

Who speaks for Poland? 3

I did not wish to forgo the dress of our forefathers.

Jerzy Ossoliński, 1633[1]

Eastern Europe defined Western Europe by contrast, as the Orient defined the Occident, but was also made to mediate between Europe and the Orient. One might describe the invention of Eastern Europe as an intellectual project of demi-Orientalization.

Larry Wolff, *Inventing Eastern Europe*[2]

Contemplating the ceremonial entry into Paris of Polish Ambassador and Lord-Palatine of Poznań Krzysztof Opaliński (1611–55), a lady-in-waiting to Queen Anne of Austria, Françoise Bertaut de Motteville (c. 1621–89), penned an acerbic remark in her memoir that might as well have been written by a nineteenth-century Orientalist:

> This Winter there was a second Embassy of the Poles, which was fine and worthy of our Curiosity for it represented to us that ancient Magnificence which passed from the Medes to the Persians, whose Luxury is so finely painted for us by the ancient Authors. Tho' the Scythians were never reckoned Men of Pleasure, yet their Descendants—who are now the Neighbours of the Turks—seem inclinable in some Measure to ape the Grandeur and Majesty of the Seraglio. There still appeared in them some Faces of their old Barbarity; and yet our French People, instead of laughing at them, as they had intended, were forced to commend them, and to own freely to the Advantage of that Nation—that their Entry was very well worth our Regard.[3]

Opaliński entered Paris on 29 October 1645 in the entourage of Polish–Lithuanian nobles, including Wacław Leszczyński (1605–66), Prince-Bishop of Ermland (Polish: Warmia). He too had ambassadorial duties, having been assigned the mission to represent King Ladislaus IV Vasa (r. 1632–48) in a proxy marriage to Princess Marie-Louise Gonzague de Nevers (1611–67) of France, and thereafter to escort her to Warsaw.[4] Motteville's account is a

detailed description of the event, but is far from objective. Biased by her own ideas about decorum and her Francocentric attitudes, Motteville overplays the lavish, theatrical style of the entry, amplifying all of its wonder and exoticism. According to her, only diplomatic protocol prevented the courtiers from revealing their real feelings towards the Polish legation, masking distaste for foreign manners under a guise of politesse. But Motteville, who wrote her memoir after the ambassador and his retinue had already left Paris—if the past tense of her description is to be believed—abandons all pretence to courtesy and portrays the Polish visitors as living relics of the past: arrested in their historical development, with 'their old barbarity' not yet entirely eradicated. Thus Polish fashions 'ape the Grandeur and Majesty of the Seraglio' and are generally more Turkish than European. She completes her sketch of Opaliński's retinue with an exoticizing image of precious fabrics and gems flaunted to no apparent purpose other than extravagant display:

> Their Habits were very fine: Vests after the Turkish Manner, over which they wore a great Cloak with long Sleeves, which they let fall loosely by the Horses' sides. Their Buttons—of both their Vests and Cloaks—were Rubies, Diamonds, and Pearls, and their Cloaks were lin'd with the same as their Vests. […] Their Stuffs were so rich, so fine, and their colours so lively, that nothing in the World was as agreeable. Their Vests glittered too with Diamonds; yet for all this Richness, it must be confessed there is something in their Magnificence that looks very Savage. They wear no Linnen, and do not lie in Sheets like other Europeans, but wrap themselves up in Furs. Their Caps are furr'd, their heads shav'd—except for a Lock upon their Crowns that hangs down behind. They are for the most Part so fat and slovenly that they are loathsome.[5]

Motteville's characterization of Poles as 'unlike other Europeans' might give the impression that she perceived them as lacking in civility. Cast as European, though exceptional, Poles in her portrayal dress 'after the Turkish manner' and 'wear no linen'—meaning linen underwear. Implicit in this declaration of cultural difference, which is mired in cliché and has little regard for actual Polish custom,[6] is that Poles were barbarians. A similarly degrading opinion was expressed by Motteville's contemporary Gédéon Tallement des Réaux (1619–92), best known for his *Historiettes* (Little Stories), a collection of short biographies. In keeping with Motteville's acerbic tone, he describes the Poles at the wedding fête in Paris as having 'the worst dining manners in the world' and as behaving in a 'savage' manner.[7] Both statements surely exaggerate the point, but staging Poland as a quasi-Ottoman realm was a relatively common rhetorical trope in early modern Europe, with outlandish costume and strange manners frequently found in other Europeans' descriptions of the country and its people.[8]

On the surface, Motteville's account falls into the particular mode of othering that was theorized as Orientalism by Edward Said (1935–2003), for whom it

is a discourse of power and knowledge production that privileges the perspectives of Western European-cultivated subjects as they buttress the supremacy of their own value systems and beliefs.[9] But while Motteville's appraisal of the ambassador is clearly embedded in her privileged position as a lady-in-waiting to a French queen-consort, it would be wrong to assume that her conception of Poland was an Orientalist simulacrum—a distorted impression of a place uninformed by knowledge from outside of France. Literary works on Poland available in Latin, French, and other European vernaculars were plentiful across the continent and could often be traced back to Polish sources.[10] Opaliński and his retinue were not simply objects of an Orientalist gaze with no agency of their own, and thus their agendas and political priorities also need to be taken into account for their impact on Motteville's understanding of Poland and its people. What follows, therefore, is an examination of the extent to which Poles themselves participated in the shaping of their country's image abroad.

The Orientalist interpretation of early modern Polish culture's overstating of its difference from the rest of Europe is in fact a later projection that only took off in the decades following the partition of the Polish–Lithuanian Commonwealth (1772–95) and was fashioned by Poles themselves as a way of rallying around lost Polish statehood.[11] The aim was to foreground Polish uniqueness. First a literary trend, this interpretation later became a separate scholarly current; among the earliest art historians to embrace such a self-exoticizing portrayal of Polish culture were Lviv-based scholars Władysław Łoziński (1843–1913) and Tadeusz Mańkowski (1878–1956), who celebrated the very same features of Polish heritage that Motteville found off-putting.[12] Not only did these men not see anything degrading in framing the early modern Polish kingdom—and by extension the entire Polish–Lithuanian Commonwealth—as a place deeply enmeshed in 'Eastern' fashion and material culture; they were also among the first to examine Polish and Ruthenian art and architecture specifically within the context of their making—as they saw it—on the edges of Latin Christendom, in the lands bordering the Ottoman Empire and Muscovy. For Łoziński, the 'Eastern element' (*pierwiastek wschodni*) of early modern Polish culture was a mark of cultural distinction that established Poland as a place historically incomparable to other Austrian possessions—of which the then-majority Polish-inhabited Lviv (Lwów before 1944) was an integral part as the capital city of the Kingdom of Galicia and Lodomeria (1772–1918), a Habsburg crownland.[13] Mańkowski, who began publishing art-historical work only after Poland regained independence in 1918, focused on 'the influence of Islamic art in Poland' to describe the country (at least as seen from multi-ethnic Lviv) as having a syncretic historical tradition distinct from anything the more westerly parts of Europe had to offer.[14] This framing reached the level of mainstream appeal after World War II, when

Mańkowski published his most influential works (having relocated to Cracow), and scholars like Tadeusz Chrzanowski (1926–2006), Zdzisław Żygulski Jr. (1921–2015), and Przemysław Mrozowski (b. 1958), all of whom were adamant that the historical vicinity of the Ottoman Empire had pressed Polish nobility into the realm of 'Eastern tastes', turned what had been an interpretation into factual received wisdom.[15]

But what exactly were those 'Eastern tastes'? While Polish cultural historians have been examining Old Poland through the lens of its alleged difference from the rest of Europe for over a century, their long-held attachment to exceptionalist interpretations follows none of the rhetoric of the region's relegation to 'barbarism', as Motteville had it. Her interpretation of Poland's 'Turkish manner' was not the same as Mańkowski's or Żygulski's ideas of Orientalism as a positive identity marker; these latter were different still from Said's notion of Orientalism as a scholarly discourse that creates the binary of 'East' and 'West', thereby making the inhabitants of these allegedly separate worlds into quintessentially distinct peoples.[16] Said—who was mostly interested in the Middle East and North Africa—does not, of course, include Poland in his account, and his selective choice of source material that pits an undifferentiated Orient against a similarly uniform Europe, not to mention his inability to incorporate the complexities of borderlands, does not suffice to explain the eastern half of the continent. Nevertheless, Said's work remains an inspiration for emancipatory projects in historical studies, and his general idea of Orientalism as a discursive mechanism for drawing a line between a 'civilized' Europe and its negative 'other' in the East has proven compelling enough that it motivated scholars of the region, most notably Larry Wolff and Maria Todorova, to demonstrate how the very idea of 'Eastern Europe' is an extension of the Orient. Embedded not in objective historical realities but in the structures of knowledge, Eastern Europe is more accurately an imagined, dynamic cultural space rather than a natural, unalterable geographical feature.[17] Wolff even coined the term 'demi-Orientalism' to describe the region's status as a complementary other half of Europe, invented in the intellectual centres of Paris, Amsterdam, and London during the Age of Enlightenment.[18] In these West-centred conceptions, 'Eastern Europe' appeared as a backward, semi-barbaric realm, and yet it could be redeemed by tapping into a Western European model of 'civilization'—an eighteenth-century neologism invented around the same time that the continent's division along the East–West axis came into being. Wolff's postcolonial critique points to the assumption that Central and Eastern Europeans were doomed to copy ideas and models developed in Western Europe, and thus could not actively define their own region, always only reacting to Western European imaginings.

But alternative interpretations have instead foregrounded the active role played by Central and Eastern European elites in inventing, creating,

manipulating, and maintaining their region's image.¹⁹ This chapter builds on this work by bringing to bear evidence from two specific events: Krzysztof Opaliński's 1645 entry to Paris, which opens this chapter, and the earlier 1633 entry of Jerzy Ossoliński to Rome. These two events generated a profusion of textual and visual representations, some of which were commissioned by the ambassadors themselves and others by their hosts; still others were made for the open market. The status of both Rome and Paris as the centres of European printing and information exchange was precisely why Polish diplomats did not spare any expense to present their country at what, in their view, was the most flattering angle: they knew that this particular image of Poland would be carried by pamphlets, engravings, and drawings to readers and viewers in all corners of Europe. In branding Poland as a regional power, diplomats joined the ranks of other Polish contributors to knowledge and creators of culture who were co-shaping European perceptions of their country. The purpose of this chapter is to reveal how Polish ambassadors spoke for their country and actively shaped the views of their Western European interlocutors.

Quid pro quo

Motteville notwithstanding, Opaliński's 1645 entry to Paris garnered much attention, and was widely commented upon in positive terms. The *Gazette de France*, essentially an organ of the French government, described the embassy in great detail, referring to the legation and its events as 'marvels exposed to the entire world'.²⁰ Although the anonymous reporter highlighted the difference between Polish and French costumes, the general tenor of the account is full of respect for the Poles:

> Everything we say of the ancient splendour of the Romans, and of that of today's Persians and other Oriental peoples, appeared in abridged form during the superb entry of the Ambassador Extraordinaries of Poland, who came to hold the ceremonies for the marriage of their King with Princess Marie-Louise de Gonzague, [and] who have made us admit that, whether it be in wealth, whether it be in the simplicity of colours, whether it be for the advantage long-robed nations gain from the shape of their costume, this century has seen nothing more worthy of admiration and of applause [than] what this great and populous City has given them.²¹

The author emphasizes the great splendour of the procession, suspended halfway between respectable magnificence and obscene excess. Poles are at once compared to the ancient Romans and the 'Oriental peoples' of the day; thus they are deemed both comparable to the French and distinctively different. But this was not the imposition of a Western European viewpoint on an Eastern European realm, a simple case of Western Europe exoticizing and

misrepresenting its 'Eastern' counterpart. A Polish version of the account had already appeared in Warsaw in 1645, around the same time of the *Gazette* description, and this local account mirrored the wording of the Parisian newspaper nearly verbatim, albeit in vernacular.[22] Numerous other accounts of Opaliński's embassy circulated in Poland–Lithuania; they all described the legation in highly positive terms, hinting at the Lord-Palatine's involvement in redacting these pamphlets.[23] The similarity of the French and Polish versions suggests that the entry was followed closely in Poland, where both the court and its detractors had a stake in latching onto news of the legation for political gain, especially as the ambassador was liable to the sejm.[24] It was in Opaliński's best interest, therefore, to create and preserve a positive tone for the legation's visit. The near-correct Polish spellings of the names of members of the ambassadorial entourage—like 'Konopnicki', 'Cielecki', and 'Boianowski', which would have been transliterated differently without tips from a Polish informant—indicate that communication between the embassy and the French government may have included appropriate forms of publicity for the event.[25] The *Gazette* writer may have been under pressure to present the entry in a manner amenable to the Poles, thereby lending support to the fledgling Franco–Polish alliance.

Poles were important contributors to various other literary and visual descriptions of the event. One example is the series of drawings depicting the entry by Stefano della Bella (1610–64), a Florentine draughtsman and printmaker then active in Paris, who was likely hired by a prominent member of the Polish legation—perhaps Opaliński himself—to prepare sketches for eventual reproduction in print.[26] Figure 3.1 represents a group of riders, including ambassadors Opaliński and Leszczyński as well as other Polish noblemen, who all wear Polish żupans (fur-lined undercoats) and plumed kalpaks (fur hats). The idiosyncratic dress of the Poles contrasts with the doublets and breeches, coiffed wigs, and wide-brimmed cavalier hats of local French dignitaries (centre and right)—a juxtaposition of fashions that enhances Poland's sartorial particularism. Altogether, della Bella's Parisian drawings depict 230 human figures, sixty-one of which are individualized portraits with participants' names indicated by notes in pencil and ink.[27] This attention to detail, including—yet again—the mostly correct spelling of Polish names, indicates that the drawings were vetted by a member of the Polish legation.[28]

The context in which the drawings were created owes much to Franco–Polish diplomatic bonds that extended back at least to Henri de Valois's ascension to the Polish throne in 1573.[29] Since that time, the French court had seen Poland as a potential ally against the Habsburgs; the marriage of Marie-Louise and Ladislaus was a crowning moment of this rapprochement, aimed at facilitating a reciprocal understanding between the two powers. In Poland, the marriage was supported by the pro-French faction at court, which hoped to forge

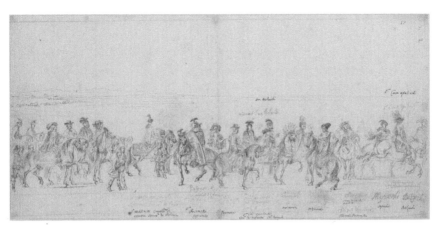

Stefano della Bella, *Entry of the Polish Embassy into Paris*, drawing on paper in pen and brown ink, over graphite, 2.30 × 4.84 cm. London, British Museum, 1895, 0617.399

3.1

an alliance with the Bourbons in an effort to break away from the Vasas' historical reliance on the Habsburgs.[30] To ensure the success of the negotiations, Opaliński's mission was preceded in September of the same year by Lord-Palatine of Pomerania Gerhard Dönhoff (1598–1648, Polish: Gerard Denhoff), ambassador extraordinary sent to Paris with the task of formally asking for the hand of the princess, negotiating agreements for the wedding, and finally signing the marriage contract.[31] Both powers wanted something for themselves out of the new alliance. Ladislaus sought to raise funds for his planned military campaign against the Ottomans; Cardinal Jules Mazarin (1602–61), acting regent for the young Louis XIV (r. 1643–1715), wanted to secure permission to draft two thousand mercenaries from Poland for deployment against the Habsburgs.[32] There clearly was quid pro quo bargaining going on, as both courts treated the marriage as a political transaction, intent on gaining their own specific desired advantages.

Judging by the mirroring of public messages in France and Poland, the French spin doctors were following the letter—be it intentionally or incidentally—of a Polish-approved communication strategy. The marriage contract published in the *Gazette* avoids any descriptions of Poland we might consider Orientalizing or demeaning. It calls Ladislaus a 'great king, so much revered by one of the most valiant nations of the North that serves as a firm bulwark of Christendom against the infidels' and provides the protocol that must be followed by the Paris celebrations to pay due respect to the Polish king and his French queen-to-be.[33] The idea of Poland as a rampart protecting the rest of Christendom against Turkish incursions had been a staple in Ladislaus's iconography and textual representation aimed at foreign publics,

at least since his victory over the Ottoman army at Khotyn (Romanian: Hotin; Polish: Chocim) in 1621.[34] A reference to this battle also appears in the dedication to Marie-Louise that opens the 1647 edition of Lucan's works by churchman and translator Michel de Marolles (1600–81). Referring to the ancient Sarmatians, he calls them 'a warlike Nation, dressed in long robes, whose Throne your Majesty possesses today, in the company of her invincible King; it will always be formidable at the Ottoman Porte'.[35] Similarly, in a report from Poland issued in the *Gazette* on 1 January 1646, we read that:

> Poland, having refused to agree to any of the alliances that the House of Austria had offered her [king], to embrace that of France, showed a part of her magnificence in that of her Ambassadors, who brought the king [of Poland] a new Queen impatiently awaiting her [new] Spouse, and for whose nuptials the whole borderland is making preparations worthy of this powerful State: which has, however, chased away a numerous army of Tatars who came to disturb the celebration.[36]

These Tatars directly reference the recurring theme of Poland's foreign information campaign as an Antemurale Christianitatis, a narrative in which the kingdom served as a firewall against the expansionism of the Ottoman Empire, represented here by its allies from the Crimean Khanate.[37] Poles are in this description the precise opposite of 'Orientals'. Polish actions are described as 'magnificent', the Aristotelian term (*megaloprepeia*) for an ethical virtue understood as lavish expenditure for the common good. They are not, therefore, overindulgent—a character flaw often attributed to Ottoman subjects.[38] By juxtaposition, Poles are here framed as 'one of us' vis-à-vis Turks and Ottomans, who are provided for comparison, prompting the reader to acknowledge that Poles are Europeans, a rhetorical trick that foregrounds Polish distinctiveness and simultaneously suggests Poles' European familiarity.

A visual example of this trope can be found in a print etched by François Campion and likely commissioned by the French court (Figure 3.2). The image is divided into two registers: the upper section depicting the wedding fête, the lower the cortège of Polish ambassadors. An article in the *Gazette*, which describes the nuptial celebration in great detail, helps to identify the figures at the table enjoying the festivities as (from left to right) Gaston, Duke of Anjou (1608–60), brother of the late Louis XIII; Philippe, Duke of Orléans (1640–1701), younger brother of the minor king; the young Louis XIV himself (r. 1643–1715); Marie-Louise, the princess bride; and Anne of Austria (1601–66), the Queen Mother.[39] Next to the royal family sit ambassadors Opaliński and Leszczyński, who, invested with surrogate authority, embody the Polish king.[40] They are flanked by Polish nobles carrying sinister-looking war hammers, whose designs, however, resemble the halberds of the French nobles in the left corner, which diminishes the weapons' potential exoticism.

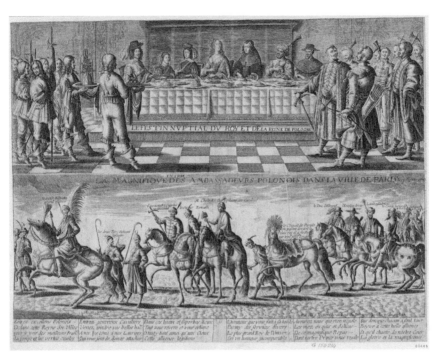

François Campion (engraver), Nicolas Berey (printer), *Le festin nuptial du Roy et de la Reine de Pologne—La magnifique entrée des Ambassadeurs Polonois dans la ville de Paris*, 1645, engraving. Paris, Bibliothèque nationale de France, département Estampes et photographie, RESERVE QB-201 (38)-FOL

3.2

The procession in the bottom register includes the most important members of the Polish legation, assisted by French dignitaries. This pairing highlights a contrast that defines French costume as much as it conveys Polish difference. The French wear jackets, trousers, and brimmed hats; the Poles don ferezja overcoats, long capes, and fur-fitted kuczma hats. The further inclusion of two infantrymen described via cursive labels as 'two Turks' (*les deux Turc* [sic]) among the group serves to delimit the differences between Poles and Turks, Christians and 'infidels'. These two soldiers wear hats decorated with Islamic crescents and carry scimitar-like scythes as well as quivers full of arrows. It is owing to these details—and to the descriptive text above them—that the beholder is prevented from confusing these figures with Polish figures, including ambassador Opaliński and Domenico Roncalli, the Polish resident envoy in Paris since 1643, both of whom are depicted in Polish costume and described as 'excellent Poles' (*excellens Polonois*). The *Turcs* in the print, likely masqueraded members of the Polish legation, recall Polish military victories over the Ottoman army and point to the convention of the classical Roman

triumph, wherein here the Turks stand for captives and the Poles for victors.[41] For all intents and purposes, this is a French representation of Poland but on Polish terms.

While Polish ambassadors in Paris were performing the spectacle of their country's military strength, the French government was ensuring that the pamphlets and engravings commemorating it simultaneously foregrounded France's might. European readers and viewers were to see Poland as aggrandizing French leadership in Europe. At this moment, the French court was in fact dependent on Poland for fashioning Parisian court culture as well as its perception both at home and abroad.[42] In this respect, Occidentalist bias only superficially explains French attitudes to Poland. Motteville, for one, is genuinely ambivalent about Poland's place among other European nations. It is true that she has a tendency to belittle the Polish visitors; at one point in the memoir she quips that 'there was some Talk of celebrating the Marriage with the Ceremonies required upon such Occasions, in order to show this barbarous Nation the Grandeur of the French'.[43] Yet megalomania was a pan-European attitude and thus not uniquely French, even though French writers in the period liked to emphasize the centrality of Paris as the world's most cultivated and powerful city.[44] But even while observing a hierarchy of civility whereby Poles figure on a lower scale than the French, Motteville describes Poles in a positive light. In these less frequently cited passages, she praises the Polish legation for the 'Display of their Magnificence and Finery'.[45] She likewise writes respectfully of the entry to Paris, which was reportedly 'made with an abundance of Solemnity, and the best Decorum in the World'.[46] Although her diary can be critical of Poles, Motteville avoids describing Poland in categorical terms as France's antithetical other. Whereas Orientalism is a binary scheme for ordering nations into those that have civilization and those that lack it, Motteville's account of the Polish embassy falls along a wider spectrum of intermediate expressions of cultural difference, ranging from ignorance to idiosyncrasy.

Motteville's penchant for enumerating Polish peculiarities may have been driven by her Francocentric geopolitics. She devotes a dozen pages to speculations on Marie-Louise's role as France's inside person in Poland, pointing to her country's expansionary ambit.[47] In this respect, Motteville's description of the Polish nobility as a 'barbarous Nation' is a useful rhetorical device: by mocking the costume of this easternmost corner of Latin Europe, she effectively amplifies the 'Grandeur of the French'.[48] Framing the encounter between French and Polish customs in comparative terms allows Motteville to effectively employ alleged Polish difference as a means of assessing the influence of her own nation—which could soon extend to Central and Eastern Europe. When representing France's new political allies, she dwells on their most unusual features in order to present Paris as a focal point whose sway extends to

the very limits of the familiar European world. Although reportedly repulsed by Polish manners and appearance, she does not diminish Poland's status as a European power. Therefore, Motteville's ambivalent attitude points to the limits of demi-Orientalist critique in understanding the commensurability and flexibility that often underlay early modern encounters between Europe's different regions, east and west. Motteville's Poland is not fully exotic, nor is it a projection of the otherness of the 'Orient' onto a land that sits along a civilizational fault line; it is simply a place to compare against France.

Close others

The commensurability of French and Polish customs is well illustrated by several transcultural episodes that challenge Poland's depiction as an exotic realm. The writings of Marc-Antoine Girard de Saint-Amant (1594–1661), a gentleman of Marie-Louise's chamber, give some sense as to how the French might have seen the faraway kingdom not as a barbaric wasteland but as the locus of an exciting potential opportunity to reinvent oneself. After seeing the Polish–Lithuanian procession, Saint-Amant confessed in a private letter to Monsieur Desnoyers, Secretary of Commandments to Marie-Louise, that he was eager to leave France for Poland in the queen's service:

> If my fortune is pressed northwards,
> If the Vistula is to be seen by my eyes,
> As the sky has given me hope,
> To dress me as a proud and noble Sarmatian,
> In beautiful velvet exploding in colour,
> Which, sombre and long, lined with precious fur,
> Makes my bearing beautiful and gracious;
> To arm my flank with a curved and rich sabre,
> To make me better than a prancing Turk,
> To transform my felt into a bonnet
> That will keep warm my neatly shaven skull
> To follow in all [ways] the Polish fashion,
> Even to the point that my boots make walking uncomfortable
> Even unto the feasts where you say we drink much,
> And at which excess astonishes me as it flatters me
> […] And the only queen in the world for whom I was born,
> I be appointed the great St. Amantsky.[49]

In this letter, Saint-Amant contemplates—not without parody—the possibility of his becoming a Polish nobleman dressed in 'Northern' (not Eastern) Polish costume that dazzles in its sumptuousness. Saint-Amant explains the characteristics of what he terms 'Sarmatian' culture partly in terms of

geopolitical factors. Poles seem to have developed their idiosyncratic way of life due to the necessity of outdoing the Turks, presumably in armed conflict. The idea of becoming a Pole is, of course, a rhetorical pose: Saint-Amant treats Polish dress almost as a theatrical prop that he must take up to become a royal courtier. Dressing up as a Pole—necessary in this case for social advancement—is clearly worth the price, especially given that Saint-Amant seems to admire the glamour that, according to his own description, attends it.

Both familiar and foreign, Poles appeared in early modern French imaginings as figures who were simultaneously similar and different, an ambiguous status best captured by historian of Central and Eastern European art Piotr Piotrowski, who developed an apt category—that of the 'close other'—to describe this intermediate epistemic position between attributed difference and acknowledged resemblance.[50] Because they partake of similar cultural models, traditions, and systems of thought, close others are—according to Piotrowski—not the same as (real) others, who are seen as quintessentially different. Close others are not incompatible with the self; they are simultaneously like and unlike the self, neither the same nor overly different. Visual imagery of Poles operated within this double bind, defying the strict confines of absolute strangeness. Poles were close others to the French: geographically proximate and yet distant; dependent and yet necessary; strange and yet similar. When representing Polish themes and subjects, French artists and writers pointed to Poland's strangeness and lavish foreignness as well as to its connections with France. Making sense of the early modern European world was thus in many cases a transcultural endeavour.

Imagining foreigners as embedded in local life is transcultural, too. Anne Marie Louise d'Orléans, Duchess of Montpensier (1627–93), seems to have appraised the 1645 Polish embassy to Paris through the lens of familiar (French) theatrical performances. In her memoir, Montpensier discussed Opaliński's entry in a manner somewhat more positive in tone than that of Motteville's ambivalent diatribe. After complaining about the long delay before the procession commenced, the duchess judged the event thus: 'There have been too many accounts for me to amuse myself in the detail of a description: all I will say is that the [Polish] manner of dress is entirely different from ours; we all watched this ceremony as a very magnificent masquerade.'[51] Montpensier saw the procession, therefore, as a successful courtly performance that may have reminded her of a recent *ballet des nations* in which Polish costume was used alongside Hungarian, Turkish and Persian garb.[52]

Such cross-cultural masquerade was explicitly theatrical, possibly evoking contemporary French plays that put Polishness on stage. The comedy *Le feint Polonois ou la veuve impertinente* (The Fake Pole or the Cheeky Widow), written by actor and playwright Noël Le Breton de Hauteroche in 1686, for instance, employed Polish costume as a prop that provides a focus for the main

plot. In one key scene, the protagonist La Franchise dresses up as a Pole to help him further a romantic affair with his beloved Marianna. The disguise initially seems a good idea because 'in Paris, there are many dressed in this way'. La Franchise thus hopes that he will be able to reach his lover unrecognized, clad in strange yet familiar attire. But instead of making things easier for the illicit couple, trouble ensues. Marianna's friend mistakes La Franchise for a Turk, refusing him access to her house. In response, La Franchise complains:

> [The disguise] does not look bad on me, but it makes people believe I am a true Mardi gras masquerader. I no longer dare show my nose in the streets: everyone stops to look at me, and children follow me, yelling after me, like they shout after masked people during Carnival.[53]

Although La Franchise dons Polish costume, he does not of course assume a foreign identity as a result.[54] Rather than claiming a radical difference with Poles, though, the masquerade serves as a performative manifestation of self as a theatrical embrace of the public and social aspects of identity formation— of how individuals come to understand themselves and their subjectivity in relation to wider society.[55] In her discussion of visual images of Europeans in Oriental garb, Claudia Swan has observed that these images' purpose was to simultaneously frame sitters as 'indigenous foreigners' and 'foreign natives'; while on the surface they transformed Europeans into exotic strangers through costume, at their core these portraits still and always depicted Europeans, albeit perhaps in the process of reframing themselves as discerning collectors of exotica, diplomats, or well-connected businessmen.[56] Similarly, while Polish costume visibly changes La Franchise, it does not alter his identity, even if it turns him into 'a Turk' in the eyes of the world, emphasizing the impact of external identifications of ethnicity on an individual's experience of self.

Theatre historian Katrin Sieg has described this sort of cross-cultural theatrical performance as 'ethnomasquerade'. Through mimicking the appearance, gestures, and speech of foreign peoples, ethnomasquerade is the 'theatrical embodiment of other ethnicities by a subject that thereby exercises power and simultaneously hides it.'[57] Although masquerading as a Pole was ostensibly a commentary on difference, it was also an exercise of comparative ethnology in which France's ascendancy as the greatest European power was manifested through its supra-European reach. Opaliński's 1645 embassy provided an ideal occasion for comparison between Frenchmen and Poles, nations situated at Europe's two opposite geographical extremities. Apart from pointing to the predominance of Ottomanesque dress in the procession, the anonymous writer for the *Gazette* also duly reported occasional displays of French fashion among the Polish elites.[58] In line with the newspaper's mission as a tool for French self-aggrandisement, the reporter foregrounded France's geopolitical pre-eminence by highlighting its cultural impact on a faraway country. The

message is here that even the Poles, who lived on the easternmost margins of Latin Europe, appreciated French fashion. The self-assigned attractiveness of local sartorial codes had the potential to strengthen the appeal of French costume, extending its reach to the very limits of the familiar world. One cannot but notice, however, that by continually addressing Polish fashion as intriguingly unusual and excitingly strange, critics, writers, and artists were in fact taming its exoticism through the use of early modern technologies of replication and visualization. The more Polish figures were represented in prints, pamphlets, and other popular media, the more familiar these strangers appeared, gradually losing their exoticism in the process. They looked weird, but not weird enough; they acted foreign, but not as foreign as others; they were almost distinct, but not quite.

Transcultural agendas

Far from serving as passive recipients of a foreign gaze, Poles were adept at using Western European printing houses and other early modern spin agencies to their own ends. Twelve years before Opaliński's entry to Paris, in late autumn of 1633, the Roman populace was granted an opportunity to witness an unusual spectacle of opulence and grandeur of similar magnitude. The performance's ultimate producer as well as its main actor was Jerzy Ossoliński, Grand-Treasurer of the Crown and envoy extraordinary of the recently elected Polish–Lithuanian ruler Ladislaus IV—who, bound by convention, needed to dispatch a legation of obedience to the papal capital as a proof of loyalty to the Holy See.[59] Fully cognizant of the gravity of his task and its concomitant potential to impress, Ossoliński made every effort to flaunt Poland–Lithuania's idiosyncratic customs and self-asserted military strength, effectively transforming the ceremonial pomp of an ambassadorial entry to Rome into one of the most memorable public pageants during the pontificate of Urban VIII (r. 1623–44).[60] An occasion to marvel at what was both foreign and enticing, the event received wide coverage as pamphlets, prints, and paintings of Ossoliński's procession were disseminated across Europe.[61] While the Romans would have been able to use these media to revisit personal memories of the ambassador's flamboyant arrival, other Europeans treated such materials as sources of information about the distinctive features of Polish dress and custom, likely read or viewed alongside the costume books and travel narratives that had preceded the entry.

Pamphlets in Italian and in Polish highlighted the scale of the event.[62] From these documents, we learn that Ossoliński reached Rome on Sunday, 20 November. This was an unofficial arrival, but he was nevertheless greeted outside the city gates by more than seventy high-born onlookers, all eager to meet the ambassador. The welcome party was led by Cosimo de Torres (1584–1642),

Cardinal Protector of Poland.[63] Among the crowd were other cardinals, foreign ambassadors, and local nobles.[64] Having stopped by his official Roman residence at Palazzo Gabrielli in Piazza della Trinità dei Monti, Ossoliński headed incognito to a papal audience at the Quirinal Palace, where he also met with the *cardinali nipoti*—relatives of the pope elevated to the status of cardinals—and other courtly figures. The ambassador subsequently left the city to retire in the papal vineyard at Villa Giulia.

One week later, on Sunday, 27 November, Ossoliński made his solemn formal entry into the capital. The route led through the Porta del Popolo and into the ambassador's lodgings in Piazza della Trinità dei Monti.[65] It was on this occasion that Ossoliński made his most lasting impression on the city's populace, the Roman nobility, and foreign visitors by orchestrating a sumptuous parade replete with lavish costumes and curious customs. Textual descriptions of the event paint an image of true magnificence: The procession is said to have been led by two couriers dressed in red satin and black velvet caftans. Behind them were twenty-two carts with the ambassador's luggage, pulled by mules and decorated in colourful fabrics. Next came ten camels in silver harnesses and halters, with saddles covered in red velvet. These exotic animals were attended by turbaned Tatars and Armenians in silk cloaks begirded with golden chains. As the turban was commonly seen as a symbol of a distinct extra-European identity in early modernity, often representing Muslim culture, these men were thus marked as non-Polish.[66] They were followed by four trumpeters wearing dress in orange satin and green velvet topped by kalpak hats.[67] Next in line were thirty mounted Cossacks (mercenaries from south-eastern Ruthenia) dressed in red silk cloaks and armoured with hand bombards, bows, and quivers. One of the most curious figures of the entire spectacle was apparently Ossoliński's valet de chambre, 'Sig. Chociszevvsky' (Kociszewski), described in pamphlets as dressed in a jewel-studded cloak made of white brocade patterned with golden flowers. Riding a dyed horse (the colour of which is unspecified), he was mounted on elaborate tack adorned with turquoises, his boots resting in golden stirrups, with a pole of crane feathers affixed to his saddle. He wore a feathered helmet and a shield, and carried a mace made 'according to the Persian custom'.[68] These adornments gave the rider a bellicose look.

Kociszewski was followed, the pamphlets recount, by twenty ambassador's servants, all clad in turquoise cloaks with orange underlining, and carrying bows and quivers. Tatars and Armenians led five dyed Turkish horses with saddles encrusted with precious jewels. The horses were fitted with golden horseshoes. To the joy of the Roman crowd, two of these were reportedly lost during the parade, adding to the sumptuousness of the affair.[69] The procession continued with many Polish–Lithuanian noblemen dressed and armoured 'alla polacca' as well as members of the Roman aristocracy and foreign

dignitaries, who paved the way for the main protagonist, the ambassador himself. Ossoliński, mounted on a dyed horse whose tack glittered with rubies and other precious gems, wore a white brocaded dolman—a long robe—heavily decorated with diamonds in addition to a fur-lined cloak. Crowned with a fur kalpak hat embellished with a large ruby, the ambassador carried a golden sabre set with rubies, a ceremonial weapon estimated in value at a staggering five thousand scudi. The cortège concluded with the ambassador's carriage, pulled by six horses.[70]

An altogether different event was staged for Tuesday, 6 December, the day of Ossoliński's public audience with the pope. Nearly seven hundred horses were paraded from Porta Flaminia to Castel Sant'Angelo, where the ambassador swore obedience to the pope on behalf of King Ladislaus and political negotiations ensued, as per the royal letter of instruction. Yet again, Ossoliński had organized a colourful procession. Poles paraded in opulent costumes 'alla polacca'. Ossoliński, mounted on a lavishly decorated stallion, was 'dressed in the costume of his country' (*de more patrio indutus*), including an orange, fur-lined velvet cloak with golden buttons encrusted with diamonds and other jewels. The horse's saddle was also adorned with gems, its tack gilded, and its head accoutred with a large diamond and a feather.[71] Pamphleteer Virginio Parisi deemed this procession perhaps even more magnificent that the earlier official entry (*più bellissime e forsi di maggior pompa della prima*).[72]

Many (if not all) of these pamphlets were most likely commissioned by Ossoliński himself,[73] with specific instructions likely given to the Italians who wrote such detailed accounts. The conflation between Polishness and exoticism was thus apparently intentional on the part of the Poles, probably as a means of impressing the Romans. The Polish-language pamphlet *Sławny wjazd do Rzymu* (The Famous Entry to Rome), which is also thought to have been Ossoliński's commission, asserts that the procession gained the accolades of the entire city of Rome, and 'there [was] no memory that could surpass such pomp'.[74] Yet as much as Ossoliński was seeking to communicate Poland–Lithuania's might to the eternal city, he also had to address the Polish–Lithuanian sejm upon his return. While he was performing in person before spectators in Rome, therefore, he was simultaneously putting on a show for his compatriots at home; the pamphlets were a means of ensuring that the message would get through to Poland as intended.[75]

To prove that he had met the expectations placed upon him by king and country, Ossoliński claimed at the 1635 sejm that he had performed all his ambassadorial duties in Polish costume. In a speech delivered to his fellow citizens, he stated: 'I did not wish to forgo the dress of our forefathers', meaning Ottomanesque costume, which by then had become considered 'native' to the Commonwealth.[76] He also reported that all the streets of Rome had filled with people who were curious to see his entry, making the fame of the 'Polish

nation' unrivalled in all Christendom.⁷⁷ What sounds like braggadocio was in fact the standard avowal of a nation's image and reputation. Early modern diplomatic exchanges were heavily ritualized events that provided a structure for the diplomat's interactions with the receiving court to allow him to maintain his prince's honour while simultaneously affirming the authority of the host.⁷⁸ By all accounts, the spectacles that Ossoliński created were *tours de force* of ostentatious pomp and calculated plaudits, the purpose of which was to dazzle and impress the Romans and—through the mediation of print—the whole of Europe. Emphasizing the visible difference of Polish costume played an important part in this pursuit if printed pamphlets, newspaper reports, speeches, and visual representations of the event are used as evidence.⁷⁹ Of these, one of the most captivating is a series of six etchings commemorating the entry by Stefano della Bella (Figures 3.3–3.8), the same man who would later work for Opaliński in Paris, but at the time a young Florentine artist residing in the papal capital.⁸⁰ Busy in detail, the prints depict the whole arsenal of outlandish props, luxurious fabrics, and extravagant customs deployed on the occasion of the entry. Although the press run is unknown, these prints likely held much appeal, given that they are still extant in four different seventeenth-century versions in many European and North American collections.⁸¹

The first of the etchings is the heavyweight of the series, serving as a point of entry into the compound representation (Figure 3.3). The most immediate visual cue that captures the beholder's attention is the title epigraph, which reads in Roman-style inscription: ENTRATA IN ROMA DELL' ECCEL^MO AMBASCIATORE DI POLLONIA L ANNO MDCXXXIII. Through this simple yet effective scripted signifier, viewers are instantly informed of the nature of the event they are to access through the mediation of print. The text ensures that the cavalcade of exotic-looking bodies is read as 'Polish'. Further textual references are in place to secure the identification of the figures, suggesting that their Polishness was perhaps not self-evident. To clarify matters, each group of figures taking part in the procession are marked by letters of alphabet, which are linked to the elucidatory captions provided in the lower margin of each etching. By bringing together image and text, beholders could link specific individuals and groups with their respective cultural backgrounds. While the visual representation creates a picture of exoticism not immediately recognized as European, the textual field attempts to divide the figures into those who are Poles and those who are not.

Accordingly, only by reading the caption corresponding to the letter 'A' do we learn that the two minuscule figures depicted in the background near the Porta del Popolo are Polish noblemen in the service of Ossoliński: 'Two Polish couriers wearing satin and velvet tunics'.⁸² Behind these extravagantly clad men are the carts pulled by 'twenty-two mules laden in different fashions' ('B').⁸³ This wagon train is followed by papal cavalry guardsmen ('C')⁸⁴

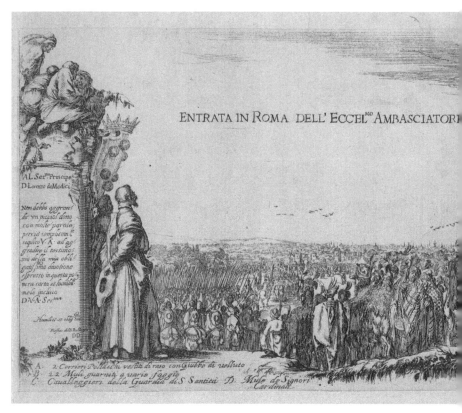

3.3 Stefano della Bella, *Entry of the Polish Ambassador into Rome*, 1633, sheet 1, etching, first or second state of three, 17.1 × 264.8 cm. 'Entrata in Roma dell'Eccl. mo ambasciatore di Polonia l'anno MDCXXXIII'. Metropolitan Museum of Art, New York, bequest of Phyllis Massar, 2011, 2012.136.965(1–6)

and the 'mules of Lord Cardinals' ('D').[85] The image renders all these figures unfamiliar, but perhaps the most exotic element of the etching—as in the pamphlets describing the entry into Rome on 27 November 1633—is the caravan of 'ten camels with the most superb saddlecloths made of red embroidered velvet, with iron headboards and silver harnesses' led 'by Persians and Armenians in diverse fashions' ('E').[86] The substitution of Tatars, who are mentioned in the pamphlets, for Persians not mentioned therein implies that della Bella—or his printer Giovanni Giacomo de Rossi (1627–91)—chose to emphasize the exoticism of the event at the cost of factual correctness. The spectacle of strangeness continues with a group of four mounted 'trumpeters in tunics from green velvet' ('F') that brings to a close the first print.[87] With fantastical plumed hats on their heads and Ottomanesque carpets used as their saddle-cloths, these men fit well with the exoticism exemplified by the

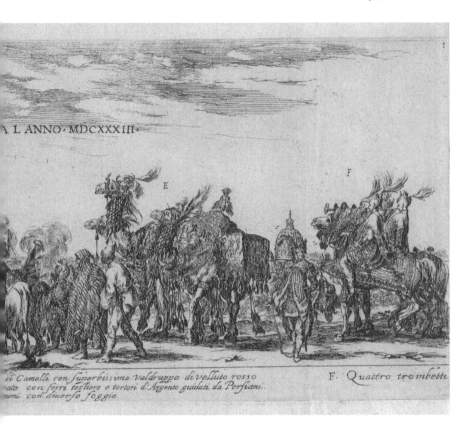

camels. Della Bella was clearly interested in foregrounding the entry's unusual aspects.

The dome of St Peter's looming behind the outlandish animals nonetheless reminds viewers that the event depicted in the print took place in Rome, the centre (albeit contested) of Latin Christendom. The quintessential symbol of papal authority, St Peter's Basilica signifies the purpose of Ossoliński's mission: to swear his king's obedience to the pontiff. It also marks the Commonwealth's official adherence to Roman (and Greek) Catholicism—despite it being home also to Protestant, Orthodox Christian, Jewish, and Muslim populations—and possibly its self-assigned status as the 'defender of Christendom', rhetoric mostly used abroad.[88] Defender of Christendom was in fact how Ladislaus IV and Ossoliński wanted Poland–Lithuania to be imagined in Europe, and this vital role was an important aspect of various textual accounts that reported

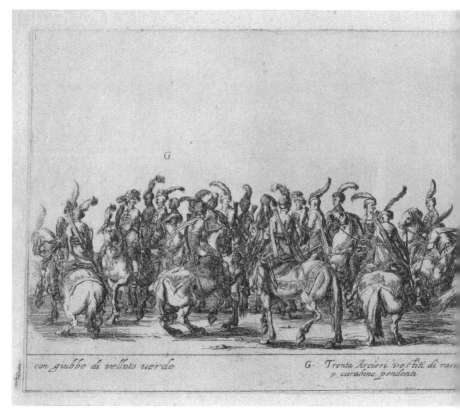

3.4 Stefano della Bella, *Entry of the Polish Ambassador into Rome*, 1633, sheet 2

on the mission. Planning for the magnificent pageant in Rome, a city that was central to European information exchange,[89] both king and ambassador likely anticipated that representations of the entry would quickly spread across the continent. Two surviving instruction letters that Ossoliński received from the king indeed reveal that the ambassador intended to convince Romans—and by extension other Europeans—of Poland–Lithuania's role as the bulwark of Christendom. A letter signed in June 1633 in Grodno (Belarusian: Hrodna) advises Ossoliński to perform the entry 'not in soft and uncustomary costume, but rather in full Sarmatian splendour that conveys military power and civil prudence'.[90] Polish costume thus serves as an extension of Polish masculine virtues. In the obedience speech Ossoliński delivered to the pope on 6 December, the Polish–Lithuanian commitment to preventing the Ottoman march on Europe was given much prominence.[91] The script makes political use of the Polish–Lithuanian victory over the Turks in Khotyn in 1621, implying that if it had not been for the Commonwealth's military presence on the northern Ottoman border, Italy itself would have been placed in peril: 'The Italian

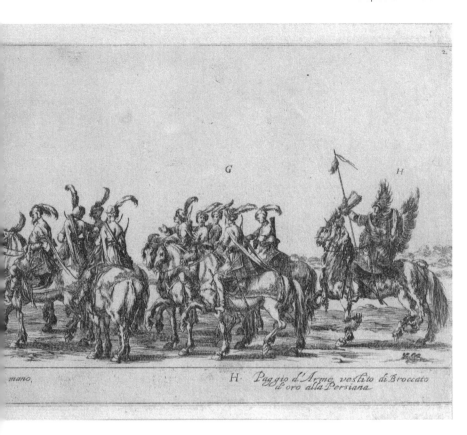

good name and its treasures would have been destroyed had it not been for the triumph at Khotyn, which saved our most holy religion.'⁹²

More emphatically, the 1634 edition of Virginio Parisi's pamphlet *Vera relatione della solenne entrata* (A True Account of the Solemn Entry) is dedicated to Stanisław Koniecpolski, the Grand-Hetman of the Crown who gained fame fighting Turks in the Polish–Ottoman war of 1620–21, and again in 1633–34. This same rhetoric of Polish–Lithuanian strategic importance for the papacy was taken up by secretary of the Polish–Lithuanian embassy Domenico Roncalli, who on 7 December gave an impassioned speech to the Accademia degli Umoristi. In this oration he praised Ossoliński's entry as evocative of the Commonwealth's economic prosperity and military might.⁹³ Later published as a pamphlet entitled *Panegyricus in laudem Polonorum* (A Panegyric in Praise of the Poles), the speech claims that 'Rome admired the splendour and the wealth of costume, and the most solemn and truly triumphal appearance of the procession', further claiming that 'all those whose imagination could move above the mundane splendour of rich fabrics would have seen the spirit

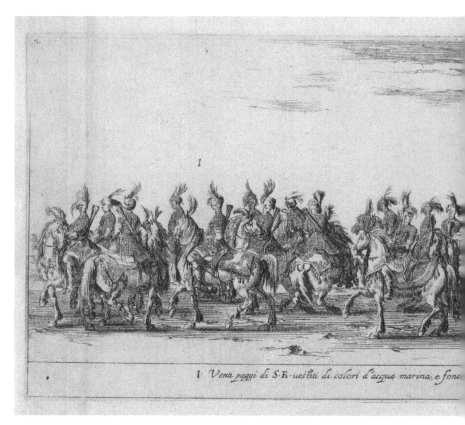

3.5 Stefano della Bella, *Entry of the Polish Ambassador into Rome*, 1633, sheet 3

of a great nation, its great valour and unbeatable might'. The valiant tone of this description suggests a comparison of Ossoliński's procession with triumphal entries. Although the battle at Khotyn, which brought fame to Ladislaus across Europe,[94] had taken place over a decade prior, Roncalli here appears to laud Ossoliński's entry as a reprise of this victory.[95] Polish–Lithuanian military power was evoked to impress the Roman political elite—and it seems that the strategy was successful. At the time that Ossoliński was visiting Rome, Poland–Lithuania was in the second year of its war with Muscovy (1632–34) as well as in military conflict with the Ottoman Empire (1633–34). The secretary of the Polish–Lithuanian embassy, auxiliary bishop of Gniezno Andrzej Gembicki (d. 1654), received unspecified subsidies for this war from the Roman Curia,[96] suggesting that military affairs were a key point of discussion in talks with papal officials.

The second instruction letter, written on 15 July 1633 in Vilnius, lists the political goals of Ossoliński's mission.[97] There were several main tasks for the

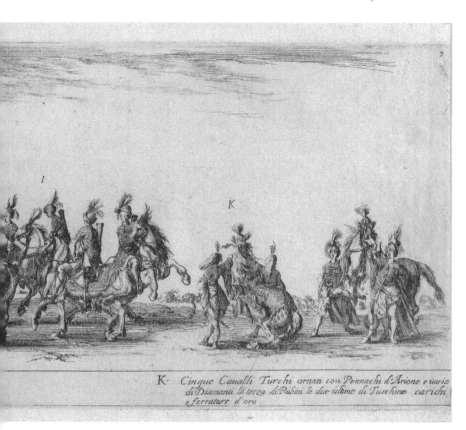

K. Cinque Caualli Turchi ornati con Pennachi d'Arione e uarie di Diamanti la terza di Rubini le due ultime di Turchine carichi e ferrature d'oro

envoy: to forbid large monastic orders from making land bequests and purchases; to support the Cracow university in its dispute against Jesuit colleges over the right to teach in the city; to secure papal subsidies for the war with Muscovy; and to acquire papal permission to establish the Order of the Knights of Immaculate Conception, a royalist endeavour aimed at fostering loyalty and allegiance to the Vasas.[98] Finally, the envoy was entrusted to obtain the pope's support for reactivating the Orthodox hierarchy in Poland–Lithuania. As Ossoliński himself stated in a report to the king, this last task was 'the most important and the most difficult in negotiation [with the Holy See]'.[99] By the act of Union of Brest (Polish: Brześć) in 1595, the Orthodox Church in the Polish–Lithuanian Commonwealth was made subject to the Holy See, thus creating the Greek (i.e., Ruthenian) Catholic Church. The union was strongly supported by Ladislaus's father, King Sigismund III, but support waned especially after Roman Catholic bishops did not allow their Greek Catholic counterparts to enter the ranks of senators. As tensions grew during the later

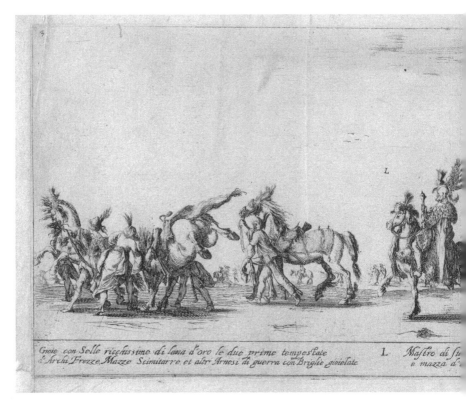

3.6 Stefano della Bella, *Entry of the Polish Ambassador into Rome*, 1633, sheet 4

reign of Sigismund, Ladislaus attempted to ease hostilities by making Eastern Orthodoxy legal again. Ossoliński's mission was to convince the Holy See that reactivating the Orthodox institutional structures in Ruthenia was crucial for political stability in Poland–Lithuania.

The danger of this request was that it risked giving the impression that Ladislaus supported the schism; Ossoliński's flamboyant spectacle in Rome was staged precisely to remove any suspicion of Poland–Lithuania's diversion from Roman Catholicism. It was to this end, therefore, that Ossoliński received such clear instructions to exploit the Commonwealth's position as the alleged 'bulwark of Christendom', hyperbolizing the threat of Turkish invasion that still loomed over Europe.[100] It is also why, in his public appearances, Ossoliński foregrounded the defeats of both the 'schismatic' Muscovy and the 'heathen' Turkey by the military might of Roman Catholic Poland–Lithuania. Papier-mâché decorations and inscriptions displayed on the façade of Palazzo Gabrielli, the ambassador's lodgings in Rome, exalted Ladislaus's victories over Lutheran Swedes, Orthodox Muscovites, and Muslim Turks and Tatars,

Who speaks for Poland? 125

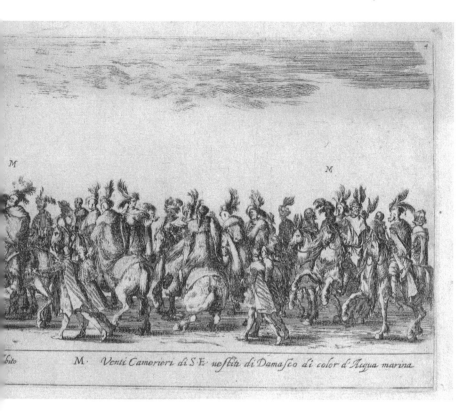

responding to potential concerns with the Commonwealth's confessional status.[101] In the previously mentioned 1635 sejm speech, Ossoliński claimed that his solemn entry to Rome on 27 November attracted 'an incredible gathering not only of Roman people but also of those from the distant Italian lands who wanted to experience the Sarmatian pomp, all of whom were well satisfied. [The entry] convinced them of [His] Majesty's future triumphs in the East and the South.'[102] Ossoliński thus maintained, before his fellow citizens, that his public performance in Rome had succeeded in reaffirming across Europe the notion of Poland–Lithuania as the rampart of Christian faith.

It is in this context that one must read the exotic figures in della Bella's prints. In the second print (Figure 3.4), we see 'thirty Archers dressed in red satin with bows in hand and rifles hanging [from their backs]' ('G').[103] These cavaliers wear Polish żupans and plumed hats; their horses are draped with carpets. The cavalcade is flanked by the 'Page of Arms [Kociszewski] wearing gold brocade dress in the Persian style' ('H').[104] He looks particularly exotic, with a long spear and imposing headgear decorated with feathers and wings

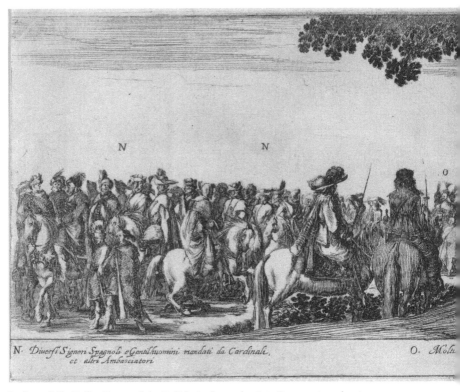

3.7 Stefano della Bella, *Entry of the Polish Ambassador into Rome*, 1633, sheet 5

attached to his Persianate tunic. The next two prints maintain the focus on exoticism by replicating the sartorial forms introduced by the first two. The third leaf (Figure 3.5) depicts 'twenty pages of the Ambassador dressed in the colour of sea water, with an orange bottom' ('I').[105] Farther down the line and continuing onto the subsequent leaf (Figure 3.6), grooms lead

> Five Turkish horses adorned with the plumes of Arion and various gems, with saddles adorned with golden tinsel, the first two studded with diamonds, the third with rubies; the last two Turkish horses are loaded with bows, arrows, maces, scimitars, and other weapons of war, with gemmed bridles and golden horseshoes ('K').[106]

This column of grooms is followed by a mounted figure: 'The Ambassador's Master Equerry in beautiful costume and holding a silver mace' ('L').[107] He is accompanied by twenty other courtiers described as 'the waitstaff of H[is] E[xcellence] dressed in damask in the colour of sea water' ('M').[108] Exoticizing language pervades della Bella's *Entrata*, but it is unlikely that the multitude of animals and garments described as Turkish or

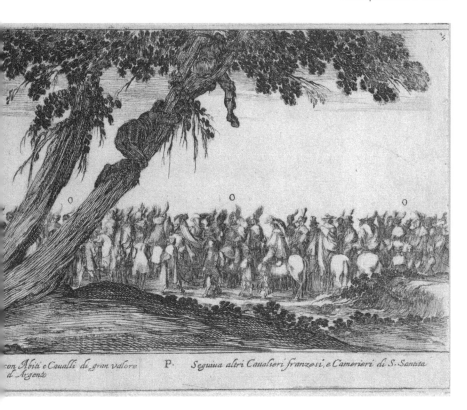

Persian were read as a sign of a cultural affinity between the Poles and these peoples. As West Asian fauna and textiles were desirable commodities in Europe, they may instead have been seen as status symbols and have signalled easy access to such luxuries in Poland owing to the kingdom's geographical location.[109]

The fifth leaf (Figure 3.7) shows 'various Spanish noblemen, the nobles sent by Cardinals, and other ambassadors' ('N').[110] On their heels are mounted Polish nobles 'with costume and horses of high value' ('O'), captivating the attention of onlookers who have climbed the tree depicted in the centre.[111] The inscription at the bottom also contains the letter 'P', designating French cavaliers and papal pages.[112] These are, however, represented in the next and final print (Figure 3.8). This last leaf, which is busier than all the others but the first, depicts 'members of the Polish nobility assisted by Roman princes and other peers of the realm' ('Q').[113] Ossoliński, referred to as 'His Excellency the Ambassador', is marked by the letter 'X'. He wears 'a cloak shimmering with gold, lined with precious pelts buckled with a gem; a beret with a jewelled feather of exquisite beauty; he rides on a steed caparisoned with an iron bridle

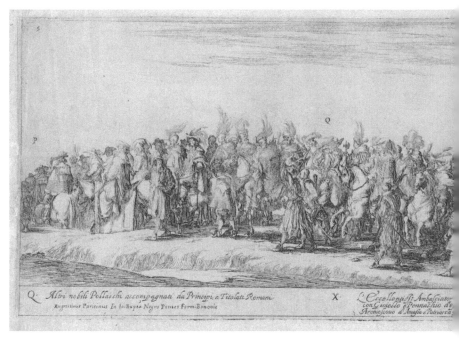

3.8 Stefano della Bella, *Entry of the Polish Ambassador into Rome*, 1633, sheet 6

and golden jewelled saddle'.[114] Like the other Polish–Lithuanian figures in della Bella's series, the ambassador projects the very image of magnificence, but also of exoticism. The entire procession concludes with Ossoliński's carriage, drawn by 'Persian horses' ('Y').[115]

The recurrent associations—in both pamphlets and images—with things Turkish and Persian highlight the status of Poland-Lithuania as a place of avid consumption of things seen as foreign. The most emphasis is placed on the Polish–Lithuanian nobles' exotic costumes and equally outlandish accessories, such as plumes of feathers and fur hats, as well as their shaven heads and moustaches. But della Bella maintains an important visual distinction between Poles on the one hand, and Armenians and Tatars on the other: the former are Europeans, the latter Orientals. Tracing the artistic process through which della Bella created his *Entrata in Roma* offers insight into this distinction. According to the artist's early modern biographer, Filippo Baldinucci (1625–96), della Bella often took a sketchbook to public festivities:

> In Florence there was no public celebration or entertainment—whether a joust, a tournament, or a horse race—that he did not attend, curious to watch the event to observe every minute detail of it, then return to his workshop in order to represent it in a drawing'.[116]

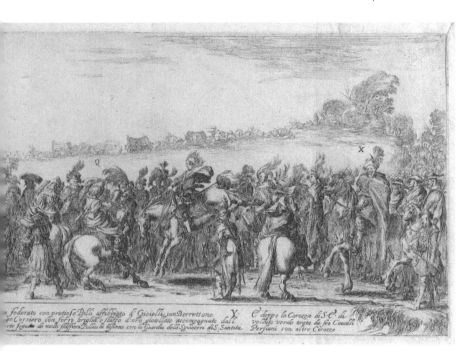

Art historians have long believed that della Bella's drawings and prints were faithful depictions of the festivities he witnessed.[117] Phyllis Dearborn Massar even claimed that the artist worked 'with his sketchbook and etching needle much the way today's magazine photographer works with his camera'.[118] More recently, however, Ulrike Ilg has challenged such claims to veracity.[119] Della Bella's drawings and prints may have some documentary value, with many participants in Ossoliński's entry, for instance, perhaps sketched from life,[120] but Ilg has shown that the artist's figures originated not only from drawings made from life but also from other artists' work, particularly images representing the more exotic aspects of the entry. Many were taken from a pattern book by Melchior Lorck (1526/27–1583), *Wolgerissene und geschnittene Figuren, in Kupfer und Holz ... für die Mahler, Bildhauer und Kunstliebenden* (Nicely Engraved and Cut Figures, in Copper and Wood ... for Painters, Sculptors and Art Lovers), which was not released during the artist's life. First published in 1619 in Hamburg, later editions were issued in 1626, 1641, and 1646; della Bella was evidently familiar with this work,[121] as there is a close correlation between some woodcuts in Lorck's volume and della Bella's version of the *Entrata* figures. A representative example is Lorck's woodcut that depicts a Turkish rider in a fantastical winged costume carrying a long spear with a gesture of panache (Figure 3.9). Large wings attached to his horse's back render the rider

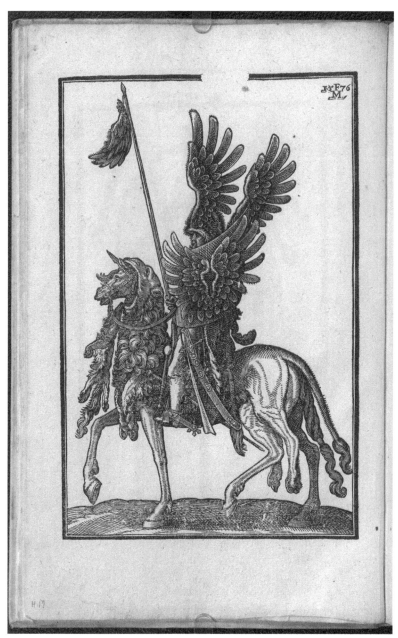

3.9 Melchior Lorck, *Turkish Horseman with Fantastical Winged Costume*, from *Wolgerissene und geschnittene Figuren zu Ross und Fuss, sampt schönen türckischen Gebäwden, und allerhand was in der Türckey zu sehen,* Hamburg: Michael Hering, 1626, fol. 19, woodcut. Copenhagen, Royal Library, Hielmst. 188 2°

even more curious to the eye.¹²² But while in della Bella's print the figure is a Pole, in Lorck's woodcut it represents a Turk.

Della Bella first copied this figure of a Turkish horseman in a drawing (Figure 3.10); only later does it reappear on the second leaf of the *Entrata*, representing Ossoliński's valet de chambre Kociszewski (Figure 3.4). The similarities among Lorck's and della Bella's versions of the soldier are too striking to ignore, and yet the figures were intended to represent entirely different ethnicities. Della Bella likely had access to pamphlets circulating around Rome in which Kociszewski is described as wearing clothing 'in Persian style', a phrase that is mirrored in the etching's lower register caption. The use of an Ottoman prop in rendering a Polish subject must therefore be seen as an attempt to convey the Persian aesthetic of Kociszewski's costume rather than as a claim about Poland's status as an Orientalized realm. A similar process of translation occurs with the figure of Turkish archer in Lorck's woodcut (Figure 3.11) and a near-identical turbaned man in della Bella's sketchbook (Figure 3.12). This same figure reappears on the first *Entrata* print, leading the camels (Figure 3.3). Indeed, the camels themselves are copied from Lorck's pattern book, and other figures are as well. The transformation of 'Turkish archer' into 'Persian' or 'Armenian' camel groom (likely impersonated by a Polish masquerader in the live entry)

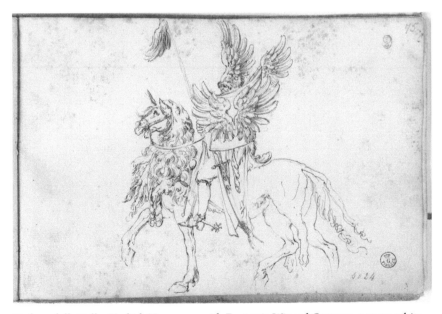

3.10 Stefano della Bella, *Turkish Horseman with Fantastic Winged Costume*, pen on white paper. Florence, Gallerie degli Uffizi, Gabineto Disegni e Stampe, inv. 6024 Santarelli, fol. 75 of the artist's sketchbook

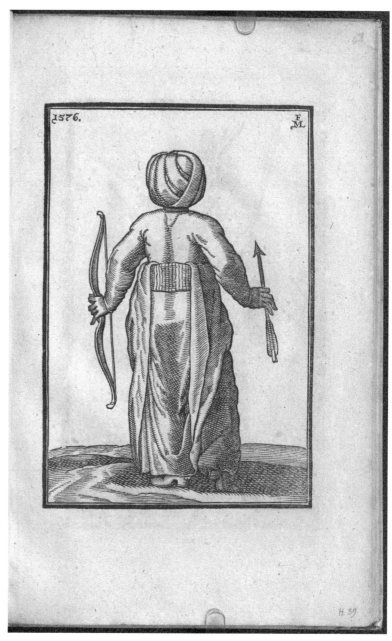

3.11 Melchior Lorck, *Turkish Archer*, from *Wolgerissene und geschnittene Figuren zu Ross und Fuss, sampt schönen türckischen Gebäwden, und allerhand was in der Türckey zu sehen*, Hamburg: Michael Hering, 1626, fol. 39, woodcut. Copenhagen, Royal Library, Hielmst. 188 2°

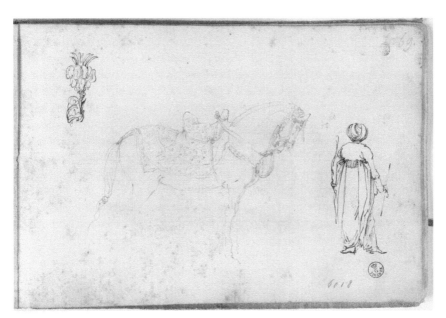

Stefano della Bella, *Studies of a Headress, Horse, and Turkish Archer*, pen and black pencil on white paper. Florence, Gallerie degli Uffizi, Gabineto Disegni e Stampe, inv. 6018 Santarelli, fol. 69 of the artist's sketchbook

3.12

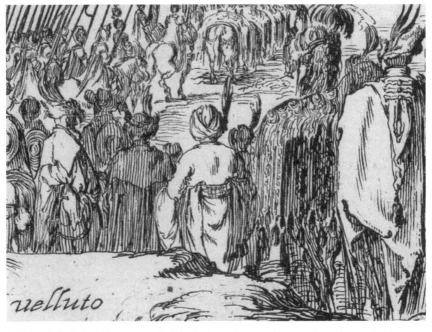

Stefano della Bella, *Entry of the Polish Ambassador into Rome*, 1633, sheet 1, detail

3.13

shows that, for della Bella, Polishness was a relational category. To render visible the Christian character of the Poles, comparative costumes and accessories must be provided to demonstrate their difference so that the viewer does not become confused. These drawings and prints are thus transcultural things that signify through divergence and dissemblance but at the same time bear witness to the entangled history of dress in Central and Eastern Europe. Lavish żupans and delias complete with kalpak hats liberally adorned with exuberant feathers signify as Polish, and thus Christian, only in context: that is, when they are set against the Muslim costume of Persians, Turks, and Tatars, and the equally exotic dress of Armenians. It is noteworthy that della Bella felt compelled to provide this contrast for the benefit of the viewer, suggesting that his perception of early modern Polish costume (as a Florentine working in Rome) was influenced by the media campaign by Ossoliński and his accomplices regarding how Polish costume should be read.

Being heard

As in della Bella's etchings, many early modern European descriptions of Poland refrain from embracing a facile exoticism of this faraway kingdom. Gaspard de Tende (1618–97) was one of the foreign visitors who lived there for a long period, arriving in 1646 with Queen Marie-Louise and remaining on a permanent basis until 1668. Returning to the Commonwealth in 1674, he decided during the next decade to collate his observations on Poland–Lithuania in a volume entitled *Relation historique de la Pologne* (Paris 1697). The book proved so influential that an English translation, *An Account of Poland* (London), followed in 1698.[123] De Tende claims his account to have been the first in many years to be founded in actual first-hand experience, rather than on a few widely available compilations, as were previous accounts of Poland–Lithuania.[124] As in other literary works of this kind, allusions to the Poles' physical attributes reverberate strongly in de Tende's volume. While his portrayal of the country is largely sympathetic, he singles out the Polish proclivity for splendour, based on their asserted sartorial extravagance:

> The *Polanders* are generally very fond of Magnificent Habits after their Mode: Most of them wear very handsom Boots, the heels of which are shod with Oron, a Furr'd Cap, and Vests that reach to their Mid-leg, and are Furred in Cold Weather. The Great Lords have them Furr'd with Sable, which is brought them from *Muscovy*, and the rest with the Skins of *Tygres, Leopards, Panthers*, &c. Some of the Fine Furs cost above 1000 Crowns, but they are only worn at *Diets*, and are kept from Father to Son.[125]

In this recital of Poles' fondness for leather and fur, the last sentence appears almost as mitigation. Although Poles do indulge in expensive clothing, he

writes, they do so only on festive occasions at sessions of sejm (referred to by de Tende as diets), and nobles are frugal enough to bequeath such garments to future generations—this disassociates Poles with proverbial Oriental excess.

While noting the strangeness of Polish–Lithuanian physical appearance and manners, de Tende does not make explicit comparisons with the Orient:

> The *Polanders* cut their Hair above their Ears, and Shave their Faces, leaving only one large Whisker. They walk gravely with a Pole-ax in their hand, and a Sword by their side, which they never lay aside but when they go to Bed; for they wear it when they go to Confession, and when they receive the Sacrament.[126]

Despite the idiosyncrasies of the Polish–Lithuanian noble lifestyle, de Tende emphasizes their Christian devotion and civility. He even mentions the vogue for French fashion among some noblemen—and a vast majority of noblewomen—thus minimizing the difference between the French and the Poles. Last but not least, the Polish political system, as elucidated by de Tende, remains vaguely in line with the values of pre-imperial ancient Rome: Poland is a commonwealth comprising three political orders—the king, the senate, and the sejm deputies—that could be equated with the ancient institutions of the consuls, the Roman senate, and the assemblies of the Roman Republic.[127] This constitution goes back generations, and so does the country's status as a firewall against enemies:

> Though *Poland* is not very Remote from us, yet one may say, it is almost unknown, few Persons going thither to Travel. However, it deserves our Curiosity, it being one of the most Ancient States of the World, the only one which has Preserved and Maintain'd the Right to Electing their Monarchs, and indeed the only one that was never Conquer'd. The Original of the *Poles*, as well as other Nations, is very uncertain and Fabulous; but the *Sarmatians* are so Ancient, that there are still some Monuments at this day, that *Jupiter Belus* [?], one of the *Assyrian* Monarchs, made War upon them, though unfortunately.[128]

The Sarmatians had allegedly never been subdued by a foreign power, as neither Greeks nor Persians, nor even Romans, were able to conquer this warlike 'nation'.[129] De Tende's Poland is a frontier country, a bulwark of liberty, and a rampart of Christendom. All these conceits, though not unique to Poland, were common rhetorical tropes used by Polish lampoonists, pamphleteers, and publicists (allies and detractors of the court alike), who depicted Poland as a realm bearing the main burden of defending Europe against the Ottomans.[130] Many of these works were translated into other languages, especially Latin, making them generally available to a readership throughout Europe.[131] De Tende's

notion of Poland was thus to a large extent co-shaped by Polish self-perceptions, which—not incidentally—also feature in diplomatic representations. In this respect, when Polish ambassadors paraded in their country's costume, they were performing the spectacle of Poland's military strength.

And this brings us to the chapter's main claim: Poles were active participants in the creation and dissemination of their country's image abroad. Polish costume, so widely discussed by commentators such as Madame de Motteville, might have drawn analogies with the Ottoman Empire, but the intention of the designers of these public performances was not to self-Orientalize but rather to self-aggrandize.[132] Using the classical template of the Roman triumph, which even French and Italian critics point to in their descriptions, diplomats like Opaliński and Ossoliński strategically weaponized the notion of Poland as a military borderland to present themselves (and, above all, their monarch) as successful Christian warriors against the Turks. While Polish costume triggered feelings of ambivalence—sometimes seen as the spoils of war, at other times too much like that of the Turks—even such malcontents as Motteville refrained from describing it along the lines of Asiatic decadence or vanity—the usual array of Orientalist stereotyping. As we have seen, the line between Poles and Ottomans is always maintained in visual and textual descriptions of the ambassadorial spectacle, even if it meant including representatives of other ethnicities to make Poles appear more European.

Perhaps seeming exotic from our twenty-first-century perspective, entries of Polish ambassadors to early modern European capitals did not trigger descriptions that can be recognized as 'Orientalist'—that is as dominating, restructuring, or claiming authority over Poland. As Polish historian Jan Kieniewicz has usefully observed, there is a difference between Orientalism (*orientalizm*) and what he calls 'Orientalness' (*orientalność*). While the former term denotes purposeful study of the 'East', often to sustain military, economic, or political advantage, the latter is a serendipitous outcome of Poland's cultural entanglements with the Ottoman Empire, manifested in, among other things, the Ottomanizing vocabulary, clothing, and weaponry of the Polish nobility.[133] Poland's 'Orientalness' was thus not 'a derivative and imitative phenomenon', as many have suggested,[134] but rather a series of cultural negotiations through interaction that led to often surprising cultural forms that nonetheless felt familiar to Poles.[135] Early modern Polish culture and its European perceptions do not fit squarely, as a result, into Wolff's demi-Orientalism—devised to understand the mechanisms of power and knowledge production by and for Western Europe in the modern era—because before the collapse of the Commonwealth in the late eighteenth century, Poles were powerful political actors, active contributors to European knowledge, and resourceful consumers and creators of culture. As an increasing number of art historians have demonstrated, to describe entanglements between early modern Latin Europe

and the Ottoman Empire as encounters between 'Occident' and 'Orient' misses the mark by failing to understand the commensurability and flexibility of European societies.[136] Poland is a case in point, with its rich history of cultural complexity, where exotic often became local and foreign turned native. Unfit subject to art-historical 'Westsplaining'—the tendency to ascribe everything that happens east of Germany to Western agency[137]—early modern Poland was not an empty vessel, waiting to be filled with meaning and intention by Western European players. As this chapter has contended, early modern Poles could speak for themselves. And, it seems, they were often heard.

Notes

1. 'Nie chciałem ojczystego odmieniać stroju.' Quoted in Kubala, *Jerzy Ossoliński*, 482.
2. Wolff, *Inventing Eastern Europe*, 7.
3. Motteville, *Memoirs*, 1: 260–61. Françoise de Motteville's memoirs were first published in French as *Mémoires pour servir à l'histoire d'Anne d'Autriche* in 1722. For the French original, see Françoise Bertaut de Motteville, *Mémoires*, vol. 1 (Paris, 1851), 104.
4. This was preceded by the royal envoy, Pomeranian palatine Gerard Denhoff who arrived in Paris in August 1645 to sign the nuptial agreement between the king and the princess. As per the convention, Denhoff made an official entry into town. Chrościcki, *Sztuka i polityka*, 131; Kazimierz Waliszewski, *Polsko-francuzkie stosunki w XVII wieku 1644–1667: Opowiadania i źródła historyczne ze zbiorów archiwalnych francuzkich publicznych i prywatnych* (Cracow: Drukarnia Uniwersytetu Jagiellońskiego, 1889), 203; Karolina Targosz, *Uczony dwór Ludwiki Marii Gonzagi, 1646–1667: Z dziejów polsko-francuskich stosunków naukowych* (Wrocław: Zakład Narodowy im. Ossolińskich, 1975). For the transcript of marriage contract, see 'Le contract de marriage du Roy et la Reine de Pologne', *Gazette de France*, no. 145 (1645): 1041–48; for the detailed description of the marriage ceremony that took place on 5 November in the Louvre's royal chapel, see *Gazette de France*, no. 146 (1645): 1049–60.
5. Motteville, *Memoirs*, 1: 262–63.
6. For one, early modern Polish inventories are full of references to underwear. See Turnau, *Ubiór narodowy w dawnej Rzeczypospolitej*, 14–15.
7. Gédéon Tallemant des Réaux, *Les historiettes*, vol. 3 (Paris, 1862), 16–17.
8. See Jasienski, 'A Savage Magnificence'.
9. Said, *Orientalism*.
10. Maciej Miechowita, *Tractatus de duabus Sarmatiis Asiana et Europeana et de contentis in eis* (Cracow, 1517); Marcin Kromer, *De origine et rebus gestis polonorum libri XXX* (Basel, 1555); Alessandro Guagnini, *Sarmatiae Europae descriptio: quae Regnum Poloniae, Lituaniam, Samogitiam, Russiam, Massoviam, Prussiam, Pomeraniam, Livoniam et Moschoviae, Tartariaeqve partem complectitur* (Cracow, 1578); *Respublica, sive Status regni Poloniae, Lituaniae, Prussiae, Livoniae, etc. diversorum*

autorum (Leiden, 1627); Charles Ogier, *Ephemerides: sive, Iter Danicvm, Svecicvm, Polonicvm, cum esset in comitatu illustriss.* (Paris, 1656); Guillaume Le Vasseur de Beauplan, *Description de l'Ukraine* (Rouen, 1660).

11 Simon Lewis, 'East Is East? Polish Orientalisms in the Early Nineteenth Century', *Central Europe* 19, no. 2 (2021): 135–52.

12 Łoziński, *Patrycjat i mieszczaństwo lwowskie w XVI i XVII wieku*; Mańkowski, 'Influence of Islamic Art in Poland'; Mańkowski, *Genealogia sarmatyzmu*.

13 Łoziński, *Patrycjat i mieszczaństwo lwowskie w XVI i XVII wieku*, 196.

14 Mańkowski, 'Influence of Islamic Art in Poland'.

15 Chrzanowski, 'Orient i orientalizm w kulturze staropolskiej', 56; Mrozowski, 'Orientalizacja stroju szlacheckiego', 260; Żygulski Jr., 'The Impact of the Orient on the Culture of Old Poland'.

16 Said, *Orientalism*, 1–28.

17 Wolff, *Inventing Eastern Europe*; Todorova, *Imagining the Balkans*; Murawska-Muthesius, *Imaging and Mapping Eastern Europe*.

18 Wolff, *Inventing Eastern Europe*, 6–7.

19 Csaba Dupcsik, 'Postcolonial Studies and the Inventing of Eastern Europe', *East Central Europe* 26, no. 1 (1999): 1–14; Ezequiel Adamovsky, 'Euro-Orientalism and the Making of the Concept of Eastern Europe in France, 1810–1880', *The Journal of Modern History* 77, no. 3 (2005): 591–628; Robert Born, 'Observations on the Pictorial Strategies of the Orientalizing Paintings from East-Central Europe', in *Central Europe and the Non-European World in the Long 19th Century*, ed. Markéta Křížová and Jitka Malečková (Berlin: Frank & Timme, 2022), 33–64.

20 'Merveilles exposées aux yeux de toute le monde', in *Gazette de France*, no. 141 (1645): 1001. For the whole relation, see pp. 1001–16.

21 'Tout ce quel'on raconte de l'ancienne splendeur des Romains, & de celle d'aujourh'huy des Perses & des autres peuples Orientaux, a paru en abregé dans sa superbe entrée des Ambassadeurs extraordinaires de Pologne, venus pour faire les cérémonies du marriage de leur Roy avec la Princesse Louïse Marie de Gonzague: qui nous ont fait confesser, que soit en la richesse, soit en la naifveté des couleurs, soit en l'avantage que tirent de la forme de leurs habits les nations long-vestues; ce siecle n'a rien veu plus digne d'admiration & de l'applaudissement que leur a donné cette grande & populeuse Ville.' *Gazette de France*, no. 141 (1645): 1001–2.

22 *Wjazd spaniały posłów polskich do Paryża* (Warsaw: Piotr Elert, 1645).

23 Andrzej Kanon, *Expeditio legatorum in Gallias, ad desponsandam deducendamque Ludovicam Mariam Gonzagam Cliviam, Mantuae et Niversi principem, Vladislao IV. Poloniae et Sueciae regi invictissimo, transacta per senatorii ordinis viros* (Cracow: Franciszek Cezary, 1646); *Ingres abo wiazd Krolowey Jey Mości do Gdańska 11 Februarii* (Cracow: Walerian Piątkowski, 1646).

24 In the mixed-form system of government (*forma mixta*) adopted in the Commonwealth, monarchic, aristocratic and popular elements shared sovereignty. See Karin Friedrich, 'Poland–Lithuania', in *European Political Thought 1450–1700: Religion, Law and Philosophy*, ed. Howell A. Lloyd, Glenn Burgess, and Simon Hodson (New Haven: Yale University Press, 2007), 208–43.

25 *Gazette de France*, no. 141 (1645): 1006.
26 Mieczysław Paszkiewicz, 'Tematyka polska w twórczości Stefano della Belli: Część II', *Rocznik Historii Sztuki* 15 (1985): 57–58.
27 Mieczysław Paszkiewicz, *Stefano della Bella, wjazd wspaniały posłów polskich do Paryża A.D. 1645: Opracował, wstepem i komentarzami opatrzył Mieczysław Paszkiewicz* (London: Nakładem Zrzeszenia Studentów i Absolwentów Polskich na Uchodźctwie, 1956).
28 The commission of etchings from the drawings never came to fruition, however. It is uncertain why the project fell through, although Polish art historian Juliusz Chrościcki speculates that it may have been due to the embassy's financial troubles, which were mentioned several times in Opaliński's letters to his brother Łukasz. See Chrościcki, *Sztuka i polityka*, 133; Krzysztof Opaliński, *Listy Krzysztofa Opalińskiego do brata Łukasza, 1641-1653*, ed. Roman Pollak (Wrocław: Zakład Narodowy im. Ossolińskich, 1957). Nonetheless, fourteen sketches in pencil and pen have survived in the British Museum, with further drawings kept in the Louvre. See Alessandro Baudi di Vesme, *Le peintre-graveur italien: Ouvrage faisant suite au Peintre-graveur de Bartsch* (Milan: Ulrico Hoepli, 1906), cat. no. 158, 274, 276. Sketches in pencil and pen of several figures, are kept at the Louvre, see Françoise Viatte, *Dessins de Stefano della Bella 1610-1664* (Paris: Éditions des Musées Nationaux, 1974), no. cat. 198–203.
29 Ewa Kociszewska, 'War and Seduction in Cybele's Garden: Contextualizing the Ballet Des Polonais', *Renaissance Quarterly* 65, no. 3 (2012): 809–63.
30 Ochmann-Staniszewska, *Dynastia Wazów w Polsce*, 191. See also *Gazette de France*, no. 107 (August 1645): 743.
31 Francesca De Caprio Motta, *Maria Luisa Gonzaga Nevers: Cerimonie e propaganda nel viaggio verso il trono di Polonia, 1645–1646* (Viterbo: Sette città, 2018), 95–99.
32 Robert I. Frost, 'The Ethiopian and the Elephant? Queen Louise Marie Gonzaga and Queenship in an Elective Monarchy, 1645-1667', *Slavonic and East European Review* 91, no. 4 (2013): 790; Marie-Louise Plourin, *Marie de Gonzague: Une princesse française, reine de Pologne* (Paris: La Renaissance du livre, 1946), 69; Albrycht Stanisław Radziwiłł, *Memoriale rerum gestarum in Polonia, 1632-1656*, ed. Adam Przyboś and Roman Żelewski, vol. 3 (Wrocław: Zakład Narodowy im. Ossolińskich, 1972), 243.
33 'Un grand roy, tant revere d'une des plus viallantes nations du Nord, qui sert d'un ferme boullevart à la Chrestienté contre les infidelles.' *Gazette de France*, no. 143 (1 October 1645): 1055.
34 Jacek Żukowski, *Żądza chwały: Władysław IV Waza w ikonografii performatywnej* (Warsaw: Muzeum Pałacu Króla Jana III w Wilanowie, 2018), 95–99.
35 'Et en plusieurs endroits il y est parlé des Sarmates, Nation belliqueuse, vestus de longues robes, de qui le Trône que possede aujourd'huy Vostre Majesté, en la compagnie de son invincible Roy, sera toujours redoutable á la Porte des Othomans.' In Michel de Marolles, 'À La Reine de Pologne et de Suede', in *Les oeuvres de Lucain: contenant l'histoire des guerres civiles entre César et Pompée* (Paris, 1647), n.p.
36 'La Pologne n'ayant point voulu entendre à aucune des alliances que la Maison d'Autriche lui avoit offertes, pour ebrasser celle de la France a fait voir une partie de ca magnificence en celle de ses Ambassadeurs, qui lui emménent une nouvelle

Reine, impatiemment attenduë de son Espoux, & pour les nopces de laquelle toute la frontiére fait des préparatifs dignes de ce puissant Estat: lequel a cependant donné la chasse à une nombreuse armée de Tartares qui vennoyent troubler la feste.' *Recueil des Gazettes Nouvelles ordinaires et extraordinaires* (1 January 1646): 4.

37 Srodecki, *Antemurale Christianitatis*.
38 See Konstanty Grzybowski's introduction in Sebastian Petrycy, *Przydatki do etyki Arystotelesowej*, ed. Wiktor Wąsik and Kontanty Grzybowski (Warsaw: PWN, 1956), xx.
39 *Gazette de France*, no. 146 (1645): 1049–60.
40 On diplomatic ceremonial, see Hennings, *Russia and Courtly Europe*, 5.
41 Dominika Walawender-Musz, *Entrata Księcia Radziwiłła do Rzymu czyli triumf po polsku* (Warsaw: Muzeum Pałac w Wilanowie, 2009), 17–29.
42 For the claims to centrality of Rome and Paris, see P. J. A. N. Rietbergen, *Power and Religion in Baroque Rome: Barberini Cultural Policies* (Leiden: Brill, 2006), 64; Karen Newman, *Cultural Capitals: Early Modern London and Paris* (Princeton: Princeton University Press, 2007), 11–33.
43 Motteville, *Memoirs*, 1: 264.
44 For the claims to centrality of Paris, see Newman, *Cultural Capitals*, 11–33.
45 Motteville, *Memoirs*, 1: 261.
46 Motteville, *Memoirs*, 1: 261–62.
47 Motteville, *Memoirs*, 1: 266.
48 Motteville, *Memoirs*, 1: 464.
49 Epistre diversifiée à Monsieur Desnoyers, secretaire des commandemens de la serenissime reine de Pologne, in Marc-Antoine Girard de Saint-Amant, *Oeuvres complètes de Saint-Amant*, vol. 1 (Paris: P. Jannet, 1855), 430. 'Si vers le Nord ma fortune est poussée, / Si la Vistule à mes yeux se fait voir, / Comme le ciel m'en a donné l'espoir, / De me vestir, en noble et fier Sarmate, / D'un beau velours, dont la couleur esclate, / Qui, grave et long, sur un poil precieux, / Rende mon port superbe et gracieux; / D'armer mon flanc d'un courbe et riche sabre, / De m'agrandir sur un turc qui se cabre, / De transformer mon feutre en un bonnet / Qui tienne chaud mon crane razé net, / De suivre en tout la polonoise mode, / Jusqu' à la botte au marcher incommode / Jusqu'aux festins où tu dis qu'on boit tant, / Et dont l'excès m'estonne en me flatant' / … Et pour [la reine] seule au monde je nasquy, / Je sois nommé le gros Saint-Amantsky.'
50 Piotr Piotrowski, 'East European Art Peripheries Facing Post-Colonial Theory', *nonsite.org*, 12, 2014, https://nonsite.org/article/east-european-art-peripheries-facing-post-colonial-theory. See also Beáta Hock, 'Introduction', in Beáta Hock and Anu Allas (eds), *Globalizing East European Art Histories: Past and Present* (New York: Routledge, 2018), 3–4.
51 'Il en a été fait trop de relations pour que je m'amuse au detail d'une description: toute ce que j'en dirai est que la manière de leurs habits, toute différente de la nôtre, nous fit regarder cette cérémonie comme une mascarade fort mágnifique.' Anne-Marie-Louise d'Orléans de Montpensier, *Mémoires de Mlle de Montpensier: Collationnés sur le manuscrit autographe*, vol. 1 (Paris: Charpentier, 1858), 131.

52 Ellen R. Welch, 'The Specter of the Turk in Early Modern French Court Entertainments', *L'Esprit Créateur* 53, no. 4 (2013): 84–97.
53 'Il [ce déguissement] ne me fait point de mal; mais il me fait passer pour vrai Carême-prenant. Je n'oserais montrer mon nez dans les rues: tout le monde s'arrête pour me regarder et les enfants me suivent en criant après moi, comme ils crient après les masques durant le carnaval.' Quoted in Mieczysław Brahmer, 'Z dziejów kostjumu polskiego wśród obcych', in *Księga pamiątkowa ku czci Leona Pinińskiego*, vol. 1 (Lviv: Gubrynowicz, 1936), 117. According to Randle Cotgrave, *A Dictionarie of the French and English Tongues* (London, 1611), 'Carême-prenant' translates as 'Shrove Tuesday'. www.pbm.com/~lindahl/cotgrave/search/162l.html
54 On masquerade and identity, see Efrat Tseëlon, 'Introduction: Masquerade and Identities', in Efrat Tseëlon (ed.), *Masquerade and Identities: Essays on Gender, Sexuality and Marginality*, London, 2001, 3.
55 On performativity, see Jones, *In Between Subjects*, 34–82.
56 Swan, 'Lost in Translation', 116.
57 Katrin Sieg, 'Ethno-Maskerade: Identitätsstrategien zwischen Multikultur und Nationalismus im deutschen Theater', *Frauen in der Literaturwissenschaft* 49 (1996): 20. See also Kader Konuk, 'Ethnomasquerade in Ottoman-European Encounters: Reenacting Lady Mary Wortley Montagu', *Criticism* 46, no. 3 (2004): 393–414.
58 'Plusieurs Gentils-hommes Polonois demeurans en cette ville, & vestus à la françoise, venoyent en suite au meilleur ordre qu'il leur fut possible, pour rendre hôneur à cette ambassade.' *Gazette de France*, no. 141 (1645): 1008
59 The previous Polish–Lithuanian embassy of obedience, led by Paweł Wołucki, Bishop of Płock, made a formal entry into Rome on 28 January 1613 to pledge obedience to Paul V on behalf of Sigismund III. Although the new Pope was elected on 16 May 1605, Sigismund was at the time engaged in conflict with Sweden, and a civil war at home. Subsequently, the war with Muscovy and the empty treasure prevented the king from sending an envoy to Rome. See Hanna Osiecka-Samsonowicz, *Polskie uroczystości w barokowym Rzymie, 1587–1696* (Warsaw: Instytut Sztuki PAN, 2012), 72–77.
60 Tomasz Makowski, *Poselstwo Jerzego Ossolińskiego do Rzymu w roku 1633* (Warsaw: Biblioteka Narodowa, 1996), 36.
61 Osiecka-Samsonowicz, *Polskie uroczystości w barokowym Rzymie*, 77–100; Makowski, *Poselstwo Jerzego Ossolińskiego do Rzymu w roku 1633*, 8–9.
62 In Polish: *Sławny wiazd do Rzymu, Jasnie Wielmoznego Pana Ie[g]o M.P. Ierzego Ossolinskiego wielkiego posla polskiego, z włoskiego na polskie przetlumaczony, de data 3. Decemb. 1633* (n.p., 1633). There is also a manuscript in the National Library in Warsaw dated 2 December 1633, BN BOZ, 855, pp. 261r–262r, *Opis Wjazdu Je[go] M[oś]ci Pana Ossolińskiego Posła Polskiego do Rzymu de data 2 Decembris 1633*. In Italian: Virginio Parisi, *Relatione della solenne entrata dell'Illustriss. ... Sig. G. Ossolinschi ... Primo Gentilhuomo di Camera del Sereniss. ... Uladislas Re di Polonia, e Suetia ... e Suo Ambasciadore Straordtnario ... alla Santita di Nostro Signore Urbano VIII* (Rome: Francesco Cavalli, 1633); Virginio Parisi, *Vera relatione*

della solenne entrata dell'illustriss. & eccellentiss. sig. Giorgio Ossolinschi: Sire d; Ossolin, conte de Thencin ... promo gentilhuomo di camera del Sereniss. e potentiss. Vladislao IV ... e suo ambasciadore straordinario d'ubedienza alla Stantità di Nostro Signor PP. Urbano VIII, et insieme ambasciadore straordinario alla Sereniss. Republica di Venetia (Rome: Francesco Cavalli, 1634); Anon., *Solennità dell'entrata in Roma e cavalcate dell'eccellentissimo Signor Giorgio Ossolinsghi Conte di Thenezun* (Rome: Paolo Masotti, 1633).

63 Parisi, *Relatione della solenne entrata*, A3.
64 'De Rome, le 28. Novembre 1633', *Gazette de France*, no. 116 (1633): 505; Parisi, *Relatione della solenne entrata*, 11.
65 'De Rome, le 29 Novembre 1633', *Gazette de France*, no. 119 (1633): 513.
66 Charlotte Colding Smith, *Images of Islam, 1453–1600: Turks in Germany and Central Europe* (London: Pickering & Chatto, 2014), 126.
67 Sławny wjazd, 1–2; Solennità dell'entrata, 4r; Relatione della solenne entrata, 3v; Vera relatione, 3v–4r.
68 Parisi, *Relatione della solenne entrata*, A3v.
69 Makowski, *Poselstwo Jerzego Ossolińskiego do Rzymu w roku 1633*, 35. Sławny wjazd, 2–3; Solennità dell'entrata, 4r; Relatione della solenne entrata, 3v; Vera relatione, 4v–r.
70 Sławny wjazd, 5; Solennità dell'entrata, 5r; Relatione della solenne entrata, 5r; Vera relatione, 5r–4v.
71 Solennità dell'entrata, 5r–v; Relatione della solenne entrata, 6r.
72 Solennità dell'entrata, 5v; Relatione della solenne entrata, 6r; Vera relatione, 6r–v.
73 Osiecka-Samsonowicz, *Polskie uroczystości w barokowym Rzymie*, 80.
74 'Pamiętnika nie masz, by widział taka pompę', in *Sławny wjazd do Rzymu*, A2v.
75 The event was widely commented by the Polish–Lithuanian writers of the day. See, for example, Samuel Twardowski, *Władysław IV, król polski i szwedzki*, ed. Roman Krzywy (Warsaw: Instytut Badań Literackich PAN, 2012), 225–34.
76 'Nie chciałem ojczystego odmieniać stroju'. Relacja [...] legata, quoted in Kubala, *Jerzy Ossoliński*, 482.
77 *Relacya poselstwa rzymskiego którą odprawował [...] Jerzy z Osolina Ossoliński*, 1634, Wrocław: Zakład Narodowy im. Ossolińskich, 4228/II.
78 Hennings, *Russia and Courtly Europe*, 5.
79 Descriptions of Ossoliński's appearances in Rome in the *Gazette de France*, which were certainly not redacted by the ambassador, maintain the laudatory tone of the pamphlets. See *Gazette de France*, no. 116 (1633): 505; *Gazette de France*, no. 119 (1633): 513; *Gazette de France*, no. 4 (1634): 13.
80 The etching is dedicated to della Bella's patron in Florence, Don Lorenzo de'Medici. We know this from the dedication inscribed on the pillar adorned with the arms of de'Medici family. The inscription reads: 'AL. Ser.mo Principe | D.Lorenzo de Medici | Non debbo aggra= | dir vn picciol dono | con molte parole; | percio semplicem.te | suplico V.A. ad ag= | gradire il testimo= | nio della mia obli= | gatissima diuotione | espresso in questa po= | nera carta et humilm.ti | mele inclino | D.V.A.Ser.ma | Humiliss. et oblig.mo Ser.re | Stefano della Bella | DD'. It is not clear, however, whether the *Entrata* was a commissioned piece, or whether it was created

for an open market. Ossoliński's patronage is unlikely, given that many Polish–Lithuanian names are misspelled. See Osiecka-Samsonowicz, *Polskie uroczystości w barokowym Rzymie*, 92–93.

81 These four versions, or states, were published by different shops. The first lacks the address of publisher; the second is inscribed 'Agustinus Parisinus Et Io: Bapta Negro Pontes Form: Bononie'; the third, 'Giovanni Battista Negroponte'; the fourth, 'Gio. Jacomo de Roßi le stampa in Roma alla Pace'. See Mieczysław Paszkiewicz, 'Tematyka polska w twórczości Stefano della Belli: Część I', *Rocznik Historii Sztuki* 14 (1984): 206–7; Jolanta Talbierska, *Stefano Della Bella, 1610–1664: Akwaforty ze zbiorów Gabinetu Rycin Biblioteki Uniwersyteckiej w Warszawie* (Warsaw: Neriton, 2001), 40–42; Chrościcki, *Sztuka i polityka*, 128.

82 A. 2. Corrieri Pollacchi vestiti di raso con Giubbe di uelluto.

83 B. 22. Muli guarniti a uarie foggie.

84 C. Caualleggieri della Guardia di S. Santita.

85 D. Mule de Signori Cardinali.

86 'E. Dieci Camelli con superbissime valdrappe di velluto rosso ricamate con ferri testiere e tortori d'Argento guidati da Persiam e Armeni con diuerse foggie.' The Persians and Armenians of della Bella's *Entrata in Roma* are identified as 'Croats' by the *Gazette de France*, see 'De Rome, le 29 Novembre', *Gazette de France*, no. 119 (1633): 513. The camels were probably taken back to Poland; French traveller Charles Ogier reports on seeing camels grazing near Marienburg, Royal Prussia, on 8 August 1635. See Gintel, *Cudzoziemcy o Polsce*, 1: 228.

87 F. Quattro trobetti con giubbe di velluto uerde.

88 Paul Srodecki, 'Validissima semper Christianitatis propugnacula: Zur Entstehung der Bollwerksrhetorik in Polen und Ungarn im Spätmittelalter und in der Frühen Neuzeit', in *Sarmatismus versus Orientalismus in Mitteleuropa: Akten der internationalen wissenschaftlichen Konferenz in Zamość vom 9. bis zum 12. Dez. 2010*, ed. Magdalena Długosz and Piotr O. Scholz (Berlin: Frank & Timme, 2012), 131–68.

89 Osiecka-Samsonowicz, *Polskie uroczystości w barokowym Rzymie*, 17–19.

90 'Nec ornatu aliquid molle ac insolens, sed splendorem Sarmaticum et militarem praeferat, virtutis enim et civilis prudentiae.' In *Instructio Illmo Georgio comiti de Tenczyn Ossoliński ... cum publica oboedientia Legato - data Grodnae die men. Juni 1633*, Lviv, Vasyl Stefanik Scientific Library of Ukraine, rkpis Ossol. Nr 225, fol. 21, cited in Kubala, *Jerzy Ossoliński*, 472. The instruction was included in the Metrica Regni Poloniae, LL 32, fol. 65–68; from there a copy in Teki Naruszewicza, Cracow, Czartoryski Library, m/s 210, fol. 227–38.

91 Makowski, *Poselstwo Jerzego Ossolińskiego do Rzymu w roku 1633*, 8.

92 'Italico nomini cura ac invidia inustam, Chocimensi victoria detersit et sanctissimam hanc religionis arcem si non ab exitio, a periculo certe liberavit.' In *Instructio Illmo Georgio comiti de Tenczyn Ossoliński ... cum publica oboedientia Legato - data Grodnae die men. Juni 1633*, Lviv, Vasyl Stefanik Scientific Library of Ukraine, rkpis Ossol. Nr 225, fol. 21, cited in Kubala, *Jerzy Ossoliński*, 472.

93 Dominicus Roncallius, *Dominici Roncallii, ... Panegyris in laudem Polonorum... habita Romae... Cui adjectae sunt aliae insignes scriptiones doctissimorum accademicorum...* (Romae: apud F. Caballum, 1633).

94 See, for example, the Latin panegyric by the Paduan humanist Antonio Querenghi, published in 1625 in Rome. In Antonio Querenghi, 'Carmen ad Urbem Romam in adventu Serenissimi Vladislai Poloniae principis', trans. Grzegorz Franczak, *Terminus* 15, no. 2 (2013): 295–305.
95 'Vladislaus ... Turcarum terror'. In Roncallius, *Panegyris in laudem Polonorum*, 4, 6.
96 Letter from Ladislaus IV to Andrzej Gembicki, Lviv, 19 October 1643. 'Wdzięczniśmy za pracę W. T., którąś czynił skutecznie w otrzymaniu subsydiow na woynę turecką'. In Ambroży Grabowski, *Władysława IV. Krola Polskiego W. Xiążęcia Lit. etc. listy i inne pisma urzędowe, które do znakomitych w kraju mężów, z kancellaryi król. wychodziły; w których tak sprawy państwa publiczne jako i prywatne królewskie, są traktowane. Materyał dziejowy* (Cracow: Stanisław Gieszkowski, 1845), 16.
97 *Instructio ex cuius praescripto Illustris Georgius Comes de Tęczyn Ossoliński ... Datae Vilnae die XV. Julii 1633*, Metrica Regni Poloniae, LL 32, pp. 68–73. From there a copy in Teki Naruszewicza, Czartoryski Library m/s 210, pp. 227–238. Transcribed in Kubala, *Jerzy Ossoliński*, 474–77.
98 While this semi-political institution aimed at creating a powerful aristocratic coterie around the king, it ended up alienating the nobility against the monarch. See Tomasz Makowski, 'Z Dziejów stosunków państwa i kościoła: Polskie poselstwa obediencyjne W XVI i XVII wieku', *Teologia Polityczna* 1 (2003/4): 208–10.
99 'Zostawał punkt najważniejszy i najtrudniejszy w konsyderacji o uspokojeniu ludzi rozróżnionych w religii greckiej'. Relacja JMP. Jerzego Ossolińskiego, Cracow, Akademia Umiejętności, rkps nr 442, transcribed in Kubala, *Jerzy Ossoliński*, 485.
100 Peter Burke, 'Did Europe Exist Before 1700?', *History of European Ideas* 1 (1980): 24.
101 Anon., *Solennità dell'entrata*, A3; *Sławny wjazd*, 4–5.
102 'Wjazd do Rzymu ... 27 *novembris* odprawił się był takim, jaki druk opisywał, porządkiem, z niewypowiedzianym zbiegowiskiem ludu nie tylko rzymskiego, ale i tych, co z odległych włoskich krajów *spectatores Sarmaticae pompae* być chcieli, za ukontentowaniem oczu i animuszów wszystkich. Tak niebo pokazało w aklamacjach Rzymu kiedyś światu panującemu nieomylną wróżbę następujących WKMci na Wschód i na Południe triumfów'. Relacja JMP. Jerzego Ossolińskiego, Cracow, Akademia Umiejętności, rkps nr 442, transcribed in Kubala, *Jerzy Ossoliński*, 484.
103 G. Trenta Arcieri vestiti di raso rosso Con archi in mano e carabine pendenti.
104 H. Paggio d'Arme vestito di Broccato d'oro alla Persiana.
105 I. Venti paggi di S.E. uestiti di colori d'acqua marina, e fondo ranciato.
106 K. Cinque Caualli Turchi ornati con Pennachi d'Arione e uarie Gioie con Selle ricchissime di lama d'oro, le due prime tempestate di Diamanti la terza di Rubini le due ultime di Turchine carichi d'Archi Frezze, Mazze, Scimitarre, et altri Arnesi di guerra con Briglie gioielate e ferrature d'oro.
107 L. Mastro di stalla di S. E con bel'Abito e mazza d'Argento in mano.
108 M. Venti Camerieri di S.E. uestiti di Damasco di color d'Acqua marina.
109 Alan Mikhail, *The Animal in Ottoman Egypt* (Oxford: Oxford University Press, 2014); Jirousek, *Ottoman Dress and Design in the West*; Amanda Phillips, *Sea*

Change: Ottoman Textiles between the Mediterranean and the Indian Ocean (Oakland: University of California Press, 2021).

110 N. Diuersi Signori Spagnoli e Gentilhuomini mandati da Cardinali, et altri Ambasciatori.

111 O. Molti Caualieri Pollacchi con Abiti e Caualli di gran valore armati di Mazza d Argento.

112 P. Seguiua altri Caualieri Franzesi, e Camerieri di S. Santita.

113 Q. Altri nobili Pollacchi accompagnati da Principi e Titolati Romani.

114 X. L'Eccellentiss: Ambasciatore con Abito d'oro cangiante foderato con pretiose Pelli affibbiato d'Gioielli con Berrettone con Gioiello d Pennachio d'esquisita bellezza sopra vago Corsiero con ferri briglia, e stasse d'oro gioiellate accompagnato dall Arciuescouo d'Amasia e Patriarca Gaetano et altri Prelati della Corte, seguito da molti stassieri Pollacchi insiemé con la Guardia delli Sguizzeri di S. Santita.

115 Y. E doppo la Carozza di S. E. di velluto verde tirata da sei Caualli Persiani con altre Carozze.

116 'Non si faceva in Firenze pubblica festa o trattenimento, o fosse di giostra o di tornei o di corsi de' barberi al palio, che egli prima non si portasse curioso a vederle ed osservarne ogni più minuto particolare, e poi tornatosene a bottega nol disegnasse.' In Filippo Baldinucci, *Notizie de' professori del disegno da Cimabue in qua: per le quali si dimostra come, e per chi le bell' arti di pittura, scultura, e architettura lasciata la rozzezza delle maniere greca, e gottica, si siano in questi secoli ridotte all'antica loro perfezione* (Florence: Per Santi Franchi, 1681), 243. Translation after Ulrike Ilg, 'Stefano Della Bella and Melchior Lorck: The Practical Use of an Artists' Model Book', *Master Drawings* 41, no. 1 (2003): 30.

117 See, for example, Sara Mamone, 'Le spectacle à Florence sous le regard de Stefano della Bella', in *Stefano della Bella, 1610-1664*, exh. cat. (Caen: Musee des Beaux-Arts, 1998), 18-19.

118 Phyllis Dearborn Massar, *Presenting Stefano Della Bella: Seventeenth-Century Printmaker* (New York: Metropolitan Museum of Art, 1971), 7.

119 Ilg, 'Stefano Della Bella and Melchior Lorck'.

120 These drawings are held in the collections of the Gabinetto dei Disegni e delle Stampe degli Uffizi in Florence, the Louvre's Cabinet des Dessins, the Pierpont Morgan Library in New York, the British Museum in London, the Biblioteca Reale in Turin, and the Graphische Sammlung Albertina in Vienna. See Paszkiewicz, 'Tematyka polska w twórczości Stefano della Belli: Część I', 195-98; Jolanta Talbierska, 'Twórczość Stefana della Bella (1610–1664)', *Rocznik Historii Sztuki* 28 (2003): 98-100.

121 See Erik Fischer, *Melchior Lorck: Drawings from The Evelyn Collection at Stonor Park England and from The Department of Prints and Drawings The Royal Museum of Fine Arts Copenhagen* (Copenhagen, 1962), 40-58.

122 Lorck himself likely copied illustrations from costume books like Abraham de Bruyn's Diversarum gentium armatura equestris [Equestrian Armours of Various Nations, Cologne, 1577], in which similar figures appear.

123 Caroline Le Mao, 'Un Français en Pologne: Gaspard de Tende à l'époque de la reine Marie-Louise de Gonzague', in *Le rayonnement français en Europe centrale: Du XVIIe siècle à nos jours*, ed. Olivier Chaline, Jarosław Dumanowski, and Michel Figeac (Pessac: Maison des Sciences de l'Homme d'Aquitaine, 2009), 137–50.
124 Gaspard de Tende, *An Account of Poland* (London: T. Goodwin, 1698), A5.
125 Tende, *An Account of Poland*, 186.
126 Tende, *An Account of Poland*, 187.
127 See Tende, *An Account of Poland*, 1–4, 79–80.
128 Tende, *An Account of Poland*, A5–6.
129 Tende, *An Account of Poland*, A5.
130 Srodecki, *Antemurale Christianitatis*, 305–38; Liliya Berezhnaya and Heidi Hein-Kircher, 'Constructing a Rampart Nation: Conceptual Framework', in *Rampart Nations: Bulwark Myths of East European Multiconfessional Societies in the Age of Nationalism*, ed. Liliya Berezhnaya and Heidi Hein-Kircher (New York: Berghahn Books, 2019), 3–30.
131 Wołodymyr Pyłypenko, *W obliczu wroga: polska literatura antyturecka od połowy XVI do połowy XVII wieku* (Oświęcim: Napoleon V, 2016), 120.
132 Sabine Jagodzinski, 'European and Exotic: Jan III Sobieski's Commemorative and Representative Strategies Towards Polish-Ottoman Relations', *Art of the Orient* 6 (2017): 144–55.
133 Kieniewicz, 'Polish Orientalness'.
134 Erazm Kuźma, *Mit Orientu i kultury Zachodu w literaturze XIX i XX wieku* (Szczecin: Wydawnictwa Naukowe Wyższej Szkoły Pedagogicznej w Szczecinie, 1980), 171.
135 Lewis, 'East Is East?'
136 Roberts, *Printing a Mediterranean World*; Ünver Rüstem, *Ottoman Baroque: The Architectural Refashioning of Eighteenth-Century Istanbul* (Princeton: Princeton University Press, 2019).
137 Linda Mannheim, ' "F*ck Leftist Westsplaining!" Listening to Voices of the Central and East European Left', *The Nation*, 4 April 2022, www.thenation.com/article/world/ukraine-russia-european-left/.

Where do Polish carpets come from? 4

[Carpets] transform somewhere that is outside into something domestic, as it were inside.

<div align="right">Marina Warner, *Stranger Magic*[1]</div>

Where are you from? [...] People tend to like things compartmentalized and simple; a simple answer to a (seemingly) simple question, right? But it's never been that simple for me. I've never actually had any sense of a 'national identity' or, for that matter, a sense of belonging to any one tribe.

<div align="right">Yann Mounir Demange, 'The Long Answer'[2]</div>

The Exhibition of Historical and Ethnographic Arts of 1878—which took place at the Palais du Trocadéro in Paris—was intended, as the official pocket guide to the show exclaimed, to be 'the most attractive and instructive in history'. The event not only promised to dazzle visitors with a multitude of the world's finest art pieces but also made a more ambitious claim to pursue 'the whole history of artistic production, century by century, in its many shapes and forms'.[3] Just like the larger Paris World's Fair of which it formed a part, the exhibition was designed to showcase the achievements of many different nations, aiming to bring to the visitor 'a much greater diversity of objects than the world's most important collections, gathering all that relates to art at the Musée du Trocadéro'. Self-reportedly inclusive and diverse—despite the exclusion of Germany and Ottoman Turkey, and notwithstanding its obvious Eurocentric and colonial overtones—the show purported to stage a microcosm of the whole history of art.[4]

In line with this lofty objective, even artefacts from oft-excluded regions found their way into the museum. And so, 'in the eleventh room', as the pocket guide tells us, a display of objects related to Poland was put together via the efforts of Polish noblemen led by Prince Władysław Czartoryski (1828–94). There, among various 'weapons and armours from different times, saddles decorated with all the ostentation of the Slavic race, precious fabrics [...], silverware, portraits, books, porcelain pieces, and enamels', the exhibition souvenir album also lists 'carpets from Cracow in the Persian style'.[5] The inclusion of these Persian-style carpets (among them, Figures 4.1 and 4.2) in a self-avowedly

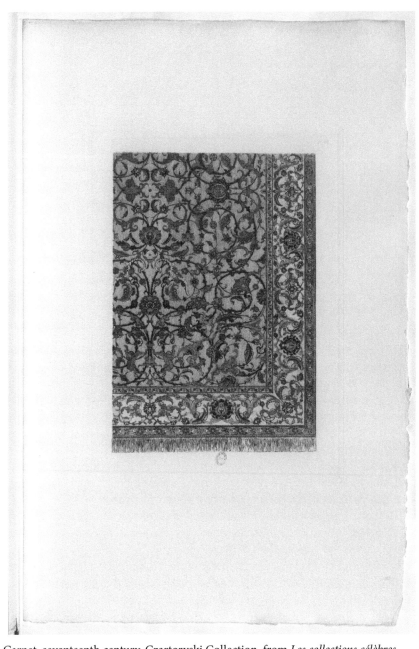

4.1 Carpet, seventeenth century, Czartoryski Collection, from *Les collections célèbres d'oeuvres d'art, dessinées et gravées d'après les originaux par Édouard Lièvre*, ed. Ambroise Firmin-Didot et al., Paris: Goupil, 1879, plate 60, photolithograph by Édouard Lièvre. Paris, Bibliothèque nationale de France, département Sciences et techniques, FOL-V-347–2

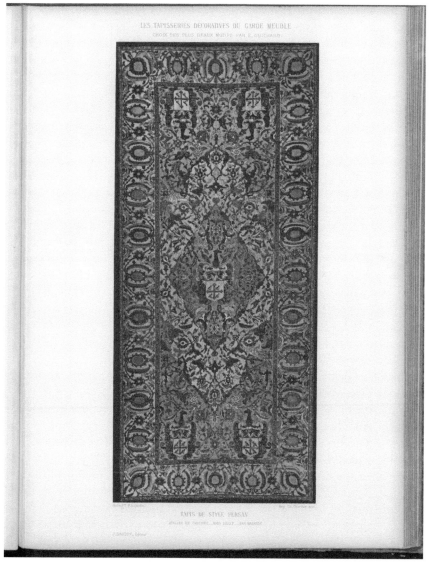

Carpet, seventeenth century, Czartoryski Collection, from Alfred Darcel, *Les tapisseries décoratives du garde-meuble … Choix des plus beaux motifs*, Paris: J. Baudry, 1881, plate 94, photolithograph by P. Dujardin. Westsächsische Hochschule Zwickau, 92050530

4.2

representative—if somewhat eclectic—assembly of Polish memorabilia seems out of place. How did something that was reportedly Persian in form find its way into an exhibit meant to typify Polish heritage? And still more puzzlingly, how could the perceived affinity of Polish material heritage with West Asian aesthetics define a national tradition that was seen as staunchly European?

This doublethink—the ability to believe and disbelieve the same idea simultaneously—pervaded conceptualizations of the style and origins of these artefacts.[6] So much so that commentators at the show struggled to define them in straightforward terms. In an attempt to address the physical appearance of the elusive Polish carpets—'from Cracow' but 'in the Persian style'—the reviewer for the *Gazette des beaux-arts* used a stylistic comparison that is clearly at odds with the views expressed in the official pocket guide. Rather than pointing to these carpets' Persian aesthetics, the author referred to one of them—reportedly, the most 'distinguished' piece in the room—as 'a *tapisserie* [tapestry or carpet] in the style of Smyrna [İzmir, Turkey]'.[7] The inconsistency in qualifying these objects' formal attributes unavoidably raises the question of stylistic influences and geographical origins: ultimately, were they Persianate, Smyrnesque, or something else altogether? While generally perceived as 'Oriental' in appearance (a fitting grouping for objects reportedly marked by 'the ostentation of the Slavic race'), the carpets in the 'Polish Room' were seemingly not distinctive enough for anyone to agree on a specific geographical reference for them.

It is thus particularly noticeable that, although the Trocadéro critics differed in their stylistic analogies, all nonetheless flatly accepted the Polish manufacture of these artefacts, possibly taking as the basis for this assumption their placement in the gallery dedicated to Poland and their apparently secure ownership history in the hands of a prominent Polish family. Provenience, the location where an artefact was made, is thus correlated in this account with provenance, the history of all places where an artefact has been held since its creation. But despite the critics' belief in the association between the so-called Polish carpets and Poland, the overreliance on indirect evidence soon led to doubts, largely magnified by the carpets' stylistic attributes. If they looked Persianate or Smyrnesque, why maintain their Polish provenience? And if they were not from Poland after all, where did they come from? In an attempt to dispel any misunderstanding of what these artefacts may have been, a comparative investigation of their formal properties shortly ensued, the Polish theory was challenged, and Safavid Iran (that is, Persia) was eventually recognized as the new, utterly correct place of the carpets' origin, an identification that has not been refuted and still stands today as a valid, widely accepted fact, closed to reinterpretation.[8]

This chapter revisits the question of these carpets' provenience, for decades understood as grounded in Iran, by taking a different approach to the

problem. Instead of pursuing a particular country of origin for these artefacts, the following pages posit a fundamental challenge to objects' association with place. Safavid carpets of the 'Polish' type belong to a large and still relatively understudied group of itinerant things that, although made someplace else, were appropriated, integrated, and reinvented as part and parcel of local custom. In this respect they are not unique: 'Transylvanian' and 'Portuguese' carpets, to give two prominent examples, were woven in Anatolia (Turkey) and Khorasan (Iran), respectively, becoming inseparable aspects of a local European identity far from their place of manufacture and with their stylistic features initially seen as foreign, however appealing, in the new context.[9] This process of merging and converging material cultures is often called transculturation, a term coined by Cuban anthropologist Fernando Ortiz (1881–1969), who was interested in tracing the ability of exogenous cultural forms and natural resources to transform and alter a society as they were adopted into its way of life.[10] Local traditions are seen in this model not as static and fixed but rather as subject to ongoing recontextualizations motivated by cultural forms that come from elsewhere and yet can play an important role in transforming vernacular customs and habits.[11] Given a wide array of European transculturation, the so-called Polish carpets in this chapter need not be treated as a distinctively paradigmatic transcultural form specific only to Iran (or Poland for that matter); instead, they contribute a suggestive case study that enables us to question the idea of cultural distinctiveness as well as the binary distinction between Asia (the Orient) and Europe (the Occident) that often accompanies it. Still often known by the disputed term 'Oriental carpets', these things were not simply defined by their West Asian manufacture but were also embedded and compressed into European imaginaries, leading to geographical misinterpretations and misattributions that challenge the dichotomy of foreign versus native. This chapter thus brings to the fore the shifting and often seemingly self-contradictory perceptions of the 'Polish' carpets' real and imagined origins, highlighting the processes of acquisition, collection, domestication, and dispersal that shaped their transcultural contexts.

Polish or not?

The need to link an object's historical association with its presumed geographical context stems, as Michel Foucault famously observed, from the wider modern inclination to frame the object within a sequence of analogies and influences.[12] In the nineteenth century, this led to the rearrangement of art collections along geographical lines and by ethnic criteria, causing most art museums in Europe and North America to organize their artworks by so-called national schools that anchored their origins to a particular place.[13] The Exposition of Historical and Ethnographic Arts was no different: it grouped together artefacts from

cultural milieus like the Greco-Roman world, the Florentine Quattrocento, the Italian High Renaissance, and the art of the Low Countries, giving each of these clusters of objects an individual gallery.[14] The carpets assembled in the Polish Room were understood—just like the artefacts in all those other galleries—as a manifestation of the culture to which they were assigned.[15] Thus, the comparative qualifiers 'in the Persian style' or 'in the style of Smyrna' did not denote these objects' origin in either of these places, rather conveying Poland's alleged 'Slavic ostentation' and intimating a sense of the region's cultural affinity with the 'Orient'. While remaining geographically in Europe, the Poland of the World's Fair was projected into a virtual realm of fantasy exoticism.

This projection is not entirely surprising: as Larry Wolff has famously remarked, places like Poland have long been consigned to Europe's eastern margins through the intellectual project of demi-Orientalism, which since the Enlightenment has been relegating Central and Eastern Europe to the role of buffer between progress and backwardness, civilization and ignorance, real Europe and its others.[16] But positioning the Trocadéro carpets within the stylistic bounds of the imaginary Orient is a different kind of othering—one that does not entail a decreasing level of civilizational or economic development sliding, in an easterly direction, away from Western European norms and values but that pushes Polish material culture away from the discourse of Europe altogether. Rather than framing Polish carpets as a peripheral offshoot of European heritage, their visual affinities with West Asia cast them into an entirely different stylistic and geohistorical register. As they are paradoxically conceived as both almost European and not European at all, the question that begs asking, then, is how the associative dualism built into the perceptions of these carpets could function without collapsing under its own seeming contradictions—especially from the viewpoint of Prince Czartoryski, who, after all, selected these objects as a quintessentially Polish artform and thus well suited for the 'Polish Room'.

The pocket guide, just like the other Trocadéro-related publications, seeks to reconcile the ambiguous status of the Czartoryski carpets, seemingly both Polish and Iranian, by interpreting their West Asian influences as simply incidental. To this end, the guide attributes the artefacts rather elusively to a Pole who had been taken hostage in Iran, where he had acquired his consummate weaver's skills. However short on details, this hypothesis at least explains why the Czartoryski carpets had previously been believed to be 'Persian' and 'of the sixteenth century'. This dating and attribution, the guide makes clear, were auspiciously rectified when the letter 'M' was found in the decorative border adorning other objects of the same type:

> Upon further research, the said letter 'M' was discovered on other carpets, repeated in satiety either in the details of the border, or in the design of

ornament at the corners. It was not long before a conviction had grown that these carpets, with all their beauty, were made in Cracow at the end of the seventeenth century by a Pole named Mazarski, who returned from Persia where he had been held prisoner and worked in a carpet loom. Get closer, and you will see the letter 'M' repeated endlessly in the border of the carpets woven by this able man; this letter is the initial of his name.[17]

Via the story of Mazarski's alleged captivity in Iran, the guide attempts to explain the Persian style of the Czartoryski carpets while simultaneously upholding their assumed manufacture in a Polish workshop. The geographical location of Poland in Central and Eastern Europe makes a necessary case for the alleged incongruence of style and the artist's ethnicity, but it is Mazarski's forced displacement and providential return that prop up his significance as artistic intermediary in the first place. Through this circular logic, the reader is to be persuaded both of the Polish provenience of the Czartoryski carpets and of the matching ethnicity of their maker—despite the artwork's Persian style.

Contemporaries did not question this reasoning. An 1879 catalogue of 'famous works of art' includes one of these carpets among the most celebrated pieces to be seen in France, describing it as 'made in Poland'. The reason for this attribution is apparently logical and straightforward, since—we are told—'in the course of the sixteenth century, many manufactories were established in Poland by rich and illustrious families'.[18] The piece is even illustrated (Figure 4.1) to help the reader appreciate this 'very fine specimen of that branch of Polish industry [that] bears witness to the degree of perfection to which the industrial arts of Poland had attained by the sixteenth century'.[19] A different contemporaneous publication (1881), devoted entirely to historical textiles, includes another of the Czartoryski carpets at the Trocadéro: a flat-woven silk kilim decorated with a floral pattern and European coats of arms (see Figure 4.2). Referring to undisclosed 'documents', the author endorses the by-then customary attribution to Mazarski without the slightest attempt to find actual evidence for the inference.[20] Since there was no document that could settle the object's provenience (such a document has yet to materialize), we must assume that the story was either blindly repeated by the author or passed on to him by Prince Czartoryski himself.

But despite the purely anecdotal value of the evidence, the whole class of flat-woven silk carpets brocaded with gold and silver thread was henceforth associated with Poland.[21] Most of these artefacts had floral design elements such as palmettes, curving leaves, and vines arranged in several field patterns, giving further credence to the theory of stylistic integrity within the classification. Additionally, there was a perception among *fin-de-siècle* Polish collectors and carpet historians, possibly shared with the critics visiting the Trocadéro exhibition, that there were many more flat-woven carpets of the Czartoryski

type in Poland, Lithuania, and Ukraine than existed elsewhere in the world.[22] These lands were at the time divided among Russia, Prussia, and Austria—the former regional power, our multi-ethnic and multi-lingual Polish–Lithuanian Commonwealth having been partitioned in 1772, 1793, and ultimately in 1795—but many Polish-speaking nobles had continued cultivating their sentimental attachment to the defunct confederate polity. Thus, out of the circumstantial use of oral tradition and visual observation, the 'Polish carpet' (*tapis polonais*) was born. Although it was a plausible attribution given the paucity of evidence available, the Polishness of these carpets was but a story invented from loosely fitted fragments, falsely perceived as a piece of history.

This state of affairs did not last forever. Early doubts about the Polish provenience of many so-attributed carpets were expressed thirteen years later by none other than eminent art historian and authority on carpets Alois Riegl (1858–1905), who noted the similarities between 'Polish carpets' (*Polenteppiche*) and objects from the Kashan and Isfahan imperial workshops in Safavid Iran.[23] Riegl began to question the Polish theory in 1891; others soon followed suit. These included carpet collector and scholar Wilhelm Bode (1845–1929), then director of Berlin's Gemäldegalerie in the Altes Museum, and later the creator and first curator of the Kaiser-Friedrich-Museum. Unconvinced by the Polish provenience of the *Polenteppiche*, Bode classified them in his 1902 survey of 'Hither Asian Knotted Carpets' among other flat-woven silk rugs with floral designs, all of which were undoubtedly of Persian provenience; he also noted that the exhibits at the Paris show could not have been woven by Mazarski, who in fact ran his loom in the eighteenth century, much later than the pundits at the Trocadéro had alleged.[24]

Bode was right: the elusive Pole Mazarski could not have been the maker. Later identified as Armenian master-weaver Jan Madżarski (d. 1800 or 1801), who was active in Niasvizh (Polish: Nieśwież) and Slutsk (Polish: Słuck), Lithuanian towns (today in Belarus) some 600 kilometres northeast of Cracow, where the French critics believed his carpets to be made. He also lived more than 150 years after these objects had begun their itinerant lives, and was best known for his kontusz sashes rather than carpets.[25] And so, a final blow to the Polish theory was struck. As carpet expert Friedrich Sarre (1865–1945) put it bluntly in the 1910 catalogue accompanying the influential Munich exhibition of the 'Masterpieces of Mohammedan Art' (*Meisterwerke muhammedanischer Kunst*), 'the fable of the Polish origin of the silk Persian rugs woven with silver and golden threads had [by then] long been destroyed.'[26] For about two decades, however, 'Polish carpets' had been treated as if they had really originated in Poland. During this relatively long period, the name *tapis polonais* had stuck among antiquarians, curators, and art historians who felt hesitant to let it go. In the end, habit won over historical accuracy, and so to this day seventeenth-century flat-woven kilims from Kashan and Isfahan are referred

to by textile experts as 'so-called Polish carpets' or 'Polonaise carpets' (as they are often ungrammatically labelled in English), evoking the erroneous 1878 attribution. They find themselves grouped together with other carpets described in European-based terms, like Holbein-, Lotto-, and Memling-type carpets named after the Renaissance artists who included the objects in paintings, pointing to these carpets' Eurocentric interpretation as well as to their popularity among early modern European elites.[27] The term 'Polish carpet', too, evokes European use, but in this case the meaning is modified still further by the qualifier 'so-called'. Thus, in a performative act of undoing the Polishness—and by extension also the Europeanness—of these artefacts, the new description simultaneously serves as a cautionary tale against geographical misattribution and a testimony to art historians' self-asserted expertise in fixing an object's epistemic status.

But how well founded is this belief in scholars' ability to resolve contestable provenience and attribution of artefacts? Consider the *Czartoryski Carpet* in the Metropolitan Museum of Art in New York, one of the exhibits that was put on display at the Trocadéro in 1878 (Figure 4.3). Although described as 'made in Cracow' by the 1881 French catalogue of tapestries and carpets (see Figure 4.2), the object is now identified as a 'so-called Polish carpet' of Persian manufacture, a classification upheld by all specialists who have assessed it since the artefact's arrival at New York in 1930.[28] Comparison with other Polonaise carpets, and in particular with the well-documented museum pieces in Munich, has allowed modern scholars to date the *Czartoryski Carpet*—along with all other objects in the group—to the seventeenth century.[29] In his thesis on the subject, Friedrich Spuhler documents some 230 examples of the Polonaise type, all produced in imperial workshops in Isfahan and Kashan.[30] One of the main characteristics of the group is their brightly coloured palette of silk woven on a cotton warp and silk weft foundation, with brocaded gold and silver thread added for an iridescent appearance. The rhythmical composition of motifs arranged in compartments or around a central medallion, as in the *Czartoryski Carpet*, adds to the effect of brilliance. The presence of these features, deemed as typical of the type, is why today the Met catalogue can claim with confidence that the rug 'occupies a special historical niche because it was mistakenly identified as Polish, hence Polonaise'.[31] The fallacy of the previous identification appears in this statement as a self-evident truth; after all, Riegl and Bode did assure the correct, Iranian manufacture of the so-called Polish carpet, and following this logic there is no longer any point in trying to prove otherwise.

One might argue, however, that Riegl's and Bode's terminological correctives, which were applied during the heyday of European ethno-nationalism, went a step too far. While they rightly debunked the idea that the Polonaise carpets were produced in Poland, they simultaneously entrenched a similarly

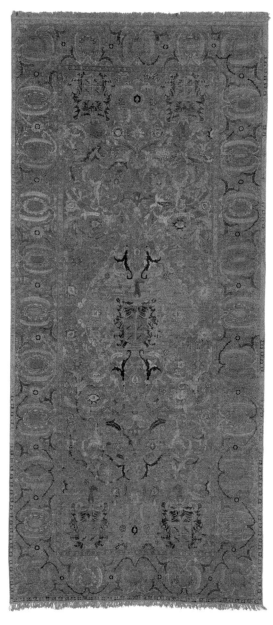

4.3 The *Czartoryski Carpet*, seventeenth century, 'Polonaise', made in Iran, probably Isfahan, cotton (warp), silk (weft and pile), metal-wrapped thread, asymmetrically knotted pile, brocaded, 486.4 × 217.5 cm. New York, Metropolitan Museum of Art, gift of John D. Rockefeller Jr. and Harris Brisbane Dick Fund, by exchange, 1945, 45.106

limiting, purist notion of their Iranian roots. Even contemporaries thought this origins theory too limiting. For example, Fredrik R. Martin (1868–1933), author of a key 1908 survey of carpets, remarked that:

> it is a curious fact that most of these carpets are in the possession of ancient Italian, Polish and Austrian families since the seventeenth century, but that very few have found their way to the West of Europe [...] nor can they be proved to have remained in the East. Not even the Treasury of the Sultan contains a single specimen, and during my many travels in the East I have never come across a single one, not even a fragment [...] This fact strengthens still more my opinion that these carpets were exclusively made as gifts for European princes.[32]

While Martin agrees on the 'Eastern' provenience of the objects, he nonetheless argues that they owe their existence to the 'European princes' for whom they were made—including those from Poland. Without reinstating the old theory of their Polish origins, Martin crucially defines the Polonaise carpets as transcultural, mobile things. This is concomitant with what we know about the objects today. Although produced and appreciated in Safavid Iran, they were often presented or sold to Europeans as documented gifts or via commercial transactions with Poles, Venetians, Muscovites, and Germans, among others.[33] In this respect, the carpets' bright and conspicuous designs, though Iranian inspired, may have been developed to cater to European tastes.[34] The manufacture of these objects also remained beyond the purview of a single origin, confirming their international makeup. Procured from the Caspian province of Gilan, the silk's fabrication and distribution were monopolized by Greek and Armenian merchants.[35] Many of the dyestuffs used in Safavid carpets came from abroad: indigo from India, Armenian cochineal from the Caucasus, American cochineal from New Spain, and Polish cochineal from Central and Eastern Europe, including Poland and Ruthenia (today Ukraine)—so there was, after all, something Polish about so-called Polish carpets.[36]

Materials, technologies, designs, and the social and economic environments of production are, of course, themselves transcultural, mobile, shared, borrowed, bricolaged, and reimagined.[37] Following Riegl's and Bode's pronouncement, however, art historians appear to have gradually accepted the monocultural origin of these rugs and thence ceased examining their fuller history, preferring to address solely their creation moment for the purpose of art-historical classification and analysis.[38] And yet: although their Iranian provenience is now confirmed and widely accepted, these artefacts' epistemic status remains far from clear. Are they Iranian, *punto e basta*, or should their popularity in Europe and subsequent assimilation into European traditions be acknowledged—and, if so, how? Only by answering these questions can we

come to fully appreciate the transcultural context of these carpets as well as the meanings they once held.

Doublethink

In 1601, the court-affiliated merchant Sefer Muratowicz (Turkish: Sefer Muratoğlu; d. after 1631) delivered eight carpets from Kashan to Sigismund III, King of Poland and Grand Duke of Lithuania (r. 1587–1632).[39] Deemed some of the best documented Safavid carpets, these artefacts are often cited by scholars who study so-called Polish carpets as an example of the great demand for West Asian textiles in Europe. One of them is Tadeusz Mańkowski (1878–1956), a Polish art historian and carpet collector who discovered many of the sources related to these objects, including important documents pertaining to Muratowicz's journey.[40] These documents reveal that Muratowicz was an Armenian from Anatolia who had moved to the Ruthenian city of Lviv (Polish: Lwów, German: Lemberg) in 1597 and already in spring 1601 was entrusted with travelling to Kashan to commission carpets and other luxury wares for the king.[41] This was a big moment in the career of a novice in royal service, one indicative of the fact that early modern European societies did not strictly demarcate citizen and foreigner but instead recognized many intermediate legal categories of belonging, with many embedded guest cultures in territorial states and cities alike.[42] Armenians in Poland–Lithuania were one such community: though not politically enfranchised, they had the right of settlement as well as extensive self-rule and other protections from the Crown, especially in Ruthenia.[43] In return, the community put its capital and expertise into maintaining the distant and often risky routes between Poland–Lithuania, the Ottoman Empire, and Safavid Iran, which relied on the vast Armenian diaspora and its business partnerships and networks scattered all across the region.[44] As Armenians were a common sight particularly in the Ruthenian towns of Lviv and Kamianets-Podilskyi (Polish: Kamieniec Podolski), Muratowicz would have not seemed a stranger there.[45]

Sigismund likely chose Muratowicz for the task because he spoke both Turkic and Iranian languages, could seek support from the Armenian diaspora along the route, and was a subject of both the Polish king and the Ottoman sultan, which would give a traveller (and whatever he was transporting) increased protection during his voyage.[46] The trip went well, and Sigismund was satisfied with the merchant's efforts. In gratitude, on 26 October 1602, the king appointed Muratowicz royal purveyor (*servitor ac negotiator*) of West Asian wares.[47] Muratowicz was henceforth exempt from customs duties on merchandise from the Ottoman and Safavid empires (*generis merces ex Turcia, Persia*), provided the king obtained pre-emption rights to secure the best items for himself. Moreover, Muratowicz was excluded from city jurisdiction to become

subject only to the king's authority. In subsequent archival documents from Lviv, Muratowicz appears as a citizen and merchant of Warsaw, proudly calling himself royal servant (*servitor regius*).[48]

No document issued by the court has survived (if such ever existed), and so the precise purpose of Muratowicz's trip remains uncertain; some scholars have suggested he might have been sent to Iran as an informal diplomatic envoy to scout out whether the Safavid empire could serve as Poland's ally in any future wars with the Ottomans.[49] It is certain, however, that he came back with carpets, since a copy of the handwritten travel account he presumably presented to Sigismund upon the merchant's return from Iran was eventually published in 1743 and again in 1777.[50] In it, Muratowicz explains that in Kashan he ordered 'for His Majesty the King […] rugs woven in silk and gold, as well as a tent, [and] Damascus steel scimitars'.[51] Additional information comes from an invoice discovered by Mańkowski: issued on September 12, 1602 to Court Treasury Notary Jerzy Młodecki, the document lists exactly which items Muratowicz acquired for Sigismund during his stay in Kashan, and at what prices.[52] Among various textiles and weapons are two pairs of carpets, 40 thalers each for a total of 160 thalers; two additional carpets, 41 thalers each for a total of 82 thalers as well as a fee of 5 thalers for the execution of his Majesty's arms (on the carpets); and two more carpets, 39 thalers each for a total of 78 thalers. Altogether, these acquisitions cost the king 325 thalers, which at the time could have bought him some eight hundred oxen or brought in annual rent from five houses in Cracow—not an insignificant amount of money to spend on textiles.[53] The invoice makes clear that Sigismund was keen on Persian carpets and was ready to spend vast sums to secure the best commissions.[54]

The highly specific content of the document gives the impression that the king knew exactly what he was looking for. This was likely the case, as he was in fact adding to an already enviable collection of Turkish and Persian carpets, which he had inherited from his uncle Sigismund II Jagiellon (r. 1548–72) as well as from his direct predecessor on the thrones of Poland and Lithuania, Stephen Báthory (r. 1576–86), who was also the spouse of the king's aunt, Anna Jagiellon (1523–96).[55] Several servants were retained for the care and preservation of these carpets, which gives a sense of the collection's size.[56] It was a prized assemblage of objects built on a nearly fifty-year legacy of acquisition; therefore acquiring carpets was a familiar practice, especially since they had begun to flow into the Polish–Lithuanian Commonwealth on a large scale during the late sixteenth century, by which time they were among the most frequently mentioned items in household inventories.[57] By the time Sigismund sent Muratowicz to Iran to increase the royal holdings, collecting carpets was no foreign custom but an established local and family tradition—a practice that in many ways was *already* local. These artefacts were not only

prestigious collectibles but also meaningful forms of communication that signified through their familiarity, and so courtiers and favour-seeking nobles would have been accustomed to this form of dynastic display in royal palaces.

Polonaise carpet expert Friedrich Spuhler has called these artefacts 'representation carpets' (*Representationsteppiche*) in recognition of their role as markers of social status and cultural distinction. Indeed, a large number of Polonaise carpets found their way into Europe as gifts from the Iranian shah to royal families, religious figures, and deserving high-ranking officials.[58] As we have seen, Sigismund specifically paid an extra fee of five thalers 'for the execution of his Majesty's arms' on two of these rugs, presumably because he deemed them a suitable conduit for dynastic representation. Two silk rugs—likely those commissioned by Muratowicz in Kashan—today on display at Munich's Residenz Museum (Figure 4.4) and Nymphenburg Palace (Figure 4.5) present us with the physical manifestation of this symbolic appropriation.[59] At the centre of the medallion design is the Polish white eagle with the Vasa sheaf in the escutcheon, the heraldic representation of Sigismund's royal Jagiellonian lineage; locally relevant and culturally resonant, the emblems' presence effectively domesticates the Persian aesthetic of the carpets.[60] By mixing his family's heraldry with the arms of his adopted realm, the Swedish-born king visually asserted a connection to the land that had been under his rule since 1587. And he did so, understandably, by employing a type of object that already carried associations with the local milieu.

His efforts must have been successful because, inferring from surviving examples, Sigismund resorted to this practice more than once. Directly below the five thalers mentioned on Muratowicz's invoice is an entry that lists two carpets 'at forty-one thalers each', possibly meaning that Sigismund's arms were only added to these specific carpets. Yet aside from the museum pieces in Munich, there are at least two other flat-woven carpets with Sigismund's arms still extant—a half-kilim in Washington, DC. (Figure 4.6)[61] and a kilim in the Quirinal Palace in Rome (Figure 4.7)[62]—implying other bespoke commissions. These carpets might have come from far away, but their Iranian provenience did not prevent the king from repurposing them as locally resonant media.

Sigismund's son and successor, Ladislaus IV Vasa (r. 1632–48), continued to use carpets for similar purposes of representation. To welcome his bride-to-be, French princess Marie-Louise de Gonzague-Nevers (1611–67), upon her arrival in February 1646 at Danzig—the Commonwealth's largest city and its main seaport located in Royal Prussia—the king sent more than 160 royal carpets to adorn the Cistercian abbey in Oliva (Polish: Oliwa) and the townhouses in Danzig where the queen and her retinue were to be lodged.[63] The collection seems to have impressed Marie-Louise: she remarked in a letter to Cardinal Mazarin that she had never seen more beautiful carpets (*tapisseries*) than those she enjoyed upon her arrival at Danzig.[64] Her enthusiasm continued as she

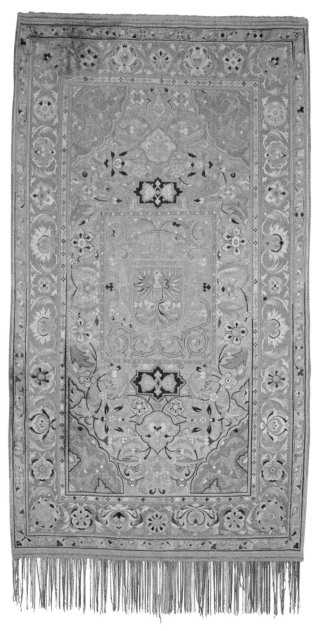

So-called Polish carpet with the coat of arms of King Sigismund III of Poland, c. 1600, **4.4**
made in Iran, silk and golden thread, 243 × 134 cm. Munich, Residenz, BSV.WA316,
formerly ResMü.WC3

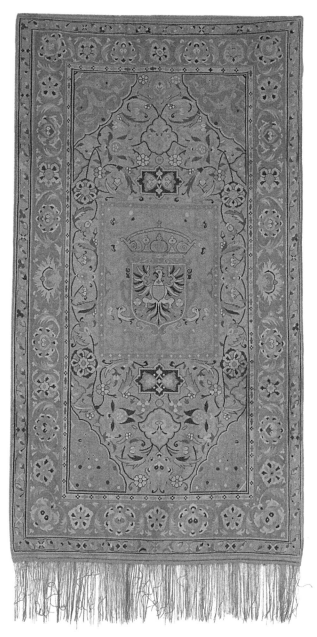

4.5 So-called Polish carpet with the coat of arms of King Sigismund III of Poland, c. 1600, made in Iran, probably Kashan, silk and metal thread, tapestry weave, 245 × 135 cm. Munich, Wittelsbacher Ausgleichsfonds, WAF Inv.-Nr. T I b 1

Safavid 'Polonaise' kilim with the coat of arms of Sigismund III of Poland, c. 1600, made in Iran, probably Kashan, silk and metal thread, tapestry weave, 206 × 59 cm. Washington, DC, Textile Museum, R33.28.4, acquired by George Hewitt Myers in 1951

4.6

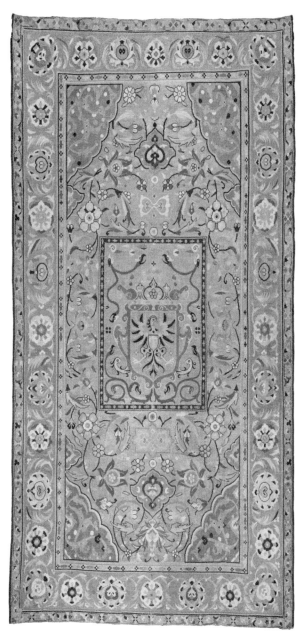

4.7 Safavid 'Polonaise' kilim with the coat of arms of Sigismund III of Poland, c. 1600, made in Iran, probably Kashan, silk and metal thread, tapestry weave, 250 × 134 cm. Rome, Quirinal Palace

reached the royal court in Warsaw. Jean Le Laboureur (1621–75), a French courtier who came to Poland with the princess, wrote an itinerary of her journey, including her arrival at Warsaw, which was reportedly marked by the French legation's admiration for 'the royal carpets [that were] the most beautiful not only in Europe but also in Asia'.[65] This is high praise from a worldly Parisian courtier at a time when Europe abounded in high-quality West Asian carpets, suggesting that despite their wide availability to European elites, Marie-Louise and her retinue saw the Polish holdings of carpets as truly outstanding.[66]

What is even more revealing is the acknowledgement of Poland's privileged access to examples of the craft best suited to European tastes. Located between a familiar Europe and an exotic Asia, Poland is in this account a place that evades strict demarcation between the conventionally separate spheres of these carpets' consumption and production. The reputed quality of the Warsaw carpets, supposedly even higher than that of similar objects in 'Asian' collections, prompted Le Laboureur to give an account of Poland as a natural habitat for these highly prized artefacts. In fact, foreign visitors often pointed out the penchant of Polish–Lithuanian elites for West Asian carpets. For example, as early as 1565, papal nuncio Fulvio Ruggieri wrote in his description of the kingdom's characteristics that 'Poles import carpets from the East'.[67] Similarly, Guillaume Levasseur de Beauplan (c. 1600–73), engineer, cartographer, and author of the first description of Ukraine (1651), writes about Cossacks looting carpets in the Ottoman Empire to resell them in Polish-administered Ruthenia.[68] The common thread connecting these accounts is that Poles were known for their keen interest in carpets, and that the Commonwealth served as one of the major entrepôts in early modern Europe where carpets and textiles from West Asia arrived in large quantities.[69]

This characterization of Poland as a locus of assimilation of 'Asian' material culture went hand in hand with the court's reportedly cosmopolitan character. Le Laboureur tells a story of 'the handkerchiefs of the Polish nobles, which are for the most part made of cotton with Turkish embroidery of gold, silver and silk'.[70] One such thing was reportedly offered to Marie-Louise's *ambassadrice extraordinaire* and *sur-intendante*, Madame la Mareschalle de Guébriant, by Prince Janusz Radziwiłł (1612–55), one of the Commonwealth grandees who was present at the wedding reception of Marie-Louise and Ladislaus in Warsaw. The handkerchief was allegedly 'made personally by his wife, the daughter of the Prince Palatine of the Wallachians, and she had embroidered their names and their arms on it'; Radziwiłł reportedly 'went to fetch it in his room, and sent it by a little dwarf from Tartary [likely Crimea], together with a Persian carpet beautifully adorned with gold thread'.[71] In this account, as in many other reports by European visitors, West Asian textiles function as a metonym of Polish cultural particularism; here they are given to a foreign official as a token of local custom.

What requires further explanation is the dual recognition of these carpets as at once Asian and Polish. European visitors, just like Polish–Lithuanian royals and nobles, knew that these carpets were Persian or Turkish, and yet still believed without any seeming contradiction that there was something specifically Polish about them. Recall the white eagle, a visual emblem of Poland, blending in confidently with the Persian aesthetics of the carpets commissioned by Sigismund III. Iranian and yet Polish, there is undeniably doublethink in this conflation of geographical provenience and adaptation to local culture. Sigismund clearly understood that these carpets were foreign: after all, he sent Muratowicz to distant Iran to buy them. But at the same time, the king used the carpets as a signifier of his Polishness, effectively availing himself of their malleable semantics. He even sent one of these prized objects (see Figure 4.7) as a gift to the Medici in Florence, presumably to boast of his ability to procure personalized Persian wares.[72] In view of how the king used them—fully aware of their foreign extraction—we may read his armorial carpets as a series of encounters and translations that infused exotic materials with locally defined symbols, entangling them to produce objects that could pass as local things. It was the carpets' 'routes not roots'—that is, what he did with them rather than what they were originally supposed to be or do—that allowed the king to endorse (and benefit from) these things as familiar cultural forms.[73] As theorist of cultural entanglement Nicholas Thomas has noted, 'objects are not what they were made but what they have become'.[74]

This doublethink, however, can only function in a specific context, requiring constant reinforcement and repetition to remain locally resonant. The very same object would signify differently in a place where it lacked added meaning accumulated over decades of use in everyday life. The Polonaise carpets at Munich (see Figures 4.4 and 4.5), where they were moved from the dispersed collection of Sigismund's daughter Anne Catherine Constance Vasa (1619–51), again provide a good example.[75] Married to Philipp Wilhelm Wittelsbach of Palatinate-Neuburg (1615–90) in 1642, the princess brought with her several of her father's carpets when she left Warsaw.[76] Only the part of her dowry listing jewels has survived, but we may infer from other sources that among the items Anne Catherine Constance brought from Poland were the armorial carpets commissioned by Sigismund.[77] The papal legate Giacomo Fantuzzi (1617–79) provides one such source in his diary. On his return journey from Warsaw to Rome in 1652, a year after Anne Catherine Constance's untimely passing, he stopped in Neuburg, where he toured the rooms of the ducal castle. There, he noticed 'magnificent rugs richly decorated with gold, the most beautiful one can see [...] brought from Poland by Her Enlightened Excellency, the Princess'.[78] The 1668 inventory of Neuburg Castle lists four different carpets (*Portiere*) 'with the Polish coat of arms' among other armorial carpets and tapestries.[79] It is uncertain whether the document describes Iranian kilims or

one of the Flemish (or Dutch) tapestries with the white eagle—which, too, are flat-woven textiles, and are still held in the former Wittelsbach palaces in Munich (e.g., Figure 4.8).[80] It is clear from both sources that the authors of the descriptions cared more about the function of these things as signifiers of the Polish realm than their provenience in either Iran or Europe. In this respect,

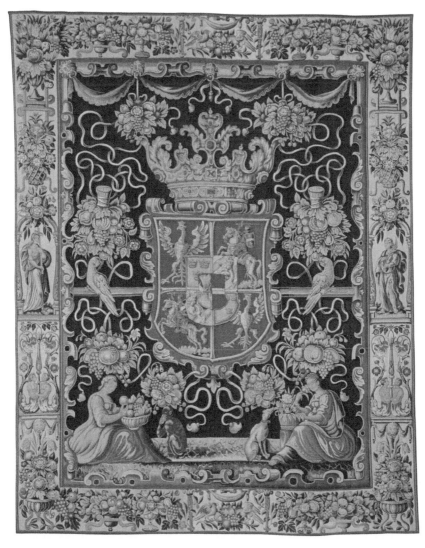

Tapestry with the coat of arms of Princess Anne Catherine Constance Vasa, Brussels, 1630/40. Munich, Residenz, BSV.WA0172

4.8

neither type of object denotes exoticism or foreignness. These were above all the carpets of Anne Catherine Constance proclaiming her royal lineage and Polish–Lithuanian heritage through the inclusion of culturally meaningful coats of arms.

Stress on association with owner rather than provenience is also seen in a 1653 inventory of Philipp Wilhelm's personal property sent to Düsseldorf, the main domicile of the Counts of Palatinate-Neuburg and Anne Catherine Constance's place of burial. Among the carpets and textiles listed in this inventory, many are described as 'Turkish', several as 'with the arms of the Palatinate', and some as 'with Polish arms'.[81] The conflation of foreign and local is evident in this document, as the same terminology is used for European and Ottoman textiles, thus it is difficult to infer the origins of these things—including those with Polish arms as part of their design. The armorial carpets were evidently appreciated for their use as dynastic props rather than for their geographical provenience. They would possibly have read as Turkish or Persian to a trained eye, but to those who knew the princess they would have more readily signified as personal items functioning as identity markers, Polish by implication.

This doublethink, so evident in the seventeenth century, is undetectable in more recent documents, likely because an interest in Anne Catherine Constance's belongings slowly faded away with the passage of time.[82] In the 1874 inventory of the Munich Residenz, the same carpets are catalogued as 'Turkish'.[83] Not only was knowledge of their actual provenience lost but so was their origin as the dowry of a Polish–Lithuanian princess. The nineteenth-century cataloguer did not even note that two of the carpets bore the arms of Sigismund III, featured prominently at their centre. These things no longer brought about an intimate association with a European polity but straightforwardly signified as Turkish exotica (erroneously so, as today they are considered unmistakably Safavid). The transition from early modern doublethink to modern historicism thus removed the potential to read these carpets as simultaneously Iranian and Polish–Lithuanian without seeing it as a contradiction of terms.

The seventeenth-century sense of epistemic ambivalence may be difficult for us to understand, as we have become accustomed to straightforward geographical classifications applied to objects by art historians and museum curators since the beginning of art history as an academic discipline.[84] Indeed, early modern doublethink is best understood precisely by forgoing the concept of origin as an act of creation tied to a singular moment in space and time, instead embracing objects' multiple belongings and contrary ideas about their provenience held at the same time.[85] The so-called Polish carpets lend themselves easily to such an interpretation. As they reappeared in new contexts, acquiring new meanings, older assumptions about their cultural relevance did not automatically lose their hold—one meaning did not necessarily contradict the other. While never losing their foreign-origin status entirely, carpets

commissioned by Polish–Lithuanian patrons opened up, integrated, and reinvented foreign forms as local things, gaining new functions and meanings each time they were reappropriated and repurposed.

Made in Poland

Some of these artefacts may have been connected with local life in a more explicit manner than what we have seen to this point. Modern Polish and Ukrainian collections contain several carpets that have been attributed to Polish and Ruthenian looms.[86] A small, seventeenth-century woollen carpet in Cracow's National Museum, dated broadly to the seventeenth century (Figure 4.9), presents an ambiguous case that triggers unanswered questions of provenience.[87] Mańkowski, whose hypothesis remains unverified, argued in 1935 that the carpet was woven in Poland, basing his analysis on the use of undyed wool; on the anecdotal inclusion of linen thread in the pile, an account passed on to him by the previous owner, Erazm Barącz (1859–1928); and on the existence of a 1568 register of royal expenses listing twelve Polish guilders (*złoty*) spent on 'a black and white carpet of Masovian manufacture'.[88] Yet the first part of this claim is specious, as carpets from Anatolia, Central Asia, Iran, and Afghanistan often use undyed wool as part of their designs.[89] Furthermore, analysis by pattern, coarseness and fineness of wool, use of dyes and colour palette, and weaving structure has been deeply complicated by modern research, which has questioned the assumptions that underlay European and North American attributions from the nineteenth century onwards.[90] These assumptions often derived from Eurocentric taste ideologies, like the fixation on authenticity among Western consumers and collectors; nostalgia for the remote and exotic; the use of European high culture as a reference point; and the creation of a canon for 'Islamic art', in itself a contested term.[91]

While the provenience of the Cracow carpet is uncertain, we are on firmer ground when it comes to historical practice of use. The tear running across the middle of the rug implies the object's employment as padding for a horse saddle, indicating its history as part of a user's daily life. Consider an engraved portrait of King John Casimir (r. 1648–68) mounted on a horse with a woollen pile carpet as its saddle cloth, the depiction probably commissioned by the court from the Nuremberg workshop of Johann Hoffmann (1629–98) in the 1650s (Figure 4.10).[92] While it is impossible to tell exactly what kind of carpet it is or where it is from, this is not because Hoffmann's engraver was not skilled enough to depict the textile accurately, but likely because its exact origin was not deemed critical knowledge for the viewer. The carpet could be represented schematically since it was recognizable as a familiar cultural form associated with the court, the army, and the Polish–Lithuanian way of life. Adding to the transcultural reading of the image, the king appears as a commander-in-chief

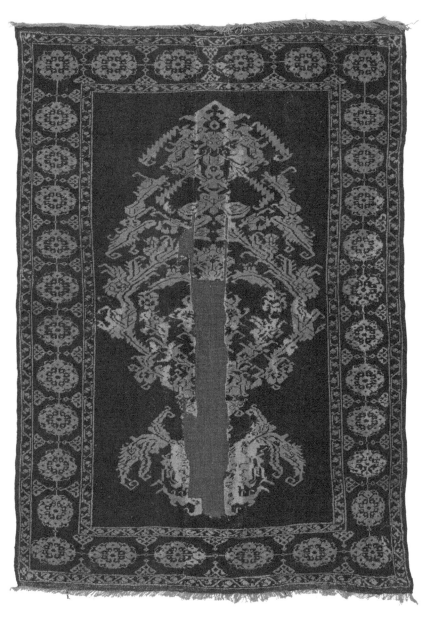

4.9 Polish rug, second half of the seventeenth century, Ghiordes knot, linen thread, and wool, 195 × 145 cm. Cracow, Muzeum Narodowe, NMK XIX-4451

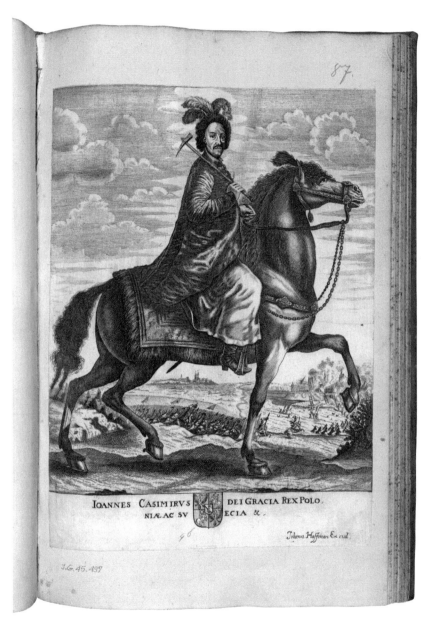

Johann Hoffman (printer), *Equestrian Portrait of King John Casimir*, second half of the seventeenth century, engraving and etching, 34.5 × 25.5 cm. Warsaw, Biblioteka Narodowa, G.45497

4.10

before a theatre of war, wearing costume that is a mix of the ceremonial robes of a Polish ruler and the attire of a Polish cavalryman: a delia (overcoat), a kalpak (fur hat), and a war hammer, all deriving from Ottoman fashion and manifesting the blurred distinction between foreign and local in this vast polity.[93] Regardless of their place of manufacture, things like the Cracow carpet belonged in such transcultural contexts.

Speculative provenience of carpets in Poland aside, carpet looms in Poland–Lithuania are no myth. The loom in Zamość was the first known Ruthenian example and was associated with the domain of Grand Crown Chancellor Jan Zamoyski (1542–1605). The workshop dates to 24 May 1585, when King Stephen (r. 1576–86) granted an exclusive privilege to the master weaver Murat Jakubowicz (d. after 1612) for the manufacturing of carpets 'in the Turkish manner' (*more turcico*).[94] The reported Turkish form of these things is partially explained by Jakubowicz's origins—he was an Armenian from Caffa (Ukrainian: Feodosiia) in Crimea, and therefore might have been seen as Turkish in Poland–Lithuania.[95] Despite the surviving act of privilege for Jakubowicz, it is uncertain whether a workshop in Zamość was actually established and, if it was, how long it survived.[96] The existence of a workshop in Brody (also in Ruthenia) that belonged to Lord Grand-Hetman of the Crown Stanisław Koniecpolski (1591–1646) is supported by more reliable sources.[97] The loom began operating around 1640 and was run by a Greek weaver referred to by the Polonized name Manuel Korfiński (d. after 1644). The workshop must have been successful because on 11 July 1641 Korfiński accepted two local apprentices for 'teaching them silk craft'.[98] The loom was still running at full steam in 1659, when panegyricist Stanisław Żyznowski wrote a poem glorifying Koniecpolski's heir Aleksander (1620–59). In his description of the palace gardens, the author takes the reader to the loom where weavers spin silk from cocoons for the yarn and make carpets and other fabrics 'as if in Persia itself' (*ac si in ipsa Perside*).[99] The comparison of the style of these carpets with that of those produced in Iran returns us again to the question of doublethink. Sources tell us that silk for the Brody loom was produced in West Asia, labour was supplied by Turkish weavers, and the carpets themselves looked Persian—even though they were woven locally.[100]

The language used in the documents implies that, despite the geographically interconnected network of suppliers, producers, and consumers, the Brody carpets were perceived as objects of local material culture that, although Persian in appearance, were Ruthenian by implication. Scholars have even attempted to link existing sixteenth- and seventeenth-century carpets in Polish and Ukrainian collections with both this loom and the one in Zamość, taking the textiles' stylistic features as a criterion. Thus if an object appeared to deviate from the Turkish or Persian mode deemed 'typical', it became a candidate for association with one of the Ruthenian workshops.[101] That some of these

carpets to this day have no conclusive provenience confirms that the difference between 'made in Persia/Turkey' and 'made in the Persian/Turkish manner' continues to confound, implying a context where the mimicry of foreign designs blended smoothly with local tastes and expectations.

Foreign or local?

One source in particular reveals that modern categories of origin and provenience fail in confrontation with early modern realities. A carpet at Wawel Castle (Figure 4.11) looks like a typical Anatolian *ushak*—a term denoting rugs named by convention after the city of Uşak, many of which were commissioned by Polish–Lithuanian patrons. Like others, this one features a family coat of arms: the Ogończyk arms of Krzysztof Wiesiołowski (c. 1580–1637). Owner of Białystok and Kamienna, and leaseholder of thirteen crown lands spanning both the Kingdom of Poland and the Grand Duchy of Lithuania, from 1635, Wiesiołowski was also Lord Grand-Marshal of Lithuania, one of the highest offices of state.[102] The identification of the Wawel rug as a piece commissioned by Wiesiołowski hinges primarily on the display of his personal coat of arms, which is incorporated into the design at the upper edge of the object. The initials 'CW' added atop the escutcheon stand for 'Christophorus Wiesiolowski', the Latinized version of the patron's name, which further imply that the carpet was his commission; the absence of any signs of marshal office suggests that the rug was woven before 1635.[103] Additional information from his wife Aleksandra Wiesiołowska's (d. 1645) last will has led to speculation that the rug was produced in Poland, Ruthenia, or Lithuania. The document lists 'five grand carpets in the Persian manner of our domestic manufacture' (*swojej domowej roboty*) and 'twelve carpets in the Turkish manner of domestic production' (*na kształt dywańskich domowej roboty*).[104]

It is unverifiable whether this document refers to carpets made on the Wiesiołowski estate or elsewhere in Poland–Lithuania, or whether Lady Wiesiołowska had them commissioned in West Asia ('domestic' here referring—not entirely convincingly—to Persia and Turkey), or whether perhaps her servants merely repaired these items. Mańkowski, who often focused on attributing carpets to Polish workshops, claims that the wool is coarser than in 'typical' Anatolian carpets and thus the object is of Polish manufacture given the country's harsh winters; he also suggests that it might have been produced by the loom in Zamość.[105] Correlation of wool fineness and the typical climate in the location of a loom does not imply causation, however; very fine pashmina, for instance, comes from cold mountain areas.[106] Also working against this attribution is the fact that many armorial carpets were commissioned by Poles, Ruthenians, and Lithuanians, who sometimes sent agents carrying specifications of the carpets' desired qualities and—as existing sources indicate—rarely

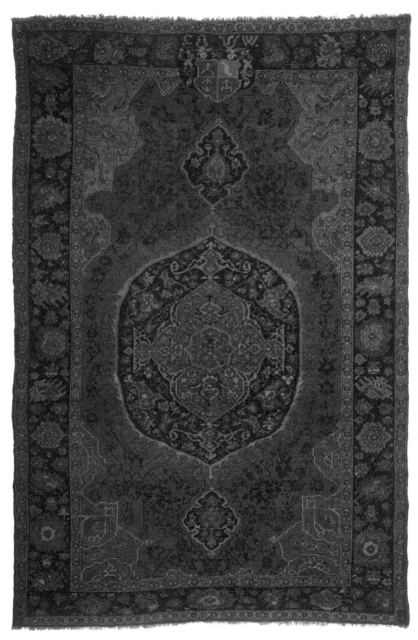

4.11 Medallion Ushak-type carpet with the coat of arms of Krzysztof Wiesiołowski, before 1635, Anatolian or Polish, knotted wool, 348 × 227 cm. Cracow, Wawel Royal Castle, inv. 240

treated these things as foreign.¹⁰⁷ Thus until the carpet undergoes laboratory analysis, we can only refer to it inconclusively as 'Polish or Anatolian', which is how Wawel Castle describes it. The case is complicated, however, by the existence of a carpet in Berlin's Museum of Islamic Art (Figure 4.12) that—with the fields of the Wiesiołowski arms reversed—was likely a twin to the carpet in Cracow.¹⁰⁸ Spuhler, who curated Islamic textiles at Berlin State Museums between 1968 and 1985, followed Mańkowski's Polish attribution. Justifying the classification, Spuhler explains that the palette contains two additional shades not known in carpets actually made in Anatolia, the wool is unusually coarse, and the composition is 'unsatisfying and awkward'.¹⁰⁹ While the Wawel curators list the inconclusive provenience, Spuhler fully endorses the Wiesiołowski armorial rugs' manufacture in Poland, referencing their description in Lady Wiesiołowska's last will as 'in the Turkish manner' as conclusive evidence.¹¹⁰

Admittedly, the rhetoric of Wiesiołowska's last will does not help today's curators: it marks only a hazy line between carpets made in Poland–Lithuania and those woven in West Asia. The Cracow and Berlin carpets were commissioned in this multivalent, transcultural context, in which—if the will is to be believed—little difference was drawn between Ottoman and Ottomanesque textiles. For art historians, it has been important to make a clear-cut distinction between Anatolian and Polish carpets; this was not the case for early modern families like the Wiesiołowskis. Regardless of where they came from, these carpets were both local and foreign, both domestic and exogenous. They were not unfamiliar, exotic objects (as they have often been erroneously thought of by modern scholars), but things that already had local meanings. Wiesiołowski patronage exemplifies this embrace of multivalenced cultural forms that escape precise definitions and limits. By featuring in two extant carpets, Krzysztof's coat of arms transforms these otherwise ambiguous artifacts into acceptable means of cultural self-expression for a Polish–Lithuanian nobleman.

A similar example is offered by the carpet at the National Museum in Munich (Figure 4.13), which also combines Ottoman forms with European arms—in this case those of Dołęga and Guldenstern. This object belonged to Jan Kazimierz Kretkowski (1634–76) and his wife Katarzyna Lukrecja (1640–81), daughter of Zygmunt Guldenstern, a courtier of Sigismund III. While its weaving technique has been deemed Turkish, Konstancja Stępowska (1878–1912) described it as a 'Polish woollen rug' in her pioneering 1912 publication, citing the use of locally derived dyes and the presence of undyed wool.¹¹¹ Other critics suggested that the Kretkowski carpet is a Polish copy of an Ottoman original, securely placing its origin in a Commonwealth location.¹¹² Yet the provenience of the Kretkowski carpet remains a hypothesis, a deadlock all the more debilitating as there is no accepted formal language to accurately render

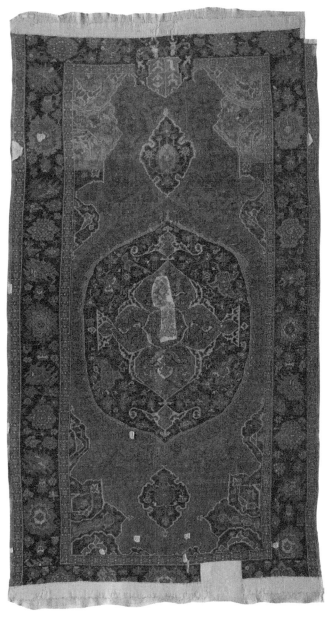

4.12 Medallion Ushak-type carpet with the coat of arms of Krzysztof Wiesiołowski, first half of the seventeenth century, Poland(?), wool, 363 × 197 cm. Berlin, Museum für Islamische Kunst der Staatlichen Museen zu Berlin – Preußischer Kulturbesitz, 4928

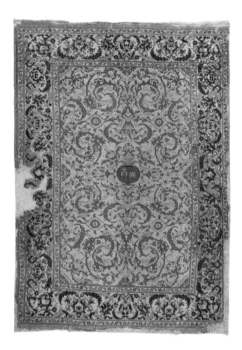

Carpet with ornamental design, seventeenth century, Poland(?), wool, 240 × 167 cm. Munich, Bayerisches Nationalmuseum, Inv.-Nr. T 1612, Foto Nr. D52101

4.13

the ambiguous status of this and other carpets without falling into the trap of geographical determinism.

Seventeenth-century inventories of movable property abound in descriptions of rugs described as Turkish and Persian that furnished many noble homes, even humbler ones.[113] Yet on closer inspection, it becomes apparent that most of the entries do not describe carpets' geographical origins. For example, the 1661 inventory of nobleman and major landowner Aleksander Michał Lubomirski's (1614–77) movable property at Wiśnicz Castle lists no fewer than 109 rugs. Only two, however, appear as specifically Persian, and fifteen as Turkish (*dywańskie*), with the qualifier that the latter be used in the Lubomirskis' Warsaw residence. No provenience is mentioned for the remaining carpets, though eleven of them are described as featuring the family's arms and having been acquired 'from a Greek merchant' (*od Greczyna*); and one 'golden' carpet was 'bought in Cracow'.[114] The 1616 inventory of the Ostrogski Palace in Dubno evinces a much larger collection: forty-eight large Persian (*adziamski*) carpets, nineteen small carpets of the same origin, and twelve Persian rugs with no sizes given. The document also includes sixty-nine carpets with no listed origins, eighteen

of which were gifts from 'His Lordship Palatine of Podolia', probably Hieronim Jazłowiecki (1570–1607), who was related to the family through marriage to Eufrozyna Ostrogska (1554–1620).[115] Given that Jazłowiecki served several times as the Polish king's diplomatic envoy to Constantinople (today Istanbul), these carpets might have been Turkish, but that is not what the inventory emphasizes. Instead, as with all the inventories mentioned here, it is family connections, points of acquisition, and sites of display that lent meaning to these objects. This is not to say that there was no attempt to define the objects' origins on the part of their owners or of notaries. There is some attention to formal appearance that suggests there was a system in place that valued a certain geographical idea of an object. But as we have seen, equally important is where it was acquired or whether it was a gift; in other words, it was the owner's personal connection to objects that justified their inclusion in the collection. The carpets were often described as Persian or Turkish, but they were also family heirlooms, status-enhancing gifts, or happy finds, and as such they were associated with local custom rather than exoticism. Polish–Lithuanian nobles saw carpets as intimately connected with their ways of life: local yet transcultural, distinct yet entangled, familiar yet outward reaching.

The exotic/local binary has recently been blurred by scholars like Peter Mason and Benjamin Schmidt,[116] and it is becoming increasingly untenable to limit artefacts and materials to national contexts.[117] Work on the transcultural dimension of Asian textiles and their assimilation in Europe and elsewhere is a particularly well-developed field as silks, cottons, and woollens were some of the most traded commodities in all of world history, generating a vast amount of revenue and touching every level of society.[118] West Asian carpets exemplify this phenomenon, with visual and archival examples available for all corners of Europe, including England, Italy, France, the Netherlands, the German-speaking lands, Spain, and Hungary.[119] Many portraits and still lifes depict tables covered in carpets, suggesting that these artefacts were widely available to European elites.[120] Carpets also make frequent appearance in depictions of enthroned rulers and of the Virgin, as a marker of majesty.[121] The immense popularity of these things led to the rise of local substitutes, for example the voluminous production of Turkish-style Spanish carpets.[122] The adaptation of West Asian carpets in Poland is one of many such examples of transculturation and should be seen in wider European perspective.

Though one of the best documented cases of merging and converging material cultures in early modern Europe, Polish carpets remain virtually unknown in Western scholarship, except by a handful of textile experts. Yet they are worth knowing about, not least because they offer a comparative view of early modern globalism that is not restricted to Western European metropoles and colonies. The carpets' widespread availability, ubiquitous distribution, and capacity to fit into local contexts allowed their owners to conflate

local and foreign forms, thereby fashioning a truly transcultural practice. Mańkowski and his followers framed this absorption of carpets into Polish lived realities as a symptom of 'Orientalization', which in their view reinforced Poland's distinctiveness from the rest of Europe.[123] But this is a problematic interpretation: all Europeans of means keenly collected these precious objects, including elsewhere in Central and Eastern Europe, Hungary, Croatia, and, in particular, the Balkans.[124] The binary arc of 'Orientalization' thus distorts West Asian carpets' early modern reception, entertaining deterministic explanations of their origins as simply West Asian, despite a larger spectrum of possible interpretations.

Foregrounding the transcultural

The pursuance of monocultural interpretation is, as many have argued, enmeshed in art-historical and museological thinking, which since the nineteenth century has favoured classification by point of geographical origin, in step and in partnership with the formation of modern nation-states.[125] If Prince Czartoryski misled visitors to the 'Polish room' at the Trocadéro in 1878, it was by no means out of wilful disregard for historical truth, but was rather in line with national expectation and sentiment. By the late nineteenth century, modern Polish ethno-nationalism was in full bloom.[126] While in premodern Poland–Lithuania a sense of nationhood had largely been reserved for the political community of the realm (i.e., the nobility), in the nineteenth century, Roman Catholicism and the Polish language provided a framework for imagining the nation alongside the previously less meaningful ethno-confessional and ethno-linguistic lines.[127] Slavic-speaking Catholic peasants were included in the ranks of this imagined community, as were the Polish-speaking noble families of Lithuania and Ruthenia, who were in turn excluded from competing ethnonational projects taking shape in Lithuania, Ukraine, and Belarus.[128] Paradoxically, Ottomanesque and Persianate carpets, however culturally ambiguous, were absorbed into this new vision of a unique, ethnically defined Polish nation—a modern association seductively projected into the past.

Take, for example, the genre painting from 1891 (Figure 4.14) by then Munich-based Polish-speaking Catholic painter and nobleman Henryk Weyssenhoff (1859–1922). The artwork depicts two men in the recognisable attire of the old Polish–Lithuanian nobility, which by the nineteenth century had come to be understood as the national costume of Poland in a much narrower, ethnic sense.[129] In addition to this display of sartorial pride, the entire wall of the room where the protagonists have gathered is covered with a grand West Asian carpet, so many of which adorned the houses of Polish elites in the period. Islamic-style furniture and weapons complete this picture of flamboyant patriotism. It is unclear whether the two men represent early modern

180 Transcultural things

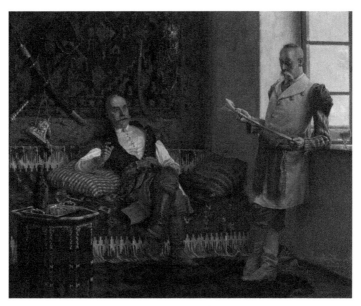

4.14 Henryk Weyssenhoff, *Story of a Yatagan*, 1891, oil on canvas, 73 × 90 cm. Warsaw, Muzeum Narodowe, MP 5357

personalities, or whether they are modern subjects re-enacting the past or simply two nostalgic patriots caught up in conversation. The subject of this conversation is nonetheless easy to discern. The men are visibly animated by the dagger one of them holds in his hands; indeed, the National Museum in Warsaw, where the painting resides, lists it as *Story of a Yatagan*, alluding to the weapon, which was Ottoman in origin.[130] A tale about this object is thus being told before our eyes; although we cannot hear the men's words, the assemblage of West Asian and Islamic things in the painting makes it conceivable that the figures are indulging in conversation about a Polish victory over the Ottomans, which—given the history of military clashes between these two polities—would have taken place in the seventeenth century.

The dagger, the grand carpet, and the other objects were possibly captured as war booty—a reference to Poland's triumphant past that would have been particularly poignant in the nineteenth century, when the former regional power was no longer a sovereign state. The story of the *yatagan* dagger animated via a feast of Ottoman artefacts thereby becomes a pride-inducing history of Poland, evoking both a nostalgia for irretrievably lost statehood and a vision of distinctiveness from the rest of Europe. Thus a historical imaginary comes into view, taking shape from material things—a conceptualization of cultural uniqueness so strong as to become the seemingly natural embodiment of a modern nation. There is, of course, an obvious contradiction in

this patriotic co-opting of West Asian material into nationalist ideology: the things that are supposed to epitomize Polish cultural heritage in the painting are not uniquely Polish, neither in origin nor in ultimate form. But although the grand carpet attached to the wall, just like the eponymous *yatagan*, is foreign by birth, it has become patriotic by adoption. To understand it as both Ottoman and Polish, however, requires a healthy dose of doublethink—of both recognizing the place of these artefacts' manufacture and ignoring it, all at once. The refusal to experience cognitive dissonance in reading these carpets as both Ottoman and Polish is precisely the condition that made their full domestication into Polish ethno-national memory possible in the first place, but it was the flattening out of their epistemic multivalence that ossified their role as national symbols.

Such cognitive conflicts and contradictions abounded in nineteenth-century Poland. The objects filling up the room in Weyssenhoff's painting aim to achieve a specific effect—that of the *long durée* of Polish cultural heritage and its alleged continuity into the present—yet this projection hinges on the acceptance of these things' possible origin outside of Poland. Even the place where the scene takes place is not in Poland: Aneta Pawłowska has suggested that the painting is set in the old wooden manor of Russakowicze (Belarusian: Rusakovichi), the Weyssenhoff family's ancestral seat, then administratively in the Minsk *gubernia* (governorate) of the Russian Empire.[131] Henryk turned the building into a museum full of objects similar to the ones depicted in the painting, the purpose of which was manifestly to evoke Polish history. Russakowicze was nonetheless never a Polish village: even under the old Commonwealth, it belonged to the Grand Duchy of Lithuania, and during Henryk's lifetime, as in previous centuries, it was inhabited by a majority Belarusian-speaking population.[132] Many local landowners in the area, however, considered themselves Polish, and so did the Weyssenhoffs, though paradoxically—to provide a fuller picture—they were originally German-speaking nobility from Livonia (today's Latvia and Estonia), and only later began to adhere to a Polish identity.[133] While for all intents and purposes the *Story of a Yatagan* is a visual relic of an older transcultural past, it effectively serves as a reifying force for Polish ethno-nationalism, which at the moment of the painting's creation was still a relatively new concept in need of definition and reappraisal.[134]

Paintings like this one reveal their relevance to contemporary concerns by exposing the role of artefacts in engendering cultural memory. Carpets had a particular function in promoting patriotic feelings among nineteenth-century Polish-speaking elites since, as domestic objects, they were both familiar and popular. Through their reappearance in images and other cultural representations, carpets' popularity grew only further, creating and sustaining a feeling of shared belonging among their owners, a feeling that now appeared historically

vindicated. The mechanism of embedding these once exogenous material forms in a discourse of vernacular tradition is relevant not only as a symptom of transculturation in the past but also as a lesson for today's societies not to fear loss of national culture and identity. During the early twenty-first century, such fears have been increasingly exploited by so-called 'tribunes of the people' in Europe and North America who—amid ongoing concerns over immigration policy and the impact of global commerce—have embraced a false vision of the West's historical distinctiveness and coherence, allegedly manifested in vernacular culture.[135]

But as this chapter has contended, the idea of cultural forms' origins is a paradox. After all, how can we ever determine what is Persian or Ottoman, and what Polish–Lithuanian; what is 'ours' and what 'theirs' about culturally ambiguous carpets that were in fact commissioned, produced, and consumed in transcultural contexts?[136] It is worth remembering how early modern beholders saw these artefacts. Sometimes they could tell a difference between one style of object and another, but often they were simply not interested in distinguishing between foreign imports and local manufacture. Things from different cultural contexts can be so closely entangled that it becomes impossible to separate them. Early modern Polish–Lithuanian owners and viewers did not make a clear-cut distinction between a Polish carpet and a 'so-called Polish carpet'; for them both types of textiles could signify local tradition.

Although debates about the movement of images and cultural exchange have been reshaping art history for quite some time, residual thinking about cultural differences prevails.[137] It is therefore critical to examine artefacts that have been linked to specific places—such as carpets possibly made in Poland–Lithuania, Anatolian carpets exported to Poland–Lithuania, and Persian carpets of the Polonaise type—with an acknowledgement of their cultural multivalence. Many art historians think of these objects as Oriental in style, but to place them on an East-vs-West spectrum is to miss the point: this antithesis overlooks early modern Europe's cultural heterogeneity, which does not fit into the conventional modern binary of Orient versus Occident. To study these carpets means to put to the test the still commonly accepted binaries of native and foreign, local and exotic, self and other. West Asian carpets are fruitful for this pursuit because they foreground local sentiments and simultaneously highlight Europe's connections with the wider world, proving that even the intimate process of trying to comprehend the specificity of one's own local context may be—and often was—shaped by transcultural flows of things and their enduring legacies. This often messy pluralism of origins is best brought to the fore rather than hidden away, amplified rather than silenced, made messier still rather than disentangled.

So: Where do Polish carpets come from? Certainly, from different places simultaneously. They are neither simply Polish nor Iranian nor Turkish,

neither European nor Islamic; these carpets are all these things at the same time, at once domestic and exogenous. To properly describe these heterotopic things we need to scrap the modern binary notion of their epistemic status as Oriental decorative arts and embrace the early modern (double) thinking of their owners, who did not see a contradiction in perceiving Iranian or Turkish objects as belonging to Polish tradition.[138] These carpets embody more layers of meaning and relationships to other places than immediately meet the eye. Their deployment in Poland might be considered imitative, but this is imitation in a generative sense, wherein one cultural context is co-opted to suit another, creating an illusion of timeless and authentic heritage. But as historian of transculturation Barbara Fuchs has aptly noted, 'imitation compromises the narratives of national distinction by emphasising inconvenient similarities and shared heritages'.[139] These carpets thus preclude a reading of Poland's culture as unique, self-contained, and coherent. After all, they do not emerge from a prior point of cultural purity or authenticity but rather share in cultural expressions that are neither fully new nor old, neither entirely local nor foreign, neither 'ours' nor 'theirs'.[140] Sometimes deemed foreign, often native, but most typically an indivisible aspect of local lifestyle, these transcultural things thus serve as the perfect platform from which to explore the mechanics of things' incorporation into local and national tradition.

Notes

1 Marina Warner, *Stranger Magic: Charmed States and the Arabian Nights* (Cambridge, MA: Belknap Press, 2013).
2 Demange, 'The Long Answer', 178.
3 Philibert Breban, *Livret-guide du visiteur à l'Exposition historique du Trocadéro* (Paris: E. Dentu, 1878), ii.
4 Moya Carey and Mercedes Volait, 'Framing "Islamic Art" for Aesthetic Interiors: Revisiting the 1878 Paris Exhibition', *International Journal of Islamic Architecture* 9, no. 1 (2020): 31–59.
5 'On y trouve des armes et des armures de différentes époques, des selles ornées avec toute l'ostentation de la race slave, des étoffes précieuses, des tapis de Cracovie de style persan, des pièces d'orfèvrerie, des portraits, des livres, des porcelaines, des émaux, etc'. In *Les merveilles de l'Exposition de 1878: Histoire, construction, inauguration, description détaillée des palais, des Annexes et des parcs* ... (Paris: Librairie contemporaine, 1879), 727.
6 For George Orwell (1903–50), the English novelist who coined the term, 'doublethink' is 'the power of holding two contradictory beliefs in one's mind simultaneously, and accepting both of them'. George Orwell, *Nineteen Eighty-Four* (London: Secker & Warburg, 1949), 220.

7 'On distinguera aussi une tapisserie dans le goût de Smyrne, sur les parois de ce salon.' In A.-R. de Liesville, 'L'exposition historique de l'art ancien', *Gazette des Beaux-Arts*, 1 July 1878, 13.
8 For the more conventional scholarship on the so-called Polish carpets, see Arthur Upham Pope, 'So-Called Polish or Polonaise Carpets (Oriental Rugs as Fine Art, V)', *International Studio* 76 (March 1923): 535–44; Maurice S. Dimand, *Loan Exhibition of Persian Rugs of the So-Called Polish Type* (New York: The Metropolitan Museum of Art, 1930); Kurt Erdmann, *Seven Hundred Years of Oriental Carpets*, ed. Hanna Erdmann, trans. May Beattie and Hildegard Herzog (Berkeley and Los Angeles: University of California Press, 1970); Donald King, 'The "Doria" Polonaise Carpet', in *Persian and Mughal Art*, ed. B. W. Robinson (London: Colnaghi, 1976), 303–7; Murray L. Eiland, 'Scholarship and a Controversial Group of Safavid Carpets', *Iran* 38, no. 1 (2000): 97–105.
9 Stefano Ionescu, ed., *Antique Ottoman Rugs in Transylvania* (Rome: Stefano Ionescu, 2005); Steven Cohen, '"Portuguese" Carpets from Khorasan, Persia', in *Textiles in Indian Ocean Societies*, ed. Ruth Barnes (London: Routledge, 2004), 35–43.
10 Ortiz, *Cuban Counterpoint, Tobacco and Sugar*, 32–33.
11 Welsch, 'Transculturality'; Codell, *Transculturation in British Art*.
12 Michel Foucault, *The Order of Things* (London: Routledge, 2002), 235–40.
13 Matthew Rampley, *The Vienna School of Art History: Empire and the Politics of Scholarship, 1847–1918* (University Park, PA: Penn State University Press, 2013), 74–75; Eilean Hooper-Greenhill, *Museums and the Shaping of Knowledge* (London: Routledge, 1992), 186–88.
14 *Les Merveilles de l'exposition de 1878*, 723–35.
15 Kathleen Curran, *The Invention of the American Art Museum* (Los Angeles: The Getty Research Institute, 2016), 9–48.
16 Wolff, *Inventing Eastern Europe*, 1–16.
17 The longer passage, also referred to above, reads in the original: 'Dans la vitrine suivante sont des tapis en brocart d'or, avec ornaments et fleurs en velours; beaucoup de nos collectionneurs possédant des tapis du même genre les croyaient persans et du XVIe siècle, quand on découvrit dans la bordure de l'un d'eux un M; on fit des recherches, on trouva dans d'autres tapis du même genre cet M répété à satiété soit dans les détails de la bordure, soit dans les dessins d'ornament des angles; et on ne tarda pas à se convaincre que ces tapis, de toute beauté du reste, avaient été fabriqué à Cracovie, vers la fin du XVIIe siècle, par un polonais, nommé Mazarski, revenu de Perse où il avait été retenu prisonnier et où il avait travaillé dans une manufacture de tapis. Approchez-vous de ces tapis et vous y verrez, répétés à l'infini dans la bordure des oeuvres de cet habile homme, les M, lettre initiale de son nom.' In Breban, *Livret-guide du visiteur à l'Exposition historique du Trocadéro*, 64.
18 'Dans le course du seizième siècle, on vit s'élever en Pologne de nombreuses fabriques établies par de riches & illustres familles.' In *Les collections célèbres d'oeuvres d'art, dessinées et gravées d'après les originaux par Edouard Lièvre* (Paris: Goupil, 1879), cat. no. 60.

19 'Le tapis de notre dessin représente un fragment de un très-beau spécimen des produits de cette branche de l'industrie polonaise, fabriqué au seizième siècle, qui a appartenu à la famille Czartoryski. [...] Ces feuilles semées à profusion & sans confusion sur un fond d'or, sont un effet splendide & attestent le degré de perfection auquel étaient déjà arrivés à cette époque les arts industriels en Pologne.' In *Les collections célèbres*, cat. no. 60.

20 'Mais des documents auxquelles nous devons nous rapporter donnent pour auteur de ce tapis un Polonais du nom Mazarski, établi à Cracovie à la fin du XVIIe siècle, au retour de Perse, où il aurait appris l'art de leur fabrication.' In Alfred Darcel, *Les tapisseries décoratives du garde-meuble ... Choix des plus beaux motifs* (J. Baudry, 1881), cat. no. 94.

21 Banas, 'Persische Kunst und polnische Identität', 123; Beata Biedrońska-Słota, 'Composition of Persian Carpets Called Polish', in *Studies in Oriental Art and Culture in Honour of Professor Tadeusz Majda*, ed. Anna Parzymies (Warsaw: Dialog, 2006), 285–86.

22 T. Krygowski, 'Polenteppiche (polnische Knüpfteppiche)', *Orientalisches Archiv* 2 (1911/12): 70–76, 106–21.

23 Alois Riegl, *Altorientalische Teppiche* (Leipzig: T.O. Weigel, 1891); Chris Dercon et al., eds., *The Future of Tradition, the Tradition of Future: 100 Years after the Exhibition 'Masterpieces of Muhammadan Art' in Munich* (Munich: Prestel, 2010), 119.

24 Wilhelm Bode, *Vorderasiatische Knüpfteppiche aus älterer Zeit* (Leipzig: Hermann Seemann, 1902), 49–60.

25 Mańkowski, *Polskie tkaniny i hafty XVI-XVIII wieku*, 100.

26 'Schon seit langem ist von Wilhelm Bode die Fabel von der polnischen Entstehung der seidenem, mit reicher Einwirkung von Silber- und Goldfäden Perserteppiche zerstört worden.' In Friedrich Sarre, 'Die Teppiche', in *Meisterwerken Muhammedanischer Kunst in München 1910: Text*, ed. Friedrich Sarre and Fredrik Robert Martin, vol. 2 (Munich: F. Bruckmann, 1912), n.p. For the significance of this exhibition, see Avinoam Shalem and Andrea Lermer, eds., *After One Hundred Years: The 1910 Exhibition 'Meisterwerke Muhammedanischer Kunst' Reconsidered* (Leiden: Brill, 2010).

27 Denise-Marie Teece, 'Through the Renaissance Frame: Carpets and the Beginnings of "Islamic Art" in Nineteenth-Century Vienna and Berlin', *The Textile Museum Journal* 44 (2017): 57–58.

28 Dimand, *Loan Exhibition of Persian Rugs of the So-Called Polish Type*, cat. no. 6; Maurice S. Dimand and Jean Mailey, *Oriental Rugs in the Metropolitan Museum of Art* (New York: The Metropolitan Museum of Art, 1973), cat. no. 17.

29 For example, Caroline Mawer, 'Polish Relations: The Vasa Silk Kilims', *Hali* 172 (2012): 50–57.

30 Friedrich Spuhler, 'Seidene Repräsentationsteppiche der mittleren bis späten Safawidenzeit: Die sog. Polenteppiche' (PhD Thesis, Berlin, Freie Universität, 1968), 163–252.

31 'The Czartoryski Carpet', in *The Met*, www.metmuseum.org/art/collection/search/450563 (accessed 26 September 2017).

32 Fredrik Robert Martin, *A History of Oriental Carpets before 1800* (Vienna: K.K. Hof- und Staatsdruckerei, 1908), 62.
33 Dimand, *Loan Exhibition of Persian Rugs of the So-Called Polish Type*, xvii.
34 Friedrich Spuhler, Preben Mellbye-Hansen, and Majken Thorvildsen, *Denmark's Coronation Carpets, Copenhagen* (Copenhagen: The Royal Collections, 1987), 32.
35 Rudolph P. Matthee, *The Politics of Trade in Safavid Iran: Silk for Silver, 1600–1730* (Cambridge: Cambridge University Press, 1999).
36 Nobuko Shibayama, Mark Wypyski, and Elisa Gagliardi-Mangilli, 'Analysis of Natural Dyes and Metal Threads Used in 16th -18th Century Persian/Safavid and Indian/Mughal Velvets by HPLC-PDA and SEM-EDS to Investigate the System to Differentiate Velvets of These Two Cultures', *Heritage Science* 3, no. 12 (2015), https://doi.org/10.1186/s40494-015-0037-2.
37 See, for example, Christy Anderson, Anne Dunlop, and Pamela H. Smith, eds., *The Matter of Art: Materials, Practices, Cultural Logics, c.1250–1750* (Manchester: Manchester University Press, 2014); Dagmar Schäfer, Giorgio Riello, and Luca Molà, eds., *Threads of Global Desire: Silk in the Pre-Modern World* (Woodbridge: Boydell Press, 2018).
38 Dorothy Armstrong, 'What Is an 'Oriental' Carpet? Reimagining, Remaking, Repossessing the Patterned Pile Carpets of South, Central and West Asia since 1840' (PhD Thesis, London, Royal College of Art, 2019).
39 See, for example, Tadeusz Mańkowski, 'Note on the Cost of Kashan Carpets at the Beginning of the Seventeenth Century', *Bulletin of the American Institute for Persian Art and Archaeology* 4, no. 3 (1936): 152–53.
40 Zdzisław Żygulski Jr., 'Wspomnienie o Tadeuszu Mańkowskim', Mój Lwów, 1996, www.lwow.home.pl/zygulski.html.
41 Tadeusz Mańkowski, 'Wyprawa po kobierce do Persji w roku 1601', *Rocznik Orientalistyczny* 12 (1951): 194. Based on the calculation of travel distances between Mangalia and Kashan, as well as Isfahan and Cracow, Mańkowski convincingly argues that regardless of the date of 1602 as evoked by the printed edition of Muratowicz's itinerary (1772), the actual departure took place in the spring of 1601.
42 Blake De Maria, *Becoming Venetian: Immigrants and the Arts in Early Modern Venice* (New Haven: Yale University Press, 2010), 20.
43 Waldemar Deluga, ed., *Ars armeniaca: Sztuka ormiańska ze zbiorów polskich i ukraińskich* (Zamość: Muzeum Zamojskie, 2010); Krzysztof Stopka, 'Armenians', in *Under a Common Sky: Ethnic Groups of the Commonwealth of Poland and Lithuania*, ed. Michał Kopczyński and Wojciech Tygielski (New York, NY: PIASA Books, 2017), 134–49.
44 Osipian, 'Between Mercantilism, Oriental Luxury, and the Ottoman Threat'.
45 Alexandr Osipian, 'Legal Pluralism in the Cities of the Early Modern Kingdom of Poland: The Jurisdictional Conflicts and Uses of Justice by Armenian Merchants', in *The Uses of Justice in Global Perspective 1600–1900*, ed. Griet Vermeesch, Manon van der Heijden, and Jaco Zuijderduijn (London: Routledge, 2019), 80–102.
46 Eleonora Nadel-Golobič, 'Armenians and Jews in Medieval Lvov: Their Role in Oriental Trade 1400–1600', *Cahiers du Monde russe et soviétique* 20, no. 3/4

(1979): 347–51; Michael Połczyński, 'The Relacyja of Sefer Muratowicz: 1601–1602 Private Royal Envoy of Sigismund III Vasa to Shah 'Abbas I', *Turkish Historical Review* 5, no. 1 (2014): 60.

47 The Central State Historical Archives of Ukraine, City of Lviv (TsDIAL), Acta Iudicii Armenorum Leopol. ab Anno 1611 ad 1615, vol. 8, in folio p. 1018. For transcription, see, Sadok Barącz, *Żywoty sławnych Ormian w Polsce* (Lviv: Zakład Narodowy im. Ossolińskich, 1856), 236 note 2.

48 TsDIAL, Acta Iudicii Armenorum Leopol. ab Anno 1607 ad 1610, vol. 7, in folio p. 679. For transcription, see Barącz, *Żywoty sławnych Ormian w Polsce*, 237 note 3.

49 It is possible that Sigismund sent Muratowicz to Iran to reopen dormant channels of communication with Shah Abbas I, circumventing the Seym's legal right to determine the Commonwealth's foreign policy. Połczyński, 'The Relacyja of Sefer Muratowicz', 60.

50 Adam Walaszek, 'Wstęp', in *Trzy rejacje z polskich podróży na Wschód muzułmański w pierwszej połowie XVII wieku*, ed. Adam Walaszek (Cracow: Wydawnictwo Literackie, 1980), 27–29.

51 Muratowicz, Relacya Sefera Muratowicza, 9. For analysis and English translation, see Połczyński, 'The Relacyja of Sefer Muratowicz'.

52 Invoice dated 12 September 1602, the Central Archives of Historical Records in Warsaw (AGAD), Archiwum Skarbu Koronnego Oddz. III, Sygn. 5, 327–328v. For full transcription and English translation, see Mańkowski, 'Note on the Cost of Kashan Carpets', 152.

53 Józef Andrzej Szwagrzyk, *Pieniądz na ziemiach polskich X-XX w.*, 2nd edn. (Wrocław: Zakład Narodowy im. Ossolińskich, 1990), 109–10; Francis W. Carter, *Trade and Urban Development in Poland: An Economic Geography of Cracow, from its Origins to 1795* (Cambridge: Cambridge University Press, 2006), 245; Edward Tomaszewski, *Ceny w Krakowie w latach 1601-1795* (Lviv: Kasa im. Rektora J. Mianowskiego, 1934), 192.

54 Around 1600, 1 thaler was equivalent of 40 *grosz*, and an unskilled labourer in Cracow would earn 3–5 *grosz* a day in 1601. Thus, Muratowicz's Kashan order was worth roughly 25 years of an unskilled labourer's daily wages (provided they worked seven days a week). See Szwagrzyk, *Pieniądz na ziemiach polskich X-XX w.*, 136, 142.

55 Some of Sigismund II's carpets were brought to Cracow by Wawrzyniec Spytko Jordan from his trip to Turkey in 1553; Several of Báthory's carpets were ordered through the mediation of Armenian merchants in 1585. See Mańkowski, 'Wyprawa po kobierce do Persji w roku 1601', 190.

56 Adam Chmiel, ed., *Wawel: Materyały archiwalne do budowy zamku*, vol. 2 (Cracow: Drukarnia Uniwersytetu Jagiellońskiego, 1913), 467; Władysław Tomkiewicz, *Z dziejów polskiego mecenatu artystycznego w wieku XVII* (Wrocław: Ossolineum, 1952), 22.

57 Konstancya Stępowska, 'Polskie dywany wełniane', *Sprawozdania Komisji Historii Sztuki w Polsce* 8, no. 3/4 (1912): 353–55; Biedrońska-Słota, 'Kobierce z polskich manufaktur', 151.

58 Spuhler, 'Seidene Repräsentationsteppiche der mittleren bis späten Safawidenzeit', 15–34.
59 Tadeusz Mańkowski has cogently demonstrated that five carpets kept in the collection of the Residenz in Munich can be plausibly traced back to the 1601 journey of Muratowicz. Mańkowski, *Orient*, 173. See also Herbert Brunner and Albrecht Miller, *Die Kunstschätze der Münchner Residenz* (Munich: Süddeutscher Verlag, 1977), 22–23, 259–60.
60 Dercon et al., *The Future of Tradition*, 118, cat. 24.
61 Carol Bier and Textile Museum, Washington DC, eds., *Woven from the Soul, Spun from the Heart: Textile Arts of Safavid and Qajar Iran, 16th–19th Centuries* (Washington, DC: Textile Museum, 1987), 230, cat. 49.
62 Maria Taboga, '1601: Un tappeto ti Sigismondo III Wasa al Quirinale', *Il Quirinale* 6 (2008): 1–12.
63 Irena Fabiani-Madeyska, 'Palatium Regium w Gdańsku', *Rocznik Gdański* 15/16 (1956/57): 167; Tadeusz Mańkowski and Mieczysław Gębarowicz, 'Arrasy Zygmunta Augusta,' *Rocznik Krakowski* 29 (1937): 171; Tomkiewicz, *Z dziejów*, 44.
64 Quoted in Wiktor Czermak, *Na dworze Władysława IV* (Cracow: Spółka Wydawnicza Polska, 1901), 72.
65 'Le tapisseries Royalles ne sont pas seulement de plus belles de l'Europe, mais de l'Asie.' In Jean Le Laboureur, *Histoire du voyage de la Reine de Pologne*, vol. 3 (Paris, 1648), 5.
66 See, for example, Marco Spallanzani, *Oriental Rugs in Renaissance Florence*, trans. Anna Moore Valeri (Florence: SPES, 2007); Onno Ydema, *Carpets and Their Datings in Netherlandish Paintings, 1540–1700* (Zutphen: Walburg Pers, 1991); David Young Kim, 'Lotto's Carpets: Materiality, Textiles, and Pictorial Composition in Renaissance Painting,' *The Art Bulletin* 98, no. 2 (2016): 181–212.
67 In Gintel, *Cudzoziemcy o Polsce*, 133. See also Fulvio Ruggieri, *La descrittione della Pollonia di Fulvio Ruggieri (1572)*, ed. Paolo Bellini (Trent: Dipartimento di scienze filologiche e storiche, Università degli studi di Trento, 1994).
68 Sieur de Beauplan, 'A Description of Ukraine, Containing Several Provinces of the Kingdom of Poland … Written in French', in *A Collection of Voyages and Travels*, vol. 1 (London, 1704), 593.
69 Yuka Kadoi, 'Carpets on the Move: Modern Trajectories of Persian Woven Treasures,' in *The Seas and the Mobility of Islamic Art*, ed. Radha Dalal, Sean Roberts, and Jochen Sokoly (New Haven: Yale University Press, 2021), 228.
70 'Mouchoirs des Seigneurs Polonois, qui sont pour la pluspart de toile de coton en broderie de Turquie, d'or & d'argent trait, & de soye.' In Le Laboureur, *Histoire du voyage de la Reine de Pologne*, 3: 9.
71 'Il le fit tres-galamment; car estant tombé sur le discours des mouchoirs des Seigneurs Polonois, qui sont pour la pluspart de toile de coton en broderie de Turquie, d'or & d'argent trait, & de soye: il dit qu'il luy en vouloit donner un, fait de la propre main de sa femme fille du Prince Palatin des Valaques, ou elle avoit tissu leurs noms & leurs armes. Il l'alla chercher dans sa chambre, & l'envoya par un petit nain de Tartarie sur un tapis de Perse fort beau rehaussé d'or, qu'il l'obligea de prendre aussi.' In Le Laboureur, *Histoire du voyage de la Reine de Pologne*, 3: 9–10.

72 Marco Spallanzani, *Carpet Studies, 1300–1600* (Genoa: Sagep Editori, 2016), 149–65.
73 See Clifford, *Routes*.
74 Thomas, *Entangled Objects*, 4.
75 There is no documentation for the Washington and Quirinal rugs, but the Munich carpets were most likely part of the dowry of Anne Catherine Constance Vasa. See Mańkowski, 'Influence of Islamic Art in Poland', 189.
76 Mańkowski, 'Wyprawa po kobierce do Persji w roku 1601', 189.
77 Jan Ptaśnik, 'Spisanie kleynotów Xiężney Jey Mości Neuburskiey, Królewney Polskiey, Anno Domini MDCXLV', *Sprawozdania Komisyi do Badania Historyi Sztuki w Polsce* 9 (1915): xcviii–xvix; Żukowski, 'Infantka Anna Katarzyna Konstancja, 290–91.
78 Giacomo Fantuzzi, *Diariusz podróży po Europie (1652)*, ed. and trans. Wojciech Tygielski (Warsaw: Instytut Wydawniczy Pax, 1990), 184–90.
79 Inventory of Neuburg Castle, 20 April 1668, Munich, Bayerisches Hauptstaatsarchiv, GHA, Pfälzer und Pfalz-Neuburger Akten 2691, fol. 7v. 'Zwey grüen samete Portier, darauf dass Polnisch Wappen undt von dollet bluen weiß ufgenehet, undt mit grüenem taffet gefüettert. Ein grüenen Portier, darauf das Polnisch wappen mit golt eingetragen, undt mit grünem Daffet gefüttert. Ein Rothsametes Portier mit dem Polnischen Wappen, undt mit Dollet darauf genehet, mit kleinen guldenen Fransen, undt Rothtaffet gefüettert.' Many thanks to Elisabeth Weinberger for help in accessing this document. See also Almut Bues and Zbigniew Krysiewicz, eds., *Royal Marriages of Princes and Princesses in Poland and Lithuania c. 1500–1800* (Warsaw: German Historical Institute, 2016), 138.
80 Gerardina Tjaberta Ysselsteyn, *Geschiedenis der tapijtweverijen in de noordelijke Nederlanden: Bijdrage tot de geschiedenis der kunstnijverheid*, vol. 2 (Leiden: Leidsche Uitgeversmaatschappij, 1936), xvii.
81 Munich, Bayerisches Hauptstaatsarchiv, Pfalz-Neuburg Akten Neuburger Abgabe 1989, 6557, 'Verzeichnis. Von auf Befehl Phil. Wilh. nach Regensburg u. Düsseldorf gesandten…', fol. 4 and 9. Many thanks to Katrin Marth for help with identifying this source.
82 In the 1680s the Wittelsbach-Neuburg branch came to rule in the Palatinate and the new electors moved to Mannheim. In 1777 the Palatine elector Carl Theodor became—according to older family contracts—Elector of the Palatinate as well as Bavaria and transferred his residence to Munich. Since 1799, his successor, Max-Joseph of Zweibrücken-Birkenfeld, united the properties of the Palatine and Bavarian branches in Munich in order to rescue them from the progressing French armies of Napoleon. It was probably in this period that the Vasa carpets were moved from Mannheim to Munich (email from Christian Quaeitzsch of 31 July 2013). See also Friedrich Sarre and Fredrik Robert Martin, *Die Ausstellung von Meisterwerken muhammedanischer Kunst in München 1910*, vol. 2 (London: Alexandria Press, 1985), plate 60.
83 Spelled 'türkisch' in the original. Bayerische Verwaltung der staatlichen Schlösser, Gärten und Seen, Inventar der Königl. Residenz München: Gelbe Zimmer 16, 1874, Gelbe Zimmer 57.01, folio 16, nos. 29–31.
84 Julien Chapuis, Jonathan Fine, and Paola Ivanov, 'Introduction', in *Beyond Compare: Art from Africa in the Bode Museum*, ed. Julien Chapuis, Jonathan Fine, and Paola Ivanov (Berlin: Staatliche Museen zu Berlin, 2017), 17.

85 On challenging the autonomy of authorship and dispersing originality into an endless web of interconnected cultural processes, see Roland Barthes, 'Death of the Author', in *Image, Music, Text*, trans. Stephen Heath (New York: Hill and Wang, 1977), 142–48; Michel Foucault, 'What Is an Author?', in *The Art of Art History: A Critical Anthology*, ed. Donald Preziosi (Oxford: Oxford University Press, 2009), 321–34. For a critical engagement with this theory by early modernists, see H. Loh, *Titian Remade*; Wood, *Forgery, Replica, Fiction*.

86 Tadeusz Mańkowski, 'Polskie kobierce wełniane', *Arkady* 4 (1938): 152–73; Halyna Kohut, 'Profesiyni maysterni na "kylymoviy mapi" Ukrayiny XVII-XVIII st.: Fakty, mify, hipotezy', *Visnik L'vivs'kogo Universitetu. Seriya Myst-vo* 2 (2002): 132–42.

87 There is a similar carpet in the costume and textile collection of the National Museum in Warsaw, possibly another of a pair. Biedrońska-Słota, 'Kobierce z polskich manufaktur (Próba podsumowania)', 152–53.

88 Tadeusz Mańkowski, *Sztuka Islamu w Polsce w XVII i XVIII wieku* (Cracow: Nakł. Polskiej Akademji Umiejętności, 1935), 53.

89 Ferenc Batári, 'White Ground Anatolian Carpets in the Budapest Museum of Applied Arts', in *Oriental Carpet and Textile Studies II*, ed. Robert Pinner and Walter B. Denny (London: Hali, 1986), 195–203.

90 May Beattie, *Carpets of Central Persia: With Special Reference to the Rugs of Kirman* (London: World of Islam Festival Publishing Company, 1976); Jon Thompson, *Carpets from the Tents, Cottages and Workshops of Asia* (London: Barrie and Jenkins, 1988).

91 Brian Spooner, 'Weavers and Dealers: The Authenticity of an Oriental Carpet,' in *The Social Life of Things*, ed. Arjun Appadurai (Cambridge: Cambridge University Press, 1988), 195–235; Eva Troelenberg, 'Islamic Art and the Invention of the "Masterpiece": Approaches in Early Twentieth-Century Scholarship', in *Islamic Art and the Museum: Approaches to Art and Archeology of the Muslim World in the Twenty-First Century*, ed. Benoît Junod et al. (London: Saqi, 2012), 183–88; Moya Carey and Margaret S. Graves, 'Introduction: Historiography of Islamic Art and Architecture, 2012,' *Journal of Art Historiography* 6 (2012): 1–15; Yuka Kadoi, ed., *Arthur Upham Pope and a New Survey of Persian Art* (Leiden: Brill, 2016).

92 *Katalog portretów i osobistości polskich i obcych w Polsce działających*, vol. 2 (Warsaw: Biblioteka Narodowa, 1992), cat. no. 1693.

93 Turnau, *History of Dress*, 71; Jasienski, 'A Savage Magnificence'.

94 Kazimierz Lepszy, ed., *Archiwum Jana Zamoyskiego, Kanclerza i Hetmana Wielkiego Koronnego* (Cracow: Polska Akademia Umiejętności, 1948), 407.

95 Mańkowski, *Polskie tkaniny i hafty XVI-XVIII wieku*, 69–70.

96 Piotr Kondraciuk, 'Sztuka ormiańska w Zamościu,' in *Ars armeniaca: Sztuka ormiańska ze zbiorów polskich i ikraińskich* (Zamość: Muzeum Zamojskie, 2010), 12–13.

97 Mańkowski, *Polskie tkaniny i hafty XVI-XVIII wieku*, 73.

98 After Mańkowski, *Sztuka Islamu w Polsce*, 42. Arch. Ziem. Lw. rkps B 92.

99 'Officina Brodensis bombycina ... Ne interim eo in horto aliqua Dea Actaeonis nobis ingerat calamitatem, transeamus in Brodensem Officinam, ibi bombyces

sericum producentes textores ac si in ipsa Perside telas sericas in varias colorum species distinguentes, tapetia, peristromata, aliaquae Phrygii operis tegumenta conficientes placebit videre,' In Stanislaus Zyznowski, *Cvrsvs Gloriae Jllustrissimi et Excellentissimi Domini d. Alexandrin in Koniecpole Koniecpolski, Palatini Sendomiriensis* (Cracow: Christoph Schedel, 1659), D2v.
100 Mańkowski, *Sztuka Islamu w Polsce*, 37.
101 Mańkowski, *Orient*, 186.
102 Elena Kamieniecka, 'Z zagadnień sztuki Grodna połowy XVII wieku: Portrety z klasztoru Brygidek,' *Rocznik Muzeum Narodowego w Warszawie* 16 (1972): 93.
103 Ostrowski, *Land of the Winged Horsemen*, 170–71, cat. 35.
104 'Podkanclerzemu W. K. L.—swojej domowej roboty naznaczam kobiercy wielkich 5 różnej maści na kształt perskich; podkanclerzemu W. K. L. ... kobierców na kształt dywańskich domowej roboty 12.' Narodowy Instytut Dziedzictwa, Warsaw, Teki Glinki, Teka 66, f. 19.
105 Mańkowski, *Polskie tkaniny i hafty XVI-XVIII wieku*, 70–73.
106 Anamika Pathak, *Pashmina* (New Delhi: Roli Books, 2003).
107 Łoziński, *Patrycjat i mieszczaństwo lwowskie w XVI i XVII wieku*, 209–10.
108 Erdmann, *Seven Hundred Years of Oriental Carpets*, 150.
109 Friedrich Spuhler, 'Medallion Ushak, Poland,' in *Oriental Carpets in the Museum of Islamic Art, Berlin*, ed. Friedrich Spuhler, exh. cat. (London: Faber and Faber, 1988), 35–36, cat. no. 14.
110 'Medaillon-Uschak (Uschak-Teppich),' in *SMB-Digital, Online Collections Database*, www.smb-digital.de/eMuseumPlus?service=ExternalInterface&module =collection&objectId=1938871&viewType=detailView (accessed 22 July 2021).
111 Stępowska, 'Polskie dywany wełniane', 356.
112 Erdmann, *Seven Hundred Years of Oriental Carpets*, 208.
113 See, for example, an inventory from 1626 listing the possessions of the Madaliński family, in Mańkowski, *Orient*, 153 note 139.
114 Tomkiewicz, *Z dziejów*, 276–79.
115 Lubomirski, 'Regestra skarbca książąt Ostrogskich', 212.
116 Mason, *Infelicities*; Schmidt, *Inventing Exoticism*.
117 To mention only several of the transcultural stories spanning early modern Europe, Chinese porcelain was appropriated, integrated, and reinvented as part and parcel of a Dutch lifestyle, even signalling 'Dutchness' as a result; İznik ceramics were embraced by the Anabaptists in Moravia to create a distinctively local style of artistic production now referred to as Habaner pottery; and Mamluk, Ottoman, and Italian silks with Arabic (and pseudo-Arabic) script were used in religious vestments in both Catholic and Orthodox Europe to denote the Holy Land. See Gerritsen, 'Domesticating Goods from Overseas'; Lisy-Wagner, *Islam, Christianity and the Making of Czech Identity*; Aleksej Konstantinovič Levykin, ed., *The Tsars and the East: Gifts from Turkey and Iran in the Moscow Kremlin* (London: Thames & Hudson, 2009); Denise-Marie Teece, 'Arabic Inscriptions in the Service of the Church: An Italian Textile Evoking an Early Christian Past?', in *The Nomadic Object: The Challenge of World for*

Early Modern Religious Art, ed. Christine Göttler and Mia M. Mochizuki (Leiden: Brill, 2017), 74–102.

118 Giorgio Riello, *Cotton: The Fabric That Made the Modern World* (Cambridge: Cambridge University Press, 2013); Susan Whitfield, *Life Along the Silk Road*, 2nd edn. (Oakland: University of California Press, 2015); Vera-Simone Schulz, 'Infiltrating Artifacts: The Impact of Islamic Art in Fourteenth- and Fifteenth-Century Florence and Pisa', *Konsthistorisk tidskrift* 87, no. 4 (2018): 214–33; Jirousek, Ottoman Dress and Design in the West; Phillips, Sea Change.

119 Robert Pinner and Walter B. Denny, eds., *Oriental Carpet and Textile Studies II* (London: Hali, 1986).

120 See Spallanzani, *Oriental Rugs in Renaissance Florence*; Ydema, *Carpets and Their Datings in Netherlandish Paintings*.

121 See Kim, 'Lotto's Carpets'.

122 Galea-Blanc, 'The Carpet in Spain and Portugal'.

123 Mańkowski, *Genealogia sarmatyzmu*; Chrzanowski, 'Orient i orientalizm w kulturze staropolskiej'.

124 Ferenc Batári, *Ottoman Turkish Carpets* (Budapest: Keszthely, 1994); Stefano Ionescu and Beata Biedrońska-Słota, eds., *Anatolian Carpets from the Collection of the Brukenthal National Museum in Sibiu* (Gdańsk: Muzeum Narodowe w Gdańsku, 2013).

125 Carol Duncan, *Civilizing Rituals: Inside Public Art Museums* (London: Routledge, 1995); Donald Preziosi and Bettina Messias Carbonell, 'Narrativity and the Museological Myths of Nationality', in *Museum Studies: An Anthology of Contexts*, 2nd edn. (Oxford: Wiley-Blackwell, 2012), 82–91; Rodini, 'Mobile Things', 247.

126 Porter, *When Nationalism Began to Hate*, 3–9.

127 Tomasz Kamusella, *The Un-Polish Poland, 1989 and the Illusion of Regained Historical Continuity* (Cham: Palgrave Macmillan, 2017), 50.

128 Timothy Snyder, *The Reconstruction of Nations: Poland, Ukraine, Lithuania, Belarus, 1569–1999* (New Haven: Yale University Press, 2003), 31–51, 119–32; Simon Lewis, *Belarus—Alternative Visions: Nation, Memory and Cosmopolitanism* (Abingdon: Routledge, 2019), 1–14.

129 Anna Sieradzka, 'Ostatni Sarmaci: Polski strój narodowy w XIX i w 1. połowie XX w.', in *Ubiory w Polsce*, ed. Anna Sieradzka (Warsaw: Stowarzyszenie Historyków Sztuki, 1994), 96–106.

130 Renata Higersberger, 'Scena Szlachecka – Historia Jataganu,' in *MNW Cyfrowe*, http://cyfrowe.mnw.art.pl/dmuseion/docmetadata?id=3463&show_nav=true (accessed 2 October 2017).

131 Aneta Pawłowska, *Henryk Weyssenhoff (1859–1922): Zapomniany bard Białorusi* (Warsaw: Wydawnictwo DiG, 2006), 20, 35.

132 Lewis, *Belarus*, 1–24.

133 Józef Weyssenhoff, *Kronika rodziny Weyssów-Weyssenhoffów* (Vilnius: Waldemar Weyssenhoff, 1935), 23.

134 Simon Lewis, 'Cosmopolitanism as Sub-Culture in the Former Polish–Lithuanian Commonwealth,' in *Identities In-Between in East-Central Europe*, ed. Jan Fellerer, Robert Pyrah, and Marius Turda (New York: Routledge, 2019), 149–69.
135 Zubrzycki, *National Matters*; Jeffrey Haynes, 'Right-Wing Populism and Religion in Europe and the USA', *Religions* 11, no. 490 (2020), https://doi.org/10.3390/rel11100490.
136 See Homi K. Bhabha, 'The Third Space', in Jonathan Rutherford (ed.), *Identity: Community, Culture, Difference* (London: Lawrence & Wishart, 1998), 211.
137 Joyeux-Prunel, 'Art History and the Global'.
138 On heterotopia, see Michel Foucault, ' "Of Other Spaces, Heterotopias" (Based on a Lecture of 1967)', trans. Jay Miskowiec, *Diacritics* 16, no. 1 (1986): 22–27; Stephen J. Campbell, *The Endless Periphery: Toward a Geopolitics of Art in Lorenzo Lotto's Italy* (Chicago: University of Chicago Press, 2019), 27–34.
139 Fuchs, *Mimesis and Empire*, 4.
140 See Bhabha, 'The Third Space', 211.

Epilogue: Beyond the binary

[T]he very same features that make nations attractive allies of the modern state—namely, being natural, historical, and continuous entities—are mostly fabricated. In order to establish authenticity and gain the loyalty of their members, nations must therefore continuously be made and remade.

Yael Tamir, *Why Nationalism*[1]

The past is a foreign country; they do things differently there.

L. P. Hartley, *The Go-Between*[2]

In 1679, the village of Kruszyniany was transferred by grand-ducal decree to mirza ('noble born') Samuel Krzeczowski, a Lithuanian Tatar landowner and a standard-bearer in the service of John III Sobieski, king of Poland and grand duke of Lithuania (r. 1674–96).[3] This was not the first time a Tatar mirza received a land title from a Lithuanian grand duke. Attracted by extensive rights and privileges in exchange for military service performed at the grand duke's request, Tatars (a term applied to descendants of the Golden Horde in Europe) have been present in the Grand Duchy of Lithuania since the fourteenth century.[4] There were differences among the various Tatar groups in the Grand Duchy, but all exercised considerable autonomy in matters of religion, military organization, and the administration of justice.[5] While they did not have full political rights and could not hold state office, Lithuanian Tatars' individual privileges and entitlements usually kept them faithful subjects of the grand duke.[6] It was thus in a rare act of disobedience that the Tatar regiments serving the Polish Crown—mostly staffed with Volhynian Tatars along with a small number of reinforcements from Lithuania—deserted to Ottoman Sultan Mehmet IV (r. 1648–87) in 1672, when an arrears in pay led them to rebel against the Polish king (who was also grand duke of Lithuania).[7] Dissatisfaction with the conditions of service in the Ottoman Empire and the election of a new monarch in Poland–Lithuania, however, sent the Tatars into another U-turn: submission to King John III and faithful service to the Commonwealth restored. Krzeczowski had participated in the rebellion, but in the wake of a pardon extended to lure Tatars back to Polish and Lithuanian

armies as well as partial recognition of Muslim mirzas' noble status in 1677 (without sejm voting rights), he decided to return to the Commonwealth.[8] The Kruszyniany grant was part incentive to loyalty and part compensation for the soldier's missing pay.

Via land grants to Tatars, local life came to be reorganized; in Kruszyniany, a mosque was soon to be built, though it is unverifiable exactly when.[9] The current structure (Figure 5.1) was thoroughly renovated first in 1846—as evinced by a plaque embedded in the foundation—and then several more times during the twentieth century. The building likely goes back to the eighteenth century, however, if not earlier.[10] Available sources confirm the presence of an imam in the village in 1765, but the archival record is incomplete for more distant periods.[11] Regardless of the initial date of construction, conservation work

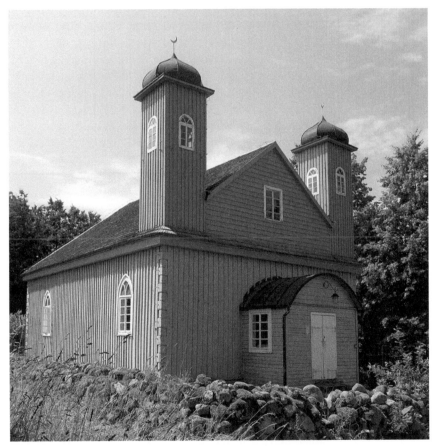

Mosque in Kruszyniany, eighteenth century(?), renovated in 1846 5.1

carried out from the mid-nineteenth century was unlikely to have changed the mosque's form or altered the materials from which it was made.[12] It is possible, therefore, that the original Kruszyniany mosque was similar in appearance to its current manifestation.

Today, the mosque stands in the centre of the village, enclosed by a fence made of fieldstones reinforced with mortar.[13] A wooden log structure resting on a low stone foundation, it is an unassuming building set on a simple rectangular plan, with a mihrab (a niche indicating the direction of Mecca) in the southern wall and two porches along the northern and western façades. The entire structure is topped with a gable roof of undyed wooden shingles that contrast with the green, painted wooden panels cladding the walls. Upon the ridge of the roof, there is a small, octagonal turret crowned with a tin-covered onion-shaped cupola with a crescent. The front gable is framed by two towers crested with octagonal, flattened cupolas, also bearing crescents, perhaps in an attempt to echo minarets.[14] Yet despite these few Islamic accents, the impact of classic Middle Eastern models on the architecture of this rural wooden mosque is limited. While the building is fit to serve as a house of Islamic worship, it was built by local—possibly Christian—carpenters according to local expertise, customs, and tastes, and with the availability of nearby materials in mind.[15] Its layout as well as its formal and material attributes call to mind many wooden two-tower Catholic, Protestant, and Orthodox churches, as well as synagogues, scattered across the Polish and Lithuanian countryside.[16]

A node at which differing customs, rituals, and traditions meet, the Kruszyniany mosque is a transcultural thing. At a glance, the exterior looks like that of a wooden church typical of the region, with only a few minor differences, but this place of worship was built for an entirely different confessional community with distinct customs and rituals that the building had to accommodate. Rather than marking difference between Tatars and their neighbours, however, the mosque converges and merges cultures, exhibiting an architecture that gathers together and blends various components into a form of cultural expression related to the local way of life.[17] The Kruszyniany mosque is a genuinely Islamic structure, of course, but one that has been subject to multiple recontextualizations and transformations; it is a building that takes after other architectural forms, not least because the Tatars had left Crimea generations ago, and thus at the time of the mosque's construction its congregation would have depended on translating and reappropriating local forms to serve their specific needs.[18] As an example of architecture indebted to Lithuanian and Polish building traditions, the mosque fits along a continuum of the region's cultural life, manifesting Islam as a European religion, not a foreign imposition. Its transcultural form effectively queers and destabilizes conventional histories of Poland and Lithuania as it repudiates binary distinctions between 'us' and 'them' that this book reveals yet again as incapable of conveying complex historical realities.

'The past is a foreign country', historian David Lowenthal reminds us.[19] That a material form appears familiar does not mean that it is inevitably embedded in a particular social and historical context, regardless of how it might signify or 'feel' to a beholder accustomed to interpretations that seek to order forms of material expression by country and place of origin. Building in wood has a long tradition in Poland that goes back to the Middle Ages—but this is also the case elsewhere in Europe.[20] The wide distribution of log structures, however, did not prevent late nineteenth-century historians, critics, and architects from elevating and enshrining wooden architecture, particularly of a style from the Podhale region of southern Poland, as a vernacular expression of the Polish nation and thus a manifestation of a specific cultural geography.[21] But as Carolyn Guile has demonstrated, such a deterministic interpretation ignores the complex cross-regional dynamics and the circulation of taste, expertise, and technology that resulted in buildings of similar morphology and typology scattered across today's Poland, Slovakia, Ukraine, and Romania—architectural styles that defy a nation-centred analysis.[22]

Monocultural explanations in fact rarely do justice to premodern realities; the Tatars of the Grand Duchy are a case in point. A vibrant minority that has survived across centuries while surrounded by other communities, Tatars both belong to and resist modern narratives of Polish statehood. The Polish–Lithuanian Commonwealth was not an abstract political entity separate from its people and with a legal personality of its own; it was not a modern state but an early modern community of political actors, with rights and responsibilities towards ruler and commonwealth (*res publica*).[23] Within such a system, Polish and Lithuanian Tatars did not need to assimilate into the dominant cultures: this minority's members were able to maintain their distinct confessional identities and autonomous ecclesiastical authority while fulfilling their legal and contractual duties, particularly military service, to the union in which they resided. For example, in 1683, Krzeczowski—at that point already the owner of Kruszyniany—led his regiment to the Vienna campaign to fight for King John III. According to Krzeczowski family lore, he saved the king's life at the Battle of Párkány (today Štúrovo), for which the mirza received a promotion to colonel; in gratitude the king visited Krzeczowski in Kruszyniany en route to the Grodno sejm of 1688.[24] Though faithful Commonwealth subjects, the Tatars simultaneously retained cultural and religious ties with other Muslims, especially through pilgrimage to Mecca and other notable places of Muslim worship.[25] Tatar mullahs taught Islam as well as the reading and writing of Arabic script.[26] Tatar congregations commissioned handwritten religious books, especially excerpts from the Quran, commentaries, collections of prayers, and religious tales. Simple prayers were written in Arabic; other texts in Belarusian and Polish but using the Arabic alphabet.[27] From the end of the fifteenth century, Lithuanian Tatars were slowly transitioning from the

Kipchak language to Polish and Belarusian as their preferred tool of communication, though they kept Tatar and Muslim customs and traditions.[28] Needless to say, these populations were not Lithuanian—let alone Polish—in a cultural or ethnic sense, but their members considered Lithuania (and later Poland and Ruthenia) their native land.

Today's Kruszyniany is a village within the administrative borders of Poland, where it ended up following the restoration of Polish sovereignty in 1918. Following the ethnic purges of World War II and the post-war expulsions, modern Poland is a very different place than its early modern namesake. A largely ethnically homogenous nation-state with only a recent tradition of immigration, Poland has become a country where attitudes to perceived cultural difference vary among its citizens across the progressive-versus-conservative spectrum familiar in twenty-first-century North America and Western Europe. The existence of dissimilar ideas about Polish nationhood has occasionally led to backlash, and places like Kruszyniany have served as catalysts for political polarization. On the night of 28 June 2014, for example, the village mosque fell victim to an act of vandalism.[29] Unknown perpetrators, using spray paint, marked the building's wall with an anchor, the symbol of 'Poland Fighting' (*Polska Walcząca*)—a World War II emblem of the Polish Underground State. They also drew a picture of a pig, an animal considered unclean in Islam, and painted a Christian cross in white on the door. The tombstones in the nearby cemetery were desecrated in a similar way.[30] The perpetrators, it seems, did not consider the mosque a native element of the Polish cultural landscape, coarsely suggesting it be replaced with a Christian (presumably Catholic) church. The message is both banal and brutal: just as the perpetrators' real and imagined ancestors fought against the Nazi and Red Army invaders of the last war, these modern Poles will fight against what they view as non-Polish elements in their 'fatherland' (*ojczyzna*). A classic manifestation of us-versus-them rhetoric, the event was shocking to locals in its bigoted and exclusivist understanding of history, and shook many in the community, who formed a 'circle of unity' around the damaged mosque in a gesture of solidarity with the Tatars.[31] The mosque was quickly renovated with the support of the Polish government, but the perpetrators were never caught.

Whoever desecrated the mosque was, of course, wrong that Islam is not a Polish religion—it has been practised in Poland for centuries. The vandal(s) were also wrong to lay a claim to Kruszyniany that they saw as somehow more genuine than that of Tatars who had been calling it home since 1679. By comparison, Kruszyniany has been a Polish village for only slightly more than a hundred years, and is located in the part of the country that Tomasz Kamusella has described as 'un-Polish Poland', historically a Belarusian-speaking part of Lithuania.[32] Although the Tatars of the Grand Duchy did not historically identify as Poles (as Tatars living in Poland do now), the two peoples had much

in common. Apart from abstaining from alcohol and wearing small pouches containing Quranic verses, early modern Tatars—especially the mirzas—differed little from early modern Lithuanian and Polish nobles, sharing customs as well as material culture, particularly dress and weapons.[33] There was occasional animosity; for example, an anti-Tatar lampoon, *Alfurkan tatarski*, published in 1616 and reissued in 1617 and 1643, criticized the customs and legal entitlements of Grand Duchy Tatars.[34] But toleration prevailed out of necessity, and Tatars had full religious rights with only two exceptions: mixed marriages and—from the mid-seventeenth century—a requirement to obtain a Catholic bishop's permission to build a new mosque.[35] The very existence of the Kruszyniany mosque suggests that, however inconvenient, such permission was not impossible to receive.

As a transcultural thing, the mosque projects historical complexity onto the contours of modern Poland. Serving as a material manifestation of the Commonwealth's cultural heterogeneity, the mosque foregrounds the union's lands as a space in which different communities lived alongside one another, where different religions overlapped, and where different traditions and material cultures converged and merged. Mediating a complex web of historical factors and developments characteristic of Central and Eastern Europe before World War II, the mosque offers a narrative that departs from still dominant nation-centric accounts of the region's history. Kruszyniany has never been a monoethnic environment inhabited by self-isolated peoples, each sharing a unique identity. Instead, the village was and is a transcultural place where Tatars have persisted for many generations not as 'Oriental' outsiders but as local communities (*tutejsi*).

Rather than offering comfort, the Kruszyniany mosque causes cognitive dissonance, presenting us with a historic building in conflict with the all too often prevailing image of a modern, ethnically homogenous Polish state. Reading the Kruszyniany mosque as a Tatar building, Polish only in a qualified sense, removes the temptation of tracing every architectural and artistic form found in the present-day Republic of Poland to distinctively Polish national traits. Such a take on artistic geography is a form of ethnic essentialism and geographical determinism, falsely representing a linear trajectory of the nation's allegedly unique culture.[36] Paying attention to transcultural things stops nativism in its tracks by removing delight in the continuity and cumulation of national heritage in favour of embracing the richness of a multitude of sources and references. Rather than demarcating culture via in-groups and out-groups, transcultural things foreground complex historical realities that expose the multi-ethnic, multi-confessional, and multi-lingual genealogies of modern nations. It is therefore by no means a paradox that a thing can be simultaneously local and exotic, native and foreign, self and other. Transcultural things provoke us to move beyond binary thinking.

Notes

1. Tamir, *Why Nationalism*, 52.
2. L. P. Hartley, *The Go-Between* (London: Hamish Hamilton, 1953), 17.
3. Henryk Mierzwiński, 'Osadnictwo tatarskie na Podlasiu za Jana III Sobieskiego', *Podlaski Kwartalnik Kulturalny* 2 (1997): 45.
4. Jan Tyszkiewicz, *Tatarzy na Litwie i w Polsce: Studia z dziejów XIII-XVIII w.* (Warsaw: Państwowe Wydawnictwo Naukowe, 1989), 125; Krzysztof Grygajtis, 'Osadnictwo Tatarów hospodarskich w Wielkim Księstwie Litewskim XIV–XVIII w.', *Rocznik Tatarów Polskich* 8 (2003): 27–29; Artur Konopacki, Joanna Kulwicka-Kamińska, and Czesław Łapicz, 'Tatarzy litewscy czy Lipkowie? Rozważania historyczno-semantyczne oraz propozycje terminologiczne', in *Wschód muzułmański w ujęciu interdyscyplinarnym: Ludzie, teksty, historia*, ed. Grzegorz Czerwiński and Artur Konopacki (Białystok: Alter Studio, 2017), 291–307.
5. Jacek Sobczak, *Położenie prawne ludności tatarskiej w Wielkim Księstwie Litewskim* (Warsaw: Państwowe Wydawnictwo Naukowe, 1984); Piotr Borawski, 'Struktura społeczna Tatarów w Wielkim Księstwie Litewskim', *Acta Baltico-Slavica* 19 (1990): 311–40.
6. Jan Tyszkiewicz, 'Tatars', in *Under a Common Sky: Ethnic Groups of the Commonwealth of Poland and Lithuania*, ed. Michał Konopczyński and Wojciech Tygielski (New York: PIASA Books, 2017), 150–62.
7. Stanisław Kryczyński, 'Bej barski: Szkic z dziejów Tatarów polskich w XVII w.', *Rocznik Tatarski* 2 (1935): 267.
8. Mierzwiński, 'Osadnictwo tatarskie na Podlasiu za Jana III Sobieskiego', 45.
9. Stanisław Kryczyński, *Tatarzy litewscy: Próba monografii historyczno-etnograficznej* (Warsaw: Rada Centralna Związku Kulturalno-Oświatowego Tatarów Rzeczypospolitej, 1938), 34.
10. Andrzej Drozd, 'Kruszyniany', in *Meczety i cmentarze Tatarów polsko-litewskich*, ed. Andrzej Drozd, Marek M. Dziekan, and Tadeusz Majda (Warsaw: Res Publica Multiethnica, 1999), 83–84.
11. Jerzy Wiśniewski, 'Osadnictwo tatarskie w Sokólskiem i na północnym Podlasiu', *Rocznik Białostocki* 16 (1991): 366.
12. Maintenance of wooden buildings often preserves the original structure, divisions, and details, even when certain elements are replaced. See Marian Kornecki, 'Spalony kościół drewniany na Woli Justowskiej w Krakowie: Problemy konserwatorskie', *Ochrona Zabytków* 32, no. 1 (1979): 37–38; Jerzy Szałygin, 'Dziedzictwo drewnianej architektury w Polsce', *Ochrona Zabytków*, no. 1–4 (2013): 283.
13. Anna Hanaka, 'Bohoniki i Kruszyniany – Meczety i mizary' (Natonal Heritage Board of Poland, 22 October 2012), https://zabytek.pl/public/upload/objects_media/5679ab4e616a0.pdf; Grzegorz Ryżewski, 'Tatar Mosque, Kruszyniany' (Register of Monuments, Monuments Records, 11 September 2014), https://zabytek.pl/en/obiekty/kruszyniany-meczet-tatarski.
14. Ignacy F. Tłoczek, *Polskie budownictwo drewniane* (Wrocław: Zakład Narodowy im. Ossolińskich, 1980), 148–50.

15 Agata S. Nalborczyk, 'Mosques in Poland: Past and Present', in *Muslims in Eastern Europe: Widening the European Discourse on Islam*, ed. Katarzyna Górak-Sosnowska (Warsaw: Faculty of Oriental Studies, University of Warsaw, 2011), 183.
16 Kryczyński, *Tatarzy litewscy*, 160; Tłoczek, *Polskie budownictwo drewniane*; Ryszard Brykowski, 'Tatarskie meczety w Rzeczypospolitej', *Ochrona Zabytków* 41, no. 3 (1988): 153–72; Marian Pokropek, *Tradycyjne budownictwo drzewne w Polsce*, vol. 2 (Warsaw: Neriton, 1996), 31–45; Andrzej Drozd, 'Meczety Tatarskie', in *Meczety i cmentarze Tatarów polsko-litewskich*, ed. Andrzej Drozd, Marek M. Dziekan, and Tadeusz Majda (Warsaw: Res Publica Multiethnica, 1999), 14–19; K. Paul Żygas, 'The Muslim Tartars of the Grand Duchy of Lithuania and Their Architectural Heritage', *Centropa* 8, no. 2 (2008): 124–33; Szałygin, 'Dziedzictwo drewnianej architektury w Polsce'.
17 Ortiz, *Cuban Counterpoint, Tobacco and Sugar*, 32–33.
18 On transculturation, see Welsch, 'Transculturality'; Codell, *Transculturation in British Art*.
19 David Lowenthal, *The Past Is a Foreign Country*, revised and updated edition (Cambridge: Cambridge University Press, 2013).
20 Hans Jürgen Hansen, ed., *Architecture in Wood: A History of Wood Building and Its Techniques in Europe and North America*, trans. Janet Seligman (New York: Viking, 1971).
21 Anna Brzyski, 'The Paradox of the Ethnographic Superaltern: Ethnonationalism and Tourism in the Polish Tatra Mountains at the Turn of the Nineteenth Century', *Res* 53–54 (2008): 282–92; Rampley, *The Vienna School of Art History*, 116–40.
22 Guile, 'Circulations', 86.
23 Pietrzyk-Reeves, *Polish Republican Discourse*.
24 Piotr Borawski and Aleksander Dubiński, *Tatarzy polscy: Dzieje, obrzędy, legendy, tradycje* (Warsaw: Iskry, 1986), 234.
25 Połczyński, 'Seljuks on the Baltic'.
26 Artur Konopacki, *Życie religijne Tatarów na ziemiach Wielkiego Księstwa Litewskiego w XVI–XIX wieku* (Warsaw: Wydawnictwa Uniwersytetu Warszawskiego, 2010), 85–94.
27 Andrzej Drozd, 'Piśmiennictwo Tatarów polsko-litewskich (XVI-XX w.): Zarys problematyki', in *Piśmiennictwo i muhiry Tatarów polsko-litewskich*, ed. Andrzej Drozd, Marek M. Dziekan, and Tadeusz Majda (Warsaw: Res Publica Multiethnica, 2000), 12–37.
28 Aleksander Dubiński, 'Charakterystyka języka Tatarów polsko-litewskich', *Acta Baltico-Slavica* 14 (1981): 83–90.
29 Jakub Medek, 'Atak na meczet i mizar: Zbezczeszczono świątynię Tatarów', *Gazeta Wyborcza Białystok*, 29 June 2014, https://bialystok.wyborcza.pl/bialystok/ 7,35241,16238626,atak-na-meczet-i-mizar-zbezczeszczono-swiatynie-tatarow-zdjecia.html.
30 Igor T. Miecik, 'Kto podłożył świnię', *Gazeta Wyborcza*, 11 July 2014, https:// wyborcza.pl/magazyn/7,124059,16311861,kto-podlozyl-swinie.html.

31 'Utworzono "krąg jedności" wokół meczetu w Kruszynianach', *Dzieje.pl*, 5 July 2014, https://dzieje.pl/aktualnosci/utworzono-krag-jednosci-wokol-meczetu-w-kruszynianach.
32 Kamusella, *The Un-Polish Poland*.
33 Tyszkiewicz, 'Tatars', 159.
34 Piotr Czyżewski, *Alfurkan tatarski prawdziwy na czterdzieści części rozdzielony*, ed. Artur Konopacki (Białystok: MKJdruk, 2013).
35 Piotr Borawski, 'Tolerancja religijna wobec ludności tatarskiej w Wielkim Księstwie Litewskim (XVI–XVIII wiek)', *Przegląd Humanistyczny* 25, no. 3 (1981): 51–66; Andrzej B. Zakrzewski, 'Tatarzy litewscy w oczach władzy i współmieszkańców, XVI-XVIII w.', in *Staropolski ogląd świata: Rzeczpospolita pomiędzy okcydentalizmem a orientalizacją*, ed. Filip Wolański and Robert Kołodziej, vol. 1 (Toruń: Adam Marszałek, 2009), 28; Konopacki, *Życie religijne Tatarów na ziemiach Wielkiego Księstwa Litewskiego w XVI–XIX wieku*, 107.
36 See Kaufmann, *Toward a Geography of Art*.

Bibliography

Manuscript Sources

Bayerische Verwaltung der staatlichen Schlösser, Gärten und Seen, Inventar der Königl. Residenz, Munich

Gelbe Zimmer 16, 1874, Gelbe Zimmer 57.01, fol. 16.

Bayerisches Hauptstaatsarchiv, Munich (BayHStA)

Pfalz-Neuburg Akten Neuburger Abgabe 1989, 6557, 'Verzeichnis. Von auf Befehl Phil. Wilh. nach Regensburg u. Düsseldorf gesandten…,' fol. 4 and 9.

Pfälzer und Pfalz-Neuburger Akten 2691, Inventory of Neuburg Castle, 20 April 1668, BayHStA, GHA, fol. 7v.

Central Archives of Historical Records in Warsaw (AGAD)

Archiwum Skarbu Koronnego Oddz. III, Sygn. 5, pp. 327–328v. Jerzy Młodecki, invoice, 12 September 1602.

The Central State Historical Archives of Ukraine, City of Lviv (TsDIAL)

Acta Iudicii Armenorum Leopol. ab Anno 1611 ad 1615, vol. 8, fol. 1018.
Acta Iudicii Armenorum Leopol. ab Anno 1607 ad 1610, vol. 7, fol. 679.
Castr. Halic., vol. 122, fol. 327.
Castr. Halic., vol. 118, fol. 429.

National Heritage Institute, Warsaw (NID)

Teki Glinki, Teka 66.

National Library, Warsaw (BN)

Opis Wjazdu Je[go] M[oś]ci Pana Ossolińskiego Posła Polskiego do Rzymu de data 2 Decembris 1633. rkpis dated 2 December 1633, BN BOZ, 855.

National Vasyl Stefanyk Scientific Library of Ukraine, Lviv (LNSL)

Instructio Illmo Georgio comiti de Tenczyn Ossoliński ... cum publica oboedientia Legato – data Grodnae die men. Juni 1633, rkpis Ossol. Nr 225.

The Princes Czartoryski Library, Cracow

Teki Naruszewicza, m/s 210.

Zakład Narodowy im. Ossolińskich, Wrocław

Relacya poselstwa rzymskiego którą odprawował [...] Jerzy z Osolina Ossoliński, 1634, 4228/II.

Printed Sources

Abrahamowicz, Zygmunt. 'Jerzy Franciszek Kulczycki'. In *Polski Słownik Biograficzny*, vol 16, 128–29, 1971.

Adamovsky, Ezequiel. 'Euro-Orientalism and the Making of the Concept of Eastern Europe in France, 1810–1880'. *The Journal of Modern History* 77, no. 3 (2005): 591–628.

Althoen, David. 'Natione Polonus and the Naród Szlachecki: Two Myths of National Identity and Noble Solidarity'. *Zeitschrift für Ostmitteleuropa-Forschung* 52, no. 4 (2003): 475–508.

Anderson, Benedict. *Imagined Communities: Reflections on the Origin and Spread of Nationalism*. London: Verso, 1991.

Anderson, Christy, Anne Dunlop, and Pamela H. Smith, eds. *The Matter of Art: Materials, Practices, Cultural Logics, c.1250–1750*. Manchester: Manchester University Press, 2014.

Anon. *Solennità dell'entrata in Roma e cavalcate dell'eccellentissimo Signor Giorgio Ossolinsghi Conte di Thenezun*. Rome: Paolo Masotti, 1633.

Applebaum, Anne. *Twilight of Democracy: The Seductive Lure of Authoritarianism*. New York: Doubleday, 2020.

Arciszewska, Barbara. 'The Role of Ancient Remains in the Sarmatian Culture of Early Modern Poland'. In *Local Antiquities, Local Identities: Art, Literature and Antiquarianism in Europe, c. 1400–1700*, edited by Kathleen Christian and Bianca de Divitiis, 286–304. Manchester: Manchester University Press, 2019.

Armstrong, Dorothy. 'What Is an "Oriental" Carpet? Reimagining, Remaking, Repossessing the Patterned Pile Carpets of South, Central and West Asia since 1840'. PhD Thesis, Royal College of Art, 2019.

Armstrong, John A. *Nations before Nationalism*. Chapel Hill: University of North Carolina Press, 1982.

Augustyniak, Urszula. *Historia Polski, 1572–1795*. Warsaw: PWN, 2008.
———. *History of the Polish-Lithuanian Commonwealth: State, Society, Culture*. Frankfurt am Main: Peter Lang, 2015.
Baldinucci, Filippo. *Notizie de' professori del disegno da Cimabue in qua: per le quali si dimostra come, e per chi le bell' arti di pittura, scultura, e architettura lasciata la rozzezza delle maniere greca, e gottica, si siano in questi secoli ridotte all'antica loro perfezione*. Florence: Per Santi Franchi, 1681.
Banas, Paulina. 'Persische Kunst und polnische Identität'. In *Sehnsucht Persien: Austausch und Rezeption in der Kunst Persiens und Europas im 17. Jahrhundert & Gegenwartskunst aus Teheran*, edited by Axel Langer, 118–35. Zürich: Scheidegger & Spiess, 2013.
Barącz, Sadok. *Żywoty sławnych Ormian w Polsce*. Lviv: Zakład Narodowy im. Ossolińskich, 1856.
Barthes, Roland. 'Death of the Author'. In *Image, Music, Text*, translated by Stephen Heath, 142–48. New York: Hill and Wang, 1977.
———. 'Myth Today'. In *Mythologies*, translated by Annette Lavers, 109–59. New York: Hill and Wang, 1984.
Bass, Marisa. *Jan Gossart and the Invention of Netherlandish Antiquity*. Princeton: Princeton University Press, 2016.
Batári, Ferenc. *Ottoman Turkish Carpets*. Budapest: Keszthely, 1994.
———. 'White Ground Anatolian Carpets in the Budapest Museum of Applied Arts'. In *Oriental Carpet and Textile Studies II*, edited by Robert Pinner and Walter B. Denny, 195–203. London: Hali, 1986.
Beattie, May. *Carpets of Central Persia: With Special Reference to the Rugs of Kirman*. London: World of Islam Festival Publishing Company, 1976.
Beauplan, Guillaume Le Vasseur de. *Description de l'Ukraine*. Rouen, 1660.
———. 'A Description of Ukraine, Containing Several Provinces of the Kingdom of Poland ... Written in French'. In *A Collection of Voyages and Travels*, vol. 1, 571–610. London, 1704.
Bennett, Jane. *Vibrant Matter: A Political Ecology of Things*. Durham, NC: Duke University Press, 2010.
Bentley, Jerry H., ed. *The Oxford Handbook of World History*. Oxford: Oxford University Press, 2011.
Berezhnaya, Liliya, and Heidi Hein-Kircher. 'Constructing a Rampart Nation: Conceptual Framework'. In *Rampart Nations: Bulwark Myths of East European Multiconfessional Societies in the Age of Nationalism*, edited by Liliya Berezhnaya and Heidi Hein-Kircher, 3–30. New York: Berghahn Books, 2019.
Berezhnaya, Liliya, and John-Paul Himka. *The World to Come: Ukrainian Images of the Last Judgment*. Cambridge, MA: Harvard University Press, 2014.
Berg, Maxine, ed. *Goods from the East, 1600–1800: Trading Eurasia*. Basingstoke: Palgrave Macmillan, 2015.
Bertling, August. *Anton Möller's Danziger Frauentrachtenbuch aus dem Jahre 1601 in getreuen Faksimile-Reprododuktionen: Neu herausgegeben nach den Original-Holzschnitten mit Begleitendem*. Danzig: Richard Bertling, 1886.

Bevilacqua, Alexander, and Helen Pfeifer. 'Turquerie: Culture in Motion, 1650–1750'. *Past and Present* 221 (2013): 75–118.

Bhabha, Homi K. 'The Third Space'. In *Identity: Community, Culture, Difference*, edited by Jonathan Rutherford, 207–21. London: Lawrence & Wishart, 1998.

Białobocki, Jan. *Zegar w krótkim zebraniu czasów Królestwa Polskiego wiekiem królów idący*. Cracow, 1661.

Białostocki, Jan. *The Art of the Renaissance in Eastern Europe: Hungary, Bohemia, Poland*. London: Phaidon, 1976.

Biedrońska-Słota, Beata. 'Composition of Persian Carpets Called Polish'. In *Studies in Oriental Art and Culture in Honour of Professor Tadeusz Majda*, edited by Anna Parzymies, 285–96. Warsaw: Dialog, 2006.

———. 'Kobierce z polskich manufaktur (próba podsumowania)'. In *Tkaniny artystyczne z wieków XVIII i XIX*, edited by Beata Biedrońska-Słota, 151–63. Cracow: Zamek Królewski na Wawelu, 1997.

———. *Polski ubiór narodowy zwany kontuszowym: Dzieje i przemiany opracowane na podstawie zachowanych ubiorów zabytkowych i ich części oraz w świetle źródeł ikonograficznych i literackich*. Cracow: Muzeum Narodowe w Krakowie, 2005.

———. 'The Art of Islam in the History of Polish Art'. In *The Orient in Polish Art: Catalogue of the Exhibition*, edited by Beata Biedrońska-Słota, 7–18. Exh. Cat. Cracow: National Museum Cracow, 1992.

———. 'Wpływ sztuki orientalnej na sztukę polską w okresie Sarmatyzmu'. In *Portret typu sarmackiego w wieku XVII w Polsce, Czechach, na Słowacji i na Węgrzech*, edited by Ewa Zawadzka, 189–94. Cracow: Muzeum Narodowe w Krakowie, 1985.

Bielski, Marcin. *Kronika polska*. Cracow, 1551.

Bielski, Marcin, and Joachim Bielski. *Kronika polska*. Cracow, 1597.

Bier, Carol, and Textile Museum, Washington DC, eds. *Woven from the Soul, Spun from the Heart: Textile Arts of Safavid and Qajar Iran, 16th–19th Centuries*. Washington, DC: Textile Museum, 1987.

Birkenmajer, Ludwik. *Mikołaj Kopernik: Studya nad pracami Kopernika oraz materyały biograficzne*. Cracow: Akademia Umiejętności, 1900.

Blaszczyk, Arkadiusz, Robert Born, and Florian Riedler, eds. *Transottoman Matters: Objects Moving through Time, Space, and Meaning*. Göttingen: V&R Unipress, 2021.

Bleichmar, Daniela, and Peter C. Mancall, eds. *Collecting Across Cultures: Material Exchanges in the Early Modern Atlantic World*. Philadelphia: University of Pennsylvania Press, 2011.

Bode, Wilhelm. *Vorderasiatische Knüpfteppiche aus älterer Zeit*. Leipzig: Hermann Seemann, 1902.

Bogucka, Maria. 'Szlachta polska wobec Wschodu turecko-tatarskiego: Między fascynacją a przerażeniem (XVI–XVIII w.)'. *Sobótka* 37, no. 3/4 (1982): 185–93.

———. *The Lost World of the 'Sarmatians': Custom as the Regulator of Polish Social Life in Early Modern Times*. Warsaw: Polish Academy of Sciences, Institute of History, 1996.

Bömelburg, Hans-Jürgen. *Polska myśl historyczna a humanistyczna historia narodowa (1500–1700)*. Translated by Zdzisław Owczarek. Cracow: Universitas, 2011.

Borawski, Piotr. 'Struktura społeczna Tatarów w Wielkim Księstwie Litewskim'. *Acta Baltico-Slavica* 19 (1990): 311–40.

———. 'Tolerancja religijna wobec ludności tatarskiej w Wielkim Księstwie Litewskim (XVI–XVIII wiek)'. *Przegląd Humanistyczny* 25, no. 3 (1981): 51–66.

Borawski, Piotr, and Aleksander Dubiński. *Tatarzy polscy: Dzieje, obrzędy, legendy, tradycje*. Warsaw: Iskry, 1986.

Born, Robert. 'Observations on the Pictorial Strategies of the Orientalizing Paintings from East-Central Europe'. In *Central Europe and the Non-European World in the Long 19th Century*, edited by Markéta Křížová and Jitka Malečková, 33–64. Berlin: Frank & Timme, 2022.

Born, Robert, and Michał Dziewulski, eds. *The Ottoman Orient in Renaissance Culture: Papers from the International Conference at the National Museum in Krakow, June 26–27, 2015*. Cracow: National Museum in Krakow, 2015.

Born, Robert, Michał Dziewulski, and Guido Messling, eds. *The Sultan's World: The Ottoman Orient in Renaissance Art*. Exh. Cat. Brussels, Cracow, and Ostfildern: Centre for Fine Arts, Brussels; and the National Museum in Kraków, in association with Hatje Cantz, 2015.

Brahmer, Mieczysław. 'Z dziejów kostjumu polskiego wśród obcych'. In *Księga pamiątkowa ku czci Leona Pinińskiego*, vol. 1, 113–20. Lviv: Gubrynowicz, 1936.

Breban, Philibert. *Livret-guide du visiteur à l'Exposition historique du Trocadéro*. Paris: E. Dentu, 1878.

Brown, Bill. 'Thing Theory'. *Critical Inquiry* 28, no. 1 (2001): 1–22.

Brückner, Aleksander. 'Sarmatyzm'. In *Encyklopedia staropolska*, vol. 2, 451–53. Warsaw: Trzaska, Evert i Michalski, 1939.

Brückner, Aleksander, and Karol Estreicher. *Ubiory w Polsce*. Cracow: Drukarnia Narodowa, 1939.

Brunner, Herbert, and Albrecht Miller. *Die Kunstschätze der Münchner Residenz*. Munich: Süddeutscher Verlag, 1977.

Brykowski, Ryszard. 'Tatarskie meczety w Rzeczypospolitej'. *Ochrona Zabytków* 41, no. 3 (1988): 153–72.

Brzyski, Anna. 'The Paradox of the Ethnographic Superaltern: Ethnonationalism and Tourism in the Polish Tatra Mountains at the Turn of the Nineteenth Century'. *Res* 53–54 (2008): 282–92.

Buczek, Karol. *The History of Polish Cartography from the 15th to the 18th Century*. Translated by Andrzej Potocki. Amsterdam: Meridian, 1982.

———. 'Wacław Grodecki'. *Polski Przegląd Kartograficzny* 11, no. 43 (1933): 69–86.

Bues, Almut, and Zbigniew Krysiewicz, eds. *Royal Marriages of Princes and Princesses in Poland and Lithuania c. 1500–1800*. Warsaw: German Historical Institute, 2016.

Burke, Peter. 'Did Europe Exist Before 1700?' *History of European Ideas* 1 (1980): 21–29.

Bzinkowska, Jadwiga. *Od Sarmacji do Polonii: Studia nad początkami obrazu kartograficznego Polski*. Cracow: Nakł. Uniwersytetu Jagiellońskiego, 1994.

Calvi, Guilia. *The World in Dress: Costume Books Across Italy, Europe, and the East*. Cambridge: Cambridge University Press, 2022.

Campbell, Stephen J. *The Endless Periphery: Toward a Geopolitics of Art in Lorenzo Lotto's Italy*. Chicago: University of Chicago Press, 2019.

Carboni, Stefano, ed. *Venice and the Islamic World, 828–1797*. Exh. Cat. New York and New Haven: Metropolitan Museum of Art, in association with Yale University Press, 2007.

Carey, Moya, and Margaret S. Graves. 'Introduction: Historiography of Islamic Art and Architecture, 2012'. *Journal of Art Historiography* 6 (2012): 1–15.

Carey, Moya, and Mercedes Volait. 'Framing "Islamic Art" for Aesthetic Interiors: Revisiting the 1878 Paris Exhibition'. *International Journal of Islamic Architecture* 9, no. 1 (2020): 31–59.

Carrier, David. *A World Art History and Its Objects*. University Park, PA: Pennsylvania State University Press, 2008.

Carter, Francis W. *Trade and Urban Development in Poland: An Economic Geography of Cracow, from its Origins to 1795*. Cambridge: Cambridge University Press, 2006.

Casale, Giancarlo. *The Ottoman Age of Exploration*. Oxford: Oxford University Press, 2010.

Castiglione, Baldassare. *Il Libro del Cortegiano*. Edited by Ettore Bonora. Milan: Mursia, 1972.

Cerulo, Karen A. *Identity Designs: The Sights and Sounds of a Nation*. New Brunswick, NJ: Rutgers University Press, 1995.

Chakrabarty, Dipesh. *Provincializing Europe: Postcolonial Thought and Historical Difference*. Princeton, NJ: Princeton University Press, 2000.

Chapuis, Julien, Jonathan Fine, and Paola Ivanov. 'Introduction'. In *Beyond Compare: Art from Africa in the Bode Museum*, edited by Julien Chapuis, Jonathan Fine, and Paola Ivanov, 8–19. Berlin: Staatliche Museen zu Berlin, 2017.

Chemperek, Dariusz. 'Historiografia i literatura dawna o tryumfie Stanisława Żółkiewskiego i hołdzie Szujskich w roku 1611'. *Res Historica* 37 (2011): 21–46.

Chmiel Adam, ed. *Wawel: Materyały archiwalne do budowy zamku*. Vol. 2. Cracow: Drukarnia Uniwersytetu Jagiellońskiego, 1913.

Chrościcki, Juliusz A. *Sztuka i polityka: Funkcje propagandowe sztuki w epoce Wazów, 1587–1668*. Warsaw: Państwowe Wydawn. Naukowe, 1983.

Chrzanowski, Ignacy and Stanisław Kot, eds. *Humanizm i Reformacja w Polsce: Wybór źródeł dla ćwiczeń uniwersyteckich*. Lviv, Warsaw, and Cracow: Wydawnictwo Zakładu Narodowego im. Ossolińskich, 1927.

Chrzanowski, Tadeusz. 'Orient i orientalizm w kulturze staropolskiej'. In *Orient i orientalizm w sztuce*, edited by Elżbieta Karwowska, 43–69. Warsaw: PWN, 1986.

———. *Portret staropolski*. Warsaw: Interpress, 1995.

———. *Wędrówki po Sarmacji Europejskiej: Eseje o sztuce i kulturze staropolskiej*. Cracow: Znak, 1988.

Clark, Leah R., and Nancy Um. 'Introduction The Art of Embassy: Situating Objects and Images in the Early Modern Diplomatic Encounter'. *Journal of Early Modern History* 20, no. 1 (2016): 3–18.

Clifford, James. 'On Orientalism'. In *The Predicament of Culture: Twentieth-Century Ethnography, Literature, and Art*, 255–76. Cambridge, MA: Harvard University Press, 1988.

———. *Routes: Travel and Translation in the Late Twentieth Century.* Cambridge, MA: Harvard University Press, 1997.

Clines, Robert. 'Edward W. Said, Renaissance Orientalism, and Imaginative Geographies of a Classical Mediterranean'. *Memoirs of the American Academy in Rome* 65 (2020): 481–533.

Codell, Julie F., ed. *Transculturation in British Art, 1770–1930.* Farnham: Ashgate, 2012.

Cohen, Steven. '"Portuguese" Carpets from Khorasan, Persia'. In *Textiles in Indian Ocean Societies*, edited by Ruth Barnes, 35–43. London: Routledge, 2004.

Cole, Michael. 'The Cult of Materials'. In *Revival and Invention: Sculpture through Its Material Histories*, edited by Sébastien Clerbois and Martina Droth, 1–15. Oxford: Peter Lang, 2011.

Conrad, Sebastian. *What Is Global History?* Princeton: Princeton University Press, 2016.

Coombes, Annie E., and Avtar Brah. 'Introduction: The Conundrum of Mixing'. In *Hybridity and Its Discontents: Politics, Science, Culture*, edited by Annie E. Coombes and Avtar Brah, 1–16. London: Routledge, 2000.

Cotgrave, Randle. *A Dictionarie of the French and English Tongues.* London, 1611.

Csombor, Márton Szepsi. *Podróż po Polsce.* Translated by Jan Ślaski. Warsaw: Czytelnik, 1961.

Curran, Kathleen. *The Invention of the American Art Museum.* Los Angeles: The Getty Research Institute, 2016.

Cynarski, Stanisław. 'Sarmatyzm – ideologia i styl życia'. In *Polska XVII wieku: Państwo, społeczeństwo, kultura*, edited by Janusz Tazbir, 220–43. Warsaw: Wiedza Powszechna, 1969.

Czermak, Wiktor. *Na dworze Władysława IV.* Cracow: Spółka Wydawnicza Polska, 1901.

Czubek, Jan. 'Dwa inwentarze firlejowskie z XVII w.' *Sprawozdania Komisyi do Badania Historyi Sztuki w Polsce* 8, no. 3/4 (1912): 381–96.

———, ed. *Pisma polityczne z czasów rokoszu Zebrzydowskiego, 1606–1608.* Vol. 1. 3 vols. Cracow: Akademia Umiejętności, 1916.

Czyżewski, Krzysztof J., and Marek Walczak. 'Picturing Continuity: The Beginnings of the Portrait Gallery of Cracow Bishops in the Cloisters of the Franciscan Friary in Cracow'. *Journal of Art Historiography*, no. 17 (2017): 1–13.

Czyżewski, Piotr. *Alfurkan tatarski prawdziwy na czterdzieści części rozdzielony.* Edited by Artur Konopacki. Białystok: MKJdruk, 2013.

Dalché, Patrick Gautier. 'The Reception of Ptolemy's Geography (End of the Fourteenth to Beginning of the Sixteenth Century)'. In *Cartography in the European Renaissance*, edited by David Woodward, vol. 3, 285–364. Chicago: University of Chicago Press, 2007.

Darcel, Alfred. *Les tapisseries décoratives du Garde-Meuble … Choix des plus beaux motifs.* Paris: J. Baudry, 1881.

De Caprio Motta, Francesca. *Maria Luisa Gonzaga Nevers: Cerimonie e propaganda nel viaggio verso il trono di Polonia (1645–1646).* Viterbo: Sette città, 2018.

De Grazia, Margreta, Maureen Quilligan, and Peter Stallybrass, eds. 'Introduction'. In *Subject and Object in Renaissance Culture*, 1–13. Cambridge: Cambridge University Press, 1996.

De Maria, Blake. *Becoming Venetian: Immigrants and the Arts in Early Modern Venice*. New Haven: Yale University Press, 2010.

Dean, Carolyn, and Dana Leibsohn. 'Hybridity and Its Discontents: Considering Visual Culture in Colonial Spanish America'. *Colonial Latin American Review* 12, no. 1 (2003): 5–35.

Decorum życia Sarmatów w XVII i XVIII wieku: Katalog pokazu sztuki zdobniczej ze zbiorów Muzeum Narodowego w Warszawie. Warsaw: Muzeum Narodowe, 1980.

Defert, Daniel. 'Un genre ethnographique profane au XVIe siècle: Les livres d'habits (Essai d'ethno-iconographie)'. In *Histoires de l'anthopologie (XVIe-XIXe siècles)*, edited by Britta Rupp-Eisenreich, 25–41. Paris: Klincksieck, 1984.

Deluga, Waldemar, ed. *Ars armeniaca: Sztuka ormiańska ze zbiorów polskich i ukraińskich*. Zamość: Muzeum Zamojskie, 2010.

Demange, Yann Mounir. 'The Long Answer'. In *The Good Immigrant: 26 Writers Reflect on America*, edited by Nikesh Shukla and Chimene Suleyman, 178–96. New York: Little, Brown and Company, 2019.

Dembołęcki, Wojciech. *Wywod iedynowłasnego panstwa swiata, w ktorym pokázuie X. W. Debolecki ... ze nastárodawnieysze w Europie Krolestwo Polskie, lubo Scythyckie ... y ... ze język słowieński pierwotny jest ná świecie*. Warsaw: J. Rossowski, 1633.

Denvir, Daniel. *All-American Nativism: How the Bipartisan War on Immigrants Explains Politics as We Know It*. London: Verso, 2020.

Dercon, Chris et al., eds. *The Future of Tradition, the Tradition of Future: 100 Years after the Exhibition 'Masterpieces of Muhammadan Art' in Munich*. Munich: Prestel, 2010.

DeSoucey, Michaela. 'Gastronationalism: Food Traditions and Authenticity Politics in the European Union'. *American Sociological Review* 75, no. 3 (2010): 432–55.

Dietz, Jost Ludwig. *De vetustatibus Polonorum*. Cracow: Hieronymus Vietor, 1521.

Dimand, Maurice S. *Loan Exhibition of Persian Rugs of the So-Called Polish Type*. New York: The Metropolitan Museum of Art, 1930.

Dimand, Maurice S., and Jean Mailey. *Oriental Rugs in the Metropolitan Museum of Art*. New York: The Metropolitan Museum of Art, 1973.

Długosz, Jan. *Roczniki czyli Kroniki Sławnego Królestwa Polskiego*. Warsaw: PWN, 1961.

Dobrowolski, Tadeusz. 'Cztery style portretu "sarmackiego"'. *Zeszyty Naukowe Uniwersytetu Jagiellońskiego* 45 (1962): 83–101.

Dobrzeniecki, Tadeusz. 'Średniowieczny portret w sakralnej sztuce polskiej'. *Rocznik Muzeum Narodowego w Warszawie* 13, no. 1 (1969): 11–51.

Drozd, Andrzej. 'Kruszyniany'. In *Meczety i cmentarze Tatarów polsko-litewskich*, edited by Andrzej Drozd, Marek M. Dziekan, and Tadeusz Majda, 83–84. Warsaw: Res Publica Multiethnica, 1999.

———. 'Meczety Tatarskie'. In *Meczety i cmentarze Tatarów polsko-litewskich*, edited by Andrzej Drozd, Marek M. Dziekan, and Tadeusz Majda, 14–19. Warsaw: Res Publica Multiethnica, 1999.

———. 'Piśmiennictwo Tatarów polsko-litewskich (XVI–XX w.): Zarys problematyki'. In *Piśmiennictwo i muhiry Tatarów polsko-litewskich*, edited by Andrzej Drozd, Marek M. Dziekan, and Tadeusz Majda, 12–37. Warsaw: Res Publica Multiethnica, 2000.

Dubiński, Aleksander. 'Charakterystyka języka Tatarów polsko-litewskich'. *Acta Baltico-Slavica* 14 (1981): 83–90.
Dumanowski, Jarosław. 'Inwentarze wielmożnych i urodzonych: Konsumpcja szlachty wielkopolskiej w XVIII w.' *Kwartalnik Historii Kultury Materialnej* 51, no. 2 (2003): 261–76.
———. 'Orientalne i zachodnie wzory konsumpcji szlachty wielkopolskiej w XVI–XVIII w.' In *Między Zachodem a Wschodem: Studia z dziejów Rzeczypospolitej w epoce nowożytnej*, 153–60. Toruń: Adam Marszałek, 2002.
Duncan, Carol. *Civilizing Rituals: Inside Public Art Museums*. London: Routledge, 1995.
Dupcsik, Csaba. 'Postcolonial Studies and the Inventing of Eastern Europe'. *East Central Europe* 26, no. 1 (1999): 1–14.
Dursteler, Eric. 'On Bazaars and Battlefields: Recent Scholarship on Mediterranean Cultural Contacts'. *Journal of Early Modern History* 15, no. 5 (2011): 413–34.
———. *Renegade Women: Gender, Identity, and Boundaries in the Early Modern Mediterranean*. Baltimore: Johns Hopkins Press, 2011.
———. *Venetians in Constantinople: Nation, Identity, and Coexistence in the Early Modern Mediterranean*. Baltimore: Johns Hopkins University Press, 2006.
Dzieje.pl. 'Utworzono "krąg jedności" wokół meczetu w Kruszynianach', 5 July 2014. https://dzieje.pl/aktualnosci/utworzono-krag-jednosci-wokol-meczetu-w-kruszynianach.
Dziubiński, Andrzej. *Na szlakach Orientu: Handel między Polską a Imperium Osmańskim w XVI–XVIII wieku*. Wrocław: Fundacja na Rzecz Nauki Polskiej, 1997.
Dziubkowa, Joanna, ed. *Szlachetne dziedzictwo czy przeklęty spadek: Tradycje sarmackie w sztuce i kulturze*. Exh. Cat. Poznań: Muzeum Narodowe w Poznaniu, 2004.
Eiland, Murray L. 'Scholarship and a Controversial Group of Safavid Carpets'. *Iran* 38, no. 1 (2000): 97–105.
Enenkel, K. A. E., and Koen Ottenheym. *Ambitious Antiquities, Famous Forebears: Constructions of a Glorious Past in the Early Modern Netherlands and in Europe*. Translated by Alexander C. Thomson. Leiden: Brill, 2019.
Erdmann, Kurt. *Seven Hundred Years of Oriental Carpets*. Edited by Hanna Erdmann. Translated by May Beattie and Hildegard Herzog. Berkeley and Los Angeles: University of California Press, 1970.
Espagne, Michel. 'Cultural Transfers in Art History'. In *Circulations in the Global History of Art*, edited by Thomas DaCosta Kaufmann, Catherine Dossin, and Béatrice Joyeux-Prunel, 97–112. Farnham: Ashgate, 2015.
———. *L'histoire de l'art comme transfert culturel: L'itinéraire d'Anton Springer*. Paris: Belin, 2009.
Espagne, Michel, and Michael Werner. 'Deutsch-französischer Kulturtransfer als Forschungsgegenstand: Eine Problemskizze'. In *Transferts: Les relations interculturelles dans l'espace franco-allemand, XVIIIe et XIXe siècle*, edited by Michel Espagne and Michael Werner, 11–34. Paris: Editions recherche sur les civilisations, 1988.
Estienne, Henri. *Traité de la conformité du langage françois avec le grec*. Geneva, 1565.
Fabiani-Madeyska, Irena. 'Palatium Regium w Gdańsku'. *Rocznik Gdański* 15/16 (1956/57): 140–98.

Fantuzzi, Giacomo. *Diariusz podróży po Europie (1652)*. Edited and translated by Wojciech Tygielski. Warsaw: Instytut Wydawniczy Pax, 1990.

Farago, Claire. 'The "Global Turn" in Art History: Why, When, and How Does It Matter?' In *The Globalization of Renaissance Art: A Critical Review*, edited by Daniel Savoy, 299–313. Leiden: Brill, 2017.

———, ed. *Reframing the Renaissance: Visual Culture in Europe and Latin America, 1450–1650*. New Haven: Yale University Press, 1995.

Faroqhi, Suraiya. 'Ottoman Silks and Their Markets at the Borders of the Empire, c. 1500–1800'. In *Threads of Global Desire: Silk in the Pre-Modern World*, edited by Dagmar Schäfer, Giorgio Riello, and Luca Molà, 127–47. Woodbridge: Boydell Press, 2018.

Feige, Johann Constantin. *Wunderbahrer Adlers-Schwung, oder fernere Geschichts-Fortsetzung Ortelii redivivi et continuati*. Vol. 2. Vienna: Leopold Voigt, 1694.

Fischer, Erik. *Melchior Lorck: Drawings from the Evelyn Collection at Stonor Park England and from the Department of Prints and Drawings, the Royal Museum of Fine Arts Copenhagen*. Copenhagen, 1962.

Foucault, Michel. '"Of Other Spaces, Heterotopias" (Based on a Lecture of 1967)', translated by Jay Miskowiec. *Diacritics* 16, no. 1 (1986): 22–27.

———. *The Order of Things*. London: Routledge, 2002.

———. 'What Is an Author?' In *The Art of Art History: A Critical Anthology*, edited by Donald Preziosi, 321–34. Oxford: Oxford University Press, 2009.

Fredro, Andrzej Maksymilian. *Przysłowia mów potocznych, albo przestrogi obyczajowe, radne, wojenne*. Sanok: Karol Pollak, 1855.

Frick, David A. 'Meletij Smotryc'kyj and the Ruthenian Question in the Early Seventeenth Century'. *Harvard Ukrainian Studies* 8, no. 3/4 (1984): 351–75.

Friedrich, Karin. 'Poland–Lithuania'. In *European Political Thought 1450–1700: Religion, Law and Philosophy*, edited by Howell A. Lloyd, Glenn Burgess, and Simon Hodson. New Haven: Yale University Press, 2007.

———. *The Other Prussia: Royal Prussia, Poland and Liberty, 1569–1772*. Cambridge: Cambridge University Press, 2006.

Frost, Robert I. 'The Ethiopian and the Elephant? Queen Louise Marie Gonzaga and Queenship in an Elective Monarchy, 1645–1667'. *Slavonic and East European Review* 91, no. 4 (2013): 787–817.

———. *The Oxford History of Poland–Lithuania*. Vol. 1. Oxford and New York: Oxford University Press, 2015.

———. 'Union as Process: Confused Sovereignty and the Polish–Lithuanian Commonwealth, 1385–1796'. In *Forging the State: European State Formation and the Anglo-Scottish Union of 1707*, edited by Andrew Mackillop and Micheál Ó Siochrú, 69–92. Dundee: Dundee University Press, 2009.

Fuchs, Barbara. *Mimesis and Empire: The New World, Islam, and European Identities*. Cambridge: Cambridge University Press, 2001.

Galea-Blanc, Clothilde. 'The Carpet in Spain and Portugal'. In *Great Carpets of the World*, edited by Susan Day, 313–45. London: Thames and Hudson, 1996.

Gałuszka, Justyna. '"Akt sławny, wielki i nigdy w Polszcze niewidziany...": Warszawski triumf Stanisława Żółkiewskiego (1611) na tle uroczystości z 1583 roku'. *Zapiski Historyczne* 84, no. 2 (2019): 171–203.
Gaudio, Michael. 'The Truth in Clothing: The Costume Studies of John White and Lucas de Heere'. In *European Visions: American Voices*, edited by Kim Sloan, 24–32. London: British Museum Press, 2009.
Gell, Alfred. *Art and Agency: An Anthropological Theory*. Oxford: Clarendon Press, 1998.
Gellner, Ernest. *Nations and Nationalism*. Ithaca, NY: Cornell University Press, 1983.
Gerritsen, Anne. 'Domesticating Goods from Overseas: Global Material Culture in the Early Modern Netherlands'. *Journal of Design History* 29, no. 3 (2016): 228–44.
Gintel, Jan, ed. *Cudzoziemcy o Polsce: Relacje i opinie*. Vol. 1. 2 vols. Cracow: Wydawnictwo Literackie, 1971.
Gloger, Maciej. 'Teologia polityczna Heryka Sienkiewicza'. In *Sienkiewicz ponowoczesny*, edited by Bartłomiej Szleszyński and Magdalena Rudkowska, 357–83. Warsaw: Wydawnictwo IBL PAN, 2019.
Gołąb, Maria, Ewa Hornowska, and Adam Soćko, eds. *Skarby sztuki: Muzeum Narodowe w Poznaniu*. Warsaw: Arkady, 2014.
Górnicki, Łukasz. *Dworzanin polski*. Wirtualna Biblioteka Literatury Polskiej. Gdańsk: NASK, 2003.
Grabowski, Ambroży. *Krola Polskiego W. Xiążęcia Lit. etc. listy i inne pisma urzędowe, które do znakomitych w kraju mężów, z kancellaryi król. wychodziły; w których tak sprawy państwa publiczne jako i prywatne królewskie, są traktowane. Materyał dziejowy*. Cracow: Stanisław Gieszkowski, 1845.
Grafton, Anthony. *New Worlds, Ancient Texts: The Power of Tradition and the Shock of Discovery*. Cambridge, MA: Belknap Press, 1992.
Grasskamp, Anna. *Art and Ocean Objects of Early Modern Eurasia: Shells, Bodies, and Materiality*. Amsterdam: Amsterdam University Press, 2021.
———. *Objects in Frames: Displaying Foreign Collectibles in Early Modern China and Europe*. Berlin: Reimer, 2019.
———. 'Unpacking Foreign Ingenuity: The German Conquest of Artful Objects with "Indian" Provenance'. In *Ingenuity in the Making: Matter and Technique in Early Modern Europe*, edited by Richard J. Oosterhoff, José Ramón Marcaida, and Alexander Marr, 213–28. Pittsburgh: University of Pittsburgh Press, 2021.
Grasskamp, Anna, and Monica Juneja, eds. *EurAsian Matters: China, Europe, and the Transcultural Object, 1600–1800*. Cham: Springer, 2018.
Groebner, Valentin. *Who Are You? Identification, Deception, and Surveillance in Early Modern Europe*. New York: Zone Books, 2007.
Gronberg, Tag. 'Coffeehouse Orientalism'. In *The Viennese Café and Fin-de-Siècle Culture*, edited by Charlotte Ashby, Tag Gronberg, and Simon Shaw-Miller, 59–77. New York: Berghahn Books, 2013.
Grygajtis, Krzysztof. 'Osadnictwo Tatarów hospodarskich w Wielkim Księstwie Litewskim XIV–XVIII w'. *Rocznik Tatarów Polskich* 8 (2003): 7–280.

Grześkowiak-Krwawicz, Anna. 'Respublica and the Language of Freedom: The Polish Experiment'. In *A Handbook to Classical Reception in Eastern and Central Europe*, edited by Zara Martirosova Torlone, Dana LaCourse Munteanu, and Dorota Dutsch, 179–89. Oxford: Wiley-Blackwell, 2017.

Guagnini, Alessandro. *Sarmatiae Europae descriptio: quae Regnum Poloniae, Lituaniam, Samogitiam, Russiam, Massoviam, Prussiam, Pomeraniam, Livoniam et Moschoviae, Tartariaeqve partem complectitur*. Cracow, 1578.

———. *Sarmatiae Europeae descriptio: quae Regnum Poloniae, Lituaniam, Samogitiam, Russiam, Massoviam, Prussiam, Pomeraniam, Livoniam et Moschoviae Tartariaeque partem complectitur*. Speyer, 1581.

———. *Kronika Sarmacyey Europskiey: w ktorey sie zamyka Krolestwo Polskie ze wszystkiemi Państwy, Xięstwy y Prowincyami swemi*. Cracow, 1611.

Guile, Carolyn C. 'Circulations: Early Modern Architecture in the Polish-Lithuanian Borderland'. In *Circulations in the Global History of Art*, edited by Thomas DaCosta Kaufmann, Catherine Dossin, and Béatrice Joyeux-Prunel, 79–96. Farnham: Ashgate, 2015.

Gutkowska-Rychlewska, Maria. *Historia ubiorów*. Wrocław: Zakład Narodowy im. Ossolińskich, 1968.

Hajdukiewicz, Leszek. *Biblioteka Macieja z Miechowa*. Wrocław: Zakład Narodowy im. Ossolińskich, 1960.

Hanaka, Anna. 'Bohoniki i Kruszyniany – Meczety i mizary'. Natonal Heritage Board of Poland, 22 October 2012. https://zabytek.pl/public/upload/objects_media/5679ab4e616a0.pdf.

Hansen, Hans Jürgen, ed. *Architecture in Wood: A History of Wood Building and Its Techniques in Europe and North America*. Translated by Janet Seligman. New York: Viking, 1971.

Harman, Graham. *Object-Oriented Ontology: A New Theory of Everything*. London: Pelican Books, 2018.

Hartknoch, Christophorus. *Alt- und neues Preussen*. Frankfurt and Leipzig, 1684.

Hartley, L. P. *The Go-Between*. London: Hamish Hamilton, 1953.

Haynes, Jeffrey. 'Right-Wing Populism and Religion in Europe and the USA'. *Religions* 11, no. 490 (2020). https://doi.org/10.3390/rel11100490.

Heidegger, Martin. 'The Thing'. In *Poetry, Language, Thought*, translated by Albert Hofstadter, 161–83. Harper & Row, 1971.

Helgerson, Richard. *Forms of Nationhood: The Elizabethan Writing of England*. Chicago: University of Chicago Press, 1992.

Hendrix, Harald. 'Imagining the Other: On Xenophobia and Xenophilia in Early Modern Europe'. *Leidschrift* 28, no. 1 (2013): 7–20.

Hennings, Jan. *Russia and Courtly Europe: Ritual and the Culture of Diplomacy, 1648–1725*. Cambridge: Cambridge University Press, 2016.

Herodotus. *Histories*. Edited by Carolyn Dewald. Translated by Robin Waterfield. Oxford: Oxford University Press, 1998.

Heumann, Johann, ed. *Documenta literaria varii argumenti*. Altorf, 1758.

Higersberger, Renata. 'Scena szlachecka – historia jataganu'. In *MNW Cyfrowe*, http://cyfrowe.mnw.art.pl/dmuseion/docmetadata?id=3463&show_nav=true (accessed 2 October 2017).
Hirschi, Caspar. *The Origins of Nationalism: An Alternative History from Ancient Rome to Early Modern Germany*. Cambridge: Cambridge University Press, 2011.
Hobsbawm, Eric. 'Inventing Traditions'. In *The Invention of Tradition*, edited by Eric Hobsbawm and Terence Ranger, 1–14. Cambridge: Cambridge University Press, 1983.
Hock, Beáta. 'Introduction'. In *Globalizing East European Art Histories: Past and Present*, edited by Beáta Hock and Anu Allas, 1–22. New York: Routledge, 2018.
Hoffman, Eva R. 'Pathways of Portability: Islamic and Christian Interchange from the Tenth to the Twelfth Century'. *Art History* 24, no. 1 (2001): 17–50.
Hooper-Greenhill, Eilean. *Museums and the Shaping of Knowledge*. London: Routledge, 1992.
Horoszkiewicz, Jan. *Strój narodowy w Polsce*. Cracow: Spółka wydawnicza polska, 1900.
Hryzaj, Ostap. *Die Ukrainer und die Befreiung Wiens 1683*. Vienna: Literarische Sektion des Exekutiv-Komitees der ukrainischen Vereine in Österreich, 1934.
Ichijo, Atsuko, and Ronald Ranta. *Food, National Identity and Nationalism: From Everyday to Global Politics*. London: Palgrave Macmillan, 2015.
Ilg, Ulrike. 'Stefano Della Bella and Melchior Lorck: The Practical Use of an Artists' Model Book'. *Master Drawings* 41, no. 1 (2003): 30–43.
———. 'The Cultural Significance of Costume Books in Sixteenth-Century Europe'. In *Clothing Culture, 1350–1650*, edited by Catherine Richardson, 29–47. Aldershot: Ashgate, 2004.
Ingres abo wiazd Krolowey Jey Mości do Gdańska 11 Februarii. Cracow: Walerian Piątkowski, 1646.
Ionescu, Stefano, ed. *Antique Ottoman Rugs in Transylvania*. Rome: Stefano Ionescu, 2005.
Ionescu, Stefano, and Beata Biedrońska-Słota, eds. *Anatolian Carpets from the Collection of the Brukenthal National Museum in Sibiu*. Gdańsk: Muzeum Narodowe w Gdańsku, 2013.
Jagodzinski, Sabine. 'European and Exotic: Jan III Sobieski's Commemorative and Representative Strategies Towards Polish-Ottoman Relations'. *Art of the Orient* 6 (2017): 144–55.
Jakowenko, Natalia. *Historia Ukrainy do 1795 roku*. Translated by Anna Babiak-Owad and Katarzyna Kotyńska. Warsaw: Wydawnictwo Naukowe PWN, 2011.
Jasienski, Adam. 'A Savage Magnificence: Ottomanizing Fashion and the Politics of Display in Early Modern East-Central Europe'. *Muqarnas* 31 (2014): 173–205.
Jirousek, Charlotte. *Ottoman Dress and Design in the West: A Visual History of Cultural Exchange*. Bloomington: Indiana University Press, 2019.
Johnson, Carina L. *Cultural Hierarchy in Sixteenth-Century Europe: The Ottomans and Aztecs*. Cambridge: Cambridge University Press, 2011.

Jones, Alexander. 'Ptolemy's Geography: A Reform That Failed'. In *Ptolemy's Geography in the Renaissance*, edited by Zur Shalev and Charles Burnett, 15–30. London: The Warburg Institute, 2011.

Jones, Amelia. *In Between Subjects: A Critical Genealogy of Queer Performance.* New York: Routledge, 2020.

Jones, Ann Rosalind. '"Worn in Venice and throughout Italy": The Impossible Present in Cesare Vecellio's Costume Books'. *Journal of Medieval and Early Modern Studies* 39, no. 3 (2009): 511–44.

Jones, Anne Rosalind. 'Habits, Holdings, Heterologies. Populations in Print in a 1562 Costume Book'. *Yale French Studies* 110 (2006): 92–121.

Joyeux-Prunel, Béatrice. 'Art History and the Global: Deconstructing the Latest Canonical Narrative'. *Journal of Global History* 14, no. 3 (2019): 413–35.

Juda, Maria. 'Mapy ziem polskich w dawnej typografii europejskiej'. *Studia Źródłoznawcze* 41 (2003): 45–63.

Kadoi, Yuka, ed. *Arthur Upham Pope and a New Survey of Persian Art.* Leiden: Brill, 2016.

Kadoi, Yuka. 'Carpets on the Move: Modern Trajectories of Persian Woven Treasures'. In *The Seas and the Mobility of Islamic Art*, edited by Radha Dalal, Sean Roberts, and Jochen Sokoly, 220–309. New Haven: Yale University Press, 2021.

Kalinowski, Lech, ed. *Portret typu sarmackiego w wieku XVII w Polsce, Czechach, na Słowacji i na Węgrzech.* Cracow: Muzeum Narodowe w Krakowie, 1985.

Kamieniecka, Elena. 'Z zagadnień sztuki Grodna połowy XVII wieku: Portrety z klasztoru brygidek'. *Rocznik Muzeum Narodowego w Warszawie* 16 (1972): 87–133.

Kamiński, Andrzej Sulima. *Historia Rzeczypospolitej Wielu Narodów 1505–1795: Obywatele, ich państwa, społeczeństwo, kultura.* Lublin: Instytut Europy Środkowo-Wschodniej, 2000.

Kamusella, Tomasz. *The Un-Polish Poland, 1989 and the Illusion of Regained Historical Continuity.* Cham: Palgrave Macmillan, 2017.

Kangal, Selmin, and Bartłomiej Świetlik, eds. *War and Peace: Ottoman-Polish Relations in the 15th–19th Centuries.* Istanbul: Museum of Turkish and Islamic Arts, 1999.

Kanon, Andrzej. *Expeditio legatorum in Gallias, ad desponsandam deducendamque Ludovicam Mariam Gonzagam Cliviam, Mantuae et Niversi principem, Vladislao IV. Poloniae et Sueciae regi invictissimo, transacta per senatorii ordinis viros.* Cracow: Franciszek Cezary, 1646.

Kármán, Gábor. 'The Polish–Ottoman–Transylvanian Triangle: A Complex Relationship in the Sixteenth and Seventeenth Centuries'. In *Türkiye-Polonya İlişkilerinde 'Temas Alanları' (1414–2014)*, edited by Natalia Królikowska and Hacer Topaktaş, 293–321. Ankara: Türk Tarih Kurumu Yayınları, 2017.

Karpowicz, Mariusz. *Sztuka oświeconego sarmatyzmu: Antykizacja i klasycyzacja w środowisku warszawskim czasów Jana III.* 2nd edn. Warsaw: PWN, 1986.

Katalog portretów i osobistości polskich i obcych w Polsce działających. Vol. 2. Warsaw: Biblioteka Narodowa, 1992.

Kaufmann, Thomas DaCosta. *Court, Cloister, and City: The Art and Culture of Central Europe, 1450–1800.* Chicago: University of Chicago Press, 1995.

———. *Toward a Geography of Art*. Chicago: University of Chicago Press, 2004.
Kaufmann, Thomas DaCosta, Catherine Dossin, Béatrice Joyeux-Prunel, and Thomas DaCosta Kaufmann, eds. *Circulations in the Global History of Art*. Farnham Surrey and Burlington, VT: Ashgate, 2015.
Kazańczuk, Mariusz. 'Wzorce osobowe w herbarzach Bartosza Paprockiego i Kaspra Niesieckiego'. In *Wzorce osobowe w dawnej literaturze i kulturze polskiej*, edited by Elżbieta A. Jurkowska and Bernadetta M. Puchalska-Dąbrowska, 53–66. Białystok: Wydawnictwo Prymat, 2018.
Keating, Jessica. *Animating Empire: Automata, the Holy Roman Empire, and the Early Modern World*. University Park, PA: Pennsylvania State University Press, 2018.
Kieniewicz, Jan. 'Polish Orientalness'. *Acta Poloniae Historica* 49 (1984): 67–103.
Kim, David Young. 'Lotto's Carpets: Materiality, Textiles, and Pictorial Composition in Renaissance Painting'. *The Art Bulletin* 98, no. 2 (2016): 181–212.
King, Donald. 'The "Doria" Polonaise Carpet'. In *Persian and Mughal Art*, edited by B. W. Robinson, 303–7. London: Colnaghi, 1976.
Kloczkowski. 'Polacy a cudzoziemcy w XV wieku'. In *Swojskość i cudzoziemszczyzna w dziejach kultury polskiej*, edited by Zofia Stefanowska, 38–67. Warsaw: PWN, 1973.
Kobos, Andrzej Michał. 'Tomasz Niewodniczański (1933–2010) i jego zbiory'. *Prace Komisji Historii Nauki PAU* 11 (2012): 149–97.
Kociszewska, Ewa. 'War and Seduction in Cybele's Garden: Contextualizing the Ballet Des Polonais'. *Renaissance Quarterly* 65, no. 3 (2012): 809–63.
Koehler, Krzysztof. *Palus sarmatica*. Warsaw: Muzeum Historii Polski, 2016.
Kohn, Hans. *The Idea of Nationalism: A Study in Its Origins and Background*. London: Routledge, 2005.
Kohut, Halyna. 'Profesiyni maysterni na "kylymoviy mapi" Ukrayiny XVII-XVIII st.: Fakty, mify, hipotezy'. *Visnik L'vivs'kogo Universitetu. Seriya Myst-Vo* 2 (2002): 132–42.
Koialovicius-Wijuk, Albertus. *Lithuanae pars prior, de rebus Lithuanorum ante susceptam Christianam religionem conjunctionemque… cum regno Poloniae*. Danzig, 1650.
Kołodziejczyk, Dariusz. 'Stosunki dawnej Rzeczypospolitej z Turcją i Tatarami: Czy naprawdę byliśmy Przedmurzem Europy'. *Praktyka Teoretyczna* 26, no. 4 (2017): 16–36.
Komornicki, Stefan S. *Essay d'une iconographie du roi Etienne Batory*. Cracow: Imprimerie de l'Université des Jagellons, 1935.
Kondraciuk, Piotr. 'Sztuka ormiańska w Zamościu'. In *Ars armeniaca: Sztuka ormiańska ze zbiorów polskich i ukraińskich*, 11–25. Zamość: Muzeum Zamojskie, 2010.
Konopacki, Artur. *Życie religijne Tatarów na ziemiach Wielkiego Księstwa Litewskiego w XVI-XIX wieku*. Warsaw: Wydawnictwa Uniwersytetu Warszawskiego, 2010.
Konopacki, Artur, Joanna Kulwicka-Kamińska, and Czesław Łapicz. 'Tatarzy litewscy czy Lipkowie? Rozważania historyczno-semantyczne oraz propozycje terminologiczne'. In *Wschód muzułmański w ujęciu interdyscyplinarnym: Ludzie, teksty, historia*, edited by Grzegorz Czerwiński and Artur Konopacki, 291–307. Białystok: Alter Studio, 2017.

Konuk, Kader. 'Ethnomasquerade in Ottoman-European Encounters: Reenacting Lady Mary Wortley Montagu'. *Criticism* 46, no. 3 (2004): 393–414.
Kopczyński, Michał, and Wojciech Tygielski, eds. *Under a Common Sky: Ethnic Groups of the Commonwealth of Poland and Lithuania*. New York: PIASA Books, 2017.
Kornecki, Marian. 'Spalony kościół drewniany na Woli Justowskiej w Krakowie: Problemy konserwatorskie'. *Ochrona Zabytków* 32, no. 1 (1979): 35–42.
Koutny-Jones, Aleksandra. 'Echoes of the East: Glimpses of the Orient in British and Polish–Lithuanian Portraiture of the Eighteenth Century'. In *Britain and Poland–Lithuania: Contact and Comparison from the Middle Ages to 1795*, edited by Richard Unger, 401–19. Leiden: Brill, 2008.
Kowalski, Jacek. *Sarmacja: obalanie mitów: Podręcznik bojowy*. Warsaw: Zona Zero, 2016.
Kozica, Kazimierz. 'The Map of the Polish–Lithuanian Commonwealth by Andrzej Pograbka Published in Venice in 1570 in the Niewodniczański Collection Imago Poloniae at the Royal Castle in Warsaw – Museum'. In *Proceedings 12th ICA Conference Digital Approaches to Cartographic Heritage, Venice, 26–28 April 2017*, edited by Evangelos Livieratos, 10–14. Thessaloniki: AUTH CartoGeoLab, 2017.
Krastev, Ivan, and Stephen Holmes. *The Light That Failed: A Reckoning*. London: Allen Lane, 2019.
Kretschmer, Helmut. *Kapuziner, Einspänner, Schalerl Gold: Zur Geschichte Der Wiener Kaffeehäuser*. Vienna: Wiener Stadt- und Landesarchiv, 2006.
Krogt, Peter van der. 'The Map of Russia and Poland in Dutch Atlases of the Sixteenth and Seventeenth Centuries'. In *Maps in Books of Russia and Poland Published in the Netherlands to 1800*, edited by Paula van Gestel-van het Schip et al., 113–31. Houten: Hes & De Graaf, 2011.
Kromer, Marcin. *De origine et rebus gestis polonorum libri XXX*. Basel, 1555.
———. *Polska: czyli o położeniu, ludności, obyczajach, urzędach i sprawach publicznych Królestwa Polskiego księgi dwie*. Translated by Stefan Kazikowski. Olsztyn: Pojezierze, 1977.
Kryczyński, Stanisław. 'Bej barski: Szkic z dziejów Tatarów polskich w XVII w.'. *Rocznik Tatarski* 2 (1935): 229–301.
———. *Tatarzy litewscy: Próba monografii historyczno-etnograficznej*. Warsaw: Rada Centralna Związku Kulturalno-Oświatowego Tatarów Rzeczypospolitej, 1938.
Krygowski, T. 'Polenteppiche (polnische Knüpfteppiche)'. *Orientalisches Archiv* 2 (1911/12): 70–76, 106–21.
Kubala, Ludwik. *Jerzy Ossoliński*. Warsaw: Księgarnia Zakładu Nar. im. Ossolińskich, 1924.
Kulczycki, Jerzy S. 'Prawdziwa legenda wiedeńskiej wiktorii'. *Wspólnota Polska*, no. 6 (2007). http://wspolnotapolska.home.pl/swp2/index3fe9.html?id=kw7_6_13.
Kumar, Krishan. *Visions of Empire: How Five Imperial Regimes Shaped the World*. Princeton: Princeton University Press, 2017.
Kurak, Ewa. 'Autokreacja Bartłomieja Paprockiego (ok. 1543–1614) w świetle listów dedykacyjnych w "Gnieździe Cnoty" oraz "Herbach Rycerstwa Polskiego"'. *Zeszyty Naukowe Towarzystwa Doktorantów UJ*, Nauki Społeczne, 14, no. 3 (2016): 39–53.

Kutrzeba, Stanisław, and Władysław Semkowicz, eds. *Akta unji Polski z Litwą, 1385–1791*. Cracow: Nakładem Polskiej Akademji Umiejętności, 1932.
Kuźma, Erazm. *Mit Orientu i kultury Zachodu w literaturze XIX i XX wieku*. Szczecin: Wydawnictwa Naukowe Wyższej Szkoły Pedagogicznej w Szczecinie, 1980.
Lambropoulos, Vassilis. *The Rise of Eurocentrism: Anatomy of Interpretation*. Princeton, NJ: Princeton University Press, 1993.
Latour, Bruno. *Reassembling the Social: An Introduction to Actor-Network-Theory*. Oxford: Oxford University Press, 2005.
Łazarski, Krzysztof. 'Freedom, State and "National Unity" in Lord Acton's Thought'. In *Citizenship and Identity in a Multinational Commonwealth: Poland-Lithuania in Context, 1550–1772*, edited by Karin Friedrich and Barbara M. Pendzich, 261–76. Leiden: Brill, 2009.
'Le contract de marriage du Roy et la Reine de Pologne'. *Gazette de France* 145 (1645): 1041–48.
Le Laboureur, Jean. *Histoire du voyage de la Reine de Pologne*. Vol. 3. 3 vols. Paris, 1648.
Le Mao, Caroline. 'Un Français en Pologne: Gaspard de Tende à l'époque de la reine Marie-Louise de Gonzague'. In *Le rayonnement français en Europe centrale: Du XVIIe siècle à nos jours*, edited by Olivier Chaline, Jarosław Dumanowski, and Michel Figeac, 137–50. Pessac: Maison des Sciences de l'Homme d'Aquitaine, 2009.
Lechicki, Czesław. *Mecenat Zygmunta III i życie umysłowe na jego dworze*. Warsaw: Kasa im. Mianowskiego, 1932.
Leitch, Stephanie. 'Cosmopolitan Renaissance: Prints in the Age of Exchange'. In *The Globalization of Renaissance Art*, edited by Daniel Savoy, 186–217. Leiden: Brill, 2017.
———. *Mapping Ethnography in Early Modern Germany: New Worlds in Print Culture*. Basingstoke: Palgrave Macmillan, 2010.
Lepszy, Kazimierz, ed. *Archiwum Jana Zamoyskiego, Kanclerza i Hetmana Wielkiego Koronnego*. Cracow: Polska Akademia Umiejętności, 1948.
Les collections célèbres d'oeuvres d'art, dessinées et gravées d'après les originaux par Edouard Lièvre. Paris: Goupil, 1879.
Les merveilles de l'Exposition de 1878: Histoire, construction, inauguration, description détaillée des palais, des Annexes et des parcs. Paris: Librairie contemporaine, 1879.
Levykin, Aleksej Konstantinovič, ed. *The Tsars and the East: Gifts from Turkey and Iran in the Moscow Kremlin*. London: Thames & Hudson, 2009.
Lewis, Simon. *Belarus – Alternative Visions: Nation, Memory and Cosmopolitanism*. Abingdon: Routledge, 2019.
———. 'Cosmopolitanism as Sub-Culture in the Former Polish-Lithuanian Commonwealth'. In *Identities In-Between in East-Central Europe*, edited by Jan Fellerer, Robert Pyrah, and Marius Turda, 149–69. New York: Routledge, 2019.
———. 'East Is East? Polish Orientalisms in the Early Nineteenth Century'. *Central Europe* 19, no. 2 (2021): 135–52.
Liesville, A.-R. de. 'L'exposition historique de l'art ancien'. *Gazette des Beaux-Arts*, 1 July 1878.
Lileyko, Jerzy. 'Z rozważań nad programem ideowym pokojów królewskich na Zamku Warszawskim za Wazów'. *Rocznik Warszawski* 15 (1979): 185–200.

Lisy-Wagner, Laura. *Islam, Christianity and the Making of Czech Identity, 1453–1683*. Farnham: Ashgate, 2013.

Loh, Maria H. *Titian Remade: Repetition and the Transformation of Early Modern Italian Art*. Los Angeles: Getty Research Institute, 2007.

Łomnicka-Żakowska, Ewa. 'Początki portretu polskiego: Adoranci w polskim malarstwie tablicowym, miniaturowym i ściennym w wieku XV i w pierwszych dziesięcioleciach wieku XVI'. *Studia Źródłoznawcze* 14 (1969): 13–34.

Łopatecki, Karol. *Organizacja, prawo i dyscyplina w polskim i litewskim pospolitym ruszeniu do połowy XVII wieku*. Białystok: Instytut Badań nad Dziedzictwem Kulturowym Europy, 2013.

Lowenthal, David. *The Past Is a Foreign Country*. Revised and updated edition. Cambridge: Cambridge University Press, 2013.

Łoziński, Władysław. *Patrycjat i mieszczaństwo lwowskie w XVI i XVII wieku*. Lviv: H. Altenberg, 1902.

Lubomirski, Tadeusz. 'Regestra skarbca Książąt Ostrogskich w Dubnie spisane w roku 1616'. *Sprawozdania Komisyi do Badania Historyi Sztuki w Polsce* 6, no. 2/3 (1898): 206–21.

Łuczyński, Jarosław. 'Ziemie Rzeczypospolitej w kartografii europejskiej XVI wieku (próba ustalenia filiacji map wydanych drukiem)'. *Polski Przegląd Kartograficzny* 41, no. 2 (2009): 128–44.

MacLean, Gerald M., ed. *Re-Orienting the Renaissance: Cultural Exchanges with the East*. Basingstoke: Palgrave Macmillan, 2005.

Majewski, Wiesław. 'The Polish Art of War in the Sixteenth and Seventeenth Centuries'. In *A Republic of Nobles: Studies in Polish History to 1864*, edited by J. K. Fedorowicz, 179–97. Cambridge: Cambridge University Press, 1982.

Makowski, Tomasz. *Poselstwo Jerzego Ossolińskiego do Rzymu w roku 1633*. Warsaw: Biblioteka Narodowa, 1996.

———. 'Z Dziejów stosunków państwa i kościoła: Polskie poselstwa obediencyjne w XVI i XVII wieku'. *Teologia Polityczna* 1 (2003/4).

Malinowski, Jerzy, ed. *Where East Meets West: Portrait of Personages of the Polish–Lithuanian Commonwealth, 1576–1763*. Exh. Cat. Warsaw: National Museum, 1993.

Mamone, Sara. 'Le spectacle à Florence sous le regard de Stefano della Bella'. In *Stefano della Bella, 1610–1664*, 18–21. Exh. Cat. Caen: Musee des Beaux-Arts, 1998.

Manikowski, Adam. *Toskańskie przedsiębiorstwo arystokratyczne w XVII wieku: Społeczeństwo elitarnej konsumpcji*. Warsaw: PWN, 1991.

Mańkowski, Tadeusz. *Genealogia sarmatyzmu*. Warsaw: Towarzystwo Wydawnicze 'Łuk', 1947.

———. 'Influence of Islamic Art in Poland'. *Ars Islamica* 2, no. 1 (1935): 93–117.

———. 'Note on the Cost of Kashan Carpets at the Beginning of the Seventeenth Century'. *Bulletin of the American Institute for Persian Art and Archaeology* 4, no. 3 (1936): 152–53.

———. *Orient w polskiej kulturze artystycznej*. Wrocław: Zakład Narodowy im. Ossolińskich, 1959.

———. 'Polskie kobierce wełniane'. *Arkady* 4 (1938): 152–73.
———. *Polskie tkaniny i hafty XVI-XVIII wieku*. Wrocław: Zakład im. Ossolińskich, 1954.
———. *Sztuka Islamu w Polsce w XVII i XVIII wieku*. Cracow: Nakł. Polskiej Akademji Umiejętności, 1935.
———. 'Wyprawa po kobierce do Persji w roku 1601'. *Rocznik Orientalistyczny* 12 (1951): 184–211.
Mańkowski, Tadeusz, and Mieczysław Gębarowicz. 'Arrasy Zygmunta Augusta'. *Rocznik Krakowski* 29 (1937): 1–219.
Mannheim, Linda. '"F*ck Leftist Westsplaining!" Listening to Voices of the Central and East European Left'. *The Nation*, 4 April 2022. www.thenation.com/article/world/ukraine-russia-european-left/.
Marchand, Suzanne L. *German Orientalism in the Age of Empire: Religion, Race, and Scholarship*. Cambridge: Cambridge University Press, 2009.
Marchwiński, Roman. 'Kromer a Grodecki: Podstawy kartograficzne kromerowskiej Polonii'. *Acta Universitatis Nicolai Copernici: Historia* 16, no. 114 (1980): 133–149.
Markey, Lia. *Imagining the Americas in Medici Florence*. University Park, PA: Penn State University Press, 2016.
Marolles, Michel de. 'À la Reine de Pologne et de Suede'. In *Les oeuvres de Lucain: Contenant l'histoire des guerres civiles entre Cesar et Pompée*. Paris, 1647.
Martin, Fredrik Robert. *A History of Oriental Carpets before 1800*. Vienna: K.K. Hof- und Staatsdruckerei, 1908.
Martin, John Jeffries. *Myths of Renaissance Individualism*. Basingstoke: Palgrave Macmillan, 2005.
Martin, Meredith and Daniela Bleichmar. 'Introduction: Objects in Motion in the Early Modern World'. *Art History* 38, no. 4 (2015): 604–19.
Mason, Peter. *Infelicities: Representations of the Exotic*. Baltimore: Johns Hopkins University Press, 1998.
Massar, Phyllis Dearborn. *Presenting Stefano Della Bella: Seventeenth-Century Printmaker*. New York: Metropolitan Museum of Art, 1971.
Matthee, Rudolph P. *The Politics of Trade in Safavid Iran: Silk for Silver, 1600–1730*. Cambridge: Cambridge University Press, 1999.
Matwiejczuk, Paweł, ed. *Melanchtoniana polonica*. Berlin and Warsaw: CBH PAN and Muzeum Historii Polski, 2022.
Mawer, Caroline. 'Polish Relations: The Vasa Silk Kilims'. *Hali* 172 (2012): 50–57.
'Medaillon-Uschak (Uschak-Teppich)'. In *SMB-Digital, Online Collections Database*, www.smb-digital.de/eMuseumPlus?service=ExternalInterface&module=collection&objectId=1938871&viewType=detailView (accessed 22 July 2021).
Medek, Jakub. 'Atak na meczet i mizar: Zbezczeszczono świątynię Tatarów'. *Gazeta Wyborcza Białystok*, 29 June 2014. https://bialystok.wyborcza.pl/bialystok/7,35241,16238626,atak-na-meczet-i-mizar-zbezczeszczono-swiatynie-tatarow-zdjecia.html.
Miechowita, Maciej. *Tractatus de duabus Sarmatiis Asiana et Europeana et de contentis in eis*. Cracow, 1517.

———. *Opis Sarmacji Azjatyckiej i Europejskiej*. Edited by Henryk Barycz. Translated by Tadeusz Bieńkowski. Wrocław: Zakład Narodowy im. Ossolińskich, 1972.

Miecik, Igor T. 'Kto podłożył świnię'. *Gazeta Wyborcza*, 11 July 2014. https://wyborcza.pl/magazyn/7,124059,16311861,kto-podlozyl-swinie.html.

Mierzwiński, Henryk. 'Osadnictwo tatarskie na Podlasiu za Jana III Sobieskiego'. *Podlaski Kwartalnik Kulturalny* 2 (1997): 40–49.

Mikhail, Alan. *The Animal in Ottoman Egypt*. Oxford: Oxford University Press, 2014.

Mikoś, Michael J. 'Monarchs and Magnates: Maps of Poland in the Sixteenth and Eighteenth Centuries'. In *Monarchs, Ministers, and Maps: The Emergence of Cartography as a Tool of Government in Early Modern Europe*, edited by David Buisseret, 168–81. Chicago: University of Chicago Press, 1992.

Mishkova, Diana. 'Balkans/Southeastern Europe'. In *European Regions and Boundaries: A Conceptual History*, edited by Diana Mishkova and Balázs Trencsényi, 143–65. New York: Berghahn Books, 2017.

Modelska-Strzelecka, Bożena. *Odrodzenie Geografii Ptolemeusza w XV w.: Tradycja kartograficzna*. Wrocław: Polskie Towarzystwo Geograficzne, 1960.

Möller, Anton. *Omnium statuum Foeminei sexus ornatus, et usitati habitus Gedanenses*. Danzig, 1601.

Monitor Warszawski. Vol. 30, 1765.

Montpensier, Anne-Marie-Louise d'Orléans de. *Mémoires de Mlle de Montpensier: Collationnés sur le manuscrit autographe*. Vol. 1. Paris: Charpentier, 1858.

Motteville, Françoise Bertaut de. *Mémoires*. Vol. 1. Paris, 1851.

———. *Memoirs for the History of Anne of Austria, Wife to Lewis XIII. of France*. Vol. 1. 5 vols. London: J. Darby, 1726.

Mrozowski, Przemysław. 'Orientalizacja stroju szlacheckiego w Polsce na przełomie XVI i XVII w.' In *Orient i orientalizm w sztuce*, edited by Elżbieta R. Karwowska, 243–61. Warsaw: PWN, 1986.

———. 'Portret Piotra Widawskiego i problem początków stroju narodowego w Polsce'. In *Velis quod possis: Studia z historii sztuki ofiarowane Profesorowi Janowi Ostrowskiemu*, edited by Andrzej Betlej, Katarzyna Brzezina-Scheuerer, Agata Dworzak, Marcin Fabiański, Piotr Krasny, Michał Kurzej, and Dagny Nestorow, 243–50. Cracow: Wydawnictwo Towarzystwa Naukowego Societas Vistulana, 2016.

———. *Portret w Polsce XVI wieku*. Warsaw: Muzeum Pałacu Króla Jana III w Wilanowie, 2021.

———. 'Ubiór jako wyraz świadomości narodowej szlachty polskiej w XVI–XVIII wieku'. In *Ubiory w Polsce*, edited by Anna Sieradzka, 19–27. Warsaw: Stowarzyszenie Historyków Sztuki, 1992.

Muratowicz, Sefer. *Relacya Sefera Muratowicza obywatela warszawskiego od Zygmunta III Krola Polskiego dla sprawowania rzeczy wysłanego do Persyi w roku 1602*. Warsaw: J. F. Minasowicz, 1777.

Murawska-Muthesius, Katarzyna. *Imaging and Mapping Eastern Europe: Sarmatia Europea to Post-Communist Bloc*. New York: Routledge, 2021.

Nadel-Golobič, Eleonora. 'Armenians and Jews in Medieval Lvov: Their Role in Oriental Trade 1400–1600'. *Cahiers du monde russe et soviétique* 20, no. 3/4 (1979): 345–88.

Nagel, Alexander, and Christopher S. Wood. *Anachronic Renaissance*. New York: Zone Books, 2010.

———. 'What Counted as an Antiquity in the Renaissance?' In *Renaissance Medievalisms*, edited by Konrad Eisenbichler, 53-74. Toronto: Centre for Reformation and Renaissance Studies, 2009.

Nagielski, Mirosław. 'Wpływ Orientu na staropolską sztukę wojenną XVI-XVII w'. In *Staropolski ogląd świata: Rzeczpospolita między okcydentalizmem a orientalizacją*, edited by Filip Wolański and Robert Kołodziej, vol. 1, 77-96. Toruń: Adam Marszałek, 2009.

Nalborczyk, Agata S. 'Mosques in Poland: Past and Present'. In *Muslims in Eastern Europe: Widening the European Discourse on Islam*, edited by Katarzyna Górak-Sosnowska, 183-93. Warsaw: Faculty of Oriental Studies, University of Warsaw, 2011.

Naumann, Friedrich. *Mitteleuropa*. Berlin: Georg Reimer, 1915.

Neville, Kristoffer. 'History and Architecture in Pursuit of a Gothic Heritage'. In *The Quest for an Appropriate Past in Literature, Art and Architecture*, edited by Karl A. E. Enenkel and Konrad Adriaan Ottenheym, 619-48. Leiden: Brill, 2018.

———. 'The Land of the Goths and Vandals: The Visual Presentation of Gothicism at the Swedish Court, 1550-1700'. *Renaissance Studies* 27, no. 3 (2012): 435-59.

Newman, Karen. *Cultural Capitals: Early Modern London and Paris*. Princeton: Princeton University Press, 2007.

Niedźwiedź, Jakub. 'Sarmatyzm, czyli tradycja wynaleziona'. *Teksty Drugie* 1 (2015): 46-62.

Nora, Pierre. *Rethinking France: Les Lieux de Mémoire*. Translated by Mary Seidman Trouille. Vol. 1: The State. 4 vols. Chicago: University of Chicago Press, 1999.

Ochmann-Staniszewska, Stefania. *Dynastia Wazów w Polsce*. Warsaw: PWN, 2006.

Ogier, Charles. *Ephemerides: sive, Iter Danicvm, Svecicvm, Polonicvm, cum esset in comitatu illustriss*. Paris, 1656.

Opaliński, Edward. 'Civic Humanism and Republican Citizenship in the Polish Renaissance'. In *Republicanism: A Shared European Heritage*, edited by Martin van Gelderen and Quentin Skinner. Cambridge: Cambridge University Press, 2002.

Opaliński, Krzysztof. *Listy Krzysztofa Opalińskiego do brata Łukasza, 1641-1653*. Edited by Roman Pollak. Wrocław: Zakład Narodowy im. Ossolińskich, 1957.

———. *Satyry*. Cracow: Nakł. K. Bartoszewicza, 1884.

Ortiz, Fernando. *Cuban Counterpoint, Tobacco and Sugar*. Durham: Duke University Press, 1995.

Orwell, George. *Nineteen Eighty-Four*. London: Secker & Warburg, 1949.

Orzechowski, Stanisław. *Mowy [o wojnie tureckiej; Turcyki]*. Sanok: K. Turowski, 1855.

Osiecka-Samsonowicz, Hanna. *Polskie uroczystości w barokowym Rzymie, 1587-1696*. Warsaw: Instytut Sztuki PAN, 2012.

Osipian, Alexandr. 'Between Mercantilism, Oriental Luxury, and the Ottoman Threat: Discourses on the Armenian Diaspora in the Early Modern Kingdom of Poland'. *Acta Poloniae Historica* 116 (2017): 171-207.

———. 'Legal Pluralism in the Cities of the Early Modern Kingdom of Poland: The Jurisdictional Conflicts and Uses of Justice by Armenian Merchants'. In *The Uses of*

Justice in Global Perspective 1600–1900, edited by Griet Vermeesch, Manon van der Heijden, and Jaco Zuijderduijn, 80–102. London: Routledge, 2019.

———. 'Uses of Oriental Rugs in Early Modern Poland–Lithuania: Social Practices and Public Discourses'. In *Transottoman Matters: Objects Moving through Time, Space, and Meaning*, edited by Arkadiusz Blaszczyk, Robert Born, and Florian Riedler, 173–217. Göttingen: V&R Unipress, 2021.

Ossewaarde, Marinus. 'The National Identities of the "Death of Multiculturalism" Discourse in Western Europe'. *Journal of Multicultural Discourses* 9, no. 3 (2014): 173–89.

Ostrowski, Jan K. 'Jeszcze o stroju polskim w malarstwie portretowym w XVII–XX wieku: Pomiędzy obrazami a źródłami'. *Artifex Novus*, no. 4 (2020): 44–67.

———, ed. *Land of the Winged Horsemen: Art in Poland, 1572–1764*. New Haven: Yale University Press, 1999.

———. *Portret w dawnej Polsce*. Warsaw: Muzeum Pałacu Króla Jana III w Wilanowie, 2019.

Ostrowski, Jan K., and Jerzy T. Petrus, eds. *Podhorce: Dzieje wnętrz pałacowych i galerii obrazów*. Cracow: Zamek Królewski na Wawelu, 2001.

Paprocki, Bartosz. *Gniazdo cnoty zkąd herby rycerstwa sławnego Krolestwa Polskiego ... początek swoy maią*. Cracow, 1578.

Parisi, Virginio. *Relatione della solenne entrata dell'Illustriss. ... Sig. G. Ossolinschi ... Primo Gentilhuomo di Camera del Sereniss. ... Uladislas Re di Polonia, e Suetia ... e Suo Ambasciadore Straordtnario ... alla Santita di Nostro Signore Urbano VIII*. Rome: Francesco Cavalli, 1633.

———. *Vera relatione della solenne entrata dell'illustriss. & eccellentiss. sig. Giorgio Ossolinschi: Sire d; Ossolin, conte de Thencin ... promo gentilhuomo di camera del Sereniss. e potentiss. Vladislao IV ... e suo ambasciadore straordinario d'ubedienza alla Stantità di Nostro Signor PP. Urbano VIII, et insieme ambasciadore straordinario alla Sereniss. Republica di Venetia*. Rome: Francesco Cavalli, 1634.

Pasek, Jan Chryzostom. *Pamiętniki*. Edited by Jan Czubek. Cracow: Polska Akademia Nauk, 1929. http://wolnelektury.pl/katalog/lektura/pamietniki.

Paszkiewicz, Mieczysław. *Stefano della Bella, wjazd wspaniały posłów polskich do Paryża A.D. 1645: Opracował, wstepem i komentarzami opatrzył Mieczysław Paszkiewicz*. London: Nakładem Zrzeszenia Studentów i Absolwentów Polskich na Uchodźctwie, 1956.

———. 'Tematyka polska w twórczości Stefano della Belli: Część I'. *Rocznik Historii Sztuki* 14 (1984): 187–261.

———. 'Tematyka polska w twórczości Stefano della Belli: Część II'. *Rocznik Historii Sztuki* 15 (1985): 55–128.

Pathak, Anamika. *Pashmina*. New Delhi: Roli Books, 2003.

Payen, Nicolas. *Les voyages de Monsieur Payen: où sont contenues les descriptions d'Angleterre, de Flandre, de Brabant, d'Holande, de Dennemarc, de Suede, de Pologne, d'Allemagne & d'Italie*. Paris, 1667.

Pawłowska, Aneta. *Henryk Weyssenhoff (1859–1922): Zapomniany bard Białorusi*. Warsaw: Wydawnictwo DiG, 2006.

Petrycy, Sebastian. *Przydatki do Etyki Arystotelesowej*. Edited by Wiktor Wąsik and Kontanty Grzybowski. Warsaw: PWN, 1956.

Pevny, Olenka Z. 'The Encrypted Narrative of Reconstructed Cossack Baroque Forms'. *Harvard Ukrainian Studies* 31, no. 1/4 (2009/2010): 471–519.

Phillips, Amanda. *Sea Change: Ottoman Textiles between the Mediterranean and the Indian Ocean*. Oakland: University of California Press, 2021.

Piechocki, Katharina N. *Cartographic Humanism: The Making of Early Modern Europe*. Chicago: University of Chicago Press, 2019.

———. 'Erroneous Mappings: Ptolemy and the Visualization of Europe's East'. In *Early Modern Cultures of Translation*, edited by Karen Newman and Jane Tylus, 76–96. Philadelphia: University of Pennsylvania Press, 2015.

Pieniążek-Samek, Marta. '"W honor domu i jego pamięć": Kilka uwag o dekoracji Pałacu Biskupów Krakowskich w Kielcach'. *Rocznik Muzeum Narodowego w Kielcach* 25 (2010): 132–64.

Pietrzyk-Reeves, Dorota. *Polish Republican Discourse in the Sixteenth Century*. Cambridge: Cambridge University Press, 2020.

Pinner, Robert, and Walter B. Denny, eds. *Oriental Carpet and Textile Studies II*. London: Hali, 1986.

Piotrowski, Andrzej. *Architecture of Thought*. Minneapolis: University of Minnesota Press, 2011.

Piotrowski, Piotr. 'East European Art Peripheries Facing Post-Colonial Theory'. *Nonsite.Org* 12 (2014). https://nonsite.org/article/east-european-art-peripheries-facing-post-colonial-theory.

Plokhy, Serhii. *The Cossack Myth: History and Nationhood in the Age of Empires*. Cambridge: Cambridge University Press, 2014.

———. *The Origins of the Slavic Nations: Premodern Identities in Russia, Ukraine, and Belarus*. Cambridge: Cambridge University Press, 2010.

Plourin, Marie-Louise. *Marie de Gonzague: Une princesse française, reine de Pologne*. Paris: La Renaissance du livre, 1946.

Pokropek, Marian. *Tradycyjne budownictwo drzewne w Polsce*. Vol. 2. Warsaw: Neriton, 1996.

Połczyński, Michael. 'Seljuks on the Baltic: Polish–Lithuanian Muslim Pilgrims in the Court of Ottoman Sultan Süleyman I'. *Journal of Early Modern History* 19, no. 5 (2015): 409–37.

———. 'The Relacyja of Sefer Muratowicz: 1601–1602 Private Royal Envoy of Sigismund III Vasa to Shah 'Abbas I'. *Turkish Historical Review* 5, no. 1 (2014): 59–93.

Połujan, Katarzyna. *Kontusz Sashes: Collection Catalogue*. Warsaw: The Royal Castle in Warsaw – Museum, 2019.

Pomponius Mela. *Description of the World*. Translated by Frank E. Romer. Ann Arbor: University of Michigan Press, 1998.

Pope, Arthur Upham. 'So-Called Polish or Polonaise Carpets (Oriental Rugs as Fine Art, V)'. *International Studio* 76 (1923): 535–44.

Porras, Stephanie. *Pieter Bruegel's Historical Imagination*. University Park, PA: Pennsylvania State University Press, 2016.

Porter, Brian. *When Nationalism Began to Hate: Imagining Modern Politics in Nineteenth-Century Poland*. Oxford: Oxford University Press, 2000.

Portrety osobistości polskich znajdujące się w pokojach i w Galerii Pałacu w Wilanowie: Katalog. Muzeum Narodowe w Warszawie, 1967.

Poskrobko-Strzęciwilk, Janina. 'Polish Kontusz Sash and Its Cross-Cultural, Artistic and Technical Connections with the 17th–18th Century Silk Sashes from Safavid Persia and Ottoman Turkey'. PhD Thesis. Uniwersytet Mikołaja Kopernika, 2019.

Pośpiech, Andrzej. *Pułapka oczywistości: Pośmiertne spisy ruchomości szlachty wielkopolskiej z XVII wieku*. Warsaw: Letter Quality, 1992.

———. 'Szkic do portretu Sarmaty na podstawie wielkopolskich szlacheckich pośmiertnych inwentarzy mobiliów z drugiej połowy XVII w.'. In *Ubiory w Polsce*, edited by Anna Sieradzka and Krystyna Turska, 28–45. Warsaw: Stowarzyszenie Historyków Sztuki, 1994.

Potocki, Wacław. *Moralia*. Vol. 2. Cracow: Akademia Umiejętności, 1916.

Preziosi, Donald, and Bettina Messias Carbonell. 'Narrativity and the Museological Myths of Nationality'. In *Museum Studies: An Anthology of Contexts*, 2nd edn., 82–91. Oxford: Wiley-Blackwell, 2012.

Price, T. Douglas, and James H. Burton. *An Introduction to Archaeological Chemistry*. New York: Springer, 2011.

Ptaśnik, Jan, ed. *Monumenta Poloniae typographica XV et XVI saeculorum*. Vol. 1. Lviv: Ossolineum, 1922.

———. 'Spisanie kleynotów Xiężney Jey Mości Neuburskiey, Królewney Polskiey, Anno Domini MDCXLV'. *Sprawozdania Komisyi do Badania Historyi Sztuki w Polsce* 9 (1915): xcviii–xvix.

Ptolemy, Claudius. *Geography*. Translated by Edward Luther Stevenson. New York: New York Public Library, 1932.

Pyłypenko, Wołodymyr. *W obliczu wroga: Polska literatura antyturecka od połowy XVI do połowy XVII wieku*. Oświęcim: Napoleon V, 2016.

Querenghi, Antonio. 'Carmen ad Urbem Romam in adventu Serenissimi Vladislai Poloniae principis'. Translated by Grzegorz Franczak. *Terminus* 15, no. 2 (2013): 295–305.

Quickel, Anthony T. 'Cairo and Coffee in the Transottoman Trade Network'. In *Transottoman Matters: Objects Moving through Time, Space, and Meaning*, edited by Arkadiusz Blaszczyk, Robert Born, and Florian Riedler, 83–98. Göttingen: V&R Unipress, 2022.

Radway, Robyn D. 'Christians of Ottoman Europe in Sixteenth-Century Costume Books'. In *The Dialectics of Orientalism in Early Modern Europe*, edited by Marcus Keller and Javier Irigoyen-García, 173–93. London: Palgrave Macmillan, 2018.

Radziwiłł, Albrycht Stanisław. *Memoriale rerum gestarum in Polonia, 1632–1656*. Edited by Adam Przyboś and Roman Żelewski. Vol. 3. Wrocław: Zakład Narodowy im. Ossolińskich, 1972.

Rampley, Matthew. *The Vienna School of Art History: Empire and the Politics of Scholarship, 1847–1918*. University Park, PA: Penn State University Press, 2013.
Respublica, sive Status regni Poloniae, Lituaniae, Prussiae, Livoniae, etc. diversorum autorum. Leiden, 1627.
Ricoeur, Paul. *Memory, History, Forgetting*. Translated by Kathleen Blamey and David Pellauer. Chicago: University of Chicago Press, 2004.
Riegl, Alois. *Altorientalische Teppiche*. Leipzig: T.O. Weigel, 1891.
Riello, Giorgio. *Cotton: The Fabric That Made the Modern World*. Cambridge: Cambridge University Press, 2013.
Rietbergen, P. J. A. N. *Power and Religion in Baroque Rome: Barberini Cultural Policies*. Leiden: Brill, 2006.
Roberts, Jennifer L. 'Things: Material Turn, Transnational Turn'. *American Art* 31, no. 2 (2017): 64–69.
Roberts, Sean. *Printing a Mediterranean World: Florence, Constantinople, and the Renaissance of Geography*. Cambridge, MA: Harvard University Press, 2013.
Roberts, Sean, and Timothy McCall. 'Object Lessons and Raw Materials'. In *The Routledge History of the Renaissance*, edited by William Caferro, 105–24. New York: Routledge, 2017.
Rodini, Elizabeth. 'Mobile Things: On the Origins and the Meanings of Levantine Objects in Early Modern Venice'. *Art History* 41, no. 2 (2018): 246–65.
Rohdewald, Stefan, Albrecht Fuess, and Stephen Conermann. 'Transottomanica: Eastern European-Ottoman-Persian Mobility Dynamics'. *Diyâr* 2, no. 1 (2021): 5–13.
Roncallius, Dominicus. *Dominici Roncallii, … Panegyris in laudem Polonorum… habita Romae… Cui adjectae sunt aliae insignes scriptiones doctissimorum accademicorum*. Romae: apud F. Caballum, 1633.
Rosu, Felicia. *Elective Monarchy in Transylvania and Poland–Lithuania, 1569–1587*. New York: Oxford University Press, 2017.
Roszak, Stanisław. 'Forms of Patriotism in the Early Modern Polish–Lithuanian Commonwealth'. In *Whose Love of Which Country? Composite States, National Histories and Patriotic Discourses in Early Modern East Central Europe*, edited by Balázs Trencsényi and Márton Zászkaliczky, 443–60. Leiden: Brill, 2010.
Rothman, E. Natalie. *Brokering Empire: Trans-Imperial Subjects between Venice and Istanbul*. Ithaca, NY: Cornell University Press, 2012.
Rublack, Ulinka. 'Befeathering the European: The Matter of Feathers in the Material Renaissance'. *The American Historical Review* 126, no. 1 (2021): 19–53.
———. *Dressing Up: Cultural Identity in Renaissance Europe*. Oxford: Oxford University Press, 2010.
———. 'Matter in the Material Renaissance'. *Past and Present* 219 (2013): 41–85.
Rudenko, Oleksii. 'The Myth, the Text, the Map: The Imaginary Homeland and Its Geographical Markers in Early Modern Poland and Lithuania'. In *Crossing Borders, Contesting Boundaries: Proceedings of the 2020 14th MEMSA Annual Conference*, edited by Irini Picolou, 78–91. Durham: MEMSA, 2021.

Ruggieri, Fulvio. *La descrittione della Pollonia di Fulvio Ruggieri (1572)*. Edited by Paolo Bellini. Trent: Dipartimento di scienze filologiche e storiche, Università degli studi di Trento, 1994.

Ruggieri, Giulio. 'Relacya o stanie polski złożona papieżowi Piusowi V przez Julliusza Ruggieri, nuncyusza jego u dworu króla Zygmunta Augusta roku 1568'. In *Relacye nuncyuszów apostolskich i innych osób o Polsce od roku 1548 do 1690*, translated by Erazm Rykaczewski, vol. 1, 165–215. Poznań: Księgarnia B. Behra, 1864.

Russo, Alessandra. *The Untranslatable Image: A Mestizo History of the Arts in New Spain*. Translated by Susan Emanuel and Joe R. Teresa Lozano. Austin: University of Texas Press, 2014.

Rüstem, Ünver. *Ottoman Baroque: The Architectural Refashioning of Eighteenth-Century Istanbul*. Princeton: Princeton University Press, 2019.

Ruszczycówna, Janina, ed. *Portret polski XVII i XVIII wieku: Katalog wystawy*. Warsaw: Muzeum Narodowe, 1977.

Rybarski, Roman. *Handel i polityka handlowa Polski w XVI stuleciu*. Vol. 1. 2 vols. Warsaw: PWN, 1958.

Ryżewski, Grzegorz. 'Tatar Mosque, Kruszyniany'. Register of Monuments, Monuments Records, 11 September 2014. https://zabytek.pl/en/obiekty/kruszyniany-meczet-tatarski.

Şahin, Kaya, Julia Schleck, and Justin Stearns. 'Orientalism Revisited: A Conversation Across Disciplines'. *Exemplaria* 33, no. 2 (2021): 196–207.

Said, Edward W. *Culture and Imperialism*. New York: Knopf, 1993.

——. *Orientalism*. New York: Pantheon Books, 1978.

Saint-Amant, Marc-Antoine Girard de. *Oeuvres complètes de Saint-Amant*. Vol. 1. Paris: P. Jannet, 1855.

Sarnicki, Stanisław. *Annales, sive de origine et rebus gestis Polonorum et Lituanorum libri octo*. Cracow: Aleksy Rodecki, 1587.

Sarre, Friedrich. 'Die Teppiche'. In *Meisterwerken Muhammedanischer Kunst in München 1910: Text*, edited by Friedrich Sarre and Fredrik Robert Martin, Vol. 2. Munich: F. Bruckmann, 1912.

Sarre, Friedrich, and Fredrik Robert Martin. *Die Ausstellung von Meisterwerken muhammedanischer Kunst in München 1910*. Vol. 2. 3 vols. London: Alexandria Press, 1985.

Savoy, Daniel, ed. *The Globalization of Renaissance Art: A Critical Review*. Leiden: Brill, 2017.

Schäfer, Dagmar, Giorgio Riello, and Luca Molà, eds. *Threads of Global Desire: Silk in the Pre-Modern World*. Woodbridge: Boydell Press, 2018.

Schmidt, Benjamin. *Inventing Exoticism: Geography, Globalism, and Europe's Early Modern World*. Philadelphia: University of Pennsylvania Press, 2015.

Schulz, Vera-Simone. 'Infiltrating Artifacts: The Impact of Islamic Art in Fourteenth- and Fifteenth-Century Florence and Pisa'. *Konsthistorisk tidskrift* 87, no. 4 (2018): 214–33.

Shalem, Avinoam. 'Histories of Belonging and George Kubler's Prime Object'. *Getty Research Journal* 3 (2011): 1–14.

Shalem, Avinoam, and Andrea Lermer, eds. *After One Hundred Years: The 1910 Exhibition 'Meisterwerke Muhammedanischer Kunst' Reconsidered*. Leiden: Brill, 2010.

Shalev, Zur. 'Main Themes in the Study of Ptolemy's Geography in the Renaissance'. In *Ptolemy's Geography in the Renaissance*, edited by Zur Shalev and Charles Burnett, 1–14. London: The Warburg Institute, 2011.

Shibayama, Nobuko, Mark Wypyski, and Elisa Gagliardi-Mangilli. 'Analysis of Natural Dyes and Metal Threads Used in 16th–18th Century Persian/Safavid and Indian/Mughal Velvets by HPLC-PDA and SEM-EDS to Investigate the System to Differentiate Velvets of These Two Cultures'. *Heritage Science* 3, no. 12 (2015). https://doi.org/10.1186/s40494-015-0037-2.

Sieg, Katrin. 'Ethno-Maskerade: Identitätsstrategien zwischen Multikultur und Nationalismus im deutschen Theater'. *Frauen in der Literaturwissenschaft* 49 (1996).

Sieradzka, Anna. 'Ostatni Sarmaci: Polski strój narodowy w XIX i w 1. połowie XX w'. In *Ubiory w Polsce*, edited by Anna Sieradzka, 96–106. Warsaw: Stowarzyszenie Historyków Sztuki, 1994.

Sławny wjazd do Rzymu, Jasnie Wielmoznego Pana Ie[g]o M.P. Ierzego Ossolinskiego wielkiego posla polskiego, z włoskiego na polskie przetlumaczony, de data 3. Decemb. 1633. n.p., 1633.

Smith, Anthony D. *The Nation Made Real: Art and National Identity in Western Europe, 1600–1850*. Oxford: Oxford University Press, 2013.

Smith, Charlotte Colding. *Images of Islam, 1453–1600: Turks in Germany and Central Europe*. London: Pickering & Chatto, 2014.

Snyder, Timothy. *The Reconstruction of Nations: Poland, Ukraine, Lithuania, Belarus, 1569–1999*. New Haven: Yale University Press, 2003.

Sobczak, Jacek. *Położenie prawne ludności tatarskiej w Wielkim Księstwie Litewskim*. Warsaw: Państwowe Wydawnictwo Naukowe, 1984.

Sobieski, Jakub. *Peregrynacja po Europie (1607–1613); droga do Baden (1638)*. Edited by Józef Długosz. Wrocław: Zakład Narodowy im. Ossolińskich, 1991.

Soćko, Adam. *Galeria Malarstwa i Rzeźby Muzeum Narodowego w Poznaniu: Przewodnik*. Poznań: Muzeum Narodowe w Poznaniu, 2008.

Sowa, Jan. 'Spectres of Sarmatism'. In *Being Poland: A New History of Polish Literature and Culture Since 1918*, edited by Tamara Trojanowska, Joanna Niżyńska, and Przemysław Czapliński, 30–47. Toronto: University of Toronto Press, 2018.

Spallanzani, Marco. *Carpet Studies, 1300–1600*. Genoa: Sagep Editori, 2016.

———. *Oriental Rugs in Renaissance Florence*. Translated by Anna Moore Valeri. Florence: SPES, 2007.

Spooner, Brian. 'Weavers and Dealers: The Authenticity of an Oriental Carpet'. In *The Social Life of Things*, edited by Arjun Appadurai, 195–235. Cambridge: Cambridge University Press, 1988.

Spuhler, Friedrich. 'Medallion Ushak, Poland'. In *Oriental Carpets in the Museum of Islamic Art, Berlin*, edited by Friedrich Spuhler, 35–36. Exh. Cat. London: Faber and Faber, 1988.

———. 'Seidene Repräsentationsteppiche der mittleren bis späten Safawidenzeit: Die sog. Polenteppiche'. PhD Thesis, Freie Universität, 1968.

Spuhler, Friedrich, Preben Mellbye-Hansen, and Majken Thorvildsen. *Denmark's Coronation Carpets, Copenhagen*. Copenhagen: The Royal Collections, 1987.

Srodecki, Paul. *Antemurale Christianitatis: Zur Genese der Bollwerksrhetorik im östlichen Mitteleuropa an der Schwelle vom Mittelalter zur Frühen Neuzeit*. Husum: Matthiesen Verlag, 2015.

——. 'Validissima semper Christianitatis propugnacula: Zur Entstehung der Bollwerksrhetorik in Polen und Ungarn im Spätmittelalter und in der Frühen Neuzeit'. In *Sarmatismus versus Orientalismus in Mitteleuropa: Akten der internationalen wissenschaftlichen Konferenz in Zamość vom 9. bis zum 12. Dez. 2010*, edited by Magdalena Długosz and Piotr O. Scholz, 131–68. Berlin: Frank & Timme, 2012.

Starowolski, Szymon. *Polska albo opisanie Królestwa Polskiego*. Translated by Antoni Piskadło. Cracow: Wydawnictwo Literackie, 1976.

Stefanowska, Zofia, ed. *Swojskość i cudzoziemszczyzna w dziejach kultury polskiej*. Warsaw: Państwowe Wydawnictwo Naukowe, 1973.

Stępowska, Konstancya. 'Polskie dywany wełniane'. *Sprawozdania Komisyi do Badania Historyi Sztuki w Polsce* 8, no. 3/4 (1912): 352–71.

Stevens, Henry Newton. *Ptolemy's Geography: A Brief Account of All the Printed Editions Down to 1730*. Amsterdam: Meridian, 1973.

Stockhammer, Philipp W. 'Questioning Hybridity'. In *Conceptualizing Cultural Hybridization: A Transdisciplinary Approach*, edited by Philipp Wolfgang Stockhammer, 1–3. Heidelberg: Springer, 2012.

Stopka, Krzysztof. 'Armenians'. In *Under a Common Sky: Ethnic Groups of the Commonwealth of Poland and Lithuania*, edited by Michał Kopczyński and Wojciech Tygielski, 134–49. New York: PIASA Books, 2017.

Strabo. *Geography*. Translated by Horace Leonard Jones. Vol. 7. Cambridge, MA: Harvard University Press, 1995.

Stryjkowski, Maciej. *Kronika*. Vol. 1. Warsaw, 1846.

——. *Kronika polska, litewska, zmodźka, y wszystkiej Rusi*. Königsberg, 1582.

——. *Rerum Polonicarum tomi tres*. Frankfurt, 1584.

Subrahmanyam, Sanjay. 'Connected Histories: Notes Towards a Reconfiguration of Early Modern Eurasia'. *Modern Asian Studies* 31, no. 3 (1997): 735–62.

Sulimirski, Tadeusz. *The Sarmatians*. London: Thames and Hudson, 1970.

Swan, Claudia. 'Lost in Translation: Exoticism in Early Modern Holland'. In *The Fascination of Persia: The Persian-European Dialogue in Seventeenth-Century Art and Contemporary Art from Tehran*, edited by Axel Langer, 100–16. Zürich: Museum Rietberg, 2013.

Sysyn, Frank E. *Between Poland and the Ukraine: The Dilemma of Adam Kysil, 1600–1653*. Cambridge, MA: Harvard Ukrainian Research Institute, 1985.

——. 'Concepts of Nationhood in Ukrainian History Writing, 1620–1690'. *Harvard Ukrainian Studies* 10, no. 3/4 (1986): 393–423.

——. 'Regionalism and Political Thought in Seventeenth-Century Ukraine: The Nobility's Grievances at the Diet of 1641'. *Harvard Ukrainian Studies* 6, no. 2 (1982): 167–90.

———. 'The Cossack Chronicles and the Development of Modern Ukrainian Culture and National Identity'. *Harvard Ukrainian Studies* 14, no. 3/4 (1990): 593–607.
Szałygin, Jerzy. 'Dziedzictwo drewnianej architektury w Polsce'. *Ochrona Zabytków* 1–4 (2013): 281–98.
Szaniawska, Lucyna. *Sarmacja na mapach Ptolomeusza w edycjach jego 'Geografii'*. Warsaw: Biblioteka Narodowa, 1993.
Szuppe, Maria. 'Un marchand du roi de Pologne en Perse, 1601–1602'. *Moyen Orient & Ocean Indien* 3 (1986): 81–110.
Szwagrzyk, Józef Andrzej. *Pieniądz na ziemiach polskich X-XX w.* 2nd edn. Wrocław: Zakład Narodowy im. Ossolińskich, 1990.
Taboga, Maria. '1601: Un tappeto di Sigismondo III Wasa al Quirinale'. *Il Quirinale* 6 (2008): 1–12.
Tacitus. *La Germanie*. Translated by Jacques Perret. Paris: Société d'Édition Les Belles Lettres, 1983.
Talbierska, Jolanta. *Stefano della Bella, 1610–1664: Akwaforty ze zbiorów Gabinetu Rycin Biblioteki Uniwersyteckiej w Warszawie*. Warsaw: Neriton, 2001.
———. 'Twórczość Stefana della Bella (1610–1664)'. *Rocznik Historii Sztuki* 28 (2003): 81–168.
Tallemant des Réaux, Gédéon. *Les historiettes*. Vol. 3. Paris, 1862.
Tamir, Yael. *Why Nationalism*. Princeton, NJ: Princeton University Press, 2019.
Targosz, Karolina. *Uczony dwór Ludwiki Marii Gonzagi, 1646–1667: Z dziejów polsko-francuskich stosunków naukowych*. Wrocław: Zakład Narodowy im. Ossolińskich, 1975.
Tazbir, Janusz. *Kultura szlachecka w Polsce: rozkwit – upadek – relikty*. Poznań: Wydawnictwo Poznańskie, 1998.
———. 'Polish National Consciousness in the Sixteenth to the Eighteenth Century'. *Harvard Ukrainian Studies* 10, no. 3/4 (1986): 316–35.
———. 'Sarmatyzm a barok'. *Kwartalnik Historyczny* 76, no. 4 (1969): 815–30.
———. 'Stosunek do obcych w dobie baroku'. In *Swojskość i cudzoziemszczyzna w dziejach kultury polskiej*, edited by Zofia Stefanowska, 80–112. Warsaw: Państwowe Wydawnictwo Naukowe, 1973.
Teece, Denise-Marie. 'Arabic Inscriptions in the Service of the Church: An Italian Textile Evoking an Early Christian Past?' In *The Nomadic Object: The Challenge of World for Early Modern Religious Art*, edited by Christine Göttler and Mia M. Mochizuki, 74–102. Leiden: Brill, 2017.
———. 'Through the Renaissance Frame: Carpets and the Beginnings of "Islamic Art" in Nineteenth-Century Vienna and Berlin'. *The Textile Museum Journal* 44 (2017): 47–69.
Tende, Gaspard de. *An Account of Poland*. London: T. Goodwin, 1698.
Teply, Karl. 'Kundschafter, Kuriere, Kaufleute, Kaffeesieder: Die Legende des Wiener Kaffeehauses auf dem Röntgenschirm der Geschichte und Volkskunde'. *Österreich in Geschichte und Literatur* 22, no. 1 (1978): 1–17.
'The Czartoryski Carpet'. In *The Met*, www.metmuseum.org/art/collection/search/450563 (accessed 26 September 2017).

Thielemans, Veerle. 'Beyond Visuality: Review on Materiality and Affect'. *Perspective* 2 (2015). https://doi.org/10.4000/perspective.5993.

Thomas, Nicholas. *Entangled Objects: Exchange, Material Culture, and Colonialism in the Pacific*. Cambridge, MA: Harvard University Press, 1991.

Thompson, Ewa. 'Sarmatism, or the Secrets of Polish Essentialism'. In *Being Poland: A New History of Polish Literature and Culture since 1918*, edited by Tamara Trojanowska, Joanna Niżyńska, and Przemysław Czapliński, 3-29. Toronto: University of Toronto Press, 2018.

Thompson, Jon. *Carpets from the Tents, Cottages and Workshops of Asia*. London: Barrie and Jenkins, 1988.

Tkanina turecka XVI-XIX w. ze zbiorów polskich. Exh. Cat. Warsaw: Muzeum Narodowe w Warszawie, 1983.

Tłoczek, Ignacy F. *Polskie budownictwo drewniane*. Wrocław: Zakład Narodowy im. Ossolińskich, 1980.

Todorova, Maria. *Imagining the Balkans*. Oxford: Oxford University Press, 1997.

Tomaszewski, Edward. *Ceny w Krakowie w latach 1601-1795*. Lviv: Kasa im. Rektora J. Mianowskiego, 1934.

Tomkiewicz, Władysław. 'Aktualizm i aktualizacja w malarstwie polskim XVII wieku'. *Biuletyn Historii Sztuki* 13, no. 1 (1951): 55-76.

———. 'W kręgu kultury Sarmatyzmu'. *Kultura* 30 (1966).

———. *Z dziejów polskiego mecenatu artystycznego w wieku XVII*. Wrocław: Ossolineum, 1952.

Torbus, Tomasz, and Malgorzata Omilanowska, eds. *Tür an Tür: Polen – Deutschland, 1000 Jahre Kunst und Geschichte*. Cologne: DuMont, 2011.

Török, Zsolt G. 'Renaissance Cartography in East-Central Europe, ca. 1450-1650'. In *Cartography in the European Renaissance*, edited by David Woodward, vol. 3, 1806-51. Chicago: University of Chicago Press, 2007.

Traub, Valerie. 'Mapping the Global Body'. In *Early Modern Visual Culture: Representation, Race, and Empire in Renaissance England*, edited by Peter Erickson and Clark Hulse, 44-97. Philadelphia: University of Pennsylvania Press, 2000.

Trevor-Roper, Hugh. 'The Invention of Tradition: The Highland Tradition of Scotland'. In *The Invention of Tradition*, edited by Eric Hobsbawm and Terence Ranger, 15-42. Cambridge: Cambridge University Press, 1983.

Troelenberg, Eva. 'Islamic Art and the Invention of the "Masterpiece": Approaches in Early Twentieth-Century Scholarship'. In *Islamic Art and the Museum: Approaches to Art and Archeology of the Muslim World in the Twenty-First Century*, edited by Benoît Junod, Georges Khalil, Gerhard Wolf, and Stefan Weber, 183-88. London: Saqi, 2012.

Tseëlon, Efrat. 'Introduction: Masquerade and Identities'. In *Masquerade and Identities: Essays on Gender, Sexuality and Marginality*, edited by Efrat Tseëlon, 1-17. London: Routledge, 2001.

Tułowiecka, Agnieszka. 'Herbarze i Quasi-Herbarze: Wokół Konstrukcji Genologicznych Bartosza Paprockiego'. PhD Thesis, Uniwersytet Śląski, 2009.

Turnau, Irena. *History of Dress in Central and Eastern Europe from the Sixteenth to the Eighteenth Century*. Warsaw: Institute of the History of Material Culture, Polish Academy of Sciences, 1991.

———. 'Rozwój ubioru narodowego od około 1530 do 1795 roku'. *Kwartalnik Historii Kultury Materialnej* 34, no. 3 (1986): 413–23.

———. 'Słownik nazw ubiorów używanych w Polsce od średniowiecza do początku XIX wieku: Źródła i koncepcja'. *Kwartalnik Historii Kultury Materialnej* 45, no. 1 (1997): 67–73.

———. *Słownik ubiorów: Tkaniny, wyroby pozatkackie, skóry, broń i klejnoty oraz barwy znane w Polsce od średniowiecza do początku XIX w*. Warsaw: Semper, 1999.

———. *Ubiór narodowy w dawnej Rzeczypospolitej*. Warsaw: Semper, 1991.

———. 'Ubiór żydowski w Polsce XVI–XVIII wieku'. *Przegląd Orientalistyczny* 3 (1987): 297–311.

Twardowski, Samuel. *Władysław IV, król polski i szwedzki*. Edited by Roman Krzywy. Warsaw: Instytut Badań Literackich PAN, 2012.

Tyszkiewicz, Jan. 'Tatars'. In *Under a Common Sky: Ethnic Groups of the Commonwealth of Poland and Lithuania*, edited by Michał Konopczyński and Wojciech Tygielski, 150–62. New York: PIASA Books, 2017.

———. *Tatarzy na Litwie i w Polsce: Studia z dziejów XIII–XVIII w*. Warsaw: Państwowe Wydawnictwo Naukowe, 1989.

Uffelmann, Dirk. 'Importierte Dinge und imaginierte Identität: Osmanische "Sarmatica" im Polen der Aufklärung'. *Zeitschrift für Ostmitteleuropa-Forschung* 65, no. 2 (2016): 193–214.

Ulewicz, Tadeusz. *Sarmacja: Studium z problematyki słowiańskiej XV i XVI w*. Cracow: Wydawnictwo Studium Słowiańskiego Uniwersytetu Jagiellońskiego, 1950.

Unowsky, Daniel. 'Stimulating Culture: Coffee and Coffeehouses in Modern European History'. *Journal of Urban History* 42, no. 4 (2016): 806–10.

Venclova, Tomas. 'Mit o początku'. *Teksty* 4 (1974): 104–16.

Vesme, Alessandro Baudi di. *Le peintre-graveur italien: Ouvrage faisant suite au Peintre-graveur de Bartsch*. Milan: Ulrico Hoepli, 1906.

Viatte, Françoise. *Dessins de Stefano della Bella 1610–1664*. Paris: Éditions des Musées Nationaux, 1974.

Walaszek, Adam. 'Wstęp'. In *Trzy rejacje z polskich podróży na Wschód muzułmański w pierwszej połowie XVII wieku*, edited by Adam Walaszek. Cracow: Wydawnictwo Literackie, 1980.

Walawender-Musz, Dominika. *Entrata Księcia Radziwiłła do Rzymu czyli triumf po polsku*. Warsaw: Muzeum Pałac w Wilanowie, 2009.

Walczak, Bogdan, and Agnieszka Mielczarek. 'Prolegomena historyczne: Wielojęzyczność w Rzeczypospolitej Obojga Narodów'. *Białostockie Archiwum Językowe* 17 (2017): 255–68.

Waliszewski, Kazimierz. *Polsko-francuzkie stosunki w XVII wieku 1644–1667: Opowiadania i źródła historyczne ze zbiorów archiwalnych francuzkich publicznych i prywatnych*. Cracow: Drukarnia Uniwersytetu Jagiellońskiego, 1889.

Walker, Shaun, and Flora Garamvolgyi. 'Viktor Orbán Sparks Outrage with Attack on "Race Mixing" in Europe'. *The Guardian*, 24 July 2022. www.theguardian.com/world/2022/jul/24/viktor-orban-against-race-mixing-europe-hungary?mc_cid=5e947248cb&mc_eid=cd1f92f96c.

Warner, Marina. *Stranger Magic: Charmed States and the Arabian Nights*. Cambridge, MA: Belknap Press, 2013.

Wasiucionek, Michał. 'Introduction: Objects, Circuits, and Southeastern Europe'. *Journal of Early Modern History* 24, no. 4/5 (2020): 303–16.

———. *The Ottomans and Eastern Europe: Borders and Political Patronage in the Early Modern World*. London: I.B. Tauris, 2021.

Weiss, Benjamin. 'The *Geography* in Print, 1475–1530'. In *Ptolemy's 'Geography' in the Renaissance*, edited by Zur Shalev and Charles Burnett, 91–120. London: The Warburg Institute, 2011.

Welch, Ellen R. 'The Specter of the Turk in Early Modern French Court Entertainments'. *L'Esprit Créateur* 53, no. 4 (2013): 84–97.

Welsch, Wolfgang. 'Transculturality: The Puzzling Form of Cultures Today'. In *Spaces of Culture: City, Nation, World*, edited by Mike Featherstone and Scott Lash, 194–213. London: Sage, 1999.

Werner, Michael. 'Kulturtransfer und Histoire croisée: Zu einigen Methodenfragen der Untersuchung soziokultureller Interaktionen'. In *Zwischen Kahlschlag und Rive Gauche: Deutsch-französische Kulturbeziehungen 1945–1960*, edited by Stephan Braese and Ruth Vogel-Klein, 21–42. Würzburg: Königshausen & Neumann, 2015.

Werner, Michael, and Bénédicte Zimmermann. 'Beyond Comparison: Histoire Croisée and the Challenge of Reflexivity'. *History and Theory* 45 (2006): 30–50.

Weyssenhoff, Józef. *Kronika rodziny Weyssów-Weyssenhoffów*. Vilnius: Waldemar Weyssenhoff, 1935.

Whitfield, Susan. *Life Along the Silk Road*, 2nd edn. Oakland: University of California Press, 2015.

Widacka, Hanna. 'Jerzy Franciszek Kulczycki: The Founder of the First Café in Vienna'. *Silva Rerum*, 4 February 2011. www.wilanow-palac.pl/jerzy_franciszek_kulczycki_the_founder_of_the_first_caf_in_vienna.html.

Wiliński, Stanisław. *U źródeł portretu staropolskiego*. Warsaw: Arkady, 1958.

Willkomm, Bernhard. 'Beiträge zur Reformationsgeschichte aus Drucken und Handschriften der Universitätsbibliothek in Jena'. *Archiv für Reformationsgeschichte* 9, no. 3 (1912): 240–62.

Wilson, Bronwen. *The World in Venice: Print, the City and Early Modern Identity*. Toronto: University of Toronto Press, 2005.

Wilson, Bronwen, and Angela Vanhaelen. 'Introduction: Making Worlds: Art, Materiality, and Early Modern Globalization'. *Journal of Early Modern History* 23, no. 2/3 (2019): 103–20.

Winichakul, Thongchai. *Siam Mapped: A History of the Geo-Body of a Nation*. Honolulu: University of Hawaii Press, 1994.

Wisner, Henryk. *Rozróżnieni w wierze*. Warsaw: Książka i Wiedza, 1982.

Wiśniewski, Jerzy. 'Osadnictwo tatarskie w Sokólskiem i na północnym Podlasiu'. *Rocznik Białostocki* 16 (1991): 325–405.
Wjazd spaniały posłów polskich do Paryża. Warsaw: Piotr Elert, 1645.
Wójcicki, Kazimierz Władysław, ed. *Pamiętniki do panowania Zygmunta III, Władysława IV i Jana Kazimierza*. Vol. 2. Warsaw: S. Orgelbrand, 1846.
Wolff, Larry. *Inventing Eastern Europe: The Map of Civilization on the Mind of the Enlightenment*. Stanford: Stanford University Press, 1994.
Wood, Christopher S. *Forgery, Replica, Fiction: Temporalities of German Renaissance Art*. Chicago: Chicago University Press, 2008.
Woodward, David. *Maps as Prints in the Italian Renaissance: Makers, Distributors and Consumers*. London: The British Library, 1996.
Wouk, Edward. 'Reclaiming the Antiquities of Gaul: Lambert Lombard and the History of Northern Art'. *Simiolus* 36, no. 1 (2012): 35–65.
Wrede, Marek. *Sejm i dawna Rzeczpospolita: Momenty dziejowe*. Warsaw: Wydawnictwo Sejmowe, 2005.
Ydema, Onno. *Carpets and Their Datings in Netherlandish Paintings, 1540–1700*. Zutphen: Walburg Pers, 1991.
Young, Robert J. C. *Colonial Desire: Hybridity in Theory, Culture, and Race*. London: Routledge, 1995.
Ysselsteyn, Gerardina Tjaberta. *Geschiedenis der tapijtweverijen in de noordelijke Nederlanden: Bijdrage tot de geschiedenis der kunstnijverheid*. Vol. 2. Leiden: Leidsche Uitgeversmaatschappij, 1936.
Zabłocki, Franciszek. *Sarmatyzm: Komedya w pięciu aktach*. Lviv: Nakł. dr. Wilhelma Zukerkandla, 1905.
Zachara, Maria, and Teresa Majewska-Lancholc. 'Instrukcja Krzysztofa II Radziwiłła dla syna Janusza'. *Odrodzenie i Reformacja w Polsce*, no. 16 (1971): 171–84.
Zakrzewski, Andrzej B. 'Tatarzy litewscy w oczach władzy i współmieszkańców, XVI-XVIII w'. In *Staropolski ogląd świata: Rzeczpospolita pomiędzy okcydentalizmem a orientalizacją*, edited by Filip Wolański and Robert Kołodziej, vol. 1, 20–31. Toruń: Adam Marszałek, 2009.
Zantop, Susanne. *Colonial Fantasies: Conquest, Family, and Nation in Precolonial Germany, 1770–1870*. Durham, NC: Duke University Press, 1997.
Zubrzycki, Geneviève, ed. *National Matters: Materiality, Culture and Nationalism*. Stanford: Stanford University Press, 2017.
Żukowski, Jacek. 'Infantka Anna Katarzyna Konstancja i kultura artystyczno-kolekcjonerska dworu wazowskiego'. *Biuletyn Historii Sztuki* 79, no. 2 (2017): 233–312.
———. 'Kniaź Wielki Moskiewski Władysław Zygmuntowicz: Przegląd ikonografii w 400-Setną Rocznicę Elekcji'. *Acta Academiae Artium Vilnensis* 65–66 (2012): 177–209.
———. 'W kapeluszu i w delii, czyli ewenement stroju mieszanego w dawnej Rzeczypospolitej'. *Kwartalnik Historii Kultury Materialnej* 57, no. 1 (2009): 19–37.
———. *Żądza chwały: Władysław IV Waza w ikonografii performatywnej*. Warsaw: Muzeum Pałacu Króla Jana III w Wilanowie, 2018.

Żygas, K. Paul. 'The Muslim Tartars of the Grand Duchy of Lithuania and Their Architectural Heritage'. *Centropa* 8, no. 2 (2008): 124–33.

Żygulski Jr., Zdzisław. 'Akcenty tureckie w stroju Batorego'. *Folia Historiae Artium* 24 (1988).

———. 'The Impact of the Orient on the Culture of Old Poland'. In *Land of the Winged Horsemen: Art in Poland, 1572–1764*, edited by Jan K. Ostrowski, 69–79. New Haven: Yale University Press, 1999.

———. 'Wspomnienie o Tadeuszu Mańkowskim'. Mój Lwów, 1996. www.lwow.home.pl/zygulski.html.

Zyznowski, Stanislaus. *Cvrsvs Gloriae Jllustrissimi et Excellentissimi Domini d. Alexandri in Koniecpole Koniecpolski, Palatini Sendomiriensis*. Cracow: Christoph Schedel, 1659.

Index

Age of Enlightenment 35, 104
ambassadors, Polish 10, 15–16, 101–3,
 105–10, 113–29, 131, 134, 136
 clothing of 15–16, 102, 105–6, 108–9, 113,
 115–17, 127–28, 136
 Opaliński, Łukasz 15–16, 101–3, 105–9,
 113–14, 117, 136
 Ossoliński, Jerzy 15–16, 77, 79, 101, 105,
 114–17, 119–28, 131, 134, 136, 143n.80
Anderson, Benedict 12
Anne of Austria 108
art history 19–20, 81, 103, 129, 136–37,
 158, 179
 Anglophone 18
 idea of origin 21n.12
 Polish-Lithuanian 19
 see also Mańkowski, Tadeusz

Barącz, Erazm 169
Battle of Khotyn 85, 122
Beauplan, Guillaume Le Vasseur de 165
Bennett, Jane 14
Białobocki, Jan 86
Białostocki, Jan 19
Biedrońska-Słota, Beata 84
Bielski, Marcin 36–37, 46, 75–76
Bode, Wilhelm 154–55, 157
Bongiovanni, Bernardo 65

Caesar, Julius 32
Campion, François 108–9
carpets see tapis polonais
cartography 15, 30–32, 34–35, 38–39, 43–45
 of Poland-Lithuania 15, 30–32, 34,
 38, 43–45

 of Sarmatia 30–32, 37–42, 44–46, 48–49
Castiglione, Baldassare 63–64
Catholicism 5, 11, 47, 63, 67, 119, 123–24,
 179, 198
 popes 47, 65, 114, 116, 141n.59
Charles V of Lorraine, Duke 6, 8
Chronica Polonorum 36
Chrzanowski, Tadeusz 81, 104
Clifford, James 1, 19
clothing
 costume books 69, 82–83, 89, 94n.52, 114,
 145n.122
 European fashions 12, 57–58, 60–61, 63,
 65, 69–72, 75, 82, 105, 109, 114
 of Georg Franz Kolschitzky 1–2,
 6–8, 12
 historicizing fashion 72–79
 of King Stephen Báthory 65–67
 as marker of identity 19, 69–70, 72,
 77, 82, 89
 Orientalization of Polish *see* Ottoman
 fashions
 Ottoman fashions 12–13, 15–16, 19, 35,
 60–70, 75, 77, 79–80, 83–86, 88–89,
 92n.30, 113, 116, 172
 of Polish ambassadors 15–16, 102, 105–6,
 108–9, 113, 115–17, 127–28, 136
 Polish costume 13, 33, 63–65, 67,
 71–75, 77, 79–80, 82–85, 88–89,
 101, 111–14, 117–29, 134–36,
 179–80
 of Sarmatians 33, 108, 111–12
 of Sebastian Lubomirski 57–61, 67
 women's 72–73, 86
 see also textiles

coats of arms
 of Anne Catherine Constance
 Vasa 166–68
 of de'Medici family 142n.80
 of Krzysztof Wiesiołowski 173–76
 of Sigismund III 159–64
 on *tapis polonais* 153, 159–68,
 173–77
 woodcuts of 77
coffee 1, 3–5, 8–9, 20
Cossacks 12, 63, 165
costume
 Polish 13, 33, 63–65, 67, 71–75, 77, 79–80,
 82–85, 88–89, 101, 111–14, 117–29,
 134–36, 179–80
 of Sarmatians 33, 108, 111–12
 see also clothing
costume books 69, 82–83, 89, 94n.52, 114,
 145n.122
Csombor, Márton Szepsi 67
Cusanus 38–39
Czartoryski Carpet (Met Museum) 155–56
Czartoryski, Władysław 147, 152–53, 179

Dantiscus, Johannes 42
de Monte, Giovanni 58
de Tende, Gaspard 134–36
Dean, Carolyn 81
Decius, Iodocus Ludovicus 42–43
della Bella, Stefano 106–7, 117–29, 131,
 133–34, 142n.80
Demange, Yann 1, 147
Dembołęcki, Wojciech 52n.39
de'Medici, Lorenzo 142n.80
demi-Orientalism 13, 88, 104, 111, 136, 152
Denhoff, Gerard 137n.4
Dichtl, Martin 7
Długosz, Jan 37–40, 43
Dolabella, Tommaso 67–68
Dönhoff, Gerhard 107
d'Orleans, Anne Marie Louise 112
doublethink 150, 166, 168, 172, 181, 183n.6
Duodo, Pietro 67

Eck, Johannes 42
elites 15, 18, 62, 81, 104–5, 113, 165

adoption of Ottoman fashions *see*
 Ottoman fashions
nobility, Lithuanian 31, 37, 43
nobility, Polish 11–12, 33, 43, 49, 57, 60,
 67, 77, 86, 88–89, 104, 117
Espagne, Michel 17
ethnomasquerade 113
European fashions 12, 57–58, 60–61, 63, 65,
 69–72, 75, 82, 105, 109, 114
Exhibition of Historical and Ethnographic
 Arts (1878) 147, 150–53, 179

Fantuzzi, Giacomo 166
Farago, Claire 18
Faroqhi, Suraiya 86
fashion
 European 12, 57–58, 60–61, 63, 65, 69–72,
 75, 82, 105, 109, 114
 historicizing 72–79
 Ottoman 12–13, 15–16, 19, 35, 60–70, 75,
 77, 79–80, 83–86, 88–89, 92n.30, 113,
 116, 172
 see also clothing
Feige, Johann Constantin 6
Firlej, Andrzej 84
Foucault, Michel 151
Fuchs, Barbara 57

Gastaldi, Giacomo 45
Gaston, Duke of Anjou 108
Gazette de France 105–8, 113
Gell, Alfred 14
Gellner, Ernest 30
Gembicki, Andrzej 122
Genealogia sarmatyzmu 18, 30, 32, 35–37
Germanus, Nicolaus 39
Gonzague de Nevers, Marie-Louise
 101, 105–8, 110–11, 134, 137n.4,
 160, 165
Górnicki, Łukasz 64–65
Grand Tour 71
Grodecki, Jan 44
Grodecki, Wacław 43–45
Guagnini, Alessandro 46, 83–84
Guile, Carolyn 197
Guldenstern, Zygmunt 175

Index

Halecki, Oskar xvii
Harman, Graham 14
Hartknoch, Christoph 48
Hartley, L. P. 194
Hauteroche, Noël Le Breton de 112–13
Havel, Václav xvii
Heidegger, Martin 14
Helgerson, Richard 45
Herburt, Jan 84
Herodotus 32, 36
Hess, Johann 40, 42
Hobsbawm, Eric 10, 20, 57
Hoffmann, Johann 169, 171
hybridity 81–82

identity
 clothes as marker of 19, 69–70, 72, 77, 82, 89
 Sarmatia as 47–49
 shaping of Polish-Lithuanian 103–5, 107–10, 114–29
Ilg, Ulrike 129
invented tradition 10, 15, 20, 35, 61
Islam 11, 19, 119, 195–99

Jagiellon, Anna 159
Jakubowicz, Murat 172
Jazłowiecki, Hieronim 178
John II Casimir, King 69–70, 169
John III Sobieski, King 85, 194, 197
Judaism 11, 81, 119
Julius III, Pope 47

Kaufmann, Thomas DaCosta 19
Kieniewicz, Jan 136
Kober, Martin 65–67
Kociszewski, valet de chambre 115, 125, 131
Kolschitzky, Georg Franz 1–10, 20
 appearance of 1–2, 6–8, 12
Koniecpolski, Stanisław 121, 172
Konrád, György xvii
Korfiński, Manuel 172
Kozica, Kazimierz 45
Krasiński, Stanisław 79–80
Kretkowski, Jan Kazimierz 175–76
Kromer, Marcin 36, 43–44

Kruszyniany 194–99
Krzeczowski, Samuel 194–95, 197
Krzysztof II Radziwiłł 71, 175
Kundera, Milan xvii
Kysil, Adam 47, 49

Ladislaus IV, King 67, 69–70, 77, 101, 106–7, 114, 119–20, 122–24, 137n.4, 160, 165
language xvi, 6, 11, 35, 158, 179, 197–98
Latour, Bruno 14
Le feint Polonois ou la veuve impertinente 112–13
Le Laboureur, Jean 165
Leibsohn, Dana 81
Leszczyński, Wacław 101, 106, 108
Leszko II, legendary ruler 75–76
Lithuania, Grand Duchy of 11, 31, 34, 36, 38, 40, 43, 46, 181, 194, 197–98
 nobility 31, 37, 43
 union with Poland *see* Poland–Lithuania
Lorck, Melchior 129–32
Louis XIV, King 107–8
Lowenthal, David 197
Łoziński, Władysław 103
Lubomirski, Aleksander 177–78
Lubomirski, Sebastian 57–61, 67

Madżarski, Jan 154
Mańkowski, Tadeusz 12–13, 18, 32–34, 79–81, 89, 103–4, 158–59, 169, 173
 Genealogia sarmatyzmu 18, 30, 32, 35–37
maps *see* cartography
Marolles, Michel de 108
Martin, Fredrik R. 157
Masaryk, Tomáš xvii
Mason, Peter 178
Massar, Phyllis Dearborn 129
materiality 14
Mazarin, Jules 107
Mazarski, carpet-maker 152–54
Mehmet IV, Sultan 194
Mela, Pomponius 38
Melanchthon, Philip 42
Mercator, Gerardus 45
metalwork 18
Metropolitan Museum of Art 155
Miechowita, Maciej 36, 42, 65

Młodecki, Jerzy 159
Monitor 35
monoculturalism 17, 19, 34, 157, 179, 197
Motteville, Françoise Bertaut de 101–5, 110–11, 136
Mrozowski, Przemysław 81, 104
Muratowicz, Sefer 85, 158–60, 166
Myszkowski, Zygmunt Gonzaga 67

Nagel, Alexander 79
names, spelling of xv–xvii, 106, 143n.80
nativism 16–17, 20
Nicholas of Cusa 38–39
Niedźwiedź, Jakub 34–35
nobility 46, 57, 60, 63, 71–74, 101, 117–29, 135, 144n.98, 179
 Lithuanian 31, 37, 43
 Polish 11–12, 33, 43, 49, 57, 60, 67, 77, 86, 88–89, 104, 117
 see also elites; *individuals*
Nora, Pierre 75

Oleśnicki, Zbigniew 38
Opaliński, Krzysztof 71
Opaliński, Łukasz 15–16, 101–3, 105–9, 113–14, 117, 136
Oporinus, Johann 43–44
Oriental carpets *see tapis polonais*
Orientalism 13, 15–16, 33, 81, 87–88, 102–4, 110, 136
Orientalization 18, 32, 79, 85–89, 101, 179
 self-Orientalization 12–13, 36, 61–62, 81, 86, 89, 136
 see also Ottoman fashions
Ortelius, Abraham 44
Orthodoxy 11–12, 123–24
Ortiz, Fernando 5, 151
Orwell, George 183n.6
Orzechowski, Stanisław 11, 47, 63, 65
Ossoliński, Jerzy 15–16, 77, 79, 101, 105, 114–17, 119–28, 131, 134, 136, 143n.80
Ostrogska, Eurfrozyna 178
Ottoman Empire 11, 13, 18, 61, 63, 82, 87, 108, 136–37
 Battle of Khotyn 85, 122
 Siege of Vienna 1, 6–8

Ottoman fashions 12–13, 15–16, 19, 35, 60–70, 75, 77, 79–80, 83–86, 88–89, 92n.30, 113, 116, 172

Pamiętniki 37
Paprocki, Bartosz 75, 77–78
Parisi, Virginio 116, 121
Pasek, Jan Chryzostom 37, 85
Paul V, Pope 141n.59
Pawłowska, Aneta 181
Payen, Nicholas 88–89
Pendl, Emanuel 1–2, 8
Philippe, Duke of Orléans 108
Piekarski, Kazimierz 40
Piotrowski, Piotr 112
Pirckheimer, Willibald 40, 42
Pius V, Pope 65
Pius VI, Pope 65
Pliny 15, 38
Pograbka, Andrzej 30–32, 34, 38, 44–46
Poland, Kingdom of 11, 34, 38, 40, 43, 45–46
 nobility 11–12, 33, 43, 49, 57, 60, 67, 77, 86, 88–89, 104, 117
 union with Lithuania *see* Poland-Lithuania
Poland-Lithuania 10–13
 ambassadors 6, 15–16, 101–3, 105–10, 113–29, 131, 134, 136
 cartography of 15, 30–32, 34, 38, 43–45
 costume *see* clothing
 identity, shaping of 103–5, 107–10, 114–29
 Ottomanization of costume in *see* Ottoman fashions
 union established 11–12
Polish carpets *see tapis polonais*
Porter, Brian 4
portraits 57–60, 65–67, 71–79, 178
Protestant Christianity 11, 119
Ptolemy 15, 32, 38, 40, 48–49
 Geography 38

Radziwiłł, Janusz 165
Réaux, Gédéon Tallement 102
reinvented tradition 89
religion 11, 195–99
 see also individual religions

Riegl, Alois 154–55, 157
Roman Catholicism *see* Catholicism
Romanticism 35
Roncalli, Domenico 109, 121–22
Rossi, Giovanni Giacomo de 118
Rothman, Natalie 9
Ruggieri, Giulio 65
Ruiz de Moros, Pedro 65
Rus 39–40, 47
Rzeczpospolita *see* Poland-Lithuania

Said, Edward 87–88, 102–4
Saint-Amant, Marc-Antoine Girard de 111–12
Sarmatia 10, 15, 30–37, 108
 cartography of 30–32, 37–42, 44–46, 48–49
 clothing of 33, 108, 111–12
 heterogeneity of 37–47
 as an identity 47–49
Sarmatism 32–35, 37, 48
 see also Genealogia sarmatyzmu
Sarmatyzm (1784) 35
Sarnicki, Stanisław 46
Sarre, Friedrich 154
Schmidt, Benjamin 178
Schultz, Daniel, the Younger 79–80
sejm 30, 60–61, 67, 70, 77, 83, 106, 135
 of 1635 116, 125
 of 1641 47, 49
 of 1688 197
 self-Orientalization 12–13, 36, 61–62, 81, 86, 89, 136
Sieg, Katrin 113
Siege of Vienna 1, 6–8
Sienkiewicz, Henryk 35
Sigismund I, King 40, 42–43
Sigismund II, King 45, 65, 159
Sigismund III, King 67–70, 85, 123–24, 141n.59, 158–61, 166, 175
 coat of arms 159–64
Sobieski, Jakub 69
Spuhler, Friedrich 155, 160, 175
Stanislaus Augustus, King 35
Starowolski, Szymon 86
Stawisz, knight 77–88

Stephen Báthory, King 65–67, 69, 75, 83, 159, 172
Stępowska, Konstancja 175
Story of a Yatagan 179–81
Strabo 15, 36, 38
Stryjkowski, Maciej 37, 46
Suleiman I 79
Swan, Claudia 113
Swoszowski, Jan 67

Tacitus 15, 32, 36, 38
Tamir, Yael 194
tapis polonais 16, 147–83
 of Anne Catherine Constance Vasa 166–68
 coats of arms on 153, 159–68, 173–77
 early doubts regarding provenience 154–55, 157
 at Exhibition of Historical and Ethnographic Arts (1878) 147, 150–53, 179
 images of 148–49, 156, 161–64, 167, 170–71, 174, 176–77
 purchase of by Muratowicz 158–60, 166
 white eagle on 160, 166–67
Tatars 11, 40, 63, 108, 115, 118, 124, 128, 134, 194–99
Tazbir, Janusz 81
textiles 18, 63, 79, 86, 168
Thomas, Nicholas 17, 166
Todorova, Maria 13, 104
Tomkiewicz, Władysław 74
Torres, Cosimo de 114–15
Trzecieski, Andrzej, the Elder 42
Twardowski, Samuel 70

Uffelmann, Dirk 74
Ulewicz, Tadeusz 32–34
Ungler, Florian 40
Urban VIII, Pope 114, 116

Valois, Henri de 106
Vasa, Anne Catherine Constance 166–68
Vasili IV Shuisky, tsar 67

Wapowski, Bernard 40–43, 45
Warner, Marina 147

Werner, Michael 17
Weyssenhoff, Henryk 179–81
white eagle 160, 166–67
Wiesiołowska, Aleksandra 173, 175
Wiesiołowski, Krzyszrof 173, 175
Wittelsbach, Philipp Wilhelm 166, 168
Wolff, Larry xvii, 13, 88, 101, 104, 136, 152
Wołucki, Paweł 141n.59
women's clothing 72–73, 86
Wood, Christopher 79

yatagan dagger 180–81

Zabłocki, Franciszek 35
Zamoyski, Jan 172
Żółkiewski, Stanisław 67–68
Żukowski, Jacek 71
Zwirina, Karl 1, 9
Żygulski, Zdzisław 65, 104
Żyznowski, Stanisław 172